Ruth Baggett

Cell 210.

H. - 443

DEGAS

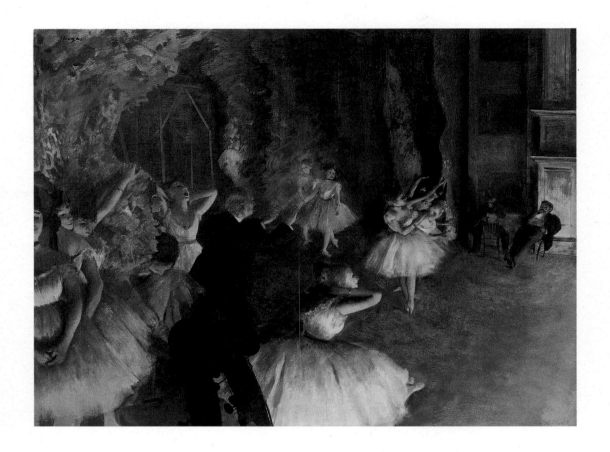

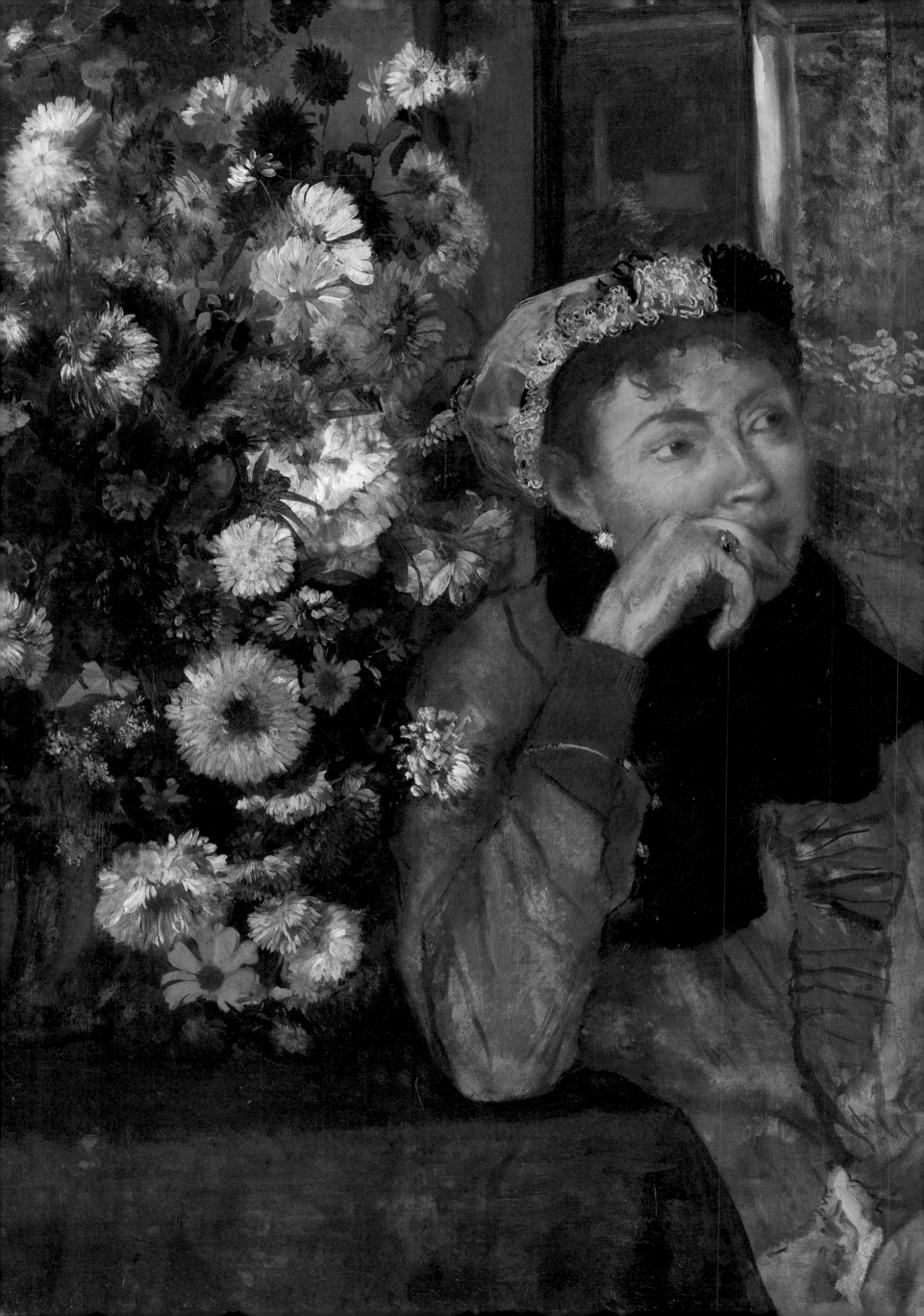

DEGAS

FRANK MILNER

GALLERY BOOKS
An imprint of W.H. Smith Publishers Inc.
112 Madison Avenue
New York, New York 10016

Published by Gallery Books
A Division of W H Smith Publishers Inc.
112 Madison Avenue
New York, New York 10016

Produced by
Brompton Books Corp.
15 Sherwood Place
Greenwich, CT 06830

ISBN 0-8317-2180-4

Printed in Italy

Page 1: *The Rehearsal of the Ballet on the Stage,*
?1874, Metropolitan Museum of Art, New York

Page 2: *A Woman with Chrysanthemums* (detail),
1865, Metropolitan Museum of Art, New York

Contents and List of Plates

Introduction 6

Self-Portrait 24
Roman Beggar Woman 26
Woman on a Terrace 28
The Bellelli Family 30
Study of A Nude 32
Copy after Delacroix's Entry of
 the Crusaders into Constantinople 34
The Daughter of Jephthah 35
Young Spartans 36
Semiramis Building Babylon 38
The Crucifixion, after Mantegna 40
The Gentlemen's Race – Before
 the Start 42
Scenes of War in the Middle Ages 44
A Woman with Chrysanthemums 46
Edouard and Thérèse Morbilli 48
The Collector of Prints 50
Racehorses before the Stands 52
James Tissot 54
Mlle Fiocre in the Ballet 'La Source' 56
Interior 58
Portrait of Monsieur and Madame
 Edouard Manet 60
The Orchestra of the Opéra 62
Madame Gobillard 64
Seascape 65
Carriage at the Races 66
Lorenzo Pagans and Auguste De Gas 68
Madame Camus 70
Sulking 71
Mlle Hortense Valpinçon as a Child 72
The Dancing Class 74

Dance Class at the Opéra 76
The Cotton Exchange 78
Cotton Merchants 80
Children on a Doorstep (New
 Orleans) 81
The Song Rehearsal 82
The Pedicure 83
Ballet Rehearsal on Stage 84
The Rehearsal of the Ballet on
 the Stage 86
The Rehearsal 88
The Dance Class 90
Women Combing their Hair 92
Three Girls Bathing 94
In the Café (L'Absinthe) 96
The Ballet Scene from 'Robert
 le Diable' 98
The Star 100
Woman at her Toilette 102
Beach Scene 104
The Racecourse, Amateur Jockeys 106
Women on the Terrace of a Café 108
The Name Day of the Madame 109
Jockeys before the Race 110
Portrait of Henri Michel-Lévy 112
Ball at the Prussian Court 114
Miss La La at the Cirque Fernando 116
Diego Martelli 118
Edmond Duranty 120
Ludovic Halévy and Albert Cave 121
The Little Fourteen-Year-Old Dancer 122
Café Concert at the Ambassadeurs 124
Uncle and Niece 126
Singer with a Glove 128

The Ballet Class 130
Dancer with a Bouquet 132
Fan: The Café Concert Singer 134
Woman Ironing 135
At the Milliners 136
At the Milliners 137
The Dancing Lesson 138
The Entrance of the Masked Dancers 140
Women Ironing 141
Visit to a Museum 142
The Battle of Poitiers after Delacroix 144
Hélène Rouart in her Father's Study 146
Woman Bathing in a Shallow Tub 148
The Morning Bath 150
The Tub 151
A Woman having her Hair Combed 152
Woman Ironing 153
The Tub 154
Rearing Horse 155
Portrait of Rose Caron 156
Landscape 157
The Billiards Room at Menil-Hubert 158
Hacking to the Race 160
A Maid Combing a Woman's Hair 162
Landscape of a Small Town 164
Four Ballerinas behind the Scenes 166
Russian Dancers 168
Madame Alexis Rouart and her
 Children 170
At the Milliners 172

Index 174

Acknowledgments 176

Introduction

Degas is not an easy artist to classify. He exhibited with the Impressionists, yet attacked the underlying principles of Impressionism. He never ceased to advocate the traditional study of the great painters of the past, and yet produced a startlingly modern vision in his own art. While arguing the priority of line over color, he made some of the most colorifically intense images of the late nineteenth century. He loathed official honors and yet could be a dogmatic patriot. The paradoxes in Degas's life and art seem to multiply the closer they are scrutinized, and yet on one point there is no contradiction – that Degas is one of the greatest of all artists, with a draftsman's facility so technically assured that it often cloaks the complexity of his endeavors.

Degas is also a very popular artist, or at least a part of his work has become extremely popular. His ballet pictures and, to a lesser extent, his horse-riding subjects, which were the most popular of his images in his own day, are still today the pictures by which he is best known. In this examination of Degas's work, which focuses principally on his pictures, an attempt has been made to give equal weight to all aspects of his subject matter. His famous ballerinas have been given their due place, but so too have the major group of his less well-known history paintings and the oil copies that he made from other artists. A rounded view of Degas's art should be informed by judgments on the weight and importance that Degas gave to his own individual pictures. Much of his art was personal – portraits of friends and family; some of it was extremely private. Degas kept a great many of his pictures because he thought they were important, but he was a notorious procrastinator, and never got around to the legal necessities that would have ensured his works being kept together in one museum. Instead, after his death, they were sold off and are now spread throughout the world. Trying to imagine which 90 plates Degas would have chosen to represent his art has been one of the criteria guiding the selection in this book.

Hilaire Germaine Edgar De Gas was born on 19 July 1834 in Paris into a prosperous Franco-Italian banking family. His father Auguste De Gas was aged 26 and had grown up in Naples; his mother Célestine Musson, who was only 19, was from a French-Creole New Orleans cotton-broking family. Edgar was the eldest son, and had his mother's undivided attention until the birth of his brother Achille in 1837, followed by Thérèse in 1840, Marguerite in 1842 and René in 1845. In 1847 Célestine died when Degas was 13 years old.

It is difficult to deduce the atmosphere in which the young Edgar grew up. Célestine's letters suggest strong conflicts of disposition between herself and Auguste, but family recollections embroider, eliminate and tidy up and Degas would not talk a great deal about it in later life. The loss of his mother affected him enormously, according to family report. He was probably taught at home by a tutor until aged eleven, when he went to the Lycée Louis-le-Grand, one of the oldest schools in Paris, which numbered among past pupils Gericault, Delacroix, Voltaire and Robespierre. At school he boarded for his seven years and graduated in 1853 as an above average but by no means brilliant student. Among the friendships he made were some that would last a lifetime, including those with Paul Valpinçon and Ludovic Halévy.

Auguste De Gas wished his son to train as a lawyer but, having shown a talent for drawing at school, Degas decided to become an artist. Degas's father was a cultivated man who loved music, kept company with collectors and connoisseurs of painting, and had a developed taste, unusual at the time, for early Italian Renaissance paintings of the fifteenth century. Growing up in such an environment and with some signs of artistic ability, it is not too surprising that Degas should have been attracted by the idea of being a painter. Although for a while he gave in to his father's wishes and briefly attended law school (he later said he spent most of the time copying in the Louvre), he then refused to continue, left home and set up a rudimentary studio on his own. Auguste, impressed with his son's resolve, graciously admitted defeat and agreed to support him financially at his studies. He was one of the most solicitous and sensitive of parents; although there is occasional anxiety expressed in his letters to Edgar about his progress, he kept faith with his son's lofty ambitions, tolerated his highly-strung anxiety, and backed his own trust with financial support.

In April 1853 Degas officially registered to copy paintings at the Louvre under the tutelage of Louis Lamothe, a worthy but rather pedestrian history painter who had been a pupil of Ingres. For two years he worked to prepare himself for the competitive examination leading to student-

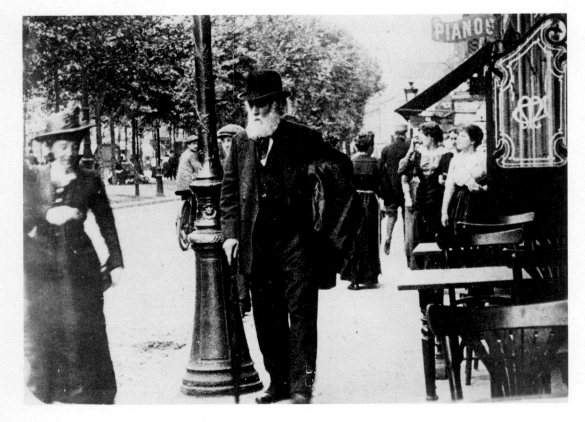

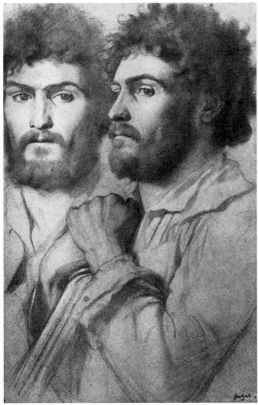

ship at the Ecole des Beaux-Arts. The most important artistic experience of his adolescence, as he recounted on many occasions in later life, was the visit he made in early 1855 to Ingres, who at age 75 was the giant of the French classical school. Degas's schoolfriend's father Edouard Valpinçon had refused to lend his picture of a bather by Ingres for the one-man show that the artist was staging at the Exposition Universelle of 1855, and Degas's entreaties apparently led to a change of heart. Ingres's words to the young Degas are famous and predictable; he told him to draw lines and then to draw more lines. Although Ingres was seen by many young artists as conservative, and his academic approach as hostile to Romantic creativity, Degas was content at this stage to embrace the traditional values that he espoused.

In April 1855 Degas obtained entry to the Ecole des Beaux-Arts and then, after just a few months, left to carry on his own studies in an extended trip to Italy where he stayed, based in Rome, for the next three years. Because of his independent income, he was thus able to do what was normally only possible for a student who had won a prize at the Ecole and been granted a scholarship to attend the Villa Medici, the Roman branch of the French Academy. The purpose of going to Rome was to pursue in traditional academic fashion an intensive course of study, drawing and painting from the wealth of Old Master pictures and frescoes and the unrivaled collections of antique statues.

Degas's earliest paintings from the period leading up to his Roman sojourn are mostly portraits – many of himself and members of his immediate family. These works establish clearly his qualifications for his chosen career and counter any possible family criticism. What is striking about this group is that they contain few juvenilia – they are surprisingly sophisticated for a partially-taught artist. His very early drawings are stiff but he quickly developed a style, influenced by Ingres, that was commandingly fluent. One needs only to look at the early works of the other Impressionists to see how unusual was Degas's youthful maturity and why he may have felt that, while he accepted the academic values of the Ecole, its programme of slow, graduated progression was already beneath his talents.

In Rome Degas attached himself to the circle of French artists studying in and around the Villa Medici. His companions were the scholarship students Bonnat, Carpeaux and Delaunay and, from early 1858, Gustave Moreau, an older artist who also had private means and who, more than any other single individual at this period, extended Degas's horizons and tastes. They all drew from the life model at the Villa Medici, which had a relaxed policy when it came to distinguishing between official and unofficial students. Degas dutifully copied Raphael's frescoes at the Villa Madama, Michelangelo's *Last Judgment* in

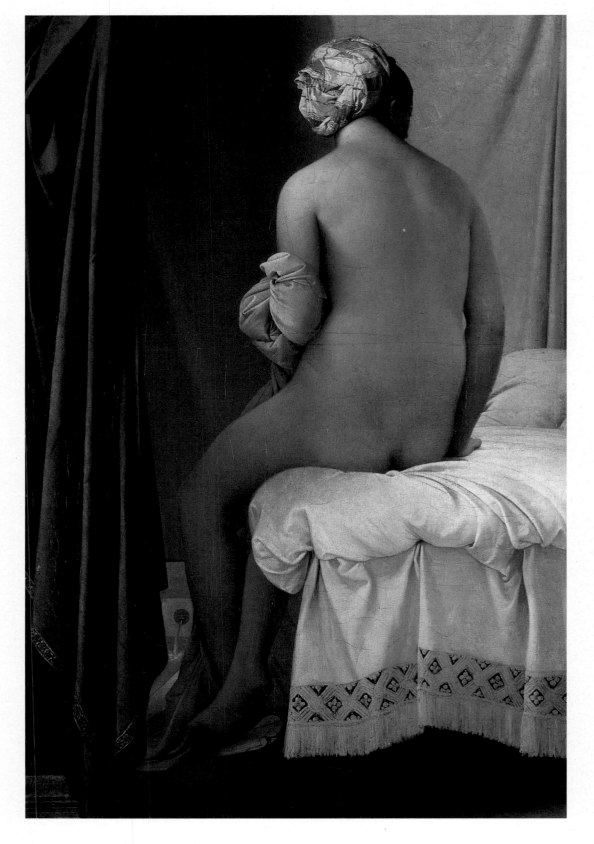

the Sistine Chapel and antique sculptures and paintings in papal and other collections, but he also pursued some less conventional masters. Perhaps stimulated by his father's enthusiasms, he looked at Giotto, Mantegna, Botticelli and Piero della Francesca; artists who had only recently emerged from the historical obscurity to which they had been consigned by that prejudicial perspective that viewed them as part of the childhood of art – 'primitive' precursors of the Raphaelesque greatness of the High Renaissance.

Together with Moreau, Degas explored many areas of past Italian art. They copied the fourteenth-century Benozzo Gozolli frescoes together at the Campo Santo in Pisa. Moreau awakened in Degas an interest in Venetian painting of the sixteenth century, in artists such as Titian, Giorgione and Veronese, whose '*colore*' was in academic eyes so potentially seductive of the student. He backed Degas's enthusiasm for the severe linear style of Mantegna, while at the same time helping to develop his

awareness of more modern colorists like Delacroix. Moreau also introduced Degas

to the debate about the symbolic capacities of color, gesture and detail; their mutual exploration of fifteenth-century painting must have provided a fruitful subject for this discussion. It would be wrong to over-remphasize Moreau's influence, for Degas was already a highly sensitive young man open to manifold influences, but Moreau's few years' seniority, established reputation, greater knowledge and serious quest for an alternative modern artistic niche to fill, was a heady combination.

While in Italy, Degas independently developed his command of print-making, producing several small densely-worked etchings influenced by Dutch seventeenth-century artists. He made a particular study of Rembrandt's prints and his own etchings show their inspiration both technically and visually. He seems also to have been attracted by Dutch portraits and domestic interiors, which had a matter-of-factness that was to become a feature of his own portraits.

During his Italian stay Degas visited several of his Italian relatives, and was given scope to prove his talents by painting their various portraits. In Naples he painted his grandfather, who had fled France in 1793 and established the family fortunes when he became banker to Murat, Napoleon's placeman on the throne of Naples. In Florence he stayed with his Aunt Laura, badly and sadly married to the Baron Bellelli, who, temporarily exiled from Naples, was living in rented rooms. Degas pitied Laura, and disliked her husband. She may have been the first woman that Degas really loved after, and to an ex-

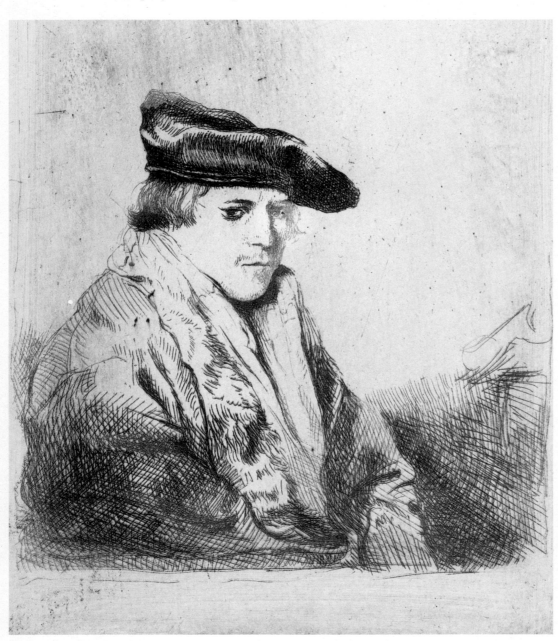

Right: This nude study for *Scenes of War in the Middle Ages* (page 44), while influenced by Ingres, also shows Degas's maturity as a draftsman.

Below: Delacroix's powerful and animated *Death of Sardanapalus* (1827) influenced Degas's early history paintings.

tent instead of, his dead mother. The picture he started in 1858 of her and her children was to be his first masterpiece (page 30).

Degas returned to Paris in late 1859 to occupy a large new studio that his father had rented for him. At first he was afflicted with a dithering lassitude that irritated his family, but was probably to do with weighing up options. By this date he had painted most of his immediate family and was still working on the large Bellelli group portrait. His father was clearly of the opinion that portrait-painting represented bread-and-butter security and encouraged this line of development. For an artist to obtain real success at the Salon, the huge annual exhibitions organised by the French Academy, however, it was still necessary to produce history paintings – large significant subjects drawn from classical, biblical or distant historical literature. Success at the Salon meant money, honors and, most important, access to state patronage.

Between 1859 and 1865 Degas painted four history paintings, each of which must have been destined for the Salon, although only one was ever sent and exhibited. The four pictures (pages 35-40), one biblical, one medieval and two broadly classical, display an extraordinary cocktail of influences. The voices of Ingres and Delacroix are strongest, but they are combined

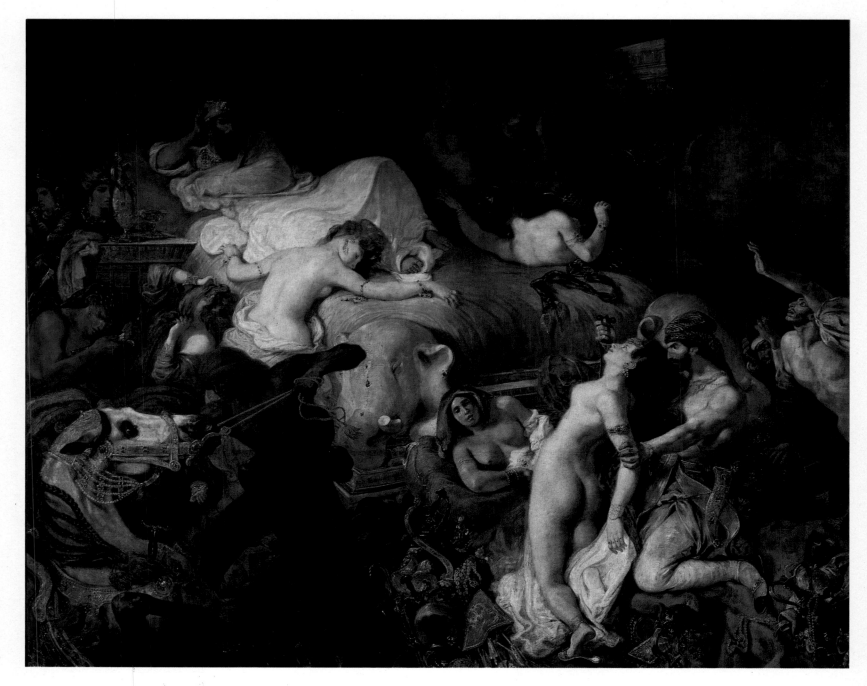

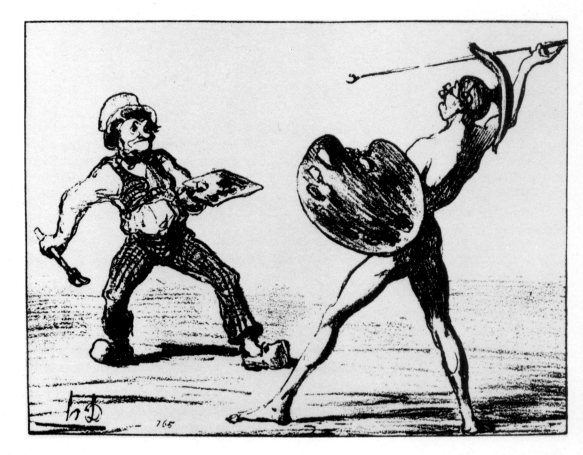

with Assyrian reliefs, Egyptian figures, the processional style of Mantegna and Piero della Francesca, and a host of other identifiable quotations.

Until recently there has been a tendency to see Degas's early history paintings as an unresolved phase of development, which he passed through before settling to his *métier* of modern portraits and urban Realism. Degas was never ashamed of these earlier works and reworked the *Young Spartans* (page 36) until 1880, considered exhibiting it at the Impressionist exhibition of the same year and kept it on view in his studio. The task that Degas set himself in his history pictures was enormous and, if he did not completely succeed, it was because he was in a sense trying to re-invent history painting, pushing out the parameters of both classical and romantic conventions to embrace earlier artistic styles, and to obtain a new fusion that would be demonstrably 'modern'. Degas

never really lost the core of this ambition; two decades later, in his famous 1886 suite of bathers (pages 148-51), he was still reaching for the same heroic end.

The year 1862 saw a development in Degas's art; he started a horse-racing picture, his first subject from contemporary life (page 42). In the same year he had his legendary (possibly apochryphal) meeting with Manet in front of a painting by Velásquez in the Louvre, where Degas was furiously etching a copy directly on to a small copper plate. Manet's curiosity made him introduce himself, because Velásquez and etching were both touchstones of Realist modernity. Velásquez and seventeenth-century painting generally were seen by Realists as heralding their own concerns, while etching was also undergoing a revival among artists within Manet's orbit. Degas may already have read Baudelaire's article entitled 'Etching is all the fashion' in the *Revue Anecdotique* of 2 April 1862, in which he highlighted Manet's copying of Spanish art and his talents as an etcher. It is also possible that he was already familiar with Manet's ideas and those of the Realist circle from his friendship with the artist James Tissot.

'Realism' was a term coined originally by Courbet to describe his own art, and it became synonymous in the public mind with the work of those late Romantic artists who, from the early 1840s onwards, took as their subject matter contemporary everyday life – in theory in all its facets, in practice with a concentration on the peasant and new urban poor, accompanied by a tendency to highlight hardship. In its aspirations to show social 'truth' Realism is one of the artistic manifestations of the Comtean and Positivistic philosophy, which wished to subject all society to

Below: Kunisada's *A Girl Washing her Hair above a Tub* is typical of the Japanese woodblock prints echoed in Degas's bather paintings.

scientific analysis in order to discover its workings. It included novelists like Balzac, whose *Comédie Humaine* aspired to describe all social types, and, later, Zola who wanted to dissect society in merciless and clinical detail. As a viewpoint it was often, although not necessarily, accompanied by republican political beliefs of a fairly left-wing or anarchistic tinge. The second generation of Realist artists, of which Manet was the acknowledged leader, took the name 'Naturalists'. They were less concerned with peasant or proletarian heroics than with a matter-of-fact registering of Paris's dramatic urban expansion, with the demi-monde rather than the simply poor providing a fertile area for subjects. Other 'Naturalists', such as Monet took nature itself as their subject and tried to pin down its fugitive effects precisely on canvas, believing themselves to be behaving scientifically.

For the gallery-going public and conservative critics, Realism and Naturalism were indistinguishable, and they correctly viewed them as a modern, potentially subversive, critical attack upon established artistic orthodoxy. Manet brought Degas into contact with Realism, but for about five years he resisted embracing its values whole-heartedly. The reason lay partly in the strong legacy of his traditional training, partly because he was still experimenting with autonomous technical and color problems that could be worked out within his own subjects, and partly because his patrician pessimism did not incline him toward Realism's political implications.

It may possibly have been through Manet that Degas made contact sometime in the early 1860s with Whistler, the young American artist who was gradually shifting the emphasis in his own paintings and prints away from Realism towards Japanese-inspired drawing-room portraits. Whistler was particularly interested in the capacity of color effectively to stimulate the viewer as distinct from any narrative – a subject which Degas had possibly already touched upon in his earlier discussions with Moreau. For a while Whistler was a more dominant influence upon Degas's art than Manet's urban Realism. When he undertook his first Paris Opéra picture of Mlle Fiocre in 1867 (page 56), Degas was inspired compositionally by Whistler's *Symphony in White No. 3*, which he had earlier copied, and in his many 1860s portraits set in bourgeois interiors, the cropped framed pictures, mirrors and Japanese-inspired motifs are recognizably part of the Whistlerian vocabulary.

Whistler, Manet, Degas and many other artists at this time shared a fascination with Japanese woodblock prints, which first appeared in France from the mid 1850s. These striking, colorful scenes of everyday life, showing the bustling streets, actors, wrestlers and courtesans of Kyoto, were interpreted as an oriental reflexion of the Parisian concern with Naturalism. Their way of handling space, with dramatic leaps from dominant cropped foreground figures to distant backdrops, was also seen to have a curious affinity with the results of snapshot photography. Together these two very different media helped to break down the traditional European perspectival system which, with receding orthogonals and graduated tonal recession, had for over four centuries served to create the illusion of depth. The use of quirky off-centre viewpoints, black-outlined figures and flat areas of color were absorbed from Japanese prints into avant-garde European art. Degas, who had already sought in his history paintings to find an accommodation between antique pre-perspective friezes and Renaissance spatial values, was attracted by this new way of seeing and,

Right: Manet's *Café Interior* (1869) illustrates the relaxed all-male society which Degas enjoyed.

Below: James McNeill Whistler's *Symphony in White No. 3* (1865-7) which Degas copied in pencil and which influenced works such as *The Dancing Class* (page 74).

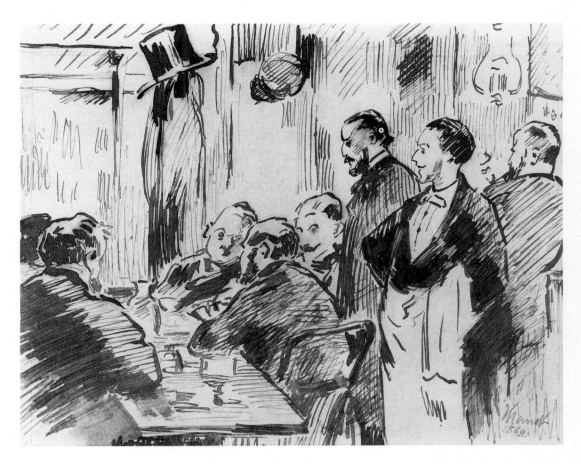

more than any other artist, explored in his pictures the principles underpinning Japanese spatial organization. His own collection of Japanese prints included fifteen drawings by Hiroshige, two prints by Utamaro, a Kiyonaga triptych that hung on his apartment wall, and a host of prints in albums. There is still a great deal of research to be done in pinning down the precise influences of individual prints upon particular Degas pictures.

During the 1860s, although Degas worked simultaneously in a variety of genres, the largest single group remained portraits. He painted further members of his family including marriage portraits of his sister Thérèse, who, as a child, had been one of his favorite models. He drew the children of the Mussons – part of his mother's family who fled New Orleans for France to escape the hardship following the defeat of the South in the Civil War. Visiting the estates in Normandy of his old schoolfriend Paul Valpinçon, he depicted the Valpinçon family and children as well as possibly picking up ideas for some racecourse themes. In Paris Degas was part of an expanding bourgeois social circle of artistic and musical individuals which in-

cluded the Fantin-Latours, the Camus, the Morisots and the Dihaus, and he painted several of this metropolitan group (page 70). He also began the important series of portraits set in study or studio, which shows artists, connoisseurs and writers in their familiar environment and in a pose expressive of their individual characters rather than drawn from the stock repertory of poses.

In the course of the 1860s Degas lost the high opinion he had of Moreau, continuing to respect the man but showing less enthusiastic about his art. In 1867 he remarked that 'Moreau's painting is the dilettantism of a great-hearted man'. Dilettantism was a major fault in the eyes of Degas who, in his own approach to art, was extremely serious – he worked slowly but he worked hard. His brother René

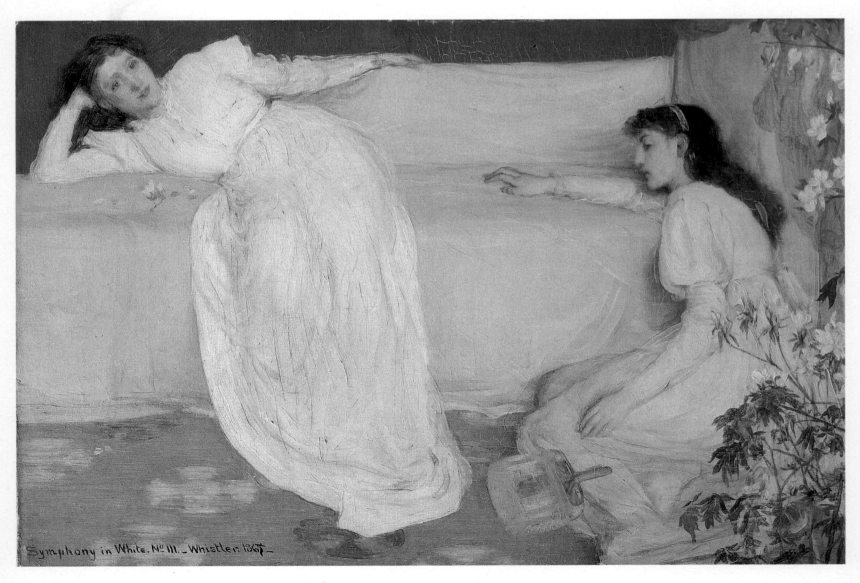

Symphony in White. No III. _Whistler 1867_

described him as working furiously with no time for anything beside his paintings, and commented on another occasion that the ferment of ideas in Degas's head was simply frightening.

It was probably in the mid-1860s that Degas began his eventually enormous collection of prints from popular journals like *Charivari*. Just as, a century later, Pop artists in Britain and America trawled the popular visual art of comics, advertizing and packaging for images and a visual vocabulary that could be used as a modern and *déclassé* attack upon High Art, so too Naturalists turned to the powerful satirical mass-produced lithographs of caricaturists like Daumier and Garvani, who were prepared to use any visual shorthand to communicate their message.

From early 1868 Degas began to frequent the Café Guerbois in the Batignolle quarter of Paris, where Manet was the leading figure in a group of Realist artists and writers which included Zola and the critic Edmond Duranty. The relationship between Degas and Manet grew closer; they exchanged pictures and the flow of ideas between them became two-way. In the evenings they also shared the same bourgeois social life, away from the all-male hurly-burly of the cafe; Manet was more gregarious and an easier mixer than Degas. He was also left-wing and, although drawing inspiration from the Old Masters, less inclined to defend artists who, to other Guerbois regulars, were thought stuffy or simply the enemy. They were both given to a considerable amount of declamatory preaching, and Degas became known as a 'theorist'.

The Café Guerbois group expanded in 1869 when Manet introduced Monet, who in turn introduced Sisley, and Cézanne and Renoir also attended. Monet later described the atmosphere as one in which there was a perpetual clash of opinion, yet from which he went away stimulated with enough ideas to last for weeks. Neither Manet nor Degas were enthusiastic about the *plein air* Naturalism of Monet and his fellow landscape artists. They shared a prejudice against the 'idiot eye' side of pursuing absolute fidelity to the motif at the expense of cerebral organization and structuring. Yet in summer 1869, possibly inspired by Manet's relenting in his opposition, Degas did embark on a series of landscape pastels (page 65), a medium that he had recently started to use for portraits. All were views of the northern French coast, and were done from memory. As well as being a significant riposte to

Monet's values, this series also for the first time explored a subject in depth through several permutations.

Degas ascribed his full-hearted conversion to Realism – the 'direct source' – to reading in 1867 the Goncourt brothers' novel *Manette Salomon*, an account of an artist of noble Italian birth, Corialis, who is seduced, debased and his art destroyed by Manette, a poor Jewish model. Quite apart from the novel's antisemitism, misogyny and its curious parallel with Degas's own descent, its Realism did not reflect liberal or democratic values, as in the work of Courbet or Zola, but instead adopted a rather condescending patrician objectivity. While sharply analytical of 'life', it was also above it, taking the view that literature created from such observation could exist as a semi-autonomous art and ultimately could be properly appreciated only by a restricted group of intelligent urbane individuals. There is no great intellectual gap between such Realism 'for art's sake' and the 'art for art's sake' argument behind the Whistlerian position on color harmonies with which Degas was dabbling at this time.

Degas capitulated to Realism but kept hold of connoisseurship. He never embraced Rationalistic or Positivistic beliefs. Already by the late 1860s he was well known at the Café Guerbois for his views on the impossibility of art being extended to the masses. When Degas turned to Realist subject matter, he was attracted by the ballet, cafés, concerts, women ironing and bathing, horseracing and the circus; it was an extremely selective vision of reality. He was not attracted by steam

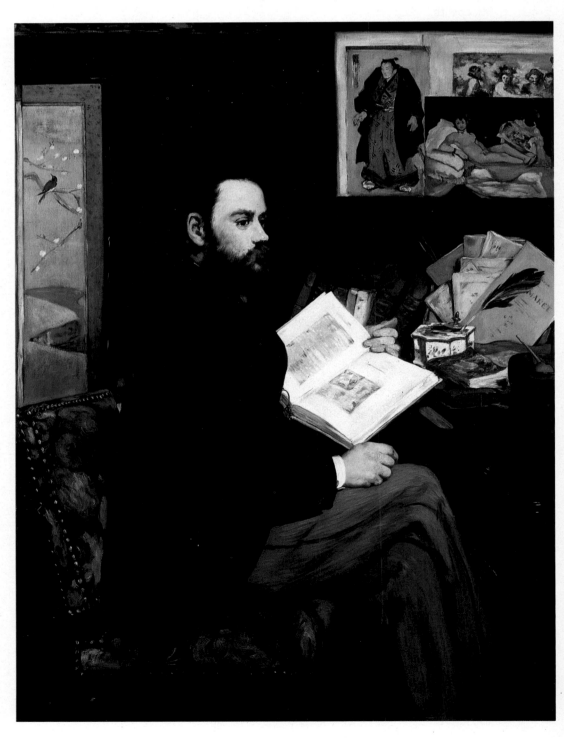

L'orchestre pendant qu'on joue une tragédie.

trains or boulevards with autobuses; nor was he concerned to highlight Parisian working-class poverty or to document extended leisure in dance halls, boating stations or swimming places. Despite being an enthusiastic consumer of many of the modern delights of Haussman's rebuilt Paris, Degas was distrustful of modernity, especially if it conflicted with the social order to which he belonged. He had little interest in the celebrating or pinning down of progress.

Degas's first Realist subjects strike a curiously English note – the two genre pictures, *Interior* (page 88) and *Sulking* (page 71), were influenced by Victorian pictures that he saw at the Exposition Universelle in 1867. Both Degas and Tissot were interested in the work of Millais, attracted by the intensity of certain of his domestic subjects. Like so many Victorian narrative artists, Degas too probably found inspiration for these works in contemporary literature. However, these are rather a deviation from the path that he was taking toward developing his own distinctive Realist vision, rooted in his own observations of his own environment. It was not

until 1868-9, when Degas painted *The Orchestra of the Opéra* (page 62), that this vision really became clear. Built around a portrait of his friend the bassoonist, Désiré Dihau, the picture brought Degas's work into the public domain of urban reality, with its bustle of musicians in the orchestra pit and the truncated line of gas-lit and tutu-clad ballerinas.

One of the features that united the Café Guerbois group of artists was that they had all, with the exception of Degas, been rejected frequently by the Salon and vilified in the press. Dissatisfaction with the Salon's organization and the artistic officialism of the Second Empire was a recurrent complaint. Degas's attitude, however, was ambivalent. The eight Salon pictures that he exhibited between 1865 and 1870 were mostly portraits. His two most daring pictures, *Scenes of War in the Middle Ages* (page 44), exhibited in 1865, and *The Steeplechase*, exhibited in 1866, attracted little comment for or against. In 1870 he wrote a long letter, published in the *Paris Journal*, criticizing the hanging policy of the Salon, but stopping short of criticizing the prejudices of the selectors.

Manet thought that no one should give up exhibiting at the Salon, seeing art as a life-and-death battleground where the fight for new values should be taken to the enemy's ground. Degas by 1870 was moving towards wanting an alternative to the Salon, and became willing to support the arguments for this being put forward by Monet and Pissarro. He may simply have felt that he had nothing to lose on the basis of his past Salon performance.

In 1870 all French life was dislocated by the disastrous war with Prussia. Manet and Degas volunteered for the National Guard, and both ended up in the artillery during the protracted siege of Paris. It was at this time that Degas first discovered that his eyesight was deteriorating, which was eventually to lead to blindness. During the Paris Commune, set up after the French defeat, Degas retreated to the country. Manet kept away from Paris but was sympathetic with the Communards at arm's length. Degas's friend Tissot was more closely involved and later had to flee to London. Although Degas did not share the socialist views of the Communards, he joined Manet in condemning the wholesale executions and brutality that was part of their crushing by the French authorities. The artist Berthe Morisot's mother, writing amid the climate of fear in Paris in June 1871, described their outspoken words as 'insane'.

The year following the war was one of great mobility for many of the group; Monet and Pissarro stayed in London, and Cézanne was in Provence. Degas visited Tissot in exile in London, and sold three works to the dealer Paul Durand-Ruel. Until then he had sold very few pictures; the small private income granted to him by his father allowed him to paint exactly what he wished, and he had reputedly turned down in 1869 an offered retainer of 12,000 francs a year from a Belgian art dealer. When he returned to Paris before setting out on a trip to the United States, Degas consolidated his position with two magnificent small ballet rehearsal scenes (pages 74 and 76) which, more clearly than any other works, announced the arrival of his complete maturity as an artist.

In the winter of 1872-3 Degas traveled via London, Liverpool and New York to New Orleans, to visit the family of his dead mother, the Mussons. He journeyed with his brother René who, along with Degas's other brother Achille, was already working in the United States. On the Liverpool-New York crossing he found his fellow English travellers stuffy, but was

impressed with the bustling modernity of New York, where steamers came and went to Europe with the regularity of an omnibus timetable, delighted with the comfort of his four-day trip by sleeping car, and enchanted, for a while anyway, with the light, color and langorous climate and society of the South. During the five-month stay he painted portraits of his American relatives – some finished, some unfinished – which as a group are among the most ambitious and successful pictures of his entire career (pages 78, 80, 81). He was full of ideas for new subjects and projects and, from the detachment of a modern country amid the heat of New Orleans, he wrote to Tissot in London that he was determined to make the Naturalist movement worthy of the great schools of art, inviting his friend to join him in getting together a Salon of Realists. This resolution was to contribute to the establishment in December 1873 of a group of artists dedicated to holding an independent exhibition without jury selection, who became better known to the world as the Impressionists. Exhibitors included Monet, Sisley, Renoir, Cézanne and Morisot; altogether thirty artists participated in the first exhibition. Manet, who in the public mind was still regarded as their leader, did not take part and doggedly continued to submit to the Salon.

Degas was 40 when the first exhibition opened in 1874. Just a few weeks before his father had died and, as details of his estate unfolded, it became clear that a catalogue of debts had accumulated. Degas's life changed and he was thrown into uncomfortable solidarity with Monet and Renoir, having to sell pictures to live. For three or four years, from about 1876 until 1880, Degas was in serious financial difficulty. He felt honor-bound to take on the debts of his father's bank, including a loan on which his brother René had defaulted. He sold his own collection of pictures, and moved into a smaller apartment in a poorer district.

Altogether there were eight Impressionist exhibitions held between 1874 and 1886, and Degas participated in all but one. Public hostility to the shows has been well chronicled – the crowds who came to laugh, the cartoons that appeared advising pregnant women not to enter in case they should instantly abort, the ubiquitous jokes about firing guns loaded with paint at a canvas and then signing it. Newspaper and journal critics were divided. There was predictable conservative condemnation of the ugliness, vulgarity and immorality of the shows, just as there had been when works by the same artists had been shown at the Salon, but there was also a growing, more sophisticated, critical appreciation of the group, and from the beginning Degas was singled out as different, with some critics wondering why he exhibited at all in such company.

The displays that Degas put on at the Impressionist exhibitions are among the most deliberately considered public statements of his artistic intentions. Although obliged to sell his art, he was very selective about what was seen and became notorious for withdrawing works from exhibition, or not including pictures listed in the printed catalogue, because he felt that they were

'Now this fan shows nothing at all.'
'Ah, but what a signature!'

incomplete or inappropriate. Some of his displays may have been deliberately designed to shock bourgeois sensibilities. The 1877 exhibition included views of prostitutes in streetside cafes (page 96); the 1881 exhibition had his vivid life-like wax statue of a young dancer (page 122); and in the final exhibition in 1886 he showed his magnificent suite of nude bathers (pages 148-151), which achieved his goal of a thoroughly modern Naturalism claiming comparison with the Old Masters. Each of these three events caused intense reaction and heated debate.

Among the several new subjects that he exhibited, the most popular were those connected with the ballet; more than half Degas's total output is concerned with ballet. His focus is more often on vigorous preparation for dance-rehearsals and back-stage activity, rather than the spectacle seen from the front of the house. His comprehensive treatment of the dance is unparalleled in any other area of his work and he approached his subject with almost scientific precision, becoming familiar with all the various stages of a dancer's education and learning for himself the action and meaning of each step. He surprised Edmond de Goncourt, who visited his studio in 1874, by the accuracy of his mime of a ballerina's steps.

At first he did not have access to the rehearsal rooms of the Opéra while in use, and his early dance rehearsal pictures (pages 74, 76) are built up from studio-posed drawings of individual dancers, supplemented by discussions with dancers and visits to the empty rooms of the rue Pelétier. Gradually he obtained the freedom he needed to wander and record at will with detached objectivity all aspects of this specialized world. He was particularly sensitive to the antithesis within the ballet – the contrast between exhausting practice and the polished facility of the final performance. In an environment characterized by poor conditions and borderline

prostitution, with the vague possibility of being taken out of the chorus and turned into a 'star', the dancer worked to develop the skills needed to create the powerful illusions of the stage. The harnessing of such effort in the production of art was very similar to Degas's own efforts to produce pictures; he once argued that no art was ever less spontaneous than his. He also compared the construction of a picture to the plotting of a great crime, and was clearly attracted by the discipline of the dance.

The Paris Opéra during Degas's time is now looked upon as a rather degenerate institution. Standards of dance had declined; wages were low; gross spectacle outweighed considerations of subtle individuality. The principle patrons, the rich *abonnés* (subscribers), were often more interested in assignations with dancers to whom they might act as 'protectors' than with the quality of their footwork. Degas saw all this and included them too – the little black-suited figures that lurk like flies in the wings of so many of his dance subjects.

His motives for producing so many dance subjects may also have been partly economic. His dealer, Durand-Ruel, took far more pastels of dance subjects, studies of individual dancers and racecourse scenes than the more controversial and less pretty subjects, and there is no doubt that he found them easier to sell.

In the mid-1870s Degas's enthusiasm for black and white printmaking returned with his development of monotypes and he used a dance rehearsal as the subject of his first print in this new medium, which he perhaps hoped would allow him to earn money quickly. Monotypes are essentially one-off prints made by covering a smooth metal or glass surface with greasy printer's

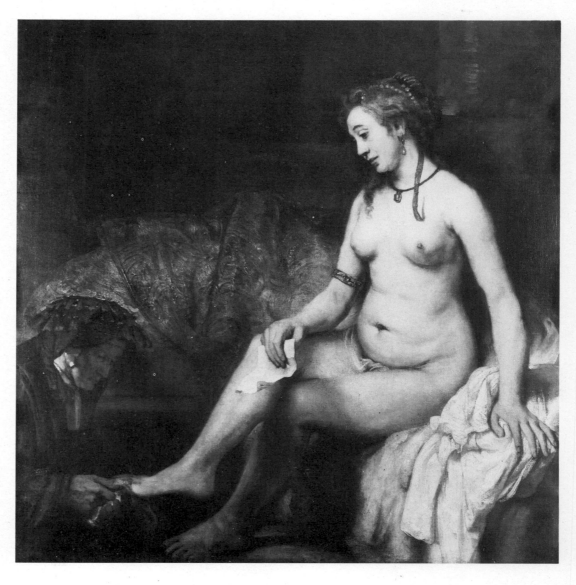

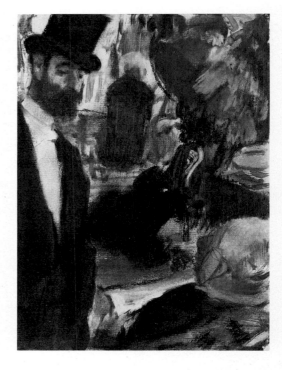

ink, either painting or smearing it on in 'additive' fashion or, after inking up the entire surface, scratching or wiping out in a 'subtractive' way. With a dampened sheet of paper on top, the plate is then passed through the large roller of a traditional printing press. A second, and sometimes third much fainter, impression could also be obtained.

Degas was introduced to monotype by Ludovic Lepic, and they signed his first print together. During the summer of 1876, Degas became obsessed with the medium and produced scores of images. Some sense of his excitement is conveyed by the effect that he had on a friend, Marcellin Desboutins, who wrote at the time, 'He is no longer a friend. He is no longer an artist! He is a 'plate' of zinc or copper blackened with printer's ink'. The monotype themes that Degas developed, apart from the ballet, included cafés and café-concerts, women bathing and a group illustrating the backstage life of the Cardinal family. These latter were based upon a popular series of short stories written by his friend Ludovic Halévy about two fictitious sisters, both ballerinas at the Opéra, whose dreadful mother acted as a combination of guardian and procuress in her endeavors to ensure that her girls were fixed up with suitably rich male 'protectors'. Several monotypes were exhibited at the 1877 Impressionist exhibition, some being strong black first-pulls from the plate, others fainter second-pulls, extensively worked over in vibrant pastels. Many of these pastel-covered monotypes are among the most famous images of Degas's career. Monotype, like a freer form of drawing, allowed for rapid change and variations in forms without having to discard an image as overworked and without having to wait, as with the alternative of wash-drawing, for the ink to dry before adding fresh passages. It also provided a short cut to the underdrawing and broad tonal organization of a picture. For an artist who usually worked slowly, and whose debts were large, it may have seemed a godsend.

Among the monotypes that Degas almost certainly did not exhibit are the

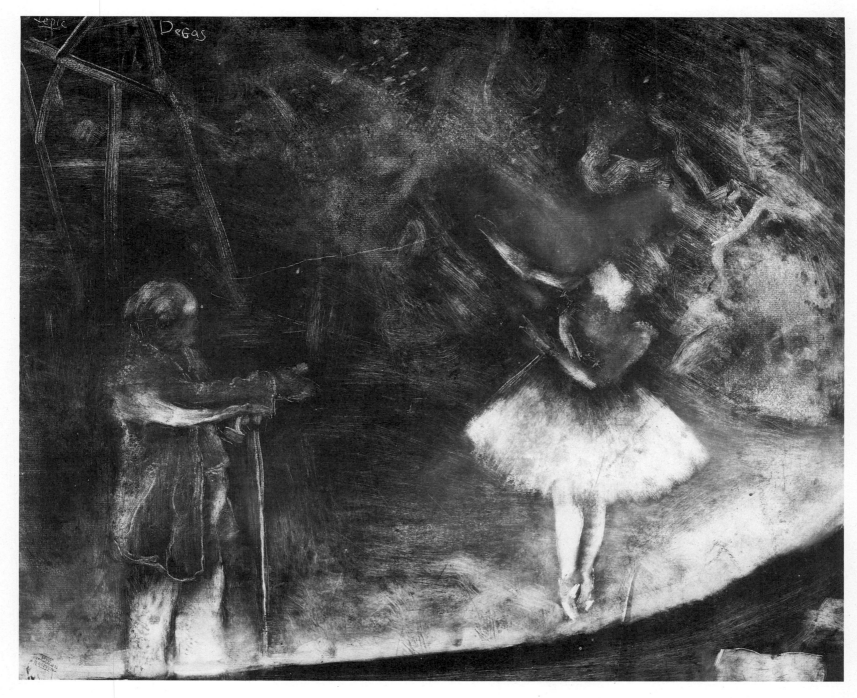

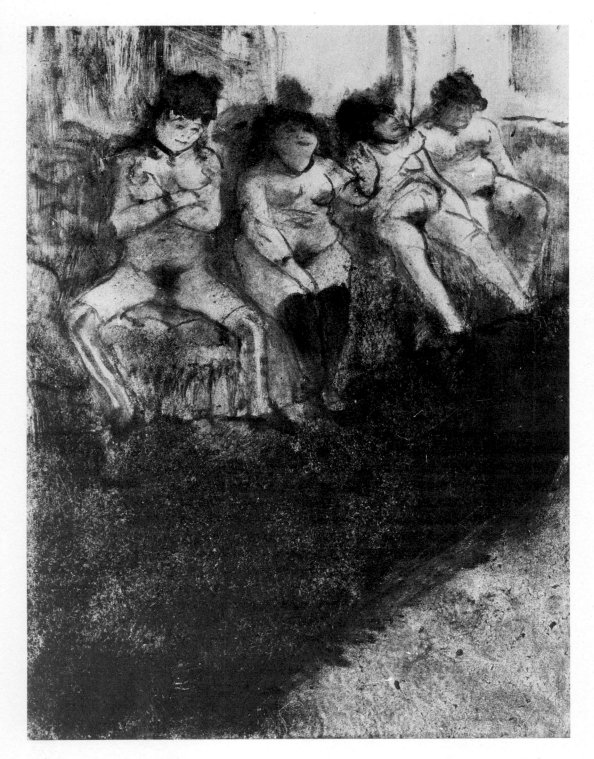

with the hilarious recreation of a woman observed on a Paris omnibus – but if the mime was accurate, was it not also cruel? Did Degas simply follow a legitimate Realist practice, or were there more complex reasons for an interest in specific areas of women's life that appears at times to be obsessive?

The debate is often also extended to include speculation about Degas's sexual appetites. It is clear from remarks made by Manet in the 1870s, and from letters written by Van Gogh at the end of the 1880s, that Degas's lack of sexual involvement with women was well known and the subject of Parisian gossip. Manet implied that Degas would not know what to do with a woman, Van Gogh said that he was impotent, but a letter that Degas wrote to Botoni before a visit to Spain in 1889, reminding him to bring contraceptives, has been cited by Richard Kendall as evidence that Degas was sexually active at least into his mid-fifties. And yet he was famous for his decorous conduct with his models, he got rid of one housekeeper because she was too young, and there is no suggestion that he ever kept a woman.

Any suggestion of romantic involvement with women of his own class is deduced from an early poem and the rumor that he had an attachment to Marie Dihau. In his protracted relationship with Mary Cassatt, the rich Philadelphia artist who came closest to being his pupil, there is not a shred of evidence (although she did burn all her letters to Degas) to suggest that their relationship extended beyond friendship. On several occasions he bemoaned his lack of wife and children, but he was also given to sermonizing about women being the ruin of men. When depressed he would sometimes focus on this failure to have a family, and in his contact with the families of the Valpinçons, Halévys and Rouarts he clearly found some surrogate comfort.

Degas could be gallant with young women of his own class. Manet's niece described his treatment of her, when she visited the 64-year-old artist in his studio in 1898, as being 'as solicitous as a lover'. He could also be discouraging; Mary Cassatt, despite valuing his opinion above that of any other man, was loath to show him a particular project lest his criticism discourage her. He could, however, show concern for the reputation of a female artist. In 1896 he played a major role in organizing the exhibition of Berthe Morisot's works, held a year after her death, and personally hung the pictures. Any overall

group of over fifty that show the interiors of Parisian brothels. Some are stock images of male sexual fantasy and include embracing lesbians and prominently offered female genitals. Many depict rather bored, gross women lying and sitting around on divans, and can only with difficulty be considered arousing. Where men appear in these prints, they have none of the swagger of the Opéra *abonnés* awaiting their dancers but are rather ridiculously dumbstruck, and need encouragement from the women about whom they now are having second thoughts.

Much has been made of these brothel monotypes. Degas has been accused of compliant indifference to the problem of Parisian prostitution, to which tens of thousands of girls and women were driven in order to supplement low wages. The images have been seen as ridiculing women and offered as evidence of Degas's misogyny; their one-sidedness in not showing the full range of brothel life has been criticized. In their defence, their good-natured humor has most often been

cited, and it has also been argued that they show in neutral fashion a subject that was enjoying a contemporary vogue among novelists like de Maupassant and the Goncourts.

They have also formed the basis for a discussion of Degas's more general attitude to women, which has been well scrutinized recently. He has become an object of particular interest to some feminist art historians concerned to clarify the precise meaning of his images. This is not surprising, since three-quarters of all Degas's pictures are of women. His themes of dancers, laundresses, bathers, milliners and prostitutes are often explored within an essentially voyeuristic framework – that of an unseen man, observing undetected a private female world. It is clear from contemporary critical reactions to certain of his pictures, particularly the bathers, that some commentators thought that he was producing a cynically ugly and misogynistic view of woman. Degas did study women closely; he was a perfect mimic of women's actions and could entertain his friends

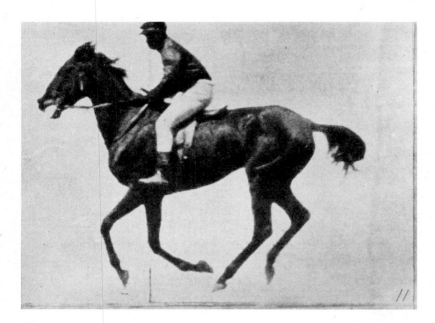 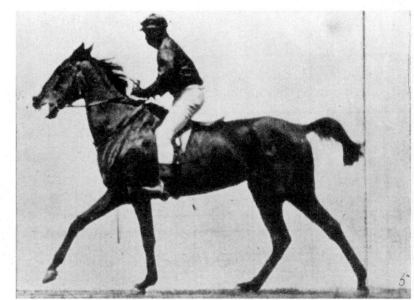

consideration of the evidence does suggest that, whatever misogynistic traits may be found in his pictures, Degas was far from being disliked by the women that he knew. The debate will no doubt continue.

During the 1870s Degas's reputation advanced and his pictures more readily found buyers. The same pattern developed, although less spectacularly, with other Impressionists, particularly Monet and Renoir, who both eventually went back to exhibiting at the Salon – a cardinal sin in Degas's eyes. Degas tended to be out of step with his co-exhibitors over many issues, and it took the peace-keeping talents of the mild-mannered Pissarro to hold the group together. When they had initially been dubbed Impressionist by Castagnary, who had picked up the word 'Impression' in the title of one of Monet's paintings, Monet, Renoir and Sisley had been content to accept the title, since it broadly summarized their *plein-air* intentions. Degas wished their group identity to remain *Indépendants* and was anxious to emphasize their Realist credentials. He was also keen to include within the group artists who were already successful, like Raffaelli, who oscillated between anecdotal sentimental Realism and more substantial work. Rafaelli's candidature was viewed as an insult by more earnest members of the group such as Caillebotte, who wrote a letter to

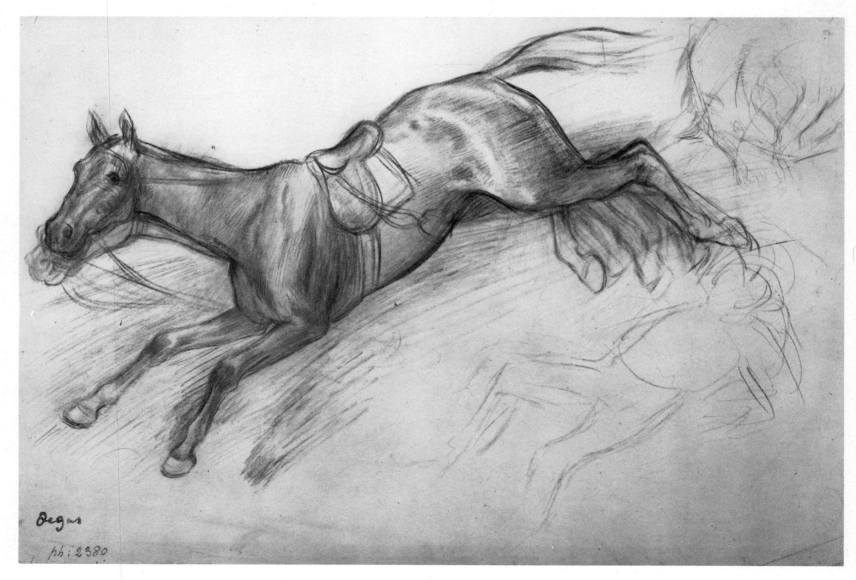

Pissarro in January 1881 which reveals very well not only the conflict with Degas, but also how Degas conducted himself while in the company of his fellow artists:

Degas has brought disorganization among us. Unfortunately for him he has a bad character. He spends his time holding forth at the Nouvelles-Athènes when he would be better occupied turning out a few more pictures. No one disagrees that he is one hundred times right in his opinion on art and that he is sensible and witty (and isn't that the basis of his reputation?) . . . He says he must earn a living but he denies that Renoir and Monet have the same need . . . this man has gone sour. He does not have the status that his abilities entitle him to and he blames the whole world . . . he pretends to want Raffaelli because Monet and Renoir have defected . . . In 1878 be brought in Zandomeneghi, Bracquemond, Madame Bracquemond – what an advance guard for the great cause of Realism! Degas . . . has a great talent . . . But that's all. As a man referring to Monet and Renoir he has gone so far as to ask me 'Do you invite such people to your home?' As you can see, although he has great ability, he does not have a good character.

Caillebotte was right to be irritated. It was a snobbish dig at Monet's and Renoir's background for Degas to appeal to some assumed social solidarity that he might have with Caillebotte because of their shared bourgeois background. Degas's total hostility to the Salon also seems rather a pose. Monet and Renoir had been dealt far greater blows of rejection by the Salon jurors in their time than Degas ever had. To demand total loyalty when for the first time in their lives they were earning money was harsh. And yet Caillebotte is not entirely fair; among the figures whom Degas encouraged and brought within the group was Mary Cassatt, and he had kind words to say for another new exhibitor whose pictures were far removed from Realism – Gauguin.

After 1886 Degas ceased to exhibit with other artists and showed little enthusiasm for the public display of his work. From about this time, the public legend of Degas began to take shape. His savage witticisms and aphorisims were noted down and retold with relish. He appeared thinly disguised in three novels, in each case portrayed as a rather bad-tempered and difficult individual. This acerbic and misanthropic public persona was partly projected by Degas himself, who rather enjoyed the pose of irascibility and would use hauteur as a defence against people he found boring, whereas with those whom he liked he could be charming and cheerful. From 1886 to 1900 he kept up a full round of social visits to friends, for dinner or musical *soirées*; to the Opéra, which he sometimes visited several times a month; and to the country retreats of friends or to various spas or seaside resorts for his summer holidays.

Degas could also be gloomily depressive and preoccupied with death, however, and there is plenty of testimony as to his unburdening his woes. He did suffer from a series of uncomfortable ailments, in addition to his deteriorating eyesight; there is a suggestion of hypochondria but his fear of

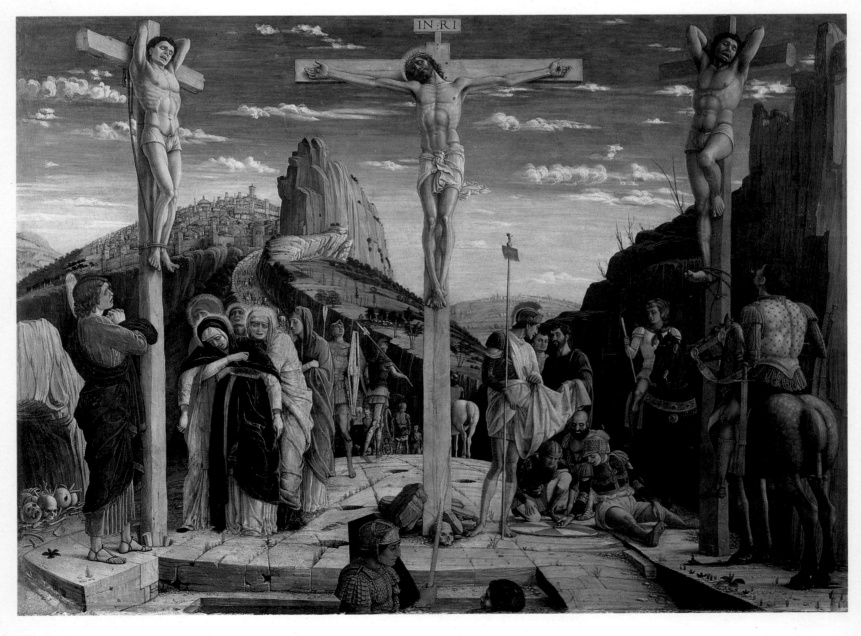

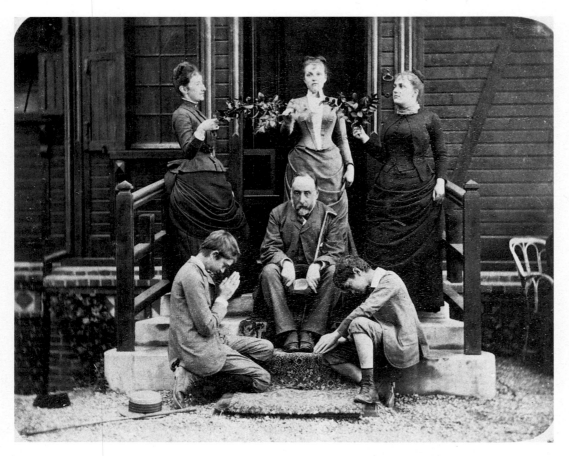

wishes were being ignored, but this established Degas's reputation as one of the greatest nineteenth-century sculptors. Renoir, who unlike the public had seen many of his pieces in the studio, thought that he was the greatest of all modern sculptors – better than Rodin – and the most important French sculptor since the stonemasons of Chartres Cathedral.

Degas's pastels developed in the 1890s, with a freer more calligraphic use of strokes. Marks are not only used to describe form but often sit over figures like shimmering colored gauze layers. His coloring became more arbitrary, with powerful clashes and contrasts of pigment. Again, suggestions that this fiercer and bolder handling was the result of worsening vision must be balanced against the possibility that Degas was responding in his own fashion to the contemporary pursuit of expressive colors which preoccupied Gauguin, Matisse and many other younger artists. Among Degas's very late paintings are some extraordinarily free interpretations of color that hark back to the Whistlerian preoccupation with color harmony in his portraits of the 1860s.

Although Degas was capable of benign tolerance for certain avant-garde strands of painting, he also became increasingly ossified in his social prejudices, railing among other things against democracy and the spread of working-class education: 'In the old days the daughters of *concierges* became *danseuses* – now they have a diploma

worsening vision was justified. As early as 1874 he had made much of his anxiety to Edmond de Goncourt. Thirty-five years later, in 1909, however, he was still able to look at the Cubist canvases of Picasso and his circle, and declare authoritatively that what they were doing was 'more difficult than painting itself.' In the same year he also dealt another put-down to Monet by telling him that his large water-lily pictures made him dizzy. Two years later, in 1911, he is reported as having had to feel the surface of pictures in an Ingres exhibition, and yet as late as 1914 he was confidently making his own way around the busy streets of Paris. He never completely lost his sight, and it is difficult to chart with any precision the degree or pace of its deterioration.

It has often been suggested that Degas's abandonment of oils around 1894, and his increased use of pastel and figure modeling in wax, was a response to his worsening eyesight. In conversations with Thiebault-Sisson in 1897 his remarks are ambiguous; he implied that he took to sculpture because of difficulties in seeing, and then contradicted this by saying that the two were not connected, that he had been making sculpture for three decades, that he regarded it primarily as a way of exploring possibilities of form related to his pictures, and never wished to see his figures cast. He was quite emphatic to others about the temporary nature of his sculpture, and his very mode of construction tends to con-

firm this. They were mixtures of wax and clay propped up by pieces of wire, bulked out with sponge and stone; disastrous concoctions doomed to fall apart, as so many did. Degas resisted Vollard's pressure to have casts made of his sculptures of horses, naked bathers and ballerinas; only after his death were the pieces salvaged and repaired and bronze casts made. Mary Cassatt protested because she felt that his final

Below: *Dancer Standing in the Fourth Position,* c. 1885; Degas's dancer statues, like his drawings, indicate his complete understanding of the steps and gestures used in the ballet.

Below right: Boucher's canvas *Diana Resting after her Bath* (1742) is one of many precedents in the Louvre for Degas's own bather series.

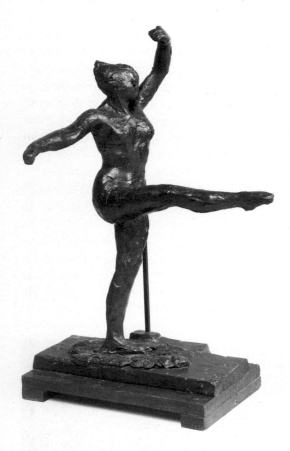

from the town hall'. He also disliked bourgeois indicators of success: 'In my day nobody really ever arrived', he once stated. This of course was nonsense, particularly in the case of his own low-born grain-speculating grandfather, whose father Degaste was a baker from Orleans.

It is difficult for an ageing pessimist not to see social change as threatening and even dangerous. Degas's hardening social traditionalism showed itself at its most unpleasant over the Dreyfus affair. French society was split by the antisemitic controversy surrounding the Jewish army officer who, in 1894, was falsely accused of treason and sentenced to solitary confinement on Devil's Island. Militarists, nationalists and royalists were pitted against anticlerical republicans and socialists. Degas broke with his liberal friends over the issue, and the greatest casualty was his close lifelong friendship with Ludovic Halévy, the old schoolfriend with whose family he dined regularly on Thursday evenings. Halévy was Jewish, and the table-talk of the younger members of his family depressed and distressed Degas so much that he chose to cease seeing them. They never met again; in 1908 Degas came to view Ludovic in his coffin. What is saddest about the whole squalid business is that, because the issue polarized opinion, Degas was forced into kinship with authoritarians with whom he had little personally in common. Degas, who spoke up for legality when the Communards were being shot, who despised official

honors, who was fiercely independent and wide-ranging in his artistic tastes, took to reading antisemitic nationalist newspapers and aligned himself with an ultra-conservative viewpoint. A charitable interpretation might see this clinging onto the crudest manifestations of old values as part of his neurotic fear, anxiety and gloom about life in general.

From the late 1880s Degas built up an extraordinary collection of paintings and prints by artists whom he admired, funded by the increasingly large sums of money that he obtained for his own pictures. He collected obsessively and he collected well. Some pictures he obtained through his own dealer Vollard, exchanging his own works directly for canvases that he felt he had to have. He also used both Durand-Ruel and Vollard as bankers, drawing money for purchases against the deposit on his own pictures. He haunted the auction rooms of Paris and was to be found at all major sales. Ingres, his first hero, was represented in his collection by 20 oils and 90 drawings. Ingres's great rival Delacroix was also included, with 190 watercolors and drawings and 20 oils. There were seven paintings each by Corot, Manet and Cézanne, supplemented by many pictures by contemporaries including Cassatt, Morisot, Pissarro, Renoir and Rouart. Predictably, Monet was not included. Among younger artists Degas owned two works by Van Gogh and, surprisingly, eight by Gauguin – he was attracted by the latter's ex-

pressive color and primitive strength and was also perhaps sympathetic toward another fierce and uncompromising individual trying to make his way in the world of art.

From the early 1900s Degas's production slowed down considerably. He dated very few of his late pictures and of those that he did, 1903 is the latest. He was certainly working in 1905, when he attempted the Rouart portraits, and was drawing in 1907 in the Pyrenees. He probably did not give up two-dimensional work entirely until about 1910. He saw and apparently drew Diaghilev's Russian Ballet when they made their sensational visit to Paris in 1909. No drawings survive, however, and we are left to speculate what wonderful images a younger Degas with his full strength might have made of the performances of Pavlova and Nijinsky. It seems likely that he gave up all work, including sculpture, from about 1912. He had continued to make himself work out of love, out of habit and, as he himself suggested, because without work there was simply the sadness of old age.

Repetition became one of the most characteristic features of Degas's late art. He had marshaled a repertoire of poses, especially of dancers and bathers, and they were deployed again and again, using tracing paper to transfer and reverse images. Yet, despite having a cache of such drawings, Degas continued to use models and must often have had the model take up a

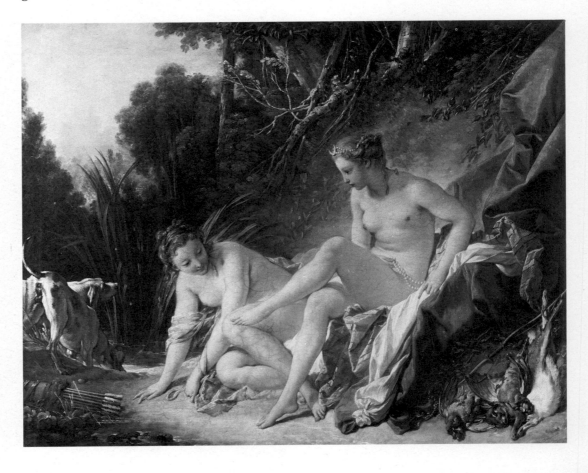

Left: One of the eight paintings by Gauguin that Degas owned was *The Day of the God*, painted in 1894.

Below: This photograph, taken by Degas in around 1896, dispels criticism about the distorted impossibility of certain of his bather poses.

In his last months Degas became bed-bound, and gradually slipped into a vacant distant state. He died on 27 September 1917 and was buried in the family vault at Montmartre. Monet, about whose landscapes he had always been so rude, was among the mourners, as was Mary Cassatt who described the scene in a letter to a friend: 'We buried him on Saturday, a beautiful sunshine, a little crowd of friends and admirers, all very quiet and peaceful in the midst of the dreadful upheaval of which he was scarcely conscious'. Some years earlier Degas had grumpily told his friend Forain, 'I don't want any orations at my funeral, simply carve my tomb "He loved drawing dearly"'.

pose that he had already drawn on a number of occasions. As late as 1910 he was sculpting and drawing from the live model.

The predominant tone of what we know about Degas's late life is one of unhappiness – of a rather crusty, dogged old man, given to repeating the well-polished stories and *bons mots* of his youth, occasionally at his best with flashes of wit and acerbity; a man who, while in company, would announce in the middle of a conversation that he was thinking of his own death. In 1912 came crisis for Degas; Zoë, his housekeeper for three decades, had to cease work and the lease on his home at 37 rue Victor Masse expired and the owners decided to demolish. Degas could probably have bought the building, for his pictures were by now fetching vast prices, but instead he decided to move to another apartment a few streets away at 6 Boulevard de Clichy. In July, his sister Thérèse died.

Information about Degas's last few years is very thin. A photograph taken in 1914 in the Boulevard de Clichy shows him at his daily exercise which, despite what must have been near-blindness, he continued to take. Mary Cassatt made sure that he was cared for – Jeanne Fèvre, a hospital nurse and the unmarried daughter of his sister Marguerite, was persuaded to come and look after her uncle. It has generally been supposed that he was unhappy, but perhaps no more than before. Daniel Halévy described him as 'a dirty defeated Prospero in the dust and semi-darkness, full of indifference'. Others compared him to Homer, Lear, Old Testament prophets and even God the Father. His independent, irascible and coarse side stayed with him. In 1914 he refused help crossing the road from an acquaintance, saying that at his age no-one could be trusted: 'You no longer hold to anything – you are destroyed'.

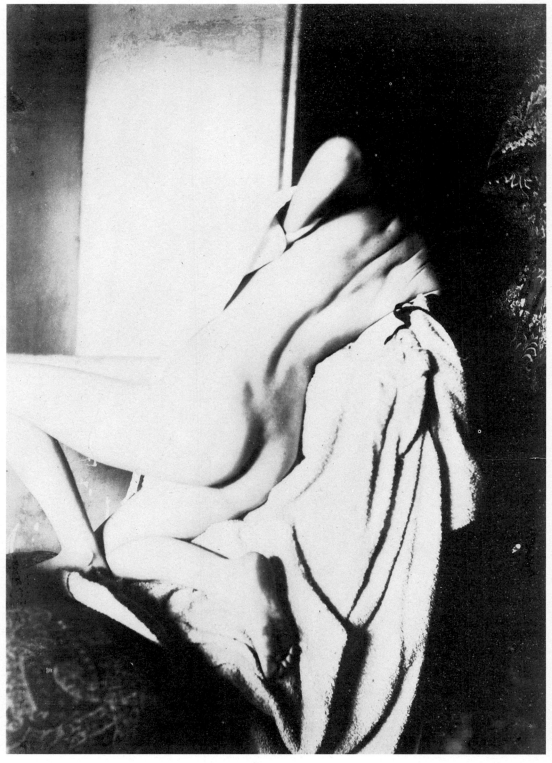

Self-Portrait, 1855

Oil on canvas
31⅞×25¼ inches (81×64 cm)
Musée d'Orsay, Paris

Thick-lipped, stern and nervously aloof, Degas stares out of this picture in the rather clichéd formal pose often adopted by artists for their self-portraits. In his hand he holds a stick of charcoal, while his elbow rests on a portfolio of drawings. Viewed as a manifesto picture expressive of his artistic concerns in 1855, it shows an awareness of the young Rembrandt's self-portrait conventions and coloring, while the depiction of the artist in the everyday clothes of a bourgeois gives just a nod in the direction of Realist conventions. Some commentators have identified a link between the overall pose of the artist and a similarly posed self-portrait by Ingres made in 1804; there is little in the loose facture of its paint handling to connect it with the surface sheen of Ingres, but Degas may have reworked some parts at a later date.

The most completely resolved of Degas's early portraits, this must have considerably reassured Degas's father about his son's abilities. It was painted at a particularly im-

portant juncture in Degas's life. In April 1855, aged 20, he was admitted to the École des Beaux-Arts after two years of preparation that included study under the conservative academic artists, Barrias and Lamothe. In May he visited both Courbet's Realist pavilion and Ingres's one-man exhibition at the great Exposition Universelle in Paris. He was directly responsible for enabling Ingres to borrow back one of his pictures that he required for the exhibition. His schoolfriend's father Edouard Valpinçon was reluctant to lend his picture of a bather until the outraged young Degas insisted that he do so.

Although conceived within the broad tenets of contemporary classicism, this portrait already shows the seeds of the conflict between different artistic traditions, both modern and ancient, that was to arise in Degas's art. Degas left the Ecole after three months and went to Italy to follow a programme of study that he could tailor to his own needs.

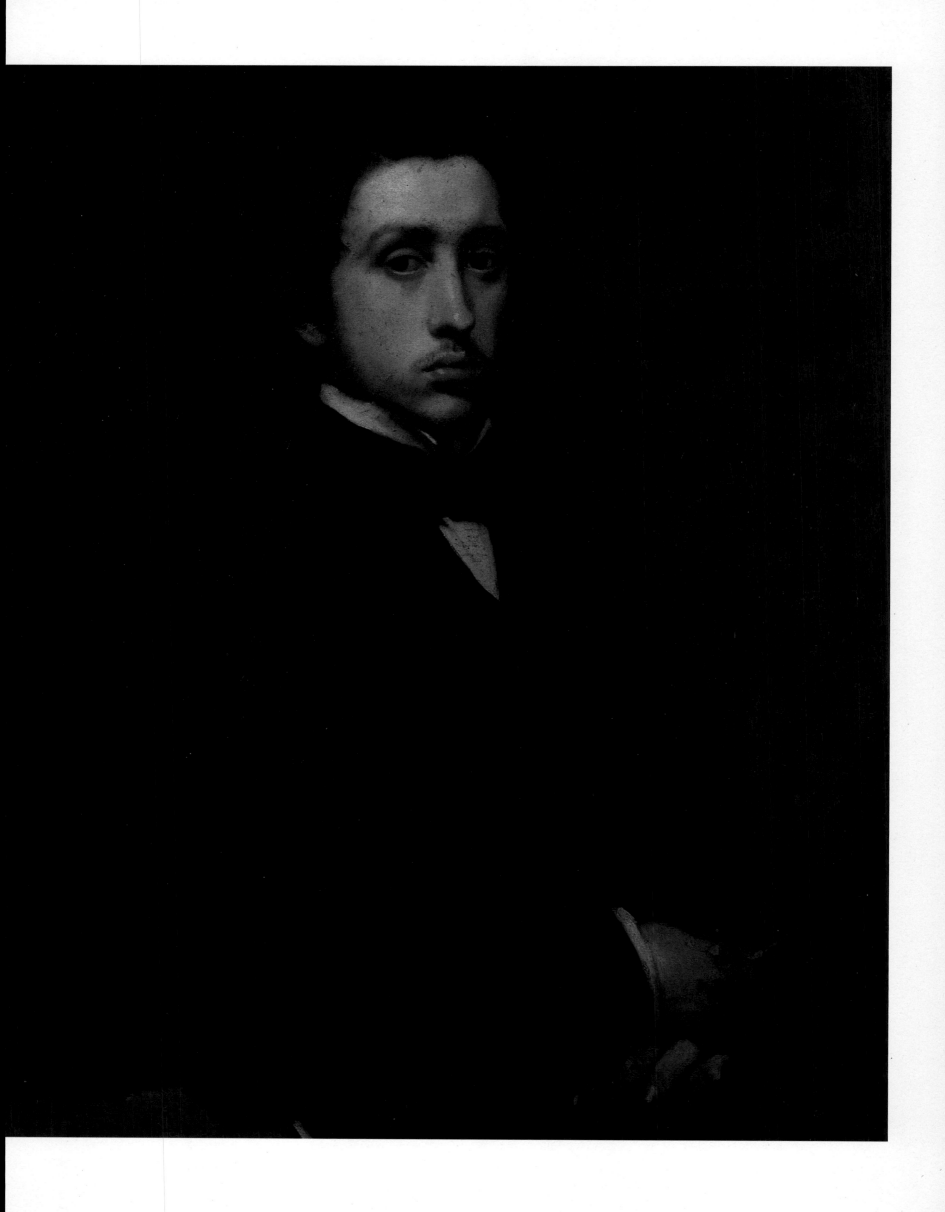

A Roman Beggar Woman, 1857

Oil on canvas
39⅜×29½ inches (100×74.9 cm)
Museum and Art Gallery, Birmingham

Among the forces that shaped the growth of nineteenth-century Realist painting was the increased availability of, and approving critical attention given to, Spanish painting of the seventeenth century, in particular, genre works by Velásquez, Murillo, Ribera and Zurbaran. Beggar children, aged musicians and the picturesque treatment of poverty became fashionable subjects. Degas made this painting while studying in Rome between 1856 and 1858. It is almost certainly from life and possibly of a model who specialized in sitting for this kind of work at the Villa Medici. The Director of the Académie de France in Rome, Jean-Victor Schmetz, whose own paintings included Roman paupers, encouraged students to take up such subjects.

Degas may have set out to paint a deliberately picturesque piece of genre, or he may possibly have sought to show accurately an aspect of Roman life that he had seen. To this day in Italy public begging can involve set pieces of mime not unlike the pose of the woman in this picture. The broken bowl, single coin and crust of bread, so carefully orchestrated as a symbolic visual narrative designed to evoke pity, also have their modern equivalents.

Degas employs similar yellow and brown tonalities to those used for his self-portrait of a year earlier. In this, his earliest Realist work, Degas does not achieve the distanced objectivity of his later urban subjects and, whatever his intentions, a feeling of pity for the woman is most strongly evoked.

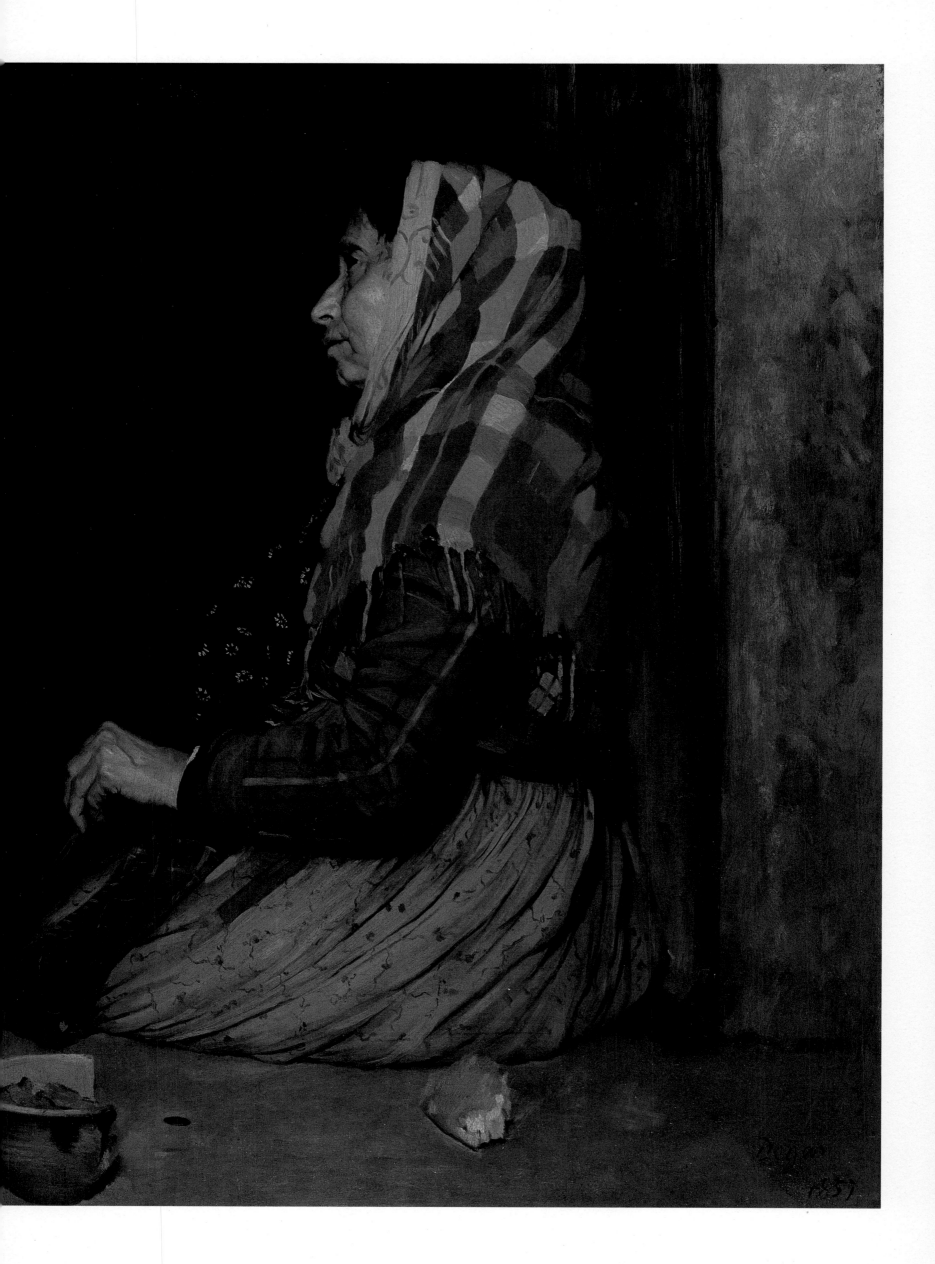

Woman on a Terrace (also called Young Woman and Ibis),

1857-8 reworked c.1860-2

Oil on canvas
38⅝×29⅛ inches (98×74 cm)
Collection of Stephen Mazoh

This painting was executed in Italy under the influence of the artist Gustave Moreau, with whom Degas became friendly during 1857. Moreau was six years older than Degas and had sufficient private means to follow his own enthusiasms in art. He, like Degas, was keen on Mantegna and Italian primitives, and encouraged the younger artist's taste for the Venetians and Delacroix. Moreau's own contemporary mentors were Chassériau and Delacroix, whose styles influenced the pictures he exhibited at the Salons of 1852 and 1853. While in Italy Moreau met Puvis de Chavannes, and their work developed towards Symbolism. The poetic, idealist and more mysteriously subjective art of Symbolism might have claimed Degas, had he not been so pulled towards the alternative Realist and Naturalist inheritance of Romanticism. This is the only example in Degas's work of a thoroughly Symbolist painting.

The white flowers rising from the right-hand pot may be roses – their color denotes purity. The two ibises have no specific symbolic meaning, beyond vaguely connoting Egypt. Their red color is symbolic of passion. Taken together with the thoughtful, calculating look on the woman's face, her one hand modestly holding a veil contrasting with the other hand that openly reaches for something indeterminate, the painting's rather rudimentary message seems to be the conflict between goodness and sexual excitement. The setting behind the balcony wall of mosques and minarets is vaguely Middle Eastern, and the woman may be in a harem, which would make this a rather well-worn image in the orientalist genre of nineteenth-century French painting.

There is an almost affected gaucheness about the foreground composition of figure, birds and flower that is redolent of the early Symbolist works of Rossetti, from about the same time. When found in Degas's studio after his death, this picture, which is indisputably by Degas, was believed by many to be by another hand, so different is it from his other work.

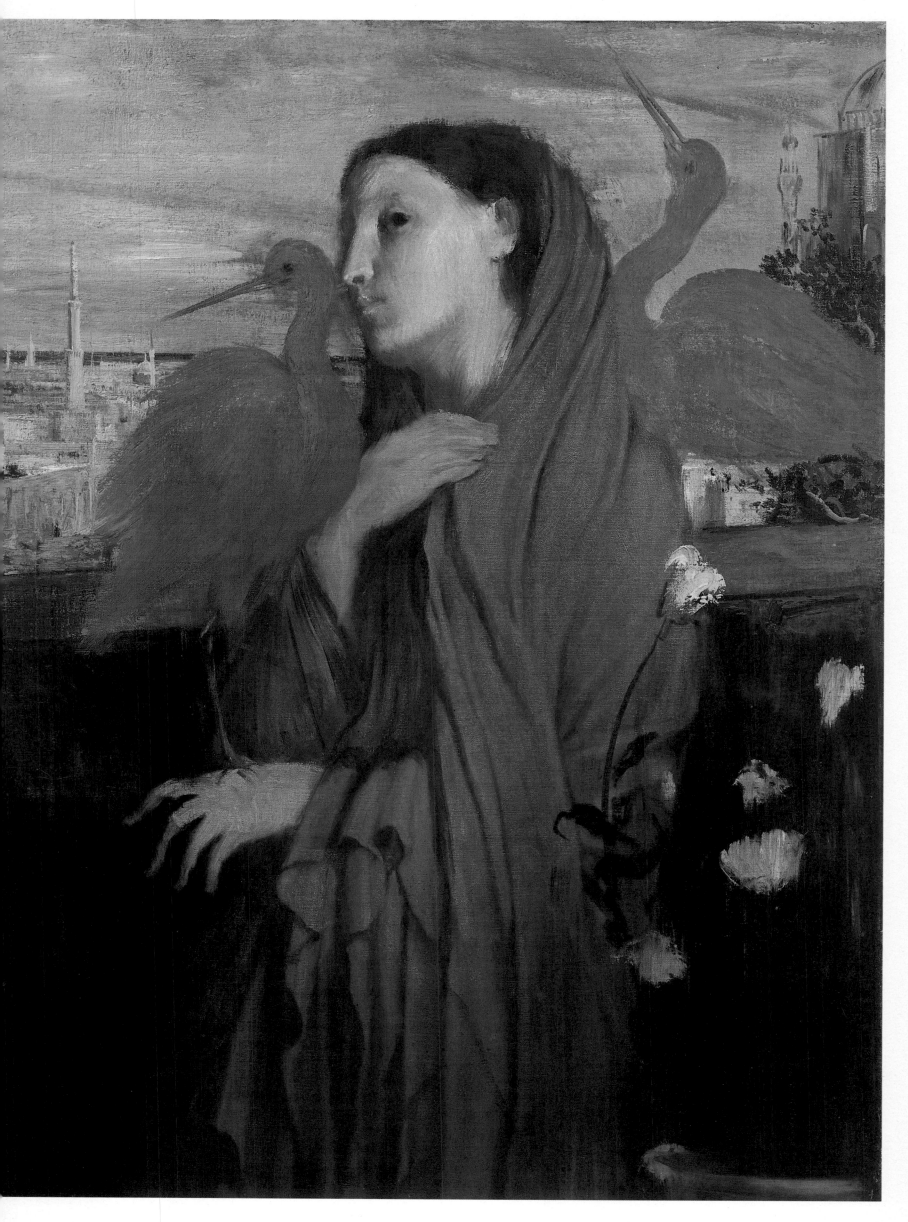

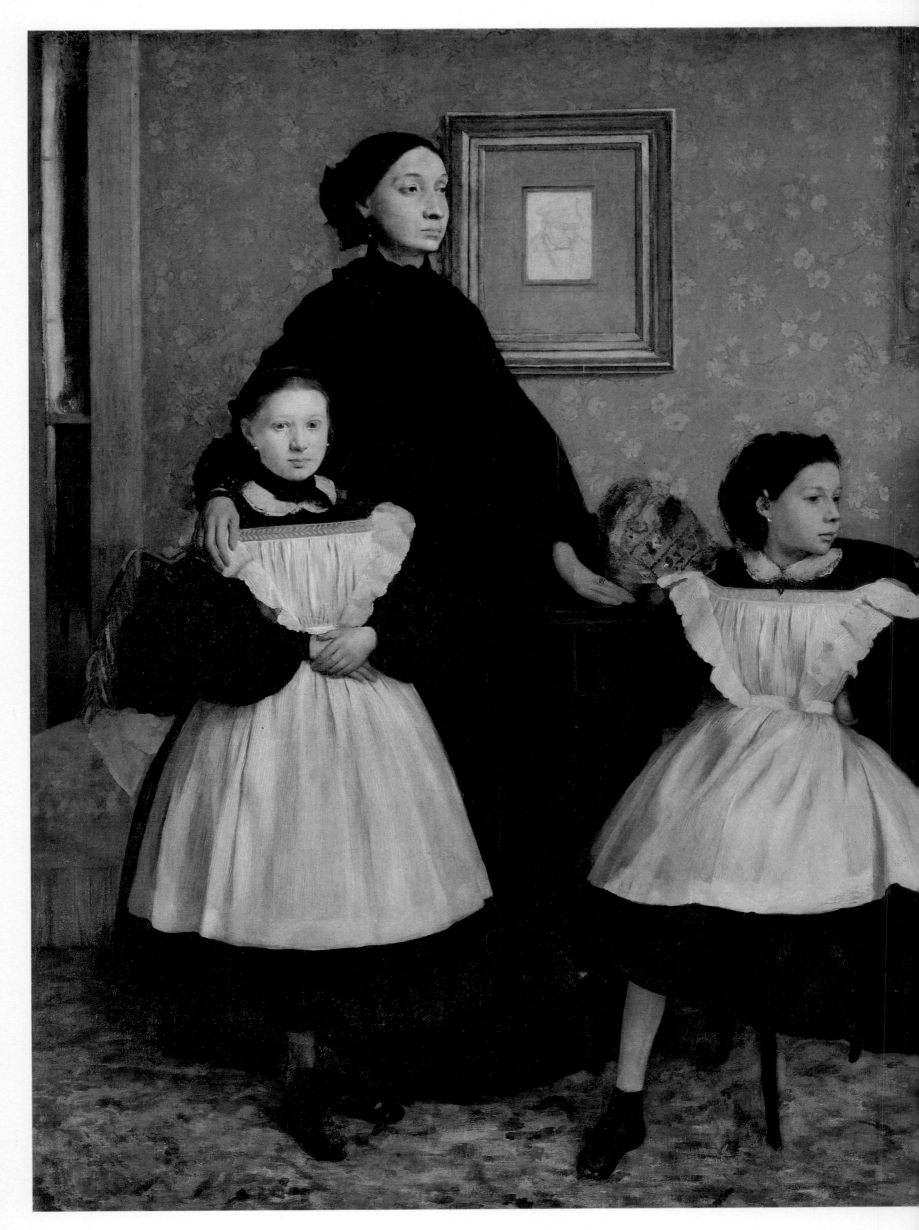

The Bellelli Family, 1858-60

Oil on canvas
78¾×98⅜ inches (200×250 cm)
Musée d'Orsay, Paris

This masterpiece of Degas's early years bristles with the claustrophobic drama of a family divided by dislike and still absorbed with a recent death. It shows Degas's favorite aunt, Laura, her husband Gennaro Bellelli and their two daughters, Giovanna and Giulia, and is set in their rented home in Florence. On the wall in the gold frame is a red pastel sketch by Degas of Hilaire Degas, the artist's grandfather and Laura's father, who died in his Naples home in August 1859 while Degas was in Florence.

The young Degas was the confidant of his nervous, highly-strung aunt, and sympathized with the apparent dislike she felt for a husband whom she had agreed to marry through family pressure. Gennaro sits hunched with his back to the viewer, his eyes downcast, making no contact with his female family. Degas lets him blend softly into the background and gives greater emphasis to the women. Laura, whose stark angular profile is silhouetted against the wall, stares into the distance, her gaze echoed by that of her daughter Giulia, while her hand rests protectively on Giovanna's shoulder, who stares impassively at the spectator. In a stiff united pyramid of contrasting black and crisp whites, the females stand out against the luxurious background. They appear defiant against the power of their brooding *paterfamilias*. Gennaro was exiled from Naples in 1848 and living in Florence, because of his support for the political unification of Italy. He later returned to Naples and became a senator under the united Italian state.

A striking feature of this painting is the emphatic architecture, in which Degas sets up a grid of rectangles consisting of mirror, clock, picture frame, doorpost and bell-pull, against which he poses his figures in a rather airless foreground.

While in Florence, Degas continued his studies of Old Masters. Although the influence of Ingres's portraiture is very evident in this picture, there are also echoes of Holbein, Dutch seventeenth-century portraiture and Mantegna.

Study of a Nude, 1858-9

Oil on canvas
20½×24⅜ inches (52×62 cm)
Von der Heydt Museum, Wuppertal

Whether this is a completed oil study from nature, a preparatory excursion leading to some intended picture, or a work that, with further elaboration, might have become a small-scale history painting in its own right, is now difficult to conclude. It is the fullest surviving realization in oil by Degas of the single female nude, painted within the academic traditions of Ingres, Lamothe and the curriculum of the Ecole des Beaux-Arts, an institution that Degas only attended for one term. In general it resembles a figure study by a third-year academic student. Any student at the Ecole, or for that matter at any major European national academy, was kept away from the use of real paint until the third year – the potentially seductive effects of *colore* were thought too risky. In year one, pencil and charcoal studies were made from plaster casts of antique statues. Using the same tools, the live nude model might be tackled in year two. Pigment was only freely handled after the student had passed through this two-year linear apprenticeship.

There is no painting or projected picture in Degas's sketchbook that corresponds to or has any obvious affinity with this work, which is broadly in tune with Venetian paint-handling and has a general kinship with the nudes of Titian or the golden-hued figures of Giorgione. The pose of the model also invites connexions with Renaissance prototypes. The model for the painting may have been associated with the Villa Medici, the Rome branch of the French Academy, where scholarship and prizewinning students studied and to which Degas was allowed ready access for drawing classes, even though not an official student.

Degas did not take up the independent treatment of the nude until the bather pictures of 1876 onwards. Unlike any of these later nudes, who stand, sit or crouch unaware of the spectator, this woman returns the gaze of the viewer.

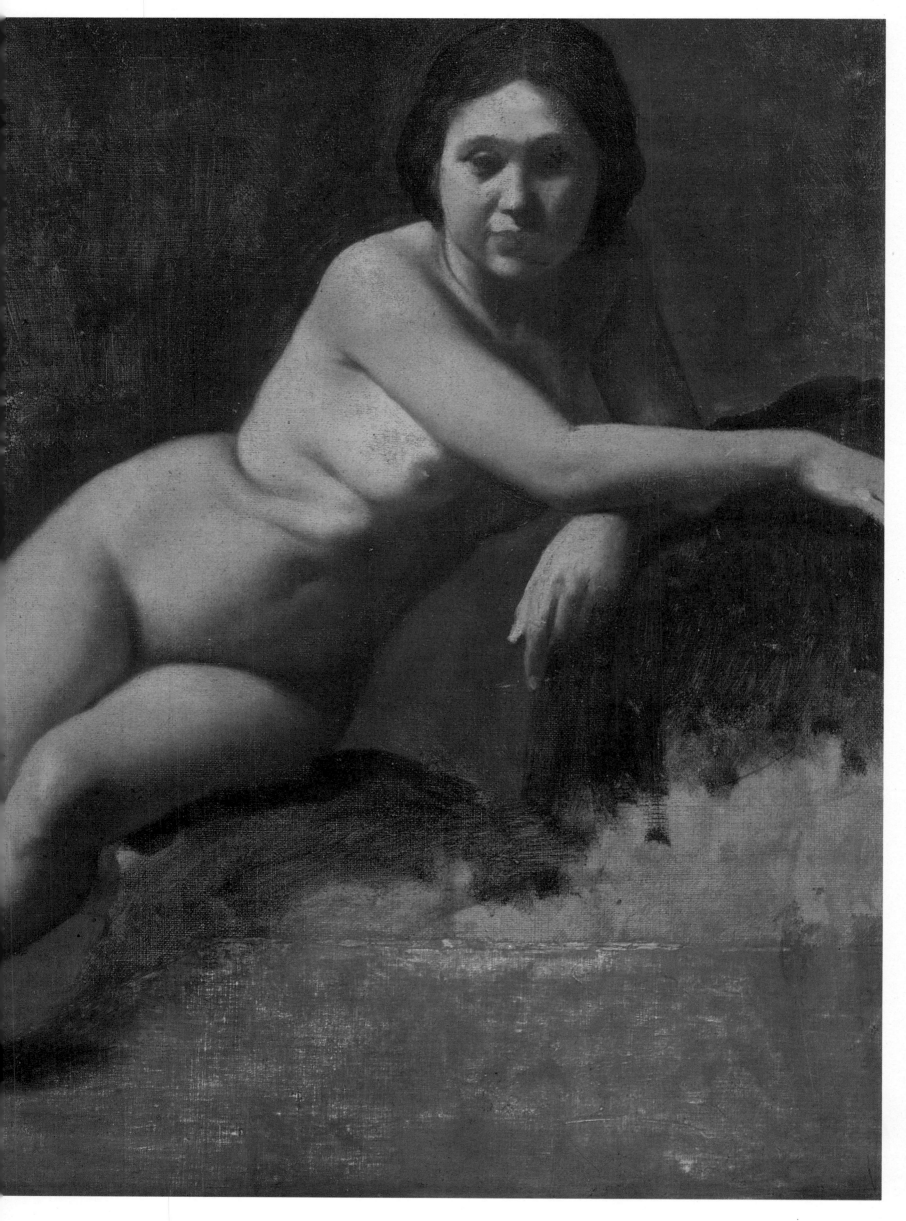

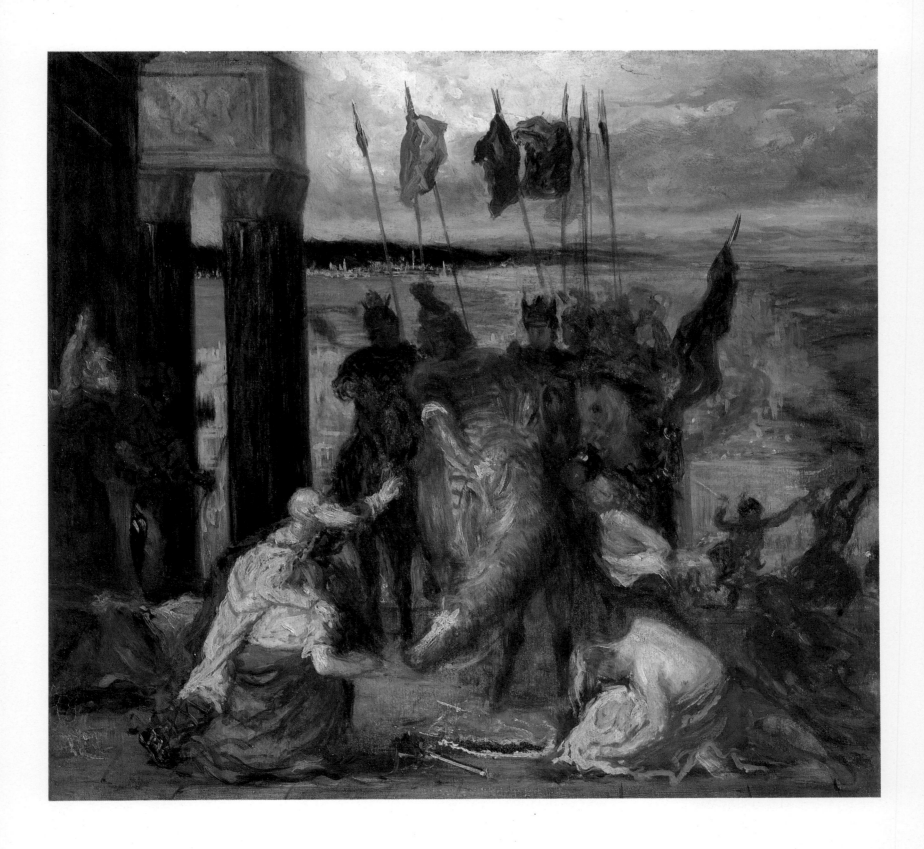

Copy after Delacroix's Entry of the Crusaders into Constantinople, c.1859-60

Oil on paper
13¾×14⅞ (35×38cm)
Private collection on loan to Kunsthaus, Zurich

At the beginning of April 1859, Degas arrived back from Italy in time to visit the Salon where, after viewing eight works on show by Delacroix, he made copies of two in pencil and pen and ink, as well as further slight copies of Delacroix's work at the Luxembourg, the Palais Bourbon, a Paris church and picture dealers. This more substantial oil copy was made at Versailles. Showing Baudoin Count of Flanders entering Constantinople, with weeping old men and women begging mercy from the sacking crusaders, this curiously shameful piece of French glory was included in Louis-Philippe's national 'Gallery of Battles'.

The enthusiasm that Degas developed in Italy for Delacroix, encouraged by Moreau, must have been rather abstract until he undertook this rigorous study of his works. In this copy Degas is primarily concerned with color, less so with light, and less still with the subtle interconnecting linear rythms of flags, drapery and smoke in Delacroix's original work. Degas's own clear-contoured Ingres-inspired drawing style had developed by this date to a point of great maturity. In preparing himself for his first major history painting of *The Daughter of Jephthah*, (page opposite), Degas turned to Delacroix's picture for assistance in orchestrating his own colors, thus doing possibly for the first time what he was later to raise to a much repeated article of faith. As he said in old age to Vollard,

The masters must be copied over and over again and it is only after proving yourself a good copyist that you can reasonably be permitted to draw a radish from nature.

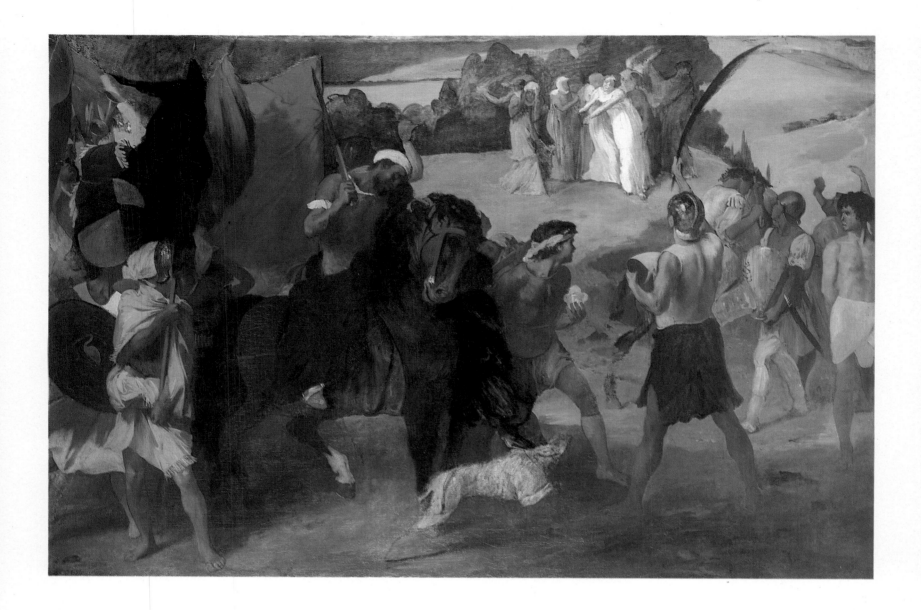

The Daughter of Jephthah,

c.1859-61

Oil on canvas
77×115½ inches (195.5×293.5 cm)
Smith College Museum of Art,
Northampton, Massachusetts

Aged 25, with three years study in Italy under his belt, Degas rented a spacious Parisian studio and set out to paint the largest painting he was ever to attempt, on a scale comparable to the history paintings of Ingres and Delacroix which, when shown at the Salon, would assure attention. It was, however, never finished, never exhibited and was uncommented upon during his lifetime.

The subject concerns Jephthah, the biblical warrior who killed his only daughter in fulfilment of a promise made to God that, if he were granted victory over the Ammonites, he would sacrifice the first thing that came towards him on his home-coming. This doom-laden tragedy, retold by several Romantic writers including Byron, may have been chosen by Degas because it not only had a barbaric mer-cilessness of theme akin to certain of Dela-croix's pictures, but could also at the same time encapsulate a more general moral cri-tique of the inevitable horrors of war. Sug-gestions that it is an allegory of any specific contemporary political events are uncon-vincing.

Degas borrowed ideas from other artists, particularly Mantegna and Delacroix; the group of women at the rear supporting

Jephthah's daughter are a quotation from Mantegna's Louvre *Crucifixion*, and the man on the left with a banner is derived from a print of his *Triumph of Caesar*. Color was a major preoccupation. En-couraged by Moreau and ultimately in-spired by Delacroix, Degas deliberately forced higher-keyed, more adventurous combinations previously unexplored, with yellow playing a particularly powerful part. In a notebook used at the time, Degas indicates that he had Delacroix's *Pieta* in mind for the orange-red robe of Jephthah. In overall conception, the head-bent horse surrounded by scattered figures is very close to the Moroccan *Sultan on Horseback* theme that Delacroix had painted in several versions.

Recent critical opinion, less concerned to view Degas's involvement with history painting as a prolonged adolescent aberra-tion, has found singular merits in this pic-ture; the discordant color harmonies and complex figure groupings have been seen as particularly strong. This re-evaluation of the picture is an interesting illustration of how an artist's work can be seen as great by several generations, but with a shifting emphasis given to the highs and lows within his output.

Young Spartans (also called *Young Spartan Girls Taunting Boys*), c.1860-2 re-worked until 1880

Oil on canvas
$42\frac{7}{8} \times 61$ inches (109×155 cm)
The Trustees of the National Gallery, London

In ancient Greece the Spartan system of education for both boys and girls was famous for its uncompromising athleticism. For a state in which active preparedness for war underpinned all social and political organization, a fit and healthy youth was vital. Degas's decision to tackle a Spartan theme for a history painting raises questions about his view of this ancient society. Despite the dour illiberality of Sparta, it was viewed by some early nineteenth-century neoclassicists as representing a chaste model of social simplicity that bordered on primitive communism. No obvious political critique seems to be intended in this painting, although Degas's full intentions regarding its meaning are unclear.

Behind the two frontal figure groups, which glow with such rude golden health, is a further group that includes women and children. The old man is the philosopher Lycurgus, the mythical author of the rigid Spartan laws and constitution, whose *Life* by Plutarch, Degas told Daniel Halévy, he had read in developing the idea for this subject. A light-hearted interpretation of this group's significance is that mothers and babies are the longterm outcome of youthful banter between boys and girls. A slightly darker reading is also possible; the mother on the edge of the group is looking back to the distant mountain of Taygetus, the place where sickly and deformed Spartan children were exposed at birth. The full force of Spartan eugenics may be about to affect her offspring.

Degas did not use idealized classical figure prototypes for the foreground groups. Both boys and girls have the coarse features of the Parisian children that he probably used as models. It is a curiously contemporary Realist touch in a subject that appears to celebrate the physical perfection of the ancients and, taken in conjuction with the deliberate inclusion of Taygetus, raises questions about a possible 'survival of the fittest' sub-theme.

In the relationship between the foreground group, Degas sets up a controled tension. On either side, there is one who expresses desire for involvement with the

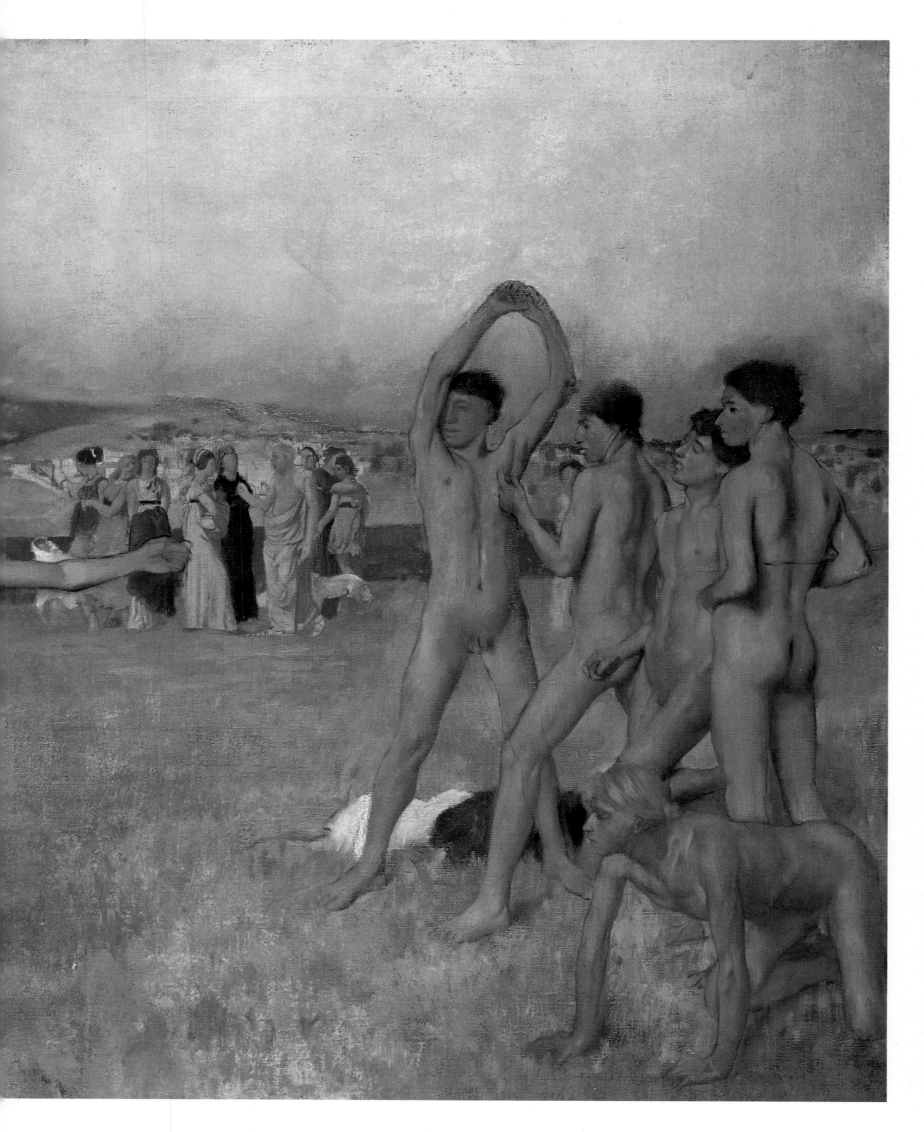

opposite sex, one who withdraws in uncertainty, and a pair who appear self-absorbedly content and detached. Degas worked and reworked his figure grouping – the 'ghosts' of overpainted limbs show through in places, particularly in the girls' group. He carried on painting the picture until 1880 when he intended to show it at the fifth Impressionist exhibition; that it was not completed to his satisfaction is the likeliest reason why it was not shown. Degas remained extremely proud of his early work, and often put it on an easel on show in his studio – 'a unique honour' according to Halévy.

Semiramis Building Babylon,

c.1860-2

Oil on canvas
59×101⅝ inches (150×258 cm)
Musée d'Orsay, Paris

Semiramis, Queen of Babylon, looks out from a high terrace across the still waters of the Euphrates at the city of Babylon that she is constructing. Rossini's opera *Semiramis*, revived at the Paris Opéra in 1860, has been suggested as a possible inspiration for the subject, but the picture's severity of architecture, figures and dress bear no relationship to the glittering exuberance of costume and sets in the opera production.

Degas provided elaborate figure and drapery studies for this picture, and a series of full compositional drawings. In successive drawings the organization of

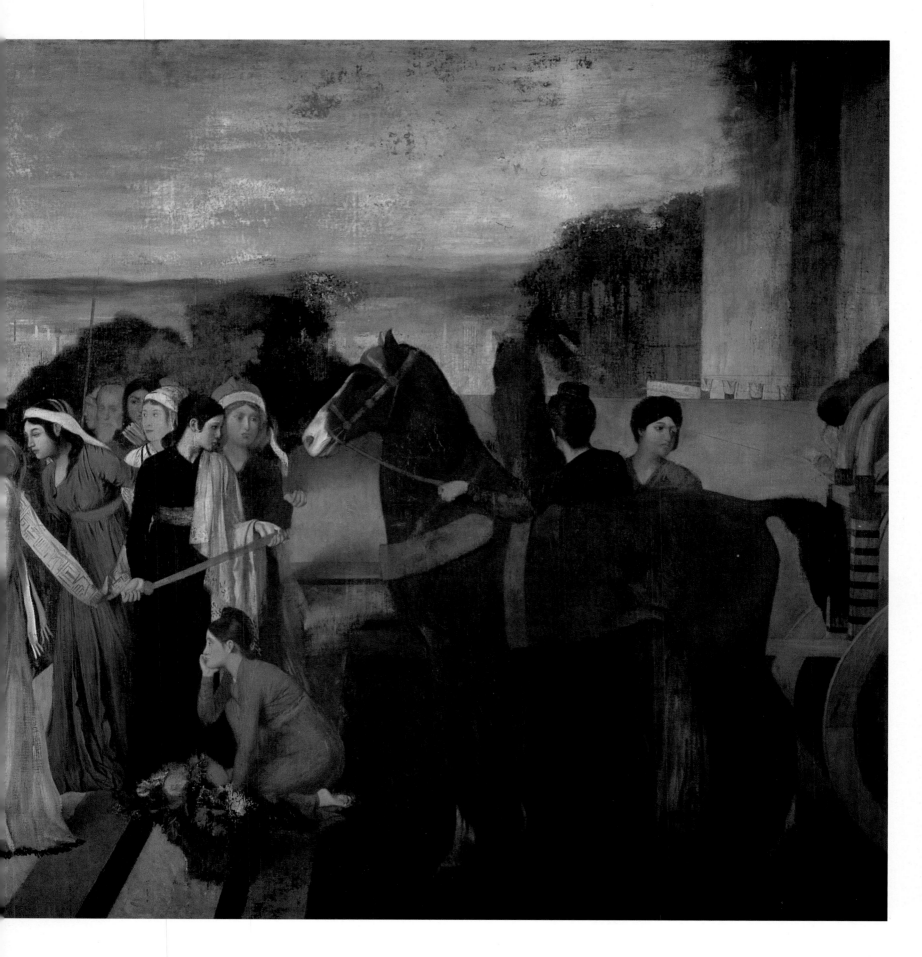

the foreground architecture and trees became increasingly simplified, and the group of figures more frieze-like and processional. For a subject set in distant pre-Greek antiquity, Degas used a geometrically severe foreground architecture that recalls the absolutist neoclassical extremism of the early nineteenth-century architects Ledoux and Boullée. The architecture of the city below, however, with its varied spires, towers and columns is more suggestive of an Italian Renaissance city.

Degas's figure style has several prototypes. The horse derives from the Panathenaic frieze in the Elgin Marbles, which he

drew from plaster casts. The chariot was copied from a seventh century BC Assyrian relief in the Louvre; at this time the Assyrian sculpture exhibited in both the Louvre and the British Museum was still thought of as 'primitive' – almost pre-art. In 1853 the British sculptor Westmacott, giving evidence before a Royal Commission, said, 'I think it impossible that any artist can look at the Nineveh marbles as works of study'. Although no copied studies survive to prove a definite connexion, the frieze of figures are very evocative of those painted by Piero della Francesca on the walls of the high altar at San

Francesco in Arezzo, which Degas visited in August 1858 when he was in Italy. Piero's status in mid-nineteenth century connoisseurship as a very recently rediscovered pure 'primitive' genius made his figure style appropriate for the evocation of a scene set on the borderline of prehistory. The figures chime in with the primitive simplicity of the foreground architecture.

Degas never finished this grand history painting. He kept it in his studio and George Moore and Manet, among others, were shown it. Manet playfully advised him to exhibit it, suggesting that it would make for variety in his work.

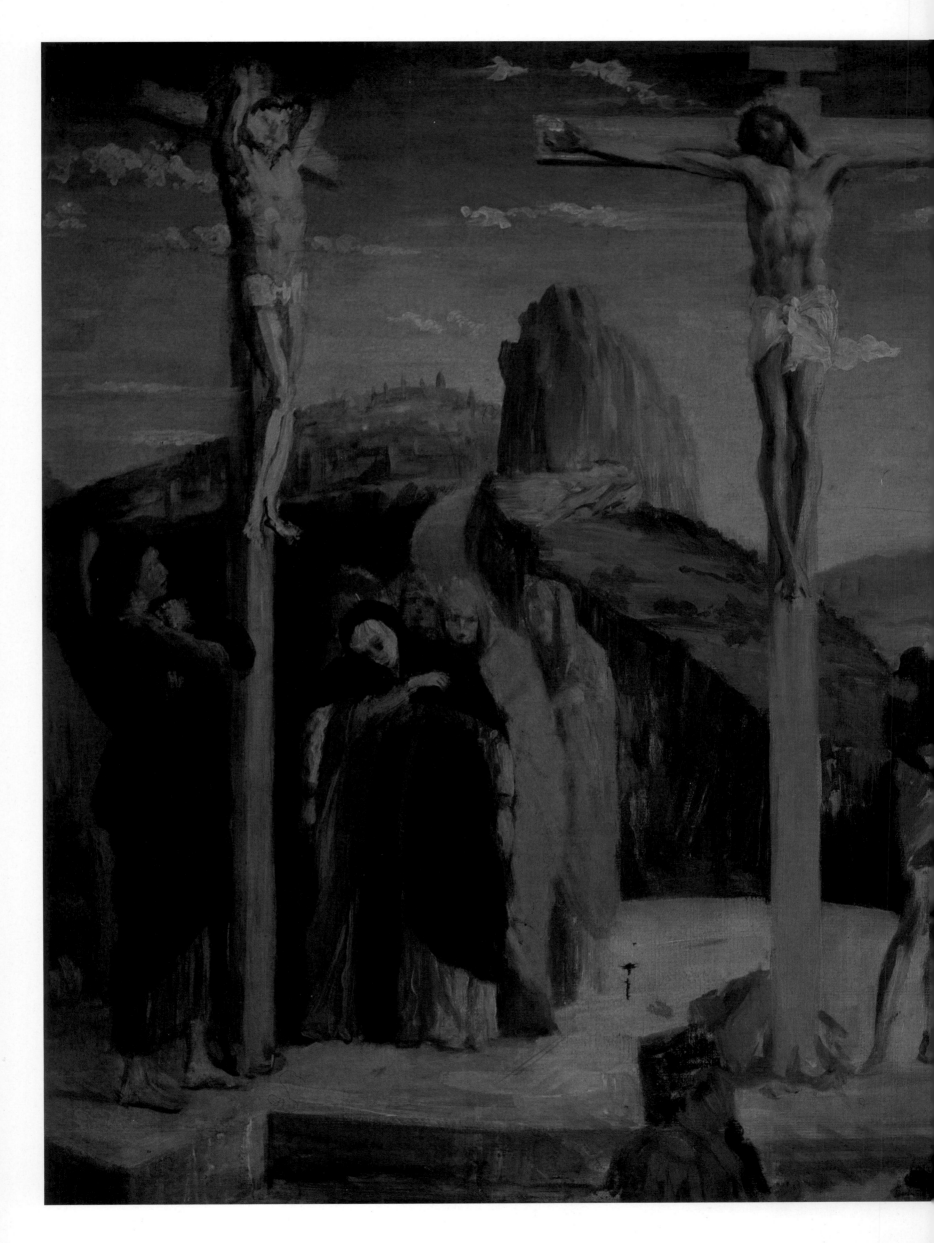

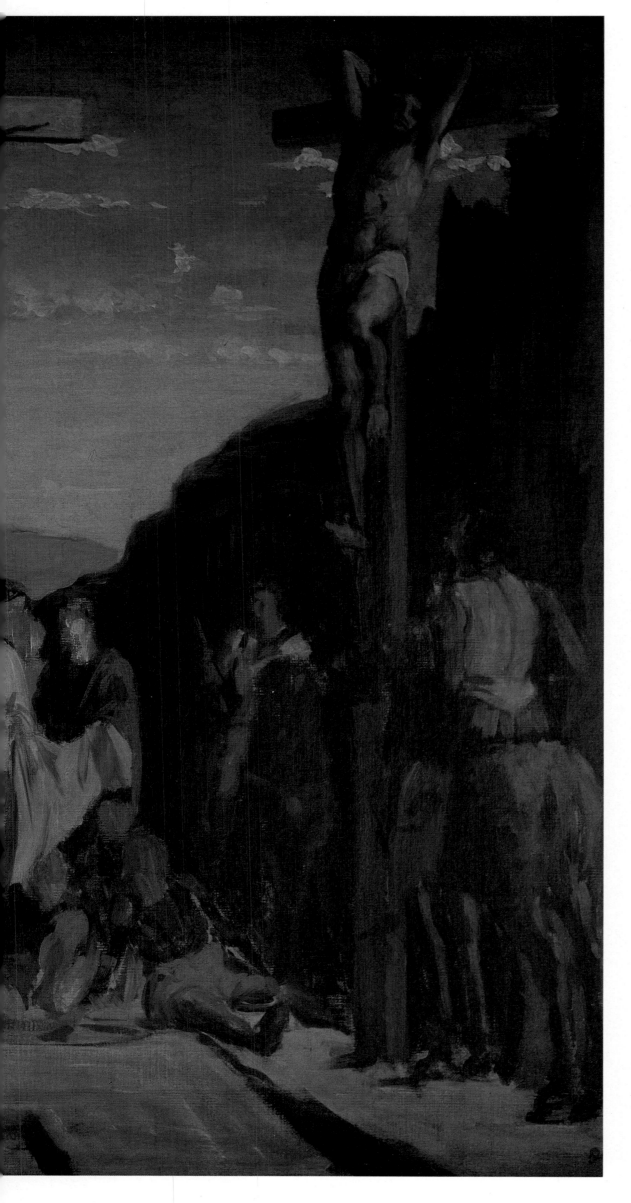

The Crucifixion, after Mantegna,
1861

27⅛×36⅜ inches (69×92.5 cm)
Musée des Beaux-Arts, Tours

Among the loot that Napoleon brought from Italy and installed in the Louvre was the large altarpiece from San Zeno in Verona, painted c.1458 by Mantegna. The central predella panel of the crucifixion remained in Paris after the upper sections of the altarpiece were returned. Mantegna had been one of the first 'primitives' to receive critical re-evaluation at the end of the eighteenth century. Goethe among others admired his combination of labored earnestness and lucidity, and praised his accuracy and integrity. Degas copied individual figures from this crucifixion in pencil between 1853-5, and studied Mantegna's paintings in Italy between 1857-60. He once wrote that he wished to combine 'the spirit and line of Mantegna with the verve and color of Veronese'.

This copy, which is the same size as the original panel, dates from about 1861. Unlike the severe linearity of Mantegna, Degas's handling of paint is loose. The range of colors used is more limited and tonally less varied than in the original, and many background details have been left out. It is as if, after pinning down the main architectural bones of the picture and taking his color cues for the foreground figures, Degas then pursued a modified organization of colors and construction closer to that of Delacroix, whose work he was also copying at this time.

Degas's father was an enthusiast for early Italian art and fostered his son's interest. He wrote to Degas in 1858,

The masters of the fifteenth century are the only true guides. Once they have been thoroughly grasped and have inspired a painter unceasingly to perfect his observation of nature, results will be guaranteed.

Throughout his life Degas sang Mantegna's praises and made over 20 copies of his work in various media. He later adapted the group of figures at the foot of the cross for the background of his largest and most ambitious history painting, *The Daughter of Jephthah* (page 35).

This picture appropriately now hangs at the Museum in Tours where the two flanking predella panels from Mantegna's original San Zeno altarpiece can also be seen. The central predella panel remains in the Louvre.

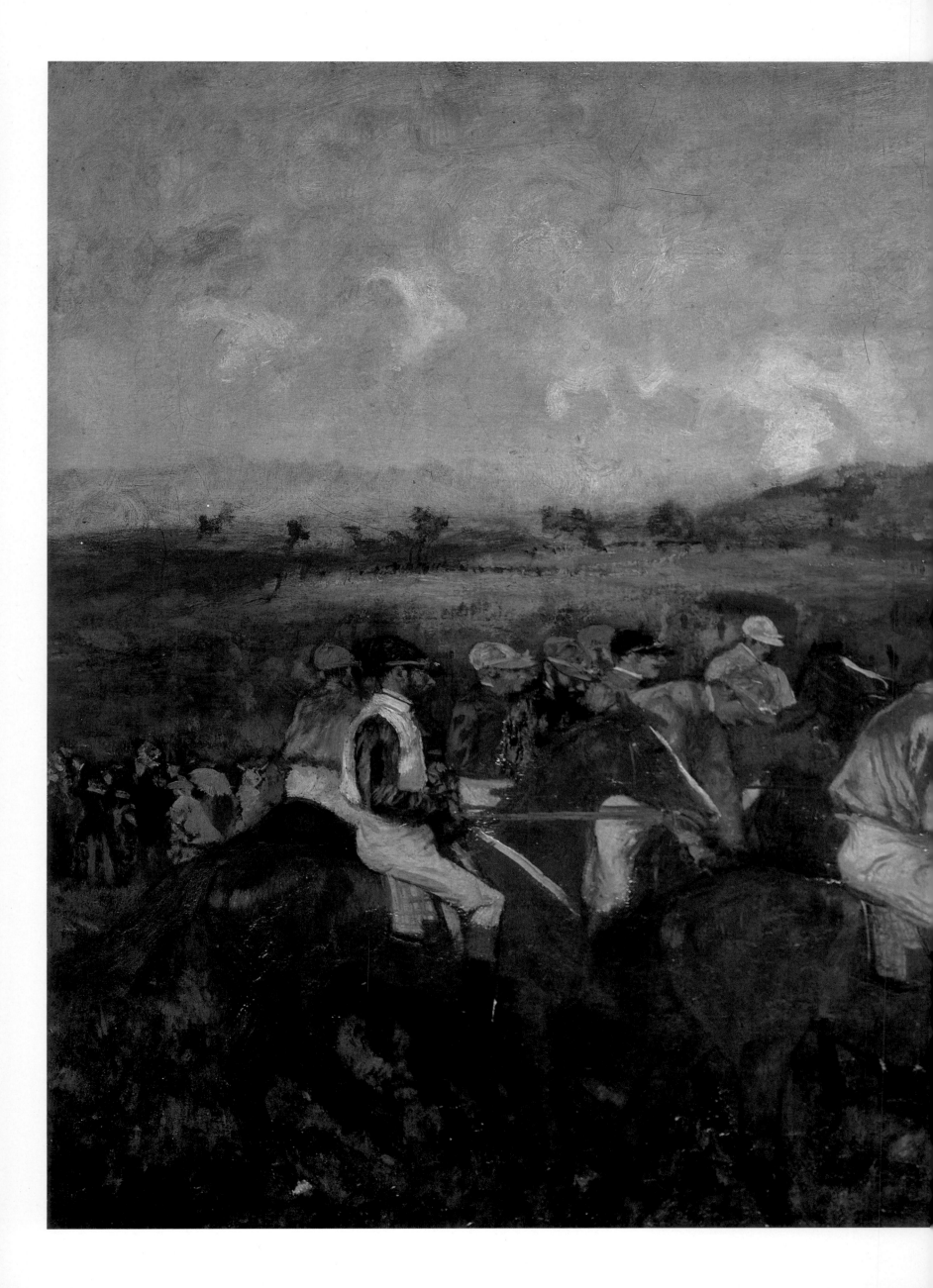

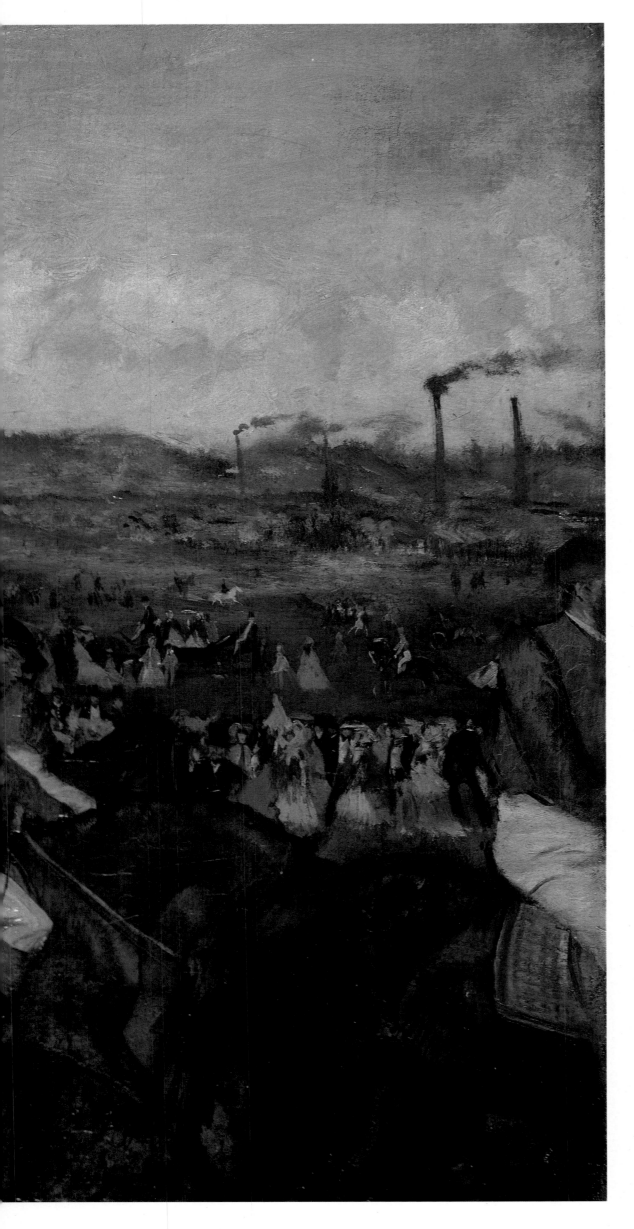

The Gentlemen's Race – Before the Start, 1862, reworked c.1882

Oil on canvas
18⅞×24 inches (48×61 cm)
Musée d'Orsay, Paris

This is possibly Degas's first painting of a racecourse and his first truly modern life subject. Degas's notebooks include copies of Delacroix's horses, a study of a horse rolling on its back inspired by Delacroix and a carefully worked-up study of horses charging into battle. Despite this Romantic exploration of the horse's energy, in both his history paintings and in his horse-racing subjects, Degas preferred a quieter mood, with the animal reigned in and governed by man – without billowing mane or careering progress. It is usually the moment just prior to a race, when a line of jockeys await the call to the starting line, that Degas depicts, rather than the race itself.

Several sources have been suggested for Degas's developing interest in the race-course. He stayed with his friends the Val-pinçons at their estate in Normandy and visited the nearby chateau of Haras-du-Pin where the French National Stud is now housed. At about this time he also studied and copied from English sporting prints. In the more general context of French society, horseracing was just beginning to become an extremely fashionable activity. Degas may have been attracted to the race-track as a subject because it was a realistic, albeit rather upper class, subject that still left scope for the use of traditional picto-rial, linear and formal balance.

The riders shown here are gentlemen amateurs not professional jockeys and their silks, like the later bows and ribbons of ballerinas, are an invention by Degas, making free play with blocks of bright color for pictorial effect. He makes particu-larly strong use of oranges and reds to evenly punctuate the frieze of figures.

This picture was much worked over two decades later, prior to Degas's selling it for 4000 francs to his dealer Durand-Ruel, and the factory chimneys were added at this time. The prices paid for the canvas in-dicate how rapid was Degas rise in popu-larity in the early 1890s. Durand-Ruel sold it for about 6000 francs in 1884 and resold it in 1889 for 7500 francs, and in 1894 a subsequent purchaser paid 35,000 francs for it.

43

Scenes of War in the Middle Ages, 1865

Essence on paper mounted on canvas
31⅞×57⅞ inches (81×147 cm)
Musée d'Orsay, Paris

This last history painting undertaken by Degas was shown at the 1865 Salon. A disturbing image of destruction, violence and rape, it is the most explicitly cruel subject that Degas ever painted, and one that still puzzles as to its precise meaning. Although the costume is vaguely fifteenth century, no specific historical event is suggested. The alternative mistaken title given to the picture after it left Degas's studio in 1917 was *The Misfortunes of the City of Orleans*. It has been suggested that it was New Orleans rather than Orleans that Degas had in mind, and that it is a response to the atrocities related to him by his American cousins, who were forced to flee their homes in 1862 and come for a while to Paris after the invasion of New Orleans by Union (northern) soldiers. Degas's treatment of the theme invites general comparison with Romantic images of male cruelty; in particular it is reminiscent of Delacroix's *Massacre of Chios* with its similar naked and dying figures and distant burning town.

Degas made a large series of superb studio-posed figure studies of the suffering women. In the painting none of their faces are visible; hands, arms or long tresses cover their features. The bow-firing figure on horseback was also posed by Degas from a naked female model – her delicate skin and rosy cheeks suggest that, even transferred to the painting in male attire, she is still female. This clothed figure of ambiguous gender shooting arrows at a group of naked tortured women raises more questions about the nuances of Degas's sexual tastes than any other image in his work.

Various artistic influences have been suggested for the genesis of this work, including Puvis de Chavannes' 1861 painting *Bellum*, which is similar in sentiment, and also Joseph Lies's 1859 salon picture *The Evils of War*, which Baudelaire had enthused over. As well as being a possible anti-war allegory centered upon New Orleans, Roy McMullen has suggested that it may have been inspired by the great loss of life among French troops at the Battle of Solferino in June 1859.

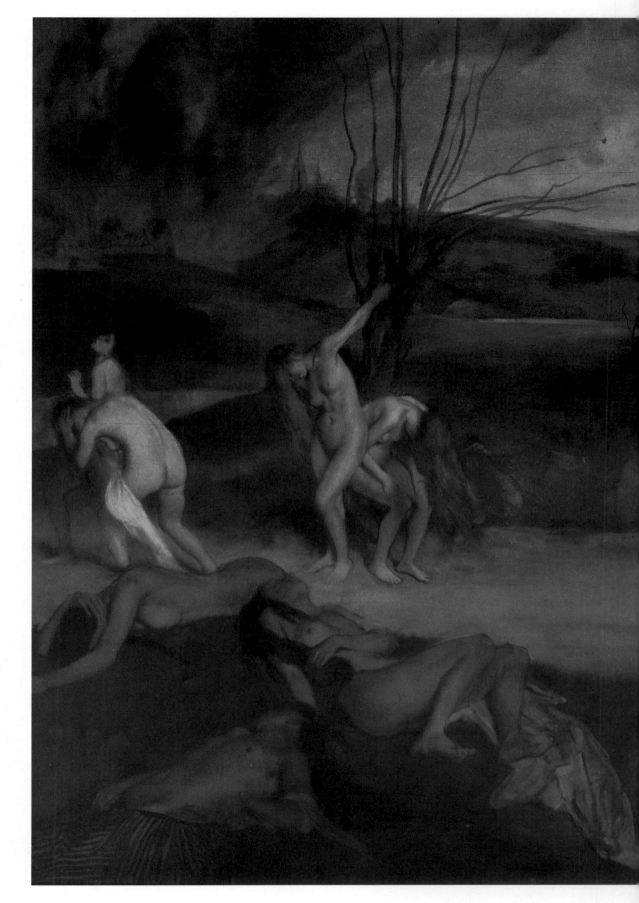

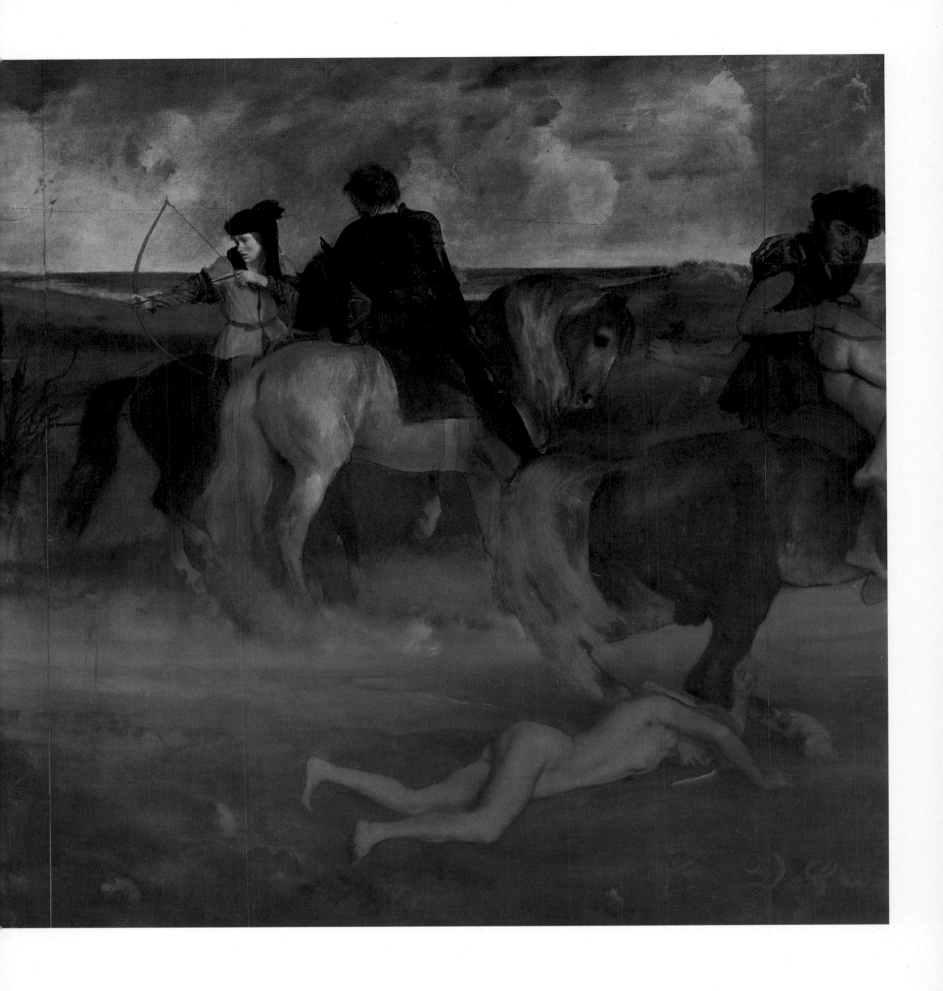

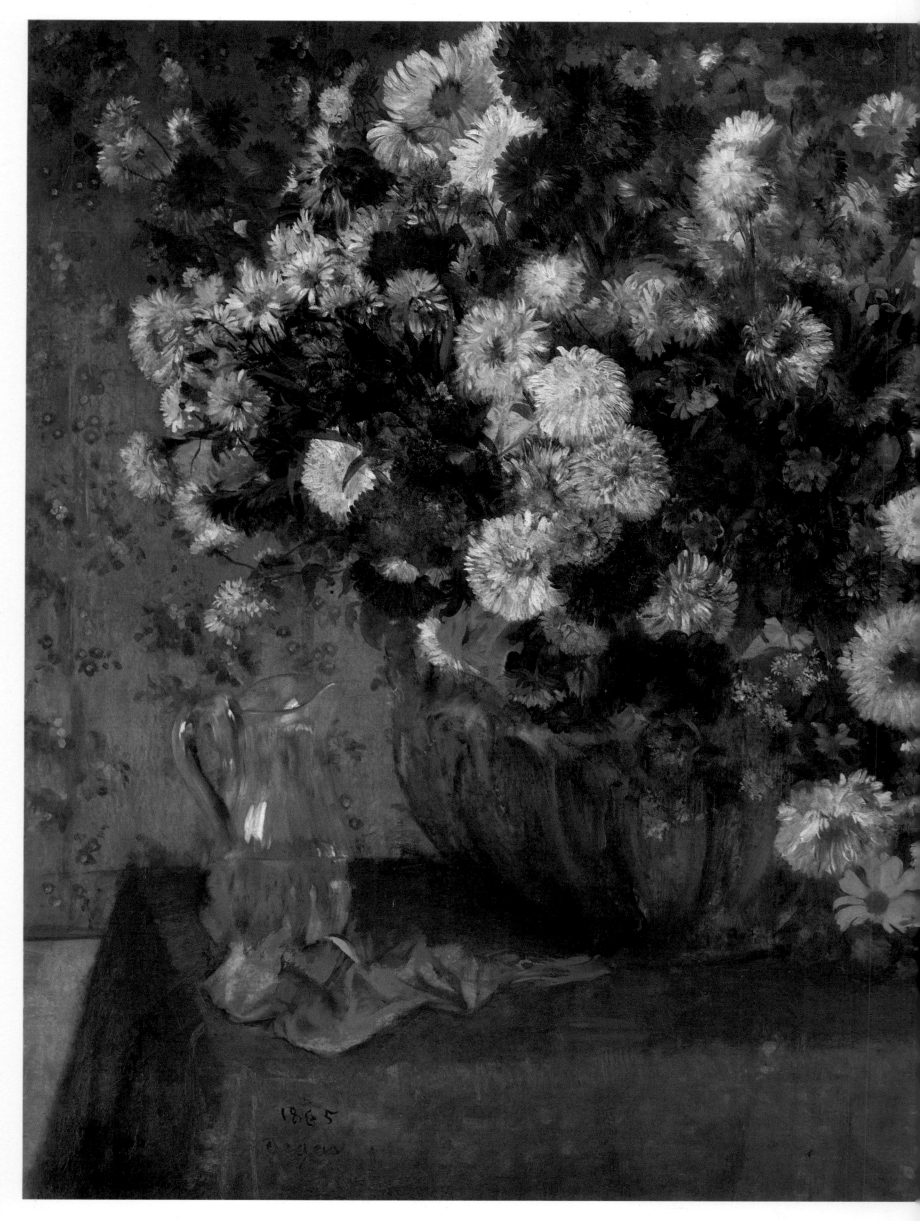

46

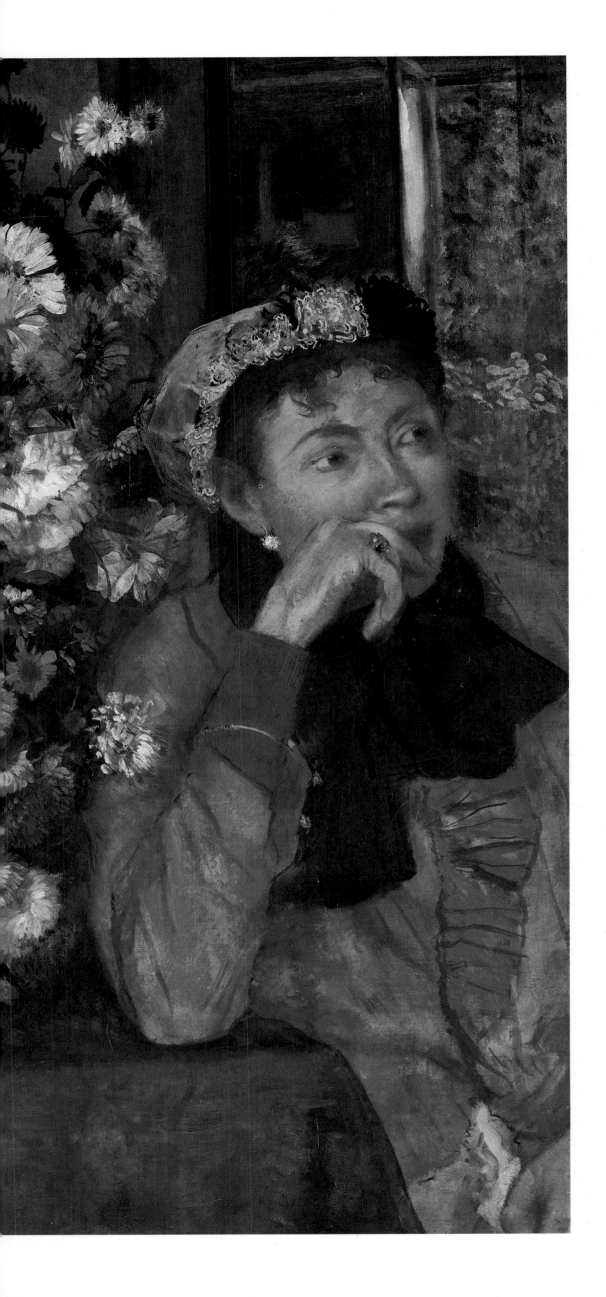

A Woman with Chrysanthemums, 1865

Oil on canvas
29×36½ inches (73.7×92.7 cm)
Metropolitan Museum of Art, New York

On no other occasion do flowers figure so significantly in Degas's art. Although he enjoyed still life and collected examples that included Cézanne and Manet, his own art did not embrace the lower key of arranged flower, fruit and foliage. Degas could generate the attraction of a multi-colored explosion in a flower vase in the bright bows of ballerinas, the clash of jockey's silks or a window full of women's hats.

Degas's lack of enthusiasm may have been prompted by the prejudices of his education, as flower painting was extremely low on the academic scale of painting genres. Additionally it savored, in the transcriptive accuracy involved, of the 'tyranny of nature' that Degas disliked in certain landscape art. He may, however, have felt obliged to tackle the challenge of a substantial still life simply to prove that he could do it. Robust flower painting was a facet of Realist art and there were also countless precedents for such subjects in the Dutch seventeenth-century art so admired by the artists into whose circle Degas was moving at this time. The status of still life must have been often discussed.

In summer 1865 Degas may have stayed at Menil-Hubert, the Normandy estate of his schoolfriend Paul Valpinçon, and the woman with the wide-spaced eyes and distinctive rather than beautiful face is possibly Paul's wife, shown resting after her labor of picking and arranging her enormous bunch of asters, stocks and dahlias. Until recently she was thought to be another woman, Mme Hertel, and the flowers were considered a self-sufficient still life into which Degas had later inserted the rather cramped figure as an afterthought. The definite identity of the sitter and Degas's original intention for this work are not yet resolved.

Among Degas's often-voiced phobias were flowers placed on dining-room tables; it is possible that these magnificently painted blooms, so grossly profuse, are an example of Degas's humor at his own expense. The picture remained with him for over 20 years until sold for 4000 francs in 1887 to Theo, the art-dealer brother of Vincent Van Gogh, making it at the time the second highest sum that he had received for a single picture.

Edouard and Thérèse Morbilli,

c. 1865

Oil on canvas
45⅞×34¾ inches (116.5×88.3 cm)
Museum of Fine Arts, Boston

Thérèse, Degas's 25-year-old sister, stares directly at the viewer beside her dull and rather pompous Neapolitan husband, Edmondo Morbilli. He was her first cousin and she obtained a papal dispensation for her marriage to him in 1863. Degas painted and drew Thérèse more than any other member of his family; as a child she had been his favorite model. Her oval face, almond eyes and centre-parted hair were reminiscent of the ideal type of female face that Ingres so much admired, and her pose in this painting, with chin resting on her hand, is evocative of the portrait by Ingres of the Comtesse d'Hausonville, now in the Frick collection.

Degas chose a strong centralized focus for the couple. This he achieved by toning down and summarily painting the gray drapery and ocher wall, by keying the tablecloth embroidery in with this dull background, and then by giving particular emphasis to highlighted faces and hands so that they form a bright circle of lightness in the upper center of the canvas. Edmondo's hands are large and prominently veined, his skin irregularly mottled and his overall pose stiff, confident and mildly expansive. Thérèse, by contrast, has a soft unlined skin that is slightly pneumatic and her gestures are nervous, alert and compact. Partly because of this suggestion of anxiety, some commentators on this picture and other paintings that Degas made of his married sister have tended to see them as revealing Thérèse's dependence upon Edmondo and her subservience to his will. If this is true then it also raises interesting questions about Degas's own feelings about an interloping male taking away his favorite sister. Henry Loyrette has suggested that the portrait may have been painted when the family came together in Paris in June 1865 to celebrate the wedding of Degas's other sister Marguérite to Henry Fevre.

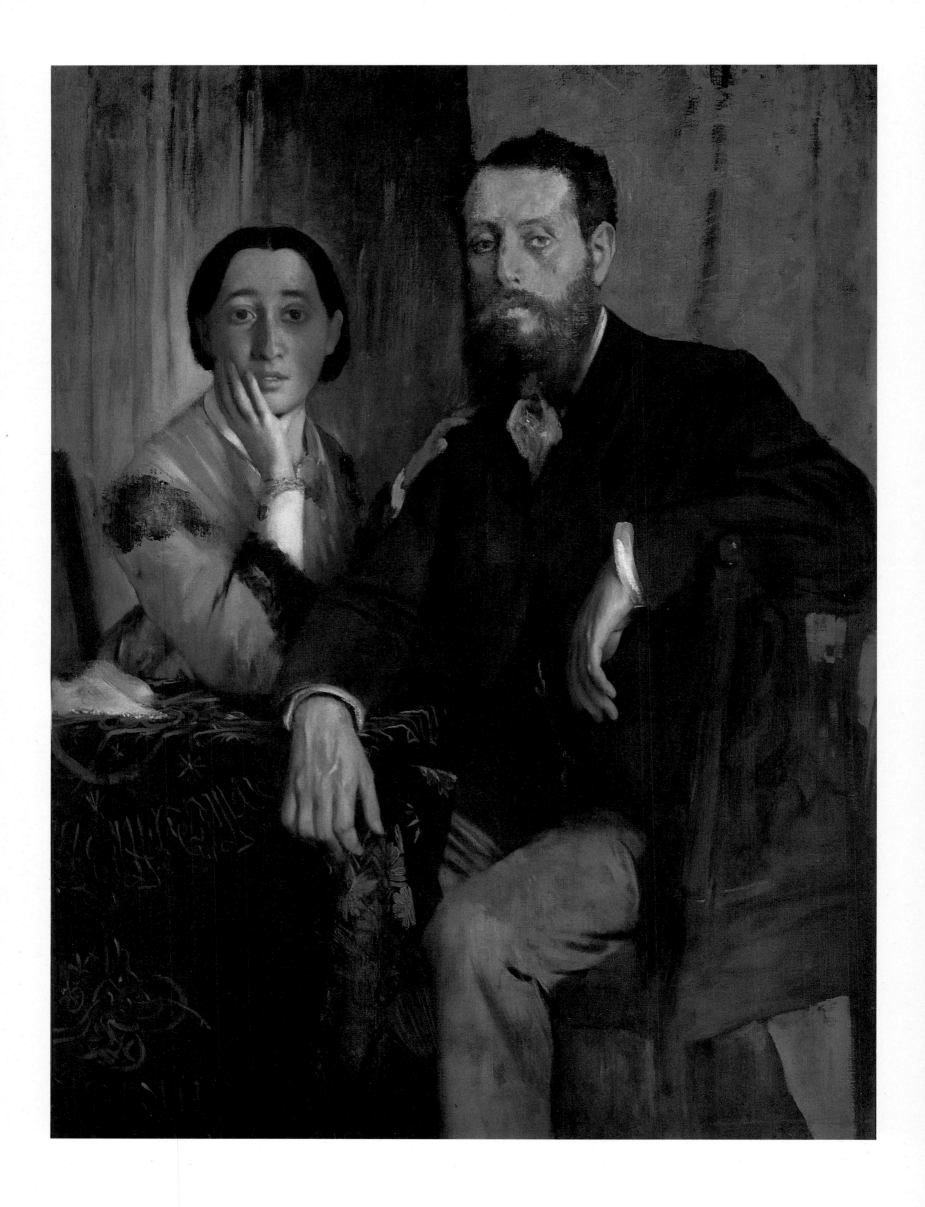

The Collector of Prints, 1866

Oil on canvas
20¼×15¾ inches (55×40 cm)
Metropolitan Museum of Art, New York

Interrupted in his private sifting through print folios, the collector looks at the spectator and stares for a moment with a grave, slightly irritated expression. The room suggests a study rather than a printshop, and it is his own collection that he presumably scans. The small colored print that he holds and the similar images on the table behind have been identified by Theodore Reff as floral wallpaper and fabric designs in lithograph by Redoute; prints of very little significance or value.

In a picture that is so overtly about European print-collecting, Degas uses a number of devices that are suggestive of Japanese woodblock prints. The glass-paneled cabinet that cuts into the picture on the left is evocative of a Japanese ribbed paper screen or wall partition. The frame that protrudes into the top of the painting, with an assemblage of rectangles of fabric and paper, is like a decorated cartouche of Japanese text. Even the angular little black hat is reminiscent of the heavily coiffured hair of a samurai or male actor. The Chinese T'ang dynasty horse in the cabinet and the rectangles of fabric and paper within the frame,

which may be of Japanese origin, reinforce this oriental reading.

Enthusiasm for Japanese prints was developing within Degas's circle when this work was painted. In 1862 M and Mme Desoye opened an oriental shop in the rue de Rivoli that attracted many artists. Degas owned several Japanese prints and this is the earliest example of his compositional borrowings and tentative experimenting with the new spatial vocabulary that they inspired.

The cropped legs of the large black-outlined figure in the foreground combine with his emphatic stare to thrust him into the viewer's own space. No name has yet been put to this man, although his idiosyncratic features make it likely that this is a portrait. When Degas sold this painting in 1895, he dated it to 1866. It therefore predates by two years Manet's famous painting of *Zola* with which it has so much in common; Manet also employed a similar arrangement of background rectangles that form a pun on Japanese print motifs. It is almost as though the two artists set out to produce variations on the same theme.

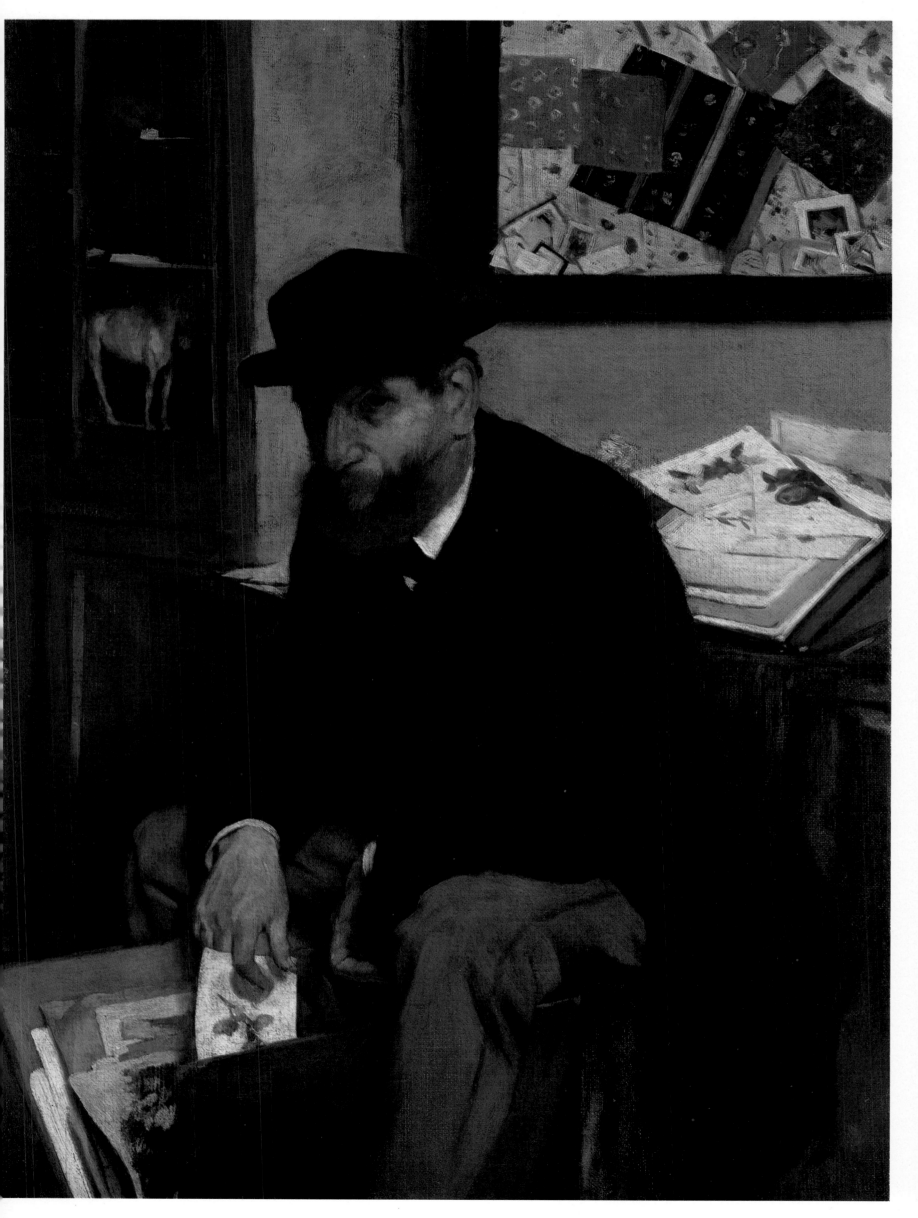

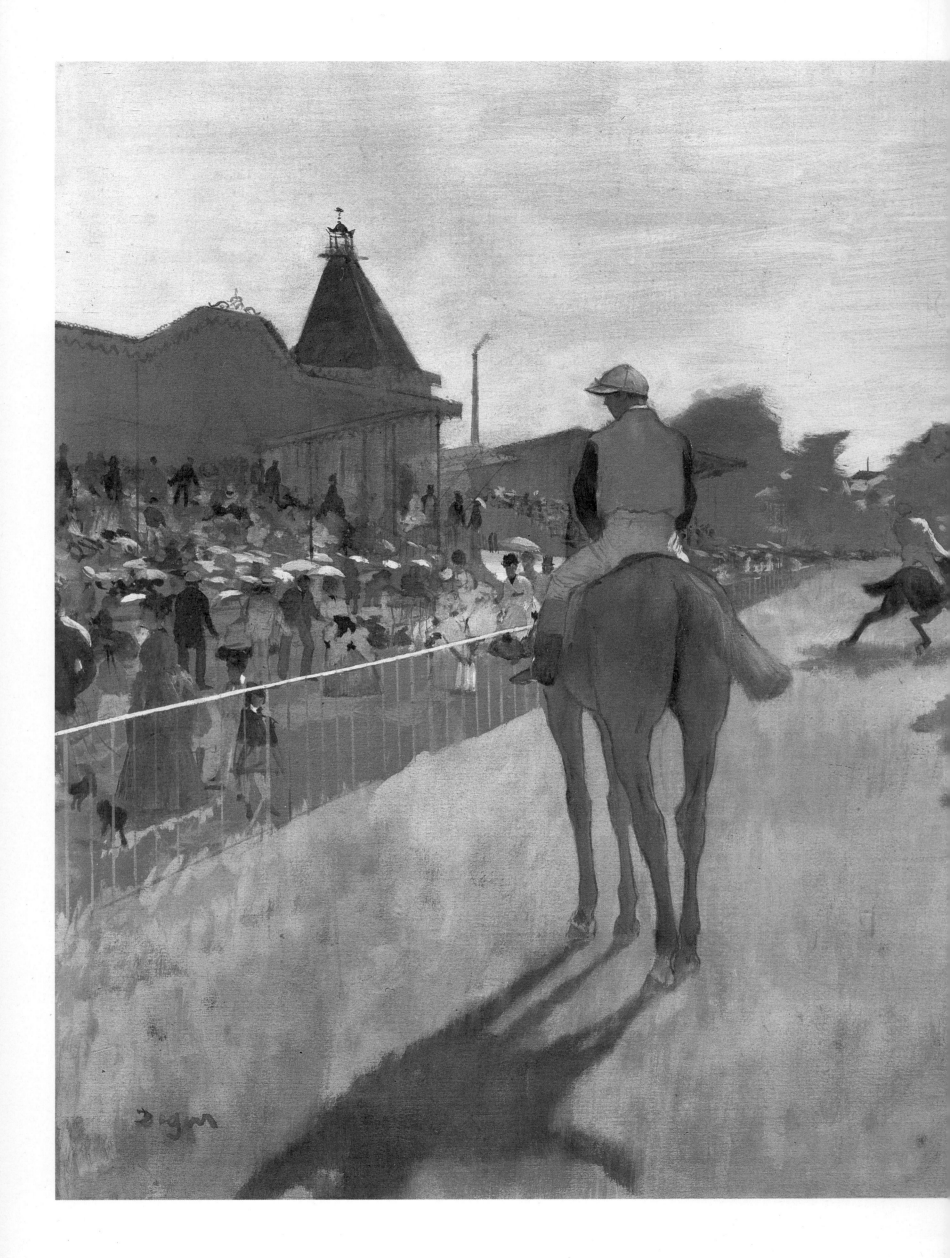

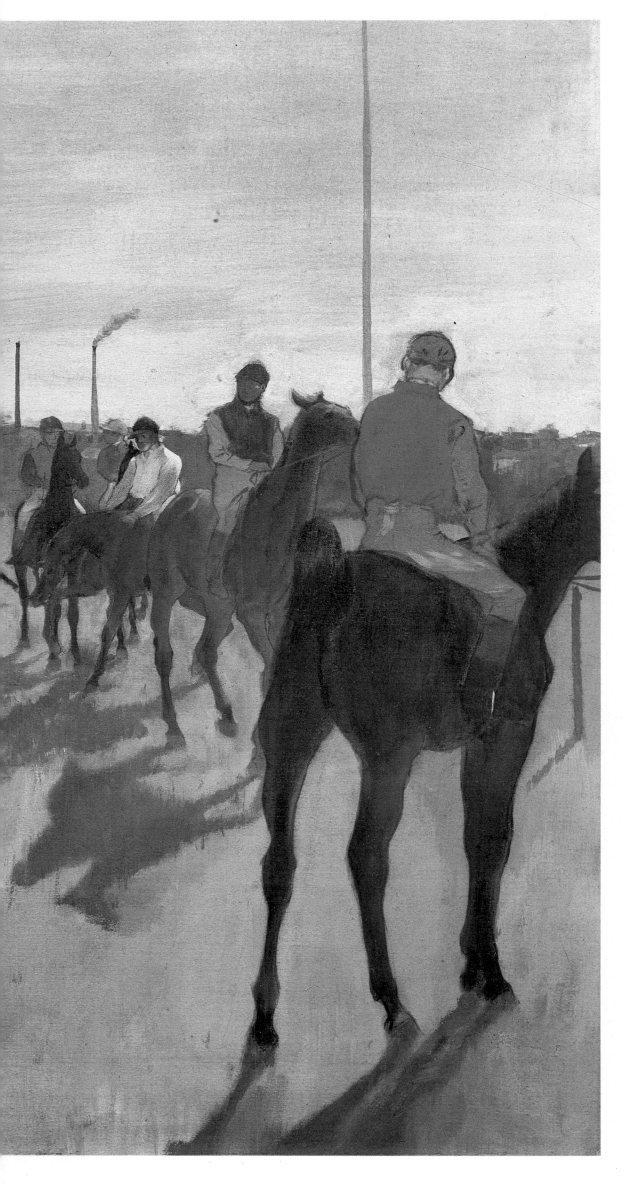

Racehorses before the Stands,
1866-8

Essence on paper mounted on canvas
18⅛×24 inches (46×61 cm)
Musée d'Orsay, Paris

Although Degas's racehorse pictures have
the convincing appearance of a particular
time, place and grouping of figures, they
are in all cases a mixture of recollection
and invention worked up in the studio.
None of these horses or jockeys are por-
traits; although the grandstand in this pic-
ture superficially resembles that at Long-
champs, it is an amalgam of remembered
and composed elements. Degas's sources
for his horses were often other paintings
and sculpture. The foreground horse on
the left is a reversed image of one in Meis-
sonier's picture of *Napoleon III at the Battle
of Solferino.* The startled one at the rear is
another reversed image from the sporting
print by J F Herring which appears in the
background of Degas's 1869 painting *Sulk-
ing* (page 71). Degas later told Vollard that
he set up small wooden models of horses in
his studio, turning them to vary the fall of
light, and the earliest of his own sculptures
are possibly horse pieces connected with
the need to have three-dimensional figures
for varied posing.

 Against a bleached blue-white band of
sky and a landscape which has been emp-
tied out of color save for a subdued range of
ochers, Degas arranged his various deliber-
ately off-center and apparently arbitrarily
positioned elements into a taut balance.
Using shadow as a counter-balancing
mass, exploiting the capacity of primary
yellow and red to vibrate strongly with
their complementaries purple and green,
and with a controled use of vertical chim-
ney heights, Degas fine-tuned this picture,
unifying the whole with a subtle dappled
distribution of highlighted white that pulls
together spectator parasols, the sleeve
edges of the jockeys and the right stirrup of
the red-shirted rider. Degas's remarks that
no art was ever more calculating than his,
and that a picture had to be planned with
the same premeditated precision that one
might use in plotting a murder, seem parti-
cularly apposite in the structuring of this
picture.

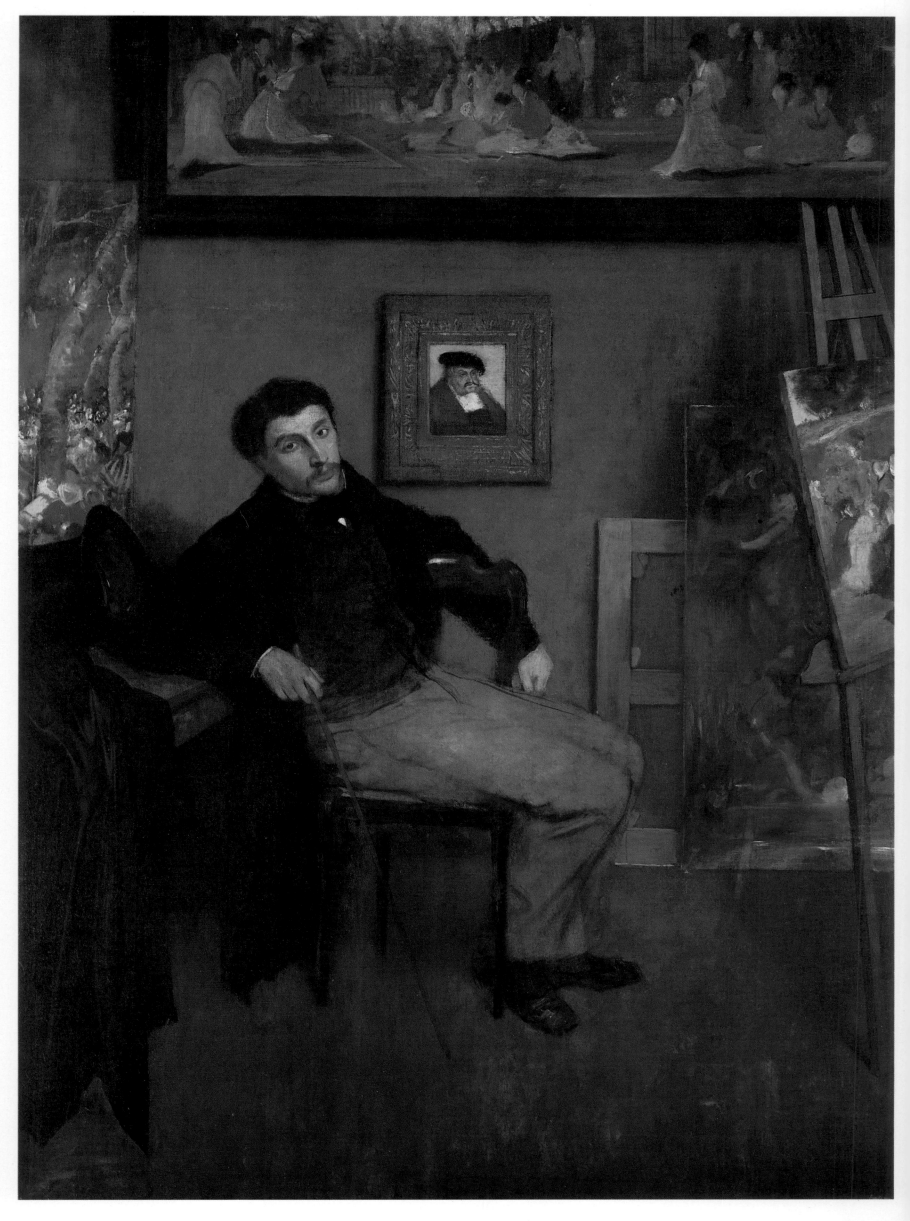

James Tissot, 1867-8

Oil on canvas
59½×44⅛ inches (151×112 cm)
Metropolitan Museum of Art, New York

The artist James Tissot was a friend of Degas's from about 1860 onward. Both men at different times studied under Lamothe, and they shared an enthusiasm for early Italian paintings. During the decade that followed their meeting, both absorbed into their pictures Japanese influences, a sensitivity to the 'symphonic' color organization of Whistler, and the challenge of combining traditional academic practice with contemporaneity. Tissot had more Salon success than Degas. He established his reputation with rather slick historical cabinet pictures of late fifteenth- and sixteenth-century Flemish and German subjects, done in the manner of the Belgian painter Henri Leys. An extremely adaptable painter, he succeeded even when at his most apparently avant-garde in maintaining an unthreatening anecdotal sentimentality that was good for sales.

In this portrait Degas shows his friend as an elegant, nonchalant *boulevardier*, interrupted before he can don his hat and coat to head off for a stroll. Tissot is surrounded by paintings that possibly connote his enthusiasms. The central framed image is an enlarged copy of Cranach's portrait of Frederick III in the Louvre; both Tissot and Degas were interested in Cranach's work. Other paintings are more difficult to decipher. The one behind Tissot's hat, with its curiously splayed trees and throng of people, looks like a Breughel, and has broad affinities, in the headdresses of the woman and in structure, with the engraving of *A Village Wedding* from the Vivant-Denon collection. The costume types in Breughel's works, like that worn by Frederick III, are used by Tissot in his own history paintings. The canvas on the other side of the room is probably a baroque treatment of *The Finding of Moses*, in front of which is another landscape with figures, some with covered heads. This time the womens' headdresses suggest nuns. Above is a large Japanese-inspired subject of palpably European construction.

It has been suggested that the portrait may be an ironic allegory by Degas on Tissot's superficiality – that the various canvases are those of a *pasticheur*, shown up by being placed next to the unquestionable quality of the little Cranach. Given Degas's and Tissot's friendship, this seems unlikely and it may be that the meanings were private – shared references that were only fully known to both artists.

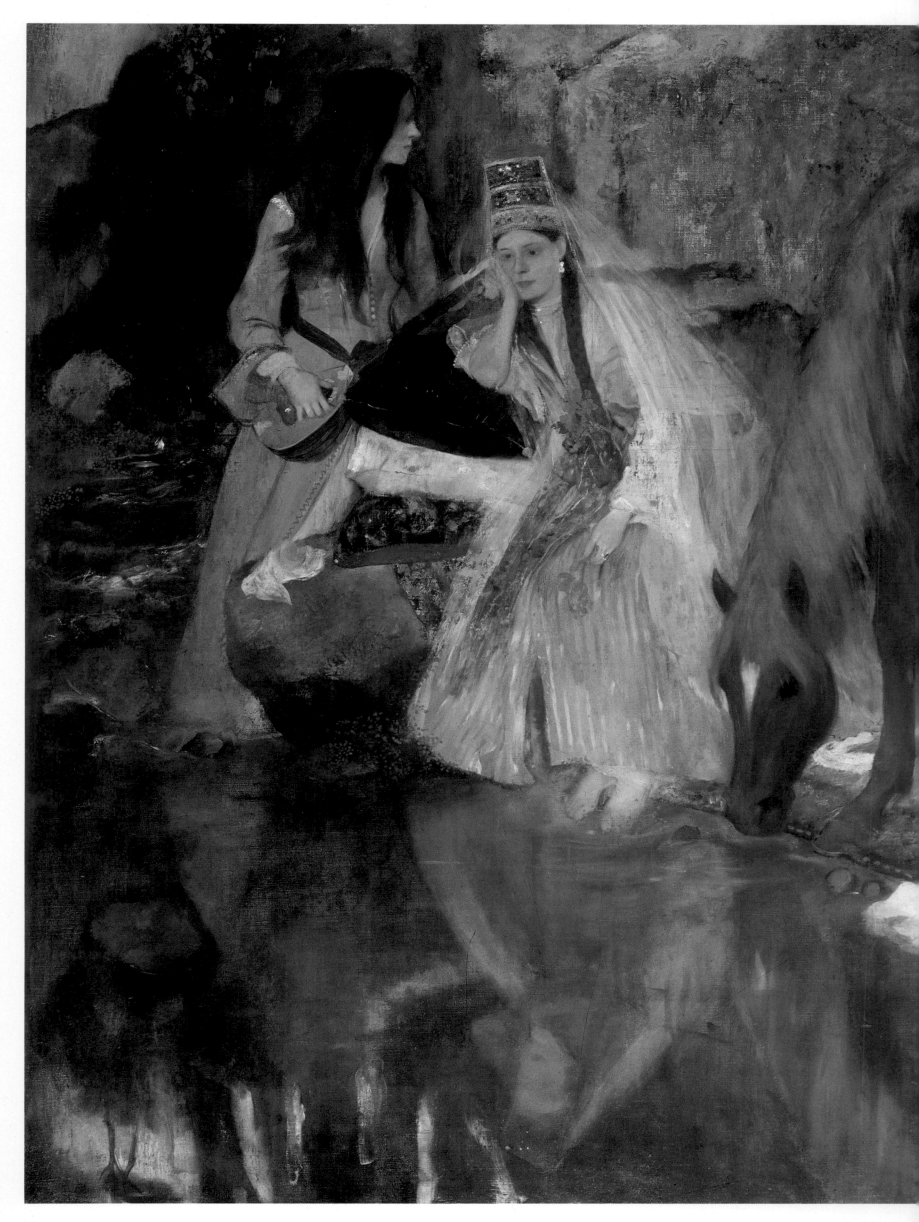

Mlle Fiocre in the Ballet 'La Source', 1867-8

Oil on canvas
51⅛×57⅛ inches (130×145 cm)
Brooklyn Museum, New York

It is characteristic of Degas that on one of the few occasions when he painted fresh water – that most pervasive of *plein air* elements in Impressionist pictures – he showed an artificial pool next to a canvas mountain on the stage of the Paris Opéra, but executed in such a way that it is completely convincing as an outside landscape, rather in the manner of Courbet.

Sitting beside the pool, dressed in vivid blue, is the 22-year-old Eugénie Fiocre who starred in the role of Nouredda in the ballet *La Source* by Ludwig Minkus. Thin on plot but strong on visuals, this was an extremely popular production and was often revived. The sets were particularly spectacular and attempts at natural fidelity included live horses on stage and a gushing spring. The exquisite figure of Eugénie and the sensational whirling dance that revealed her diaphanous, sequined pantaloons also contributed much to the popularity of the show. Théophile Gautier described her body as one that 'managed to bring together the perfections of young boy and girl in a sexless beauty that is beauty itself'.

In the first act, after an energetic dance, Nouredda kicks off her slippers, cools her feet in the water and listens to the lute being played by an attendant. It is this moment that Degas chose to show. Although strictly speaking this is his first dance picture, it more properly belongs with his portraits, or even with his history pictures as a piece of vaguely oriental genre.

In structuring this work Degas borrowed the positions of Nouredda and the nearest red-dressed figure from Whistler's *Symphony in White No.3* and for the horse he probably made a small wax sculpture from which he made drawings. Several drawings of Mlle Fiocre were made either at rehearsals or during performances.

Mlle Fiocre retired from the stage at 30, having attracted a sufficiently rich string of lovers to guarantee her financial security. For many young Opéra dancers supplementing their low wages by acquiring a 'protector', she represented the pinnacle of potential success.

Interior, also called The Rape,

c.1868-9

Oil on canvas
32×45 inches (81×116 cm)
Museum of Art, Philadelphia

Controversy still surrounds the subject matter of this strange picture; clearly a narrative, it is without parallel in the rest of Degas's work. Degas described it as 'my genre picture' and may have been influenced by English painting, examples of which he saw in Paris in 1867. Although more highly charged, it is similar in approach to Victorian narrative pictures of the period. Direct literary sources have been suggested, including Zola's novel *Thérèse Raquin* in which Thérèse and her lover murder her husband. The painting has similarities with Zola's description of the guilty couple's room on their wedding night a year after the husband's death. Whatever the inspiration for the picture, it is clear that something terrible has just happened.

The color red plays a prominent part: in the roses, possibly symbolic of passion, which cover the wallpaper; in the glow from the fire which casts an eerie light over the room; and in the prominent open sewing-box that shines in the centre of the picture beneath an oil lamp. This fleshy-red lined container, out of which slips a piece of white cloth, is the forceful image of violation that probably led to the picture's alternative title of *The Rape*; a title given to the work after 1912, but almost certainly never intended by Degas.

On the floor beside the single bed (which suggests that this is the woman's own room rather than the wedding chamber of Thérèse Raquin) lies a discarded corset. The hunched woman, her petticoat off her shoulder, is crying and turns away from the man, perhaps in shame. His defiant legs-astride posture and stare suggest intense anger.

A clue to unraveling the narrative may lie in the necklace shining on the table beside the open workbox. Read symbolically, it may imply that the young woman compromised herself, perhaps sold her virtue, and that regret, guilt, fear and disdain have now taken over. If this reading is allowed then the work could be seen as an altogether more powerful and more sexually explicit treatment of the theme of *The Awakening Conscience*, painted by Holman Hunt in 1853. The painting could also be read as a variant on the theme of *Found* where, like Rossetti's picture of the same title, a young man confronts his former betrothed, who has turned to prostitution, and seeks to return her to the path of righteousness. Indeed it is possible that Degas set out specifically to paint a genre picture capable of multiple interpretations – a

'problem picture' like those that regularly turned up on the walls of the Royal Academy and deliberately courted public speculation about their meaning.

Over 40 years elapsed before the work left Degas's studio, and it was then sold through Degas's dealer without any public exhibition.

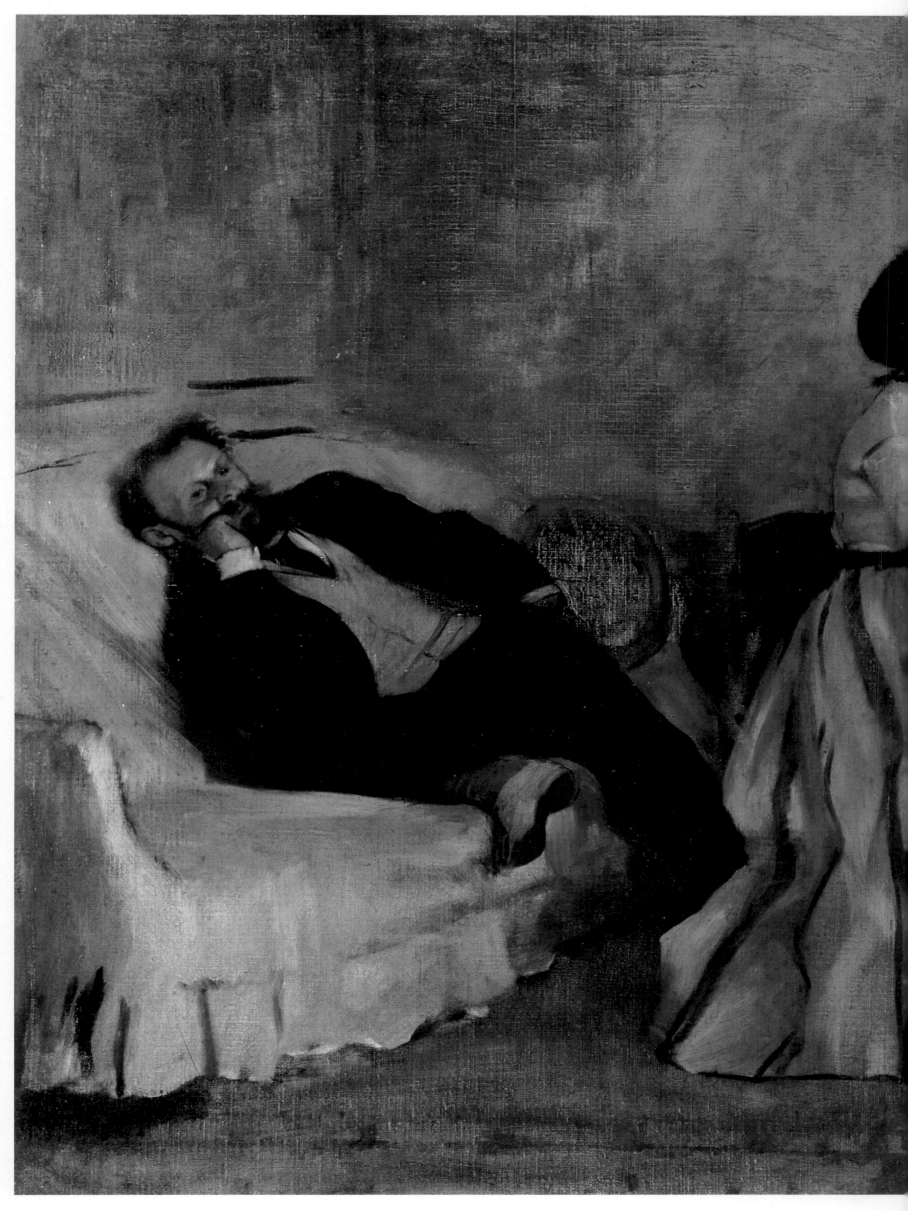

Portrait of Monsieur and Madame Edouard Manet, c.1868-9

Oil on canvas
25⅝×28 inches (65×71 cm)
Kitakyushu Municipal Museum of Art,
Japan

'One could write a book about what he (Degas) has criticized Manet for', wrote Caillebotte to Pissarro in 1880. Although the artists publicly squabbled and criticized each other, Degas and Manet were for many years on close and friendly terms. They were from similar backgrounds – Manet was the son of a rich lawyer. Both respected the Old Masters – Manet apparently first met Degas in 1862 in the Louvre while the latter was etching a copy of a Velásquez picture, and their paintings shared a similar urban Realist subject matter. During the late 1860s and 1870s they met socially in each other's family homes, and this painting is probably set in Manet's apartment in the rue Saint-Petersbourg.

Degas gave the painting to Manet, apparently in exchange for a still life. The circumstances surrounding the obliteration of the right-hand side were described by Degas to his dealer Vollard:

It seems incredible, but Manet did it. He thought that the figure of Madame Manet detracted from the general effect . . . I had a fearful shock when I saw it like that at his house. I picked it up and walked off without even saying goodbye. When I reached home I took down the little still life he had given me, and sent it back to him with a note saying 'Monsieur, I am returning your *Plums*'.

Degas and Manet made up, but by then Manet had sold the *Plums*.

Degas added the strip of blank canvas sometime around 1900, but never got around to restoring the full figure of Madame Manet. After Manet's death Degas acquired several of his paintings, among them a superb little still life of a ham which he hung next to this mutilated study of his old friend, whose art he so deeply respected. When Vollard asked Degas whether he thought Manet would have been equally capable of cutting up a painting by Ingres or Delacroix, he replied:

A Delacroix or an Ingres? – oh yes I believe so, the bastard! But . . . I think I would have finished with him for ever.

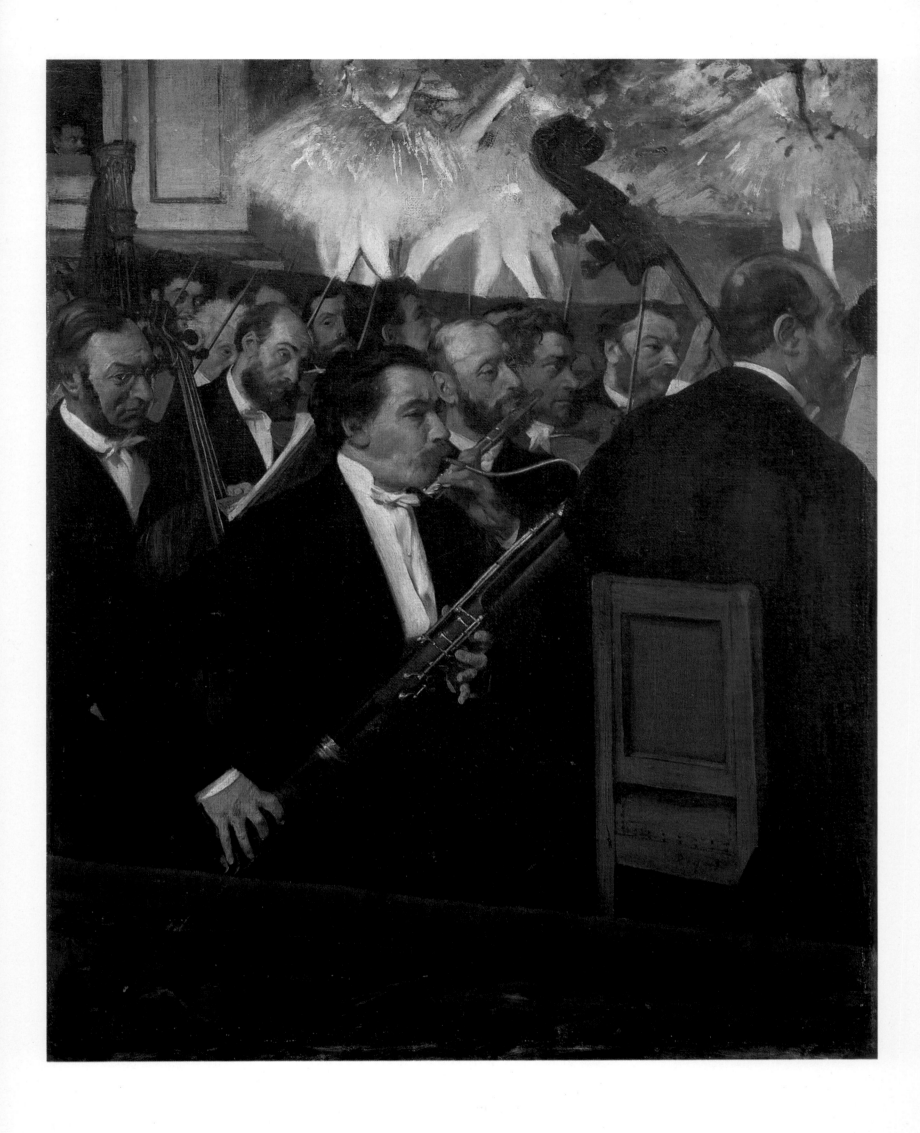

Orchestra of the Opéra, 1868-9

Oil on canvas
22¼×18¼ inches (56.5×46.2 cm)
Musée d'Orsay, Paris

Toulouse-Lautrec, just before his death, gave a dinner one night for a group of friends including Edouard Vuillard. After dinner he took his guests to a cousin's Montmartre apartment. Pointing to this picture on the wall, he told them, 'This is your dessert'.

Lautrec's cousin, Désiré Dihau, is the bassoonist in the foreground, surrounded by other musicians who really did play alongside him in the orchestra pit of the Paris Opéra, interspersed with a few interloping friends of Degas's and his. Dihau and his sister Marie, a concert singer, were members of Degas's social circle and guests, and probably performers, at his father's Monday evening musical gatherings. There is some evidence that Marie was the object of Degas's affections, but not enough to be certain that it extended beyond his usual gallantry.

In this first painting showing ballerinas in action on the Opéra stage, Degas progressed slowly. The velvet-topped front stall barrier was added to achieve a sense of spectator involvement. Then, to break up the three horizontal strips of the composition, Degas added the verticals of the harp and the double-bass neck, which not only became a recurrent motif in his own ballet and café concert pictures but was adopted and much used by Lautrec in his dance hall subjects – a factor that might have disposed him so strongly towards this work.

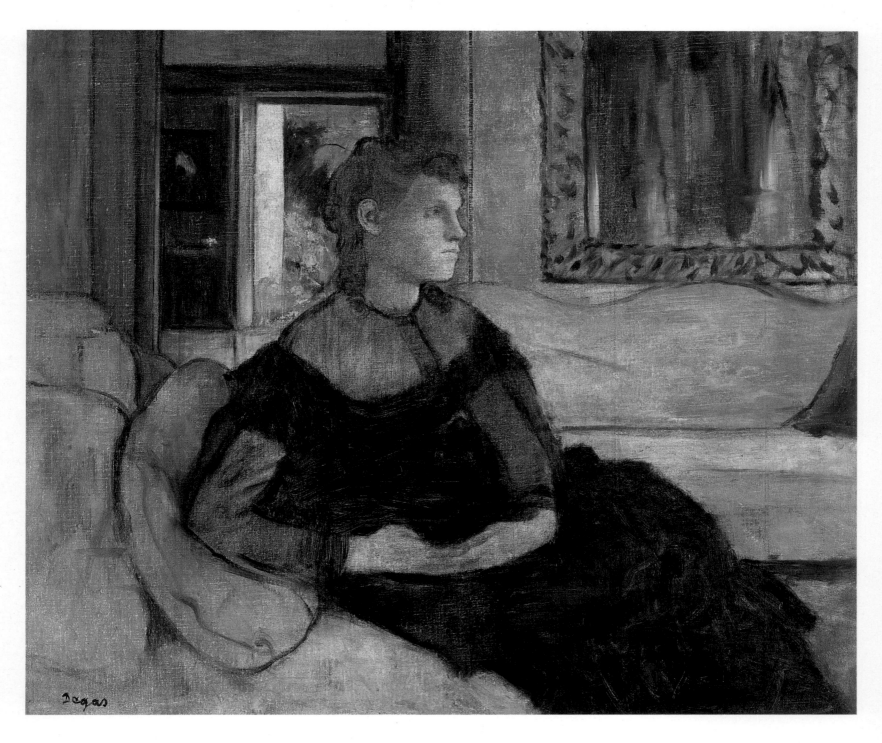

Madame Gobillard (née Yves Morisot), 1869

Oil on canvas
21⅜×25⅝ inches (54.3×65.1 cm)
Metropolitan Museum of Art, New York

Yves Morisot, sister of the artist Berthe Morisot, sat for this picture in summer 1869 while staying with her family in Paris. Letters from Yves Morisot's mother and Berthe Morisot indicate that Degas was infatuated with Yves's features. He often visited the Morisot household and made a pastel portrait, several elaborate pencil studies of the setting and sitter, and this unfinished oil. Yves and her mother enthusiastically admired Degas's facility as he chatted, joked and worked in front of them. Berthe Morisot was more guarded. Seven years after the picture was painted, it was exhibited in the second Impressionist exhibition in 1876 and Berthe described it as a 'masterpiece', but at the time he made his studies she thought Degas's work 'indifferent' – provoked into prejudice by her dislike of Degas's personality and perhaps suspicious of his gallantry towards her married sister.

Degas's preparatory studies indicate the care with which he constructed the placing of the figure along a diagonal that cuts from top right to bottom left – a compositional feature used in his earlier *Bellelli*

Family. Other shared connexions include the placing in profile of Yves's face (like that of Giulia Bellelli) and the complex rectangular build-up of the background. This constructive clarity later led Mary Cassatt to compare the painting to a Vermeer. The most characteristic affinities between this portrait and some seventeenth-century Dutch work including that of Vermeer and De Hoogh is the setting of a figure within an interior with one wall parallel to the picture plane – a wall then divided and subdivided into rectangles of maps, pictures, mirrors and doorways. Degas acknowledged Dutch antecedents for his portraits of this period. He described Whistler, Fantin-Latour and himself as all being concerned with 'the Dutch road'. Like his later New Orleans picture of *Children on a Doorstep* (page 81), painted in 1873, this work is unfinished and they were both exhibited together. The primacy for Degas of the structural 'architecture' of some of his pictures is suggested by the incomplete but nevertheless resolved nature of these works which are as finished as Degas ever intended them to be.

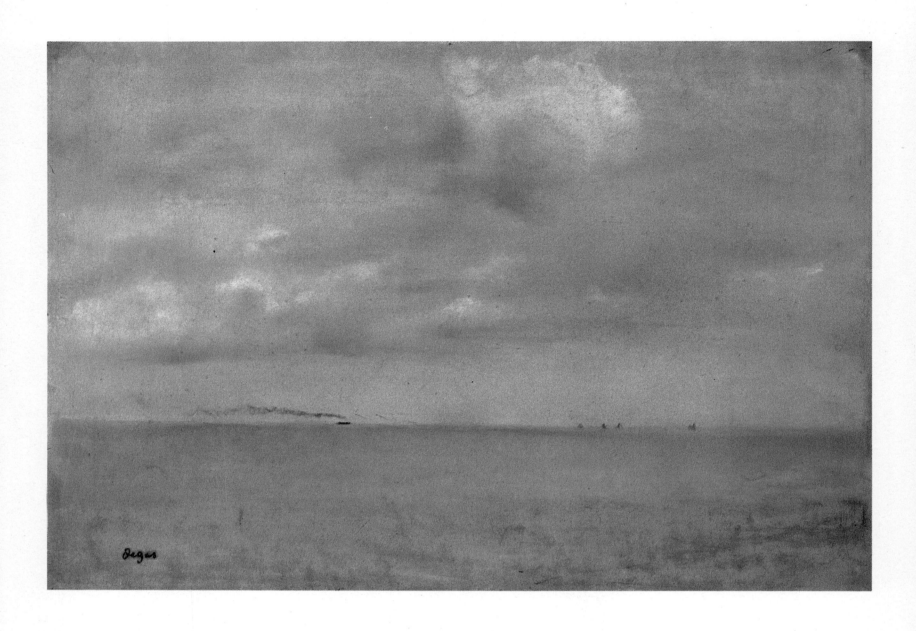

Seascape, 1869
Pastel on buff wove paper
12⅜×18½ inches (31.4×46.9 cm)
Musée d'Orsay, Paris

Among Degas's often-voiced phobias, which included animals indoors and flowers on dining tables, was his apparent dislike of landscape painting. Vollard records him saying:

If I were the government I would have a squad of gendarmes to keep an eye on those painting landscapes from nature. Oh I do not wish anyone dead: I would, however, agree to spraying them with a little birdshot for starters!

Degas's exaggerated responses were directed against the Impressionist landscape artists with whom he later exhibited. The meticulous planning of figures and settings to give the appearance of the natural, which was at the core of Degas's art, was at odds with any literal transcription of nature, however fresh. It is therefore curious to find him producing, in the summer of 1869, a group of over 40 pastels,

all landscapes and seascapes of Normandy and northern France. The inspiration may have come from Manet who, while staying with his family at the Hotel Folkestone in Boulogne the same summer, painted a number of port scenes from his hotel window. Degas is known to have visited Manet at Boulogne. Manet's approach to the subject, however, was that of one looking outdoors from a room, Degas's was that of places recollected after being seen, aided by a few written notes, with little attempt at a faithful record, and showing only the general appearance of coast and landscape.

These private pictures were possibly made back in Degas's Parisian studio. They may have been intended collectively as an experiment in decorative color values using nature. As with all Degas's work, the mediation of mind in the construction of art remained paramount.

Carriage at the Races, 1869

Oil on canvas
14⅜×22 inches (36.5×55.9 cm)
Museum of Fine Arts, Boston

This picture grew out of a visit made by Degas in the summer of 1869 to Menil-Hubert in Normandy, home of Paul Valpinçon, Degas's friend from schooldays. It is probably set at Argentin, the nearest racecourse to their home.

On the carriage driving seat is Paul Valpinçon; next to him his bulldog; while in the seats behind, his six-month-old son Henri has just fallen asleep after being breastfed by the woman employed as his wet nurse. The child's mother modestly shades them with her parasol. The plump infant is the centre of adult attention. Poised anxiously, they await confirmation that he is fast asleep so that the carriage can turn around and they can go back to watch the racing. It is a delightful intimate moment in a family outing. As a subject for a painting, however, it is unusual. Nineteenth-century Realist paintings of nurses, poor women feeding their own or other children, were not uncommon, and pedigrees for such pictures in a secular vein can be found in Dutch seventeenth-century works, but it is unusual to have a man watching it take place. It is also uncommon to see the authoritative and proprietorial interlocking of husband to wife, wife to servant, servant to young master so clearly, albeit affectionately, stated. Without any heroics, melodrama or obvious narrative, their mutual positions are made clear.

Degas collected English sporting prints and the background horses, with legs stretched out in torpedo-like progress, owe a clear debt to hunting and racing scenes by English artists like Francis Calcraft Turner and J F Herring. Against the pale background of banded sky and heath, Degas constructs the human content of this ambitiously organized work, using clear black accents as visual cues to suggest depth. The strong dark foreground carriage, cropped at side and bottom, thrusts forward into spectator space and we are invited to study the sunlight-dappled baby on the white blanket, placed on the centre line of the picture.

This was one of the earliest pictures that Degas sold. It was bought by the singer Jean-Baptiste Faure, who acquired a number of Degas's works but who eventually had to go to law to obtain them from the artist, who insisted on constant reworking.

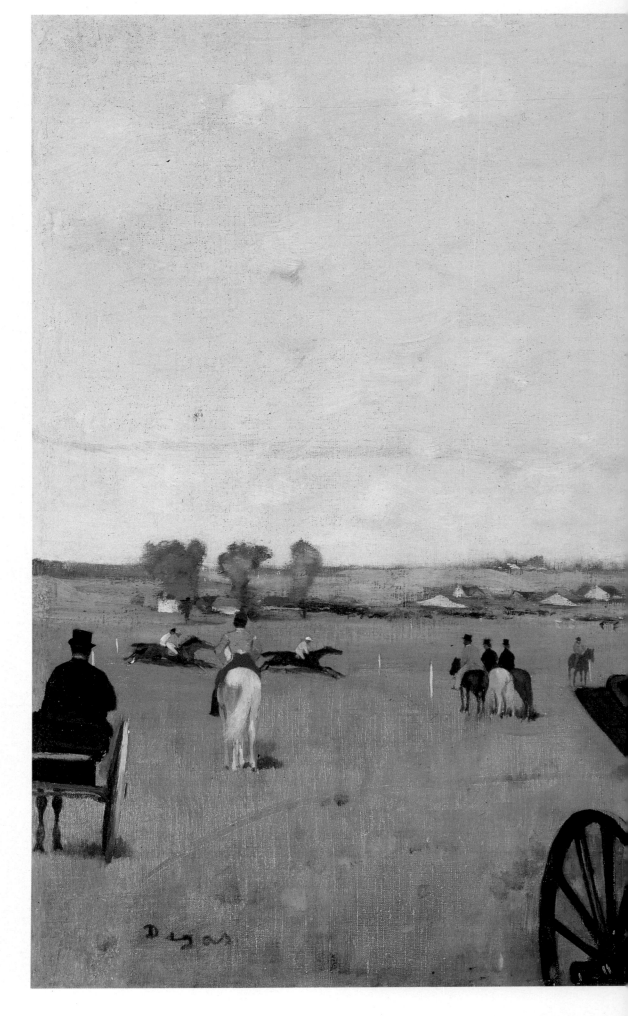

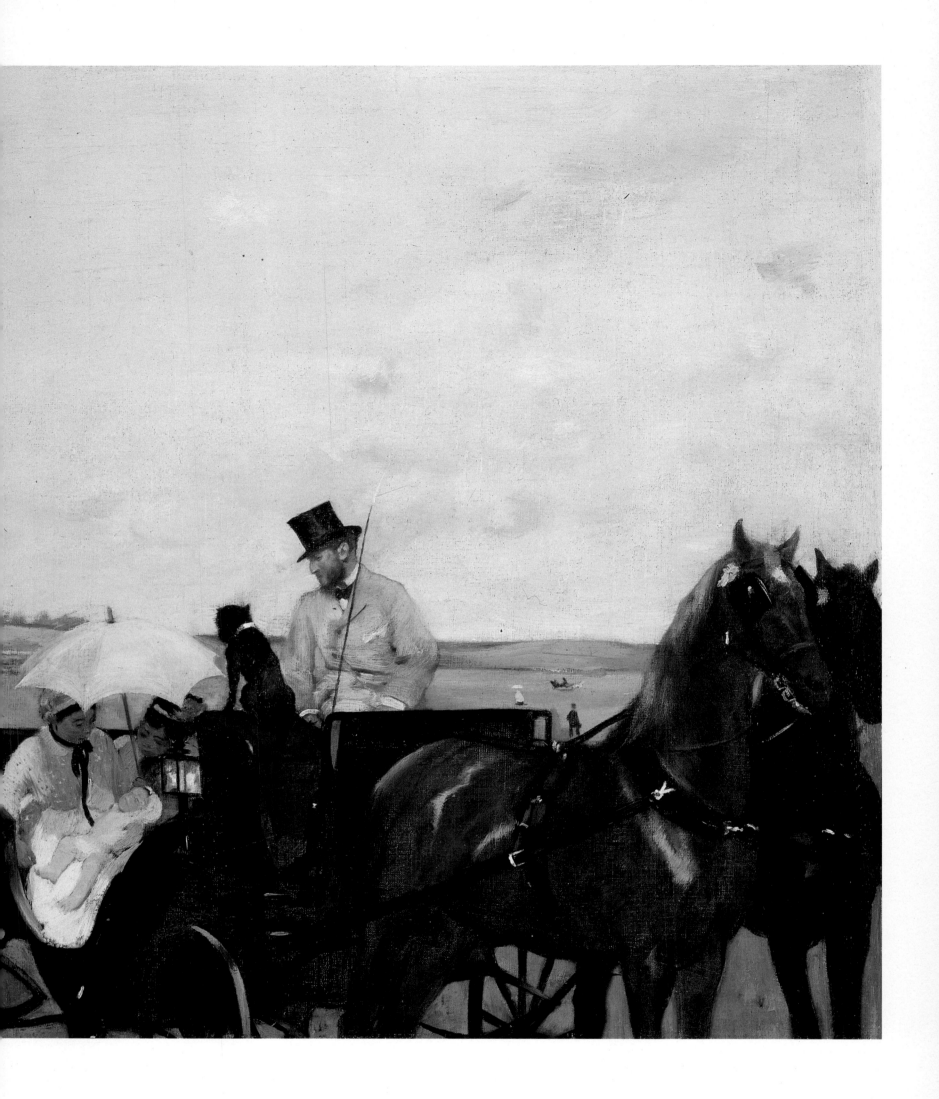

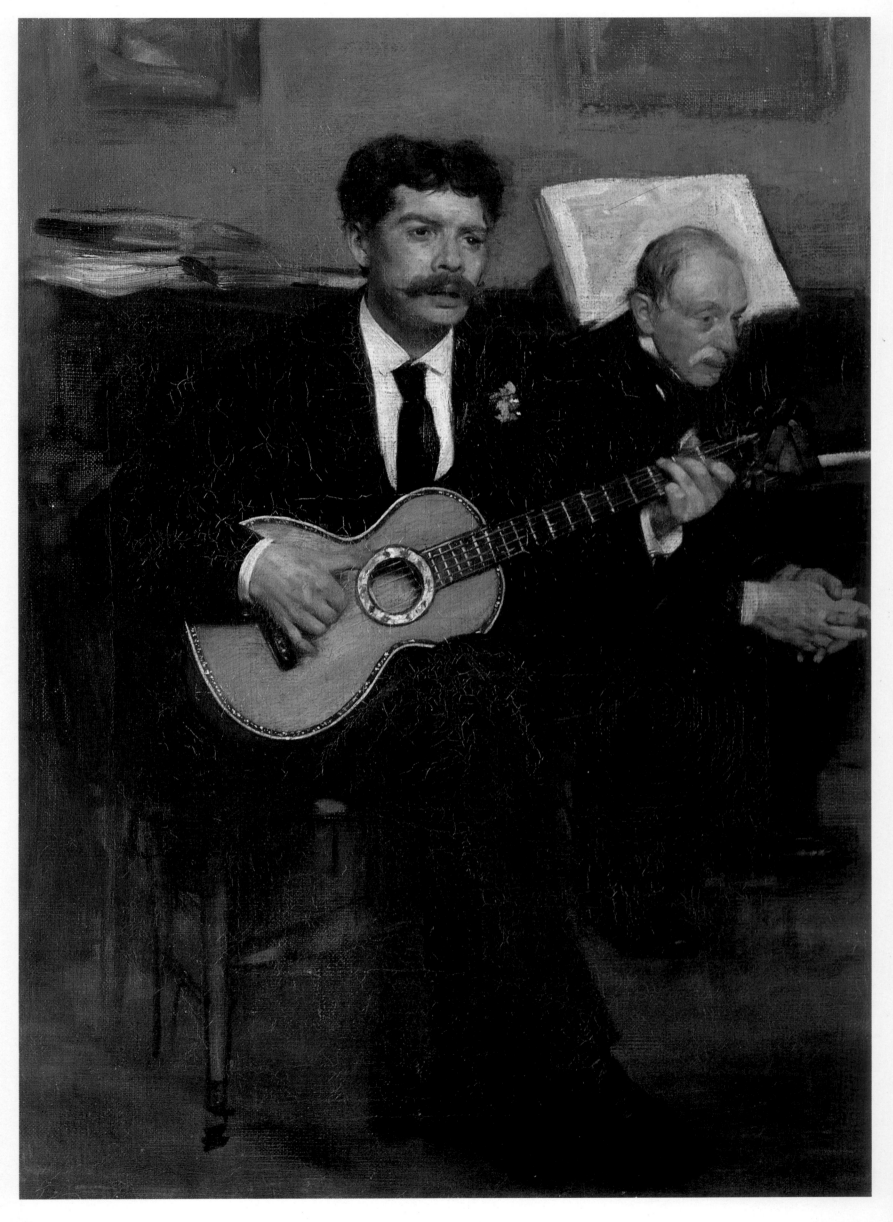

Lorenzo Pagans and Auguste De Gas, c. 1869

Oil on canvas
21¼×15¾ inches (54×40 cm)
Musée d'Orsay, Paris

The Spanish singer Pagans was a popular entertainer in Parisian drawing rooms, and is seen here at one of Auguste De Gas's regular Monday evening musical gatherings. The company included musicians, other musical friends and also Degas, Manet and his wife. Manet, who had a passion for all things Spanish, also had Pagans play for him at his home, and Degas is known to have attended at least one such gathering. Among the several Spanish subjects that Manet painted was one of a *Music Lesson* dated to 1870, which includes a similarly positioned guitar player and may have influenced Degas in choosing this subject.

Pagans sang traditional Spanish love songs as well as his own compositions. The pained expression on his face suggests that he has reached a poignant climax in a particularly sad song. The hunched figure of Degas's father stares into the distance, engrossed in the words being sung. Auguste De Gas died in February 1874, and this was probably painted two to three years earlier. The picture was one of Degas's most prized works, and he kept it hanging above his bed, his closest visual record of his father. Perhaps with intimations of his father's death and a deliberate desire to record him, Degas chose to show him absorbed in his characteristic favorite pastime of listening to music – a pleasure that father and son shared wholeheartedly.

The small head of the old man stands out against the broad white spread of sheet music behind. Indeed, Degas plays with white as a dominant motif throughout this painting; it is used on cuffs, shirt fronts, the edge of the guitar and the pile of sheet music at the back of the piano. He offsets white against the dense black of the men's suits and the generalized yellow-brown tones of the background. Not even the green tassel of the guitar neck and the faded buttonhole of the guitarist disturbs the interplay of these three dominant color ranges.

Degas seems to invite a reading of this picture that goes beyond straightforward portraiture towards some implied narrative on the theme of old age and regret.

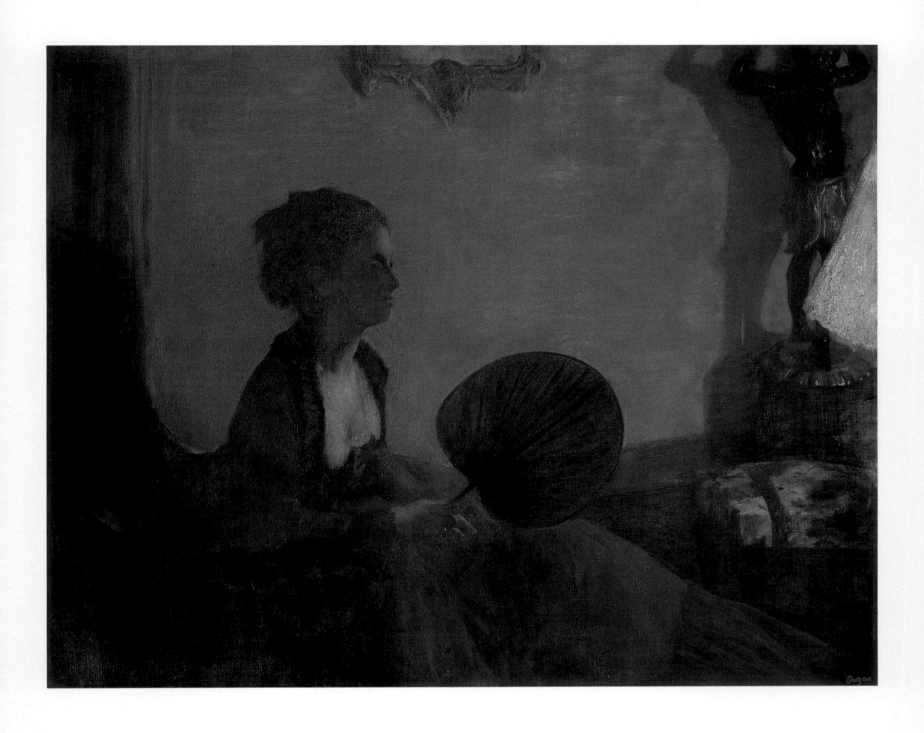

Madame Camus, c.1869-70

Oil on canvas
28⅝×36¼ inches (72.7×92.1 cm)
National Gallery of Art, Washington

Madame Camus is Degas's most thorough-going exploration of the position pro-pounded by Whistler, who suggested that color and line were independent of, and more important than, pictorial narrative. Color in particular, according to Whistler, was capable in the same way as music of acting directly upon the spectator's sensi-bilities. During the 1860s Whistler entitled his pictures 'Arrangements' and 'Harmo-nies' and his *Symphony in White No.3* (page 12) was copied in pencil by Degas in 1868. *Madame Camus* is above all about the color red. Degas had already investigated, in his *Interior* of 1868-9 (page 58), the capacity of red to evoke a mood of menace; now he ex-plores the altogether more difficult task of using it in various shades in a depiction of a serene, reflective and calm woman in her own secure environment. Madame Camus was a friend of Degas, and her husband was a prosperous physician who treated the artist. Edmond de Goncourt once des-cribed her as an aristocratic bloodless god-dess who was never seen to eat anything.

Degas's linear style in this picture shows a twofold influence. Madame Camus's emphatic silhouetted profile suggests Japanese prints while the serpentine and oval rythms of her body, the chairback, her fan and the curves of the eighteenth-century blackamoor candlestand are evo-cative of the Rococo – that last great purely decorative European style. The ornamen-tal gilt-framed wall mirror is eighteenth century and may be a piece of chinoiserie. Degas's interest in using rococo rythms for this picture may have been prompted by Madame Camus's husband's collection of eighteenth-century Meissen ceramics.

When this picture was exhibited at the Salon in 1870, the Realist critic Edmond Duranty attacked it for being bizarre and over-intense, and suggested that it would make a useful frontispiece for Chevreul's treatise on color, illustrating the use of one color through its full tonal range. It is fruit-ful to compare this with the almost con-temporary *Madame Gobillard* (page 64) with its less forceful color harmonies.

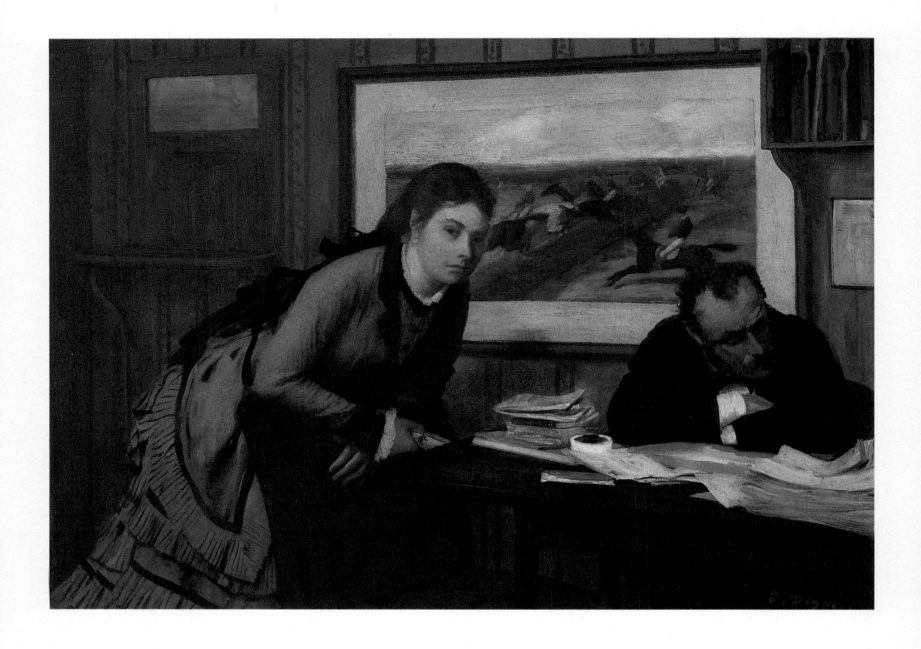

Sulking, c.1869-71

Oil on canvas
12¾×18¼ inches (32.4×46.4 cm)
Metropolitan Museum of Art, New York

The model for the man in this picture is probably Edmond Duranty, the pioneering Realist novelist and journalist, and one of the group with whom Degas associated at the Café Guerbois from about 1868 onwards. The woman is Emma Dobigny, a favorite model of the artist. The setting is unclear, and the picture's alternative title *The Banker* is conjectural. The interior suggests a small-time legal office or estate agents rather than a bank; it may be that the man is *her* banker, hence the alternative title.

Like Degas's contemporary picture *Interior* (page 58) and the later painting *In the Café (L'Absinthe)* (page 96), there is considerable ambiguity both as to the precise relationship between the man and woman and the symbolic significance, if any, of the various items in the room. Connexions have often been made with English genre paintings, which Degas studied at the 1867 Exposition Universelle. The colored print behind the couple is English, *Steeple Chase*

Cracks, after the painting by J F Herring, and may be linked in some way with the overall meaning of the work, possibly some association between gambling, bookmaking and the sulking couple. The regularizing of bookmaking for the French track had only been achieved two years before this picture was painted. The woman is holding a scroll in her hand, bound with blue rather than the red tape of legal bureaucracy, which may be significant in this puzzling drama.

Although the face of the man is extremely malevolent, there is nothing in the pouting of the girl to suggest potential catastrophe, as in the guilty anguish of *Interior* or the despair of *In the Café* – it is a tiff rather than impending bankruptcy or disintegration. The most straightforward explanation may lie in the fact that the man is clearly much older than the woman and visual homilies on mercenary love and the regrets of marrying a younger spouse had many precedents in European art.

Mlle Hortense Valpinçon as a Child, 1871

Oil on canvas
29⅞×43⅝ inches (76×110 cm)
Minneapolis Institute of Arts

After the surrender of Paris to the Prussians in late January 1871, Degas remained in the capital for a few weeks before going to Menil-Hubert, the country home of his friends the Valpinçons. It was a relaxed and welcome contrast to the winter-long sufferings of the city under siege. Degas was also leaving behind the Commune set up on 18 March, with which he was politically not in sympathy.

During the weeks that he spent recuperating in Normandy, Degas concentrated on two portraits of the Valpinçon children. Henri, who appeared in the 1869 *Carriage at the Races* as a breast-fed baby (page 66), was depicted as a plump two-year-old in his perambulator, while Hortense is shown here aged nine in an interior portrait that may have been intended as a companion to that done of her mother around 1865 (page 46). Although wider than the earlier canvas, the height is approximately the same, the positioning of the figure on the right in relation to the table is very broadly similar and a floral theme, albeit now on a table-cloth, is also carried through.

Over half a century later, Hortense recalled to a reporter the genesis of this picture. Because of a scarcity of materials, Degas used a piece of herringbone-weave upholstery ticking, found at the bottom of a wardrobe, for his canvas. Hortense was given a quartered apple to hold, to help her keep still, and apparently drove Degas into a rage by eating it and by her childish inability to hold for long the pose he required. On the table is an unusually vibrant cloth, designed and embroidered by Madame Valpinçon, and a further piece of embroidery tumbling from a sewing basket. Hortense is probably in her 'dressing-up' clothes; aside from the appropriate linen pinafore that covers her black dress, she has an adult shawl over her shoulders and tied around her waist, and a hat that is also adult. In organizing props for this picture Degas's emphasis, apart from any need to balance mass and color, is on the traditional female domestic virtue of sewing, allied to the theme of feminine vanity that he was later to explore in the 'Milliners' series.

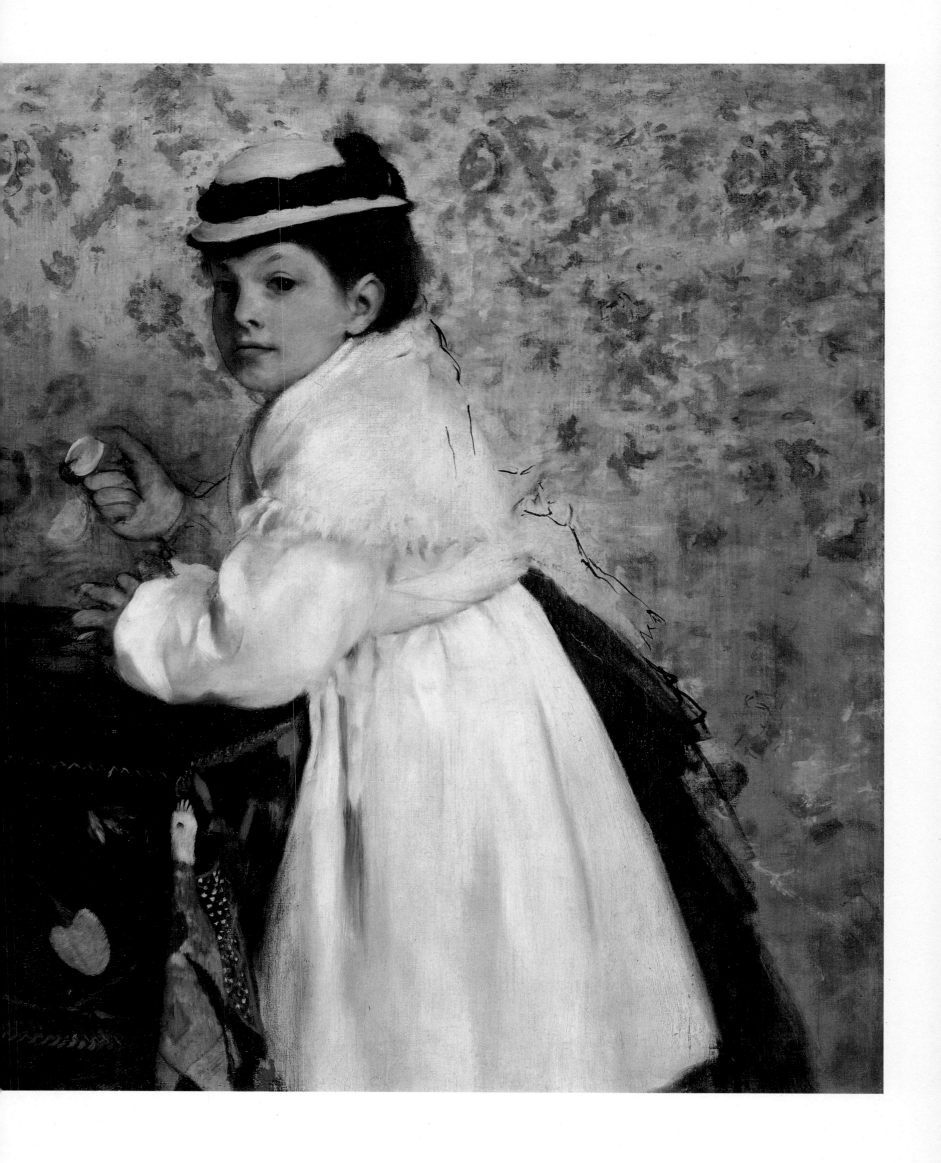

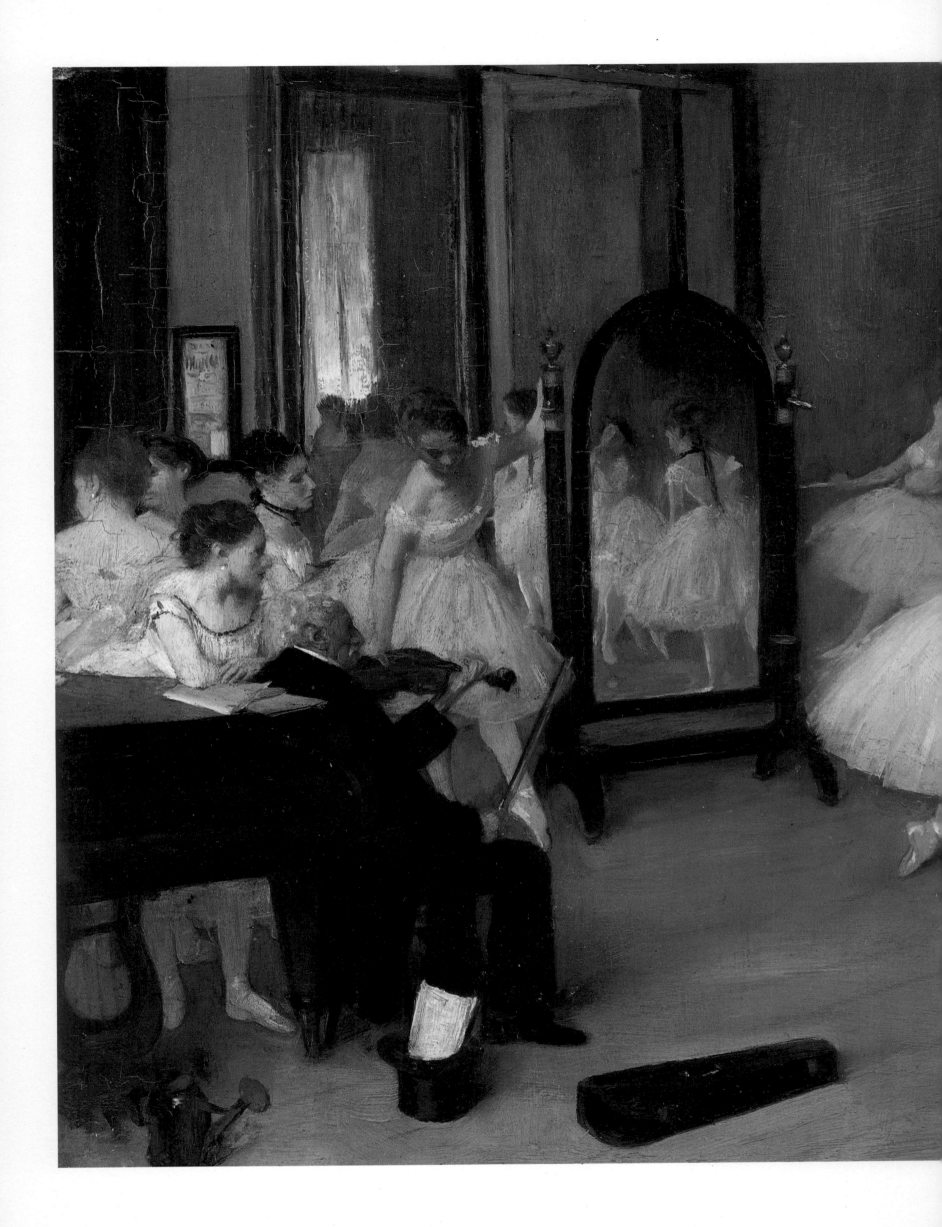

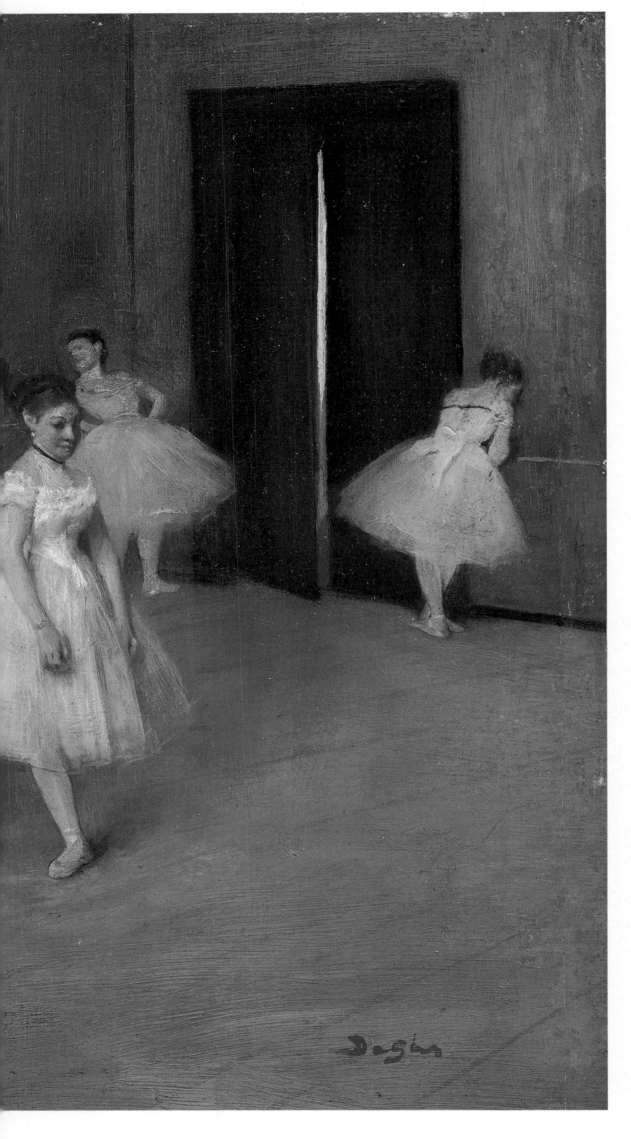

The Dancing Class, 1871

Oil on panel
7¾×10⅝ inches (19.7×27 cm)
Metropolitan Museum of Art, New York

This small picture, the first fully realized dance subject by the artist, deals with two distinct pictorial compositional problems. First, the arrangement of a dozen or more individuals linked in a common pursuit within an interior setting, in a way that stays full of movement and appears unposed (like the best of eighteenth-century conversation pictures). Second, the disciplined harmonic organization across the picture surface of a limited group of colors so that, like separate notes of more or less equivalent value, their arrangement is, as a whole, balanced and visually satisfying. Degas's predominant color play is with the white of the dresses, with pink shoes and ribbons in a subordinate role.

Whistler, whose work Degas admired, focused attention on the question of pictorial color and musical equivalents. In this painting, and in its companion rehearsal picture of a few months later (page 76), Degas tackles in complex fashion his own resolution of the 'symphonic' organization of white. The setting is the Green Room at the Opéra in the rue Le Peletier. Degas knew the room but, without access to daytime rehearsal areas, it is unlikely that he witnessed this scene, although he paid individual dancers to pose for him at his studio and no doubt discussed with them at length the format of the rehearsal programme. Around the wall dancers are doing preliminary warm-up exercises at the barre, while the dancer before the cheval glass in the centre (probably Joséphine Gaujelin) awaits the ballet master Gard's command to start her individual rehearsal.

Degas keeps strong sunlight at bay within this daylight room. Light from a window illuminates the backs of dancers nearest the ballet master. The same thin-draped window can be seen reflected in the wall mirror and a narrow shaft of exterior light gleams in the slightly ajar door. Within the enclosed privacy of this room, Degas uses a complex interplay of mirrors and reflexions to open up the space. It was a bold stroke to make a dancer and her mirrored reflexion the center of the picture, begging questions about illusion and reality that permeate this entire series of dance pictures.

Dance Class at the Opéra, 1872

Oil on canvas
12⅝×18⅛ inches (32×46 cm)
Musée d'Orsay, Paris

In the expanded vold of a larger and grander rehearsal room at the Opéra, Degas repeats the subject of the previous picture; the moment when the ballet master raises his hand to call silence for the start of the music that will accompany a dancer through her individual step rehearsal. The master is Louis Merante (1828-1887), a retired Opéra dancer who, from 1870, became first ballet master; the dancer poised for action is Mlle Hugues.

A more confident use of open space characterizes this work. The central portion is like an empty circle around which are grouped, to left and to right in unequal balance, the white masses of the dancers. Degas unites these disparate figures using a series of subtle red links that pull the picture together. The partially-open fan has its red-tipped blades pointing inward toward the center circle; the corner dancer with the large red bow has her back turned towards the circle; the thin red line of the barre edges the central space. Even Degas's own red signature is used to close the space between Mlle Hugues' pointed toe and heel. This masterly and economical device of circular unification is aided by the outstretched leg of the seated right-hand dancer. She too is Mlle Hugues, who posed for drawings related to this picture at Degas's studio.

Mirrors and open doors expand the pictorial space, but once again generate ambiguity. The dancer visible through the open door strikes an almost identical pose to that of Mlle Huges; for a moment one could think she is a mirrored reflexion. The genuine reflexion of Mlle Huges' face in the arched mirror opposite appears to be looking over the shoulder of the dancer beside Merante's violin player. Degas arranged and rearranged the figures on his canvas to achieve perfect balance; x-rays of the surface show up the many changes.

Painted just prior to his departure for the United States to visit his New Orleans relatives, this most cerebral painting synthesizes the artist's exploration of broader spatial settings and ultimately underpins the structuring and approach of the most important picture that resulted from that visit – *The Cotton Exchange* (page 78).

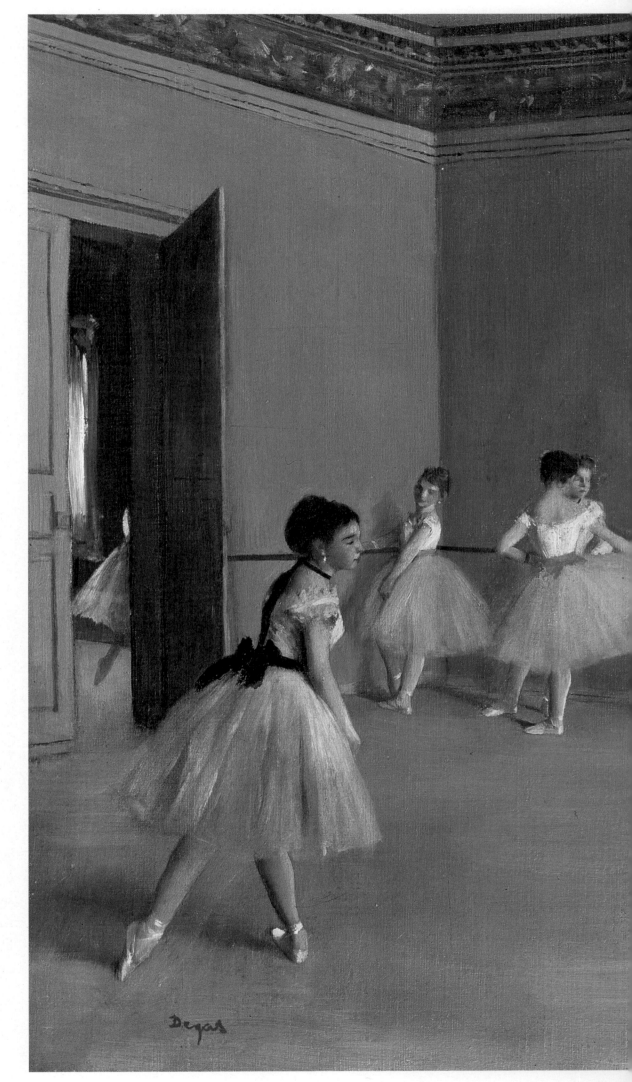

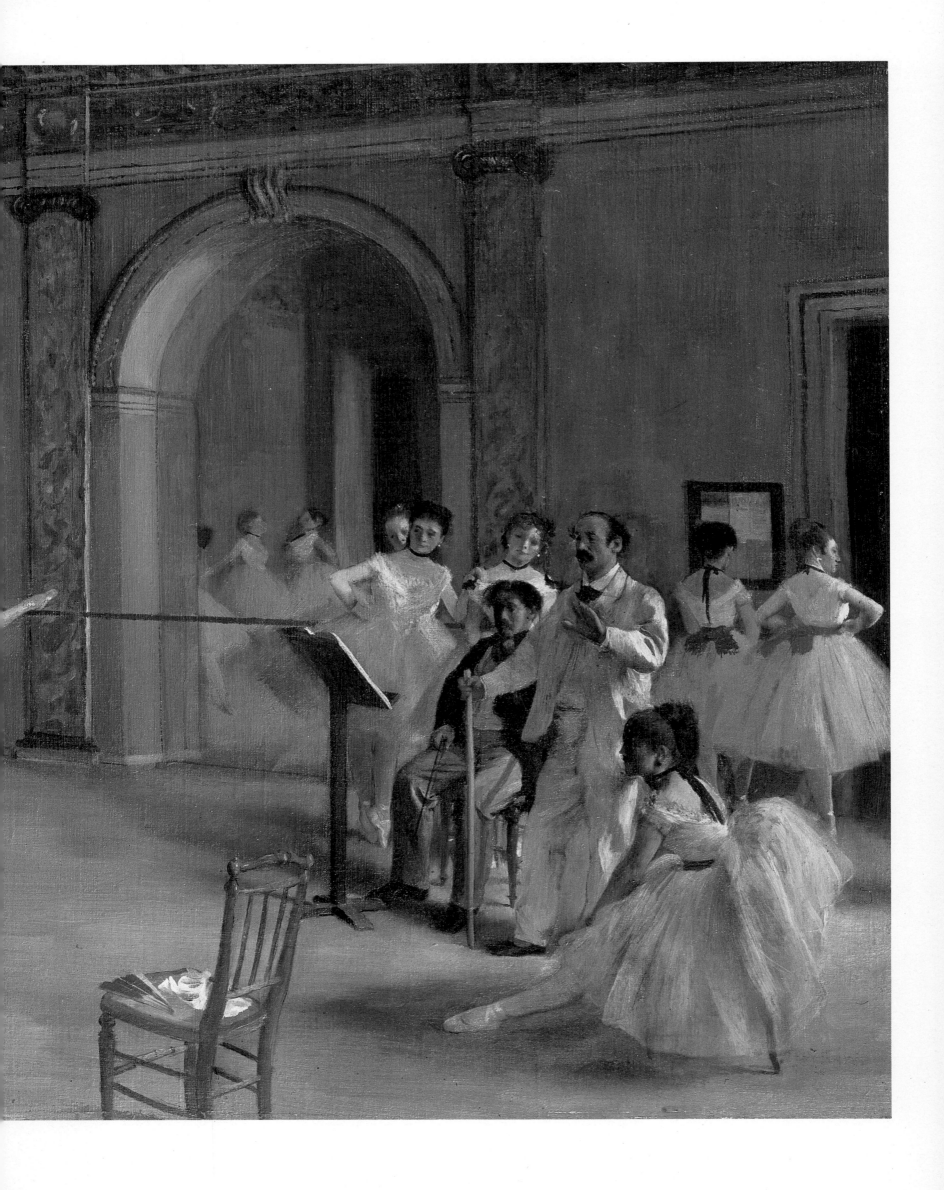

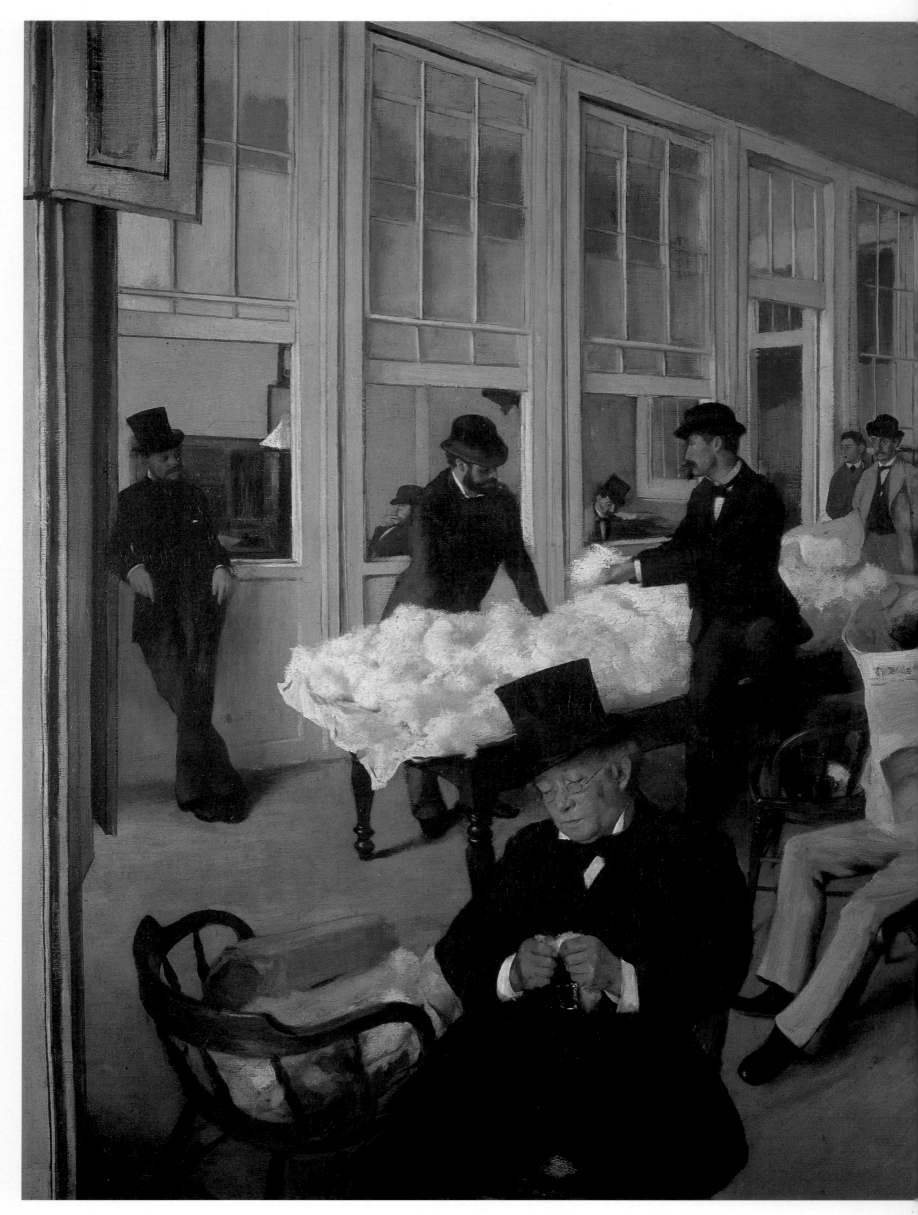

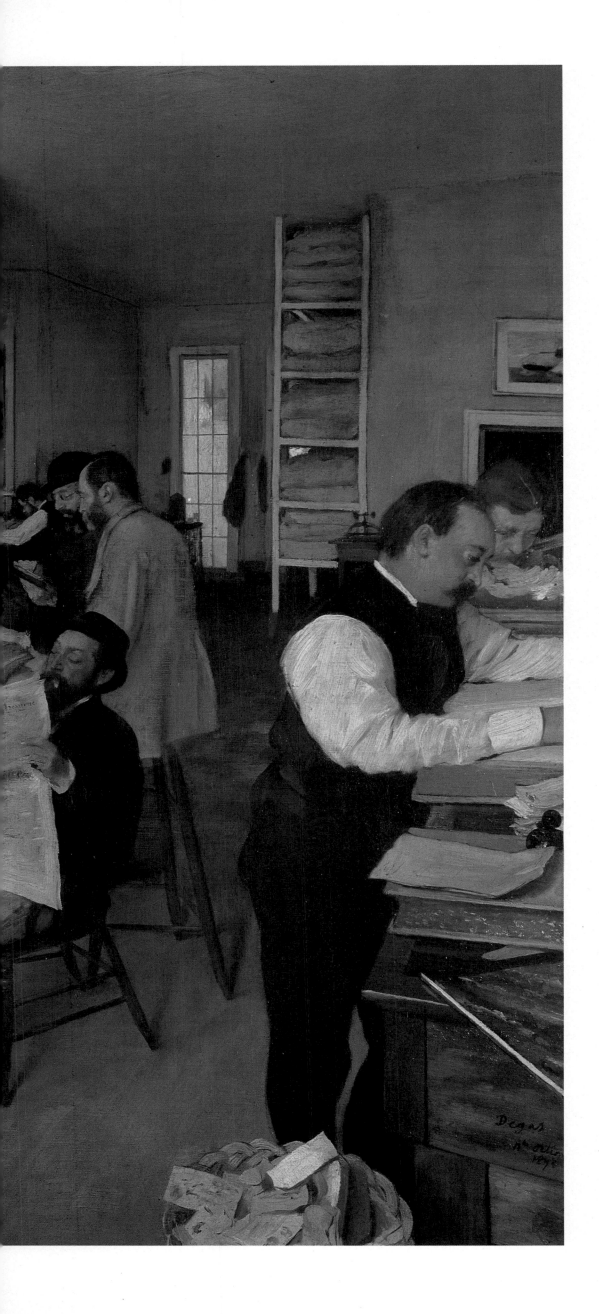

The Cotton Exchange, 1873

Oil on canvas
28¾×36¼ inches (73×92 cm)
Musée des Beaux-Arts, Pau

The Cotton Exchange was the most import-
ant picture that resulted from the visit that
Degas made to his relatives in New Orleans
between October 1872 and March 1873.
The office at 63 Carondolet, New Orleans
is that of his maternal uncle, Michel Mus-
son, who is the old man seated in the fore-
ground testing, in the daylight from an
open window, the quality and fiber length
of a cotton sample. Degas's brother René is
the languid smoking young man reading
the *Daily Times Picayune* in the centre of
the room, while his other brother Achille
leans cross-legged against the office win-
dow-sill in the left-hand corner.

Degas's chosen viewpoint is toward an
angled corner of the room, with the floor
raking up from the foreground – a com-
positional formula similar to the two ballet
rehearsal paintings that he worked on just
prior to this American visit. Office genre
takes the place of ballet genre, but with a
similar intention of giving the accidentally
glimpsed quality of individuals collectively
absorbed in their various tasks.

In a letter to his friend Tissot in
February 1873, Degas optimistically stated
that the picture was intended for the Man-
chester picture dealer Agnew, and that he
hoped it might find a place in the collection
of Cotterel, a Lancashire spinner. The
greater degree of finish in this work, and its
closer affinity with more conservative
genre pictures of the period, were com-
mented upon when it was shown at the
second Impressionist Exhibition in 1875.
Zola was particularly caustic about what he
regarded as the artist's compromise,
describing the picture as 'halfway between
a seascape and a plate from an illustrated
journal'. Nothing came of the projected
Manchester sale, and the picture was
eventually bought for 2000 francs by the
Musée des Beaux-Arts at Pau – the first
painting by Degas to enter a public collec-
tion and, despite the low price, he was
delighted.

Zola's remark on the affinity of the pic-
ture with illustrated pictures is not inap-
propriate. The complex interplay of strong
black and white against the extremely sub-
dued pale greens and browns has a similar
visual punch to the best black and white
wood-engraved magazine illustration of
the period.

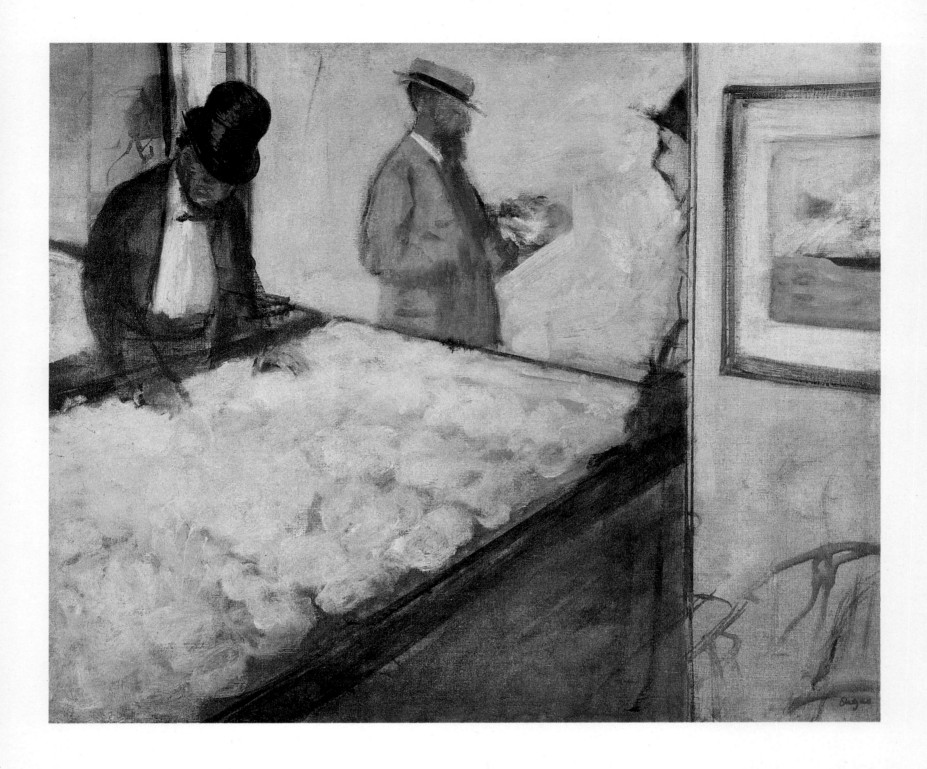

Cotton Merchants, 1873

Oil on canvas
23⅝×28¾ inches (58.4×71.1 cm)
Harvard University Art Museums,
Cambridge, Mass.

This second, simpler view of a cotton office in New Orleans has a flatter and more dramatic handling of spatial planes, suggesting that once again Degas drew inspiration from Japanese prints. Although unfinished, it seems unlikely that Degas would ever have carried it forward to the same degree of polish as his previous cotton office subject.

Writing to Tissot in February 1873, he said:

I am preparing another (painting) less complicated and more spontaneous, better art, where the people are all in summer dress, white walls, a sea of cotton on the tables.

While not all these features are found in this painting, enough are there to suggest that this is the painting Degas was writing about. By his comment Degas suggests that the earlier work represented a significant compromise and implies that this more

fluid picture is a more authentic treatment. There are even suggestions in Degas's comment to Tissot of the critical tone that Zola later adopted in his exhibition review of the earlier picture. Zola wrote:

This painter is taken with modernity, like indoors and everyday life. What is annoying, though, is the way he spoils everything as soon as he adds the final touches. His best pictures are sketches.

The framed seascape on the wall is the same as that seen in the earlier picture, as is the table with its huge packet of cotton, now seen from a bird's-eye view. Rather summary brown strokes in the right-hand corner suggest a chair similar to that in the foreground of the earlier picture. None of the figures are identifiable as portraits. It is not clear why Degas never completed this work, and it remained in his studio until his death.

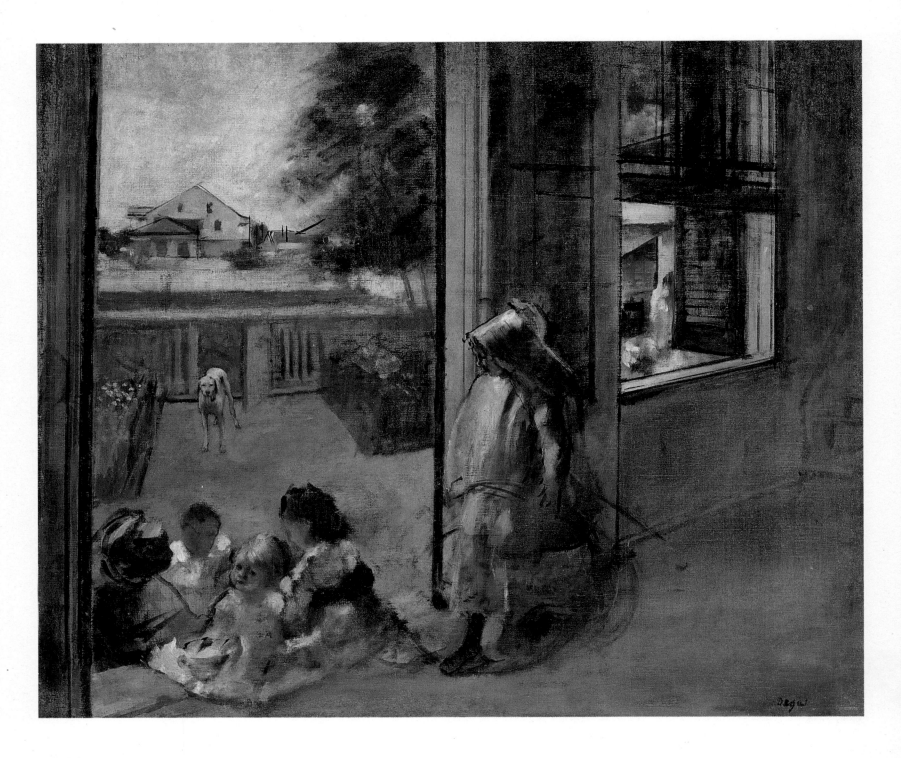

Children on a Doorstep (New Orleans), 1872

Oil on canvas
23⅝×29½ inches (60×75 cm)
Ordrupgaardsamlingen, Copenhagen

Degas was one of the first artists to introduce time into art. His use of separate figures that are sequentially glimpsed, yet simultaneously exist in one picture, has been viewed as a kind of proto-cinematic technique. His later wax sculptures and repetitions in pastel of the same traced figures, each with slight variations of position, also suggest the pursuit of the duration of movement. And in this canvas, which Degas exhibited at the second Impressionist Exhibition of 1876, he offered a public statement about the time involved in artistic creation itself: the process of making and the time spent doing it, a picture as a point of arrest.

That he should have chosen to exhibit this along with (perhaps alongside) his *The Cotton Exchange* (page 78), the most polished and highly-finished canvas in his later output, invites analysis as to his possible intentions. Degas was notoriously fussy about his exhibited works and was known to withdraw pictures even after the catalogues listing them had been printed. This unfinished work was described in the catalogue as 'a sketch' and Zola was the

only critic who made a comparative judgment of Degas's sketches as better than the office painting.

The setting is the front porch of the house of Michel Musson in the French quarter of New Orleans. It is a hot afternoon and a black nurse is looking after the children. All the faces, absorbed in play, are blurred except for the blond-headed Odelle De Gas, who stares directly at the viewer as she must have stared at her uncle the artist, sitting indoors sketching to protect his eyes from the harsh light. Odelle's gaze is echoed by that of the stocky hunting dog in the path behind, whom Degas nicknamed Vasco da Gama.

This picture has not been extensively exhibited and is one of the least well-known Degas images. Its dull coloring makes it less obviously appealing than other work. It is, however, one of the most powerful of all Degas's paintings, far more shockingly novel than the co-exhibited Impressionist pictures and, in its melancholy tone, grid-like structuring and varied paint facture, is very evocative of the present-day paintings of Francis Bacon.

The Song Rehearsal, 1872-3

Oil on canvas
31⅞×25⅝ inches (81×65 cm)
Dumbarton Oaks Research Library and
Collection, Washington DC

During the 1860s, as camera shutter speeds became faster, it became possible to capture more precisely the suspended motion of figures. Very rapid movements, however, still left a blurred semi-transparent edge and this fuzzy slipstream was viewed by some artists as a useful pictorial device that could indicate movement itself; Monet and Renoir sometimes used it to evoke the bustle of a crowd. In this picture Degas employs both frozen action and blurred movement.

In a New Orleans interior that is possibly his uncle's house, Degas shows his brother René at the piano, rapidly turning his head towards his wife Estelle and either Mathilde or Désirée Musson, depicted in frozen mid-gesture. In a preliminary sketch for the left-hand woman, Degas showed her standing still with an open-handed pleading gesture, which he changed to the more fierce hand-aloft pose. Read in conjunction with the blur of her light muslin dress and the defensive angled arm of the second woman, this gives an exaggeratedly dramatic quality to both figures – as though one was advancing in histrionic full cry to slap the other. They may be rehearsing a comic song, with appropriate gestures, for late evening performances to a large Musson family gathering.

The influence of Japanese prints upon Degas is usually seen in his general application of its novel spatial vocabulary, but in this work the bulkily-dressed singers set against the flat walls are directly reminiscent of the black-outlined and kimono-clad women of a domestic Kyoto setting.

The pentimenti that are visible on the canvas show Degas's compositional reworking. The arm of the left-hand figure went through several changes. The foreground couch has been truncated and overpainted to make for greater clarity of the central void, which helps emphasize the electric tension between the two women's gestures.

Unlike the New Orleans painting of *Children on a Doorstep* (page 81), which was exhibited publicly as a sketch and may be considered a fully resolved picture, Degas never showed this unfinished work, and it remained in his studio until his death.

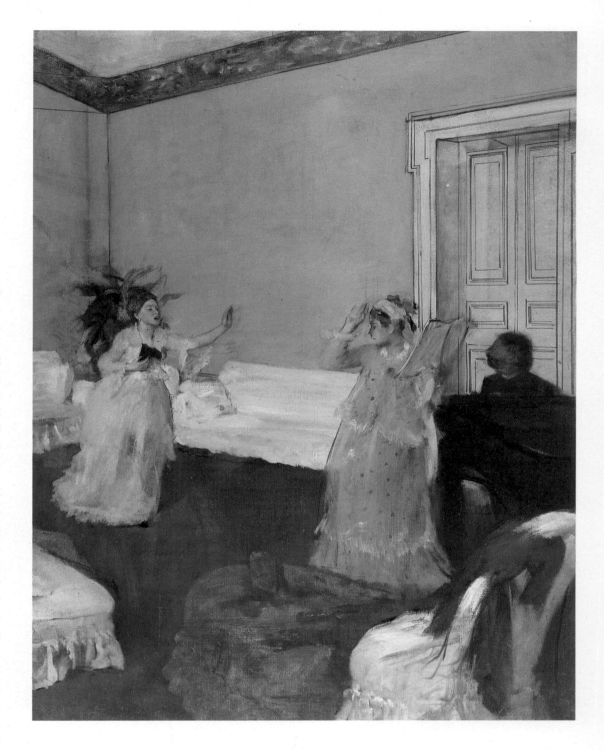

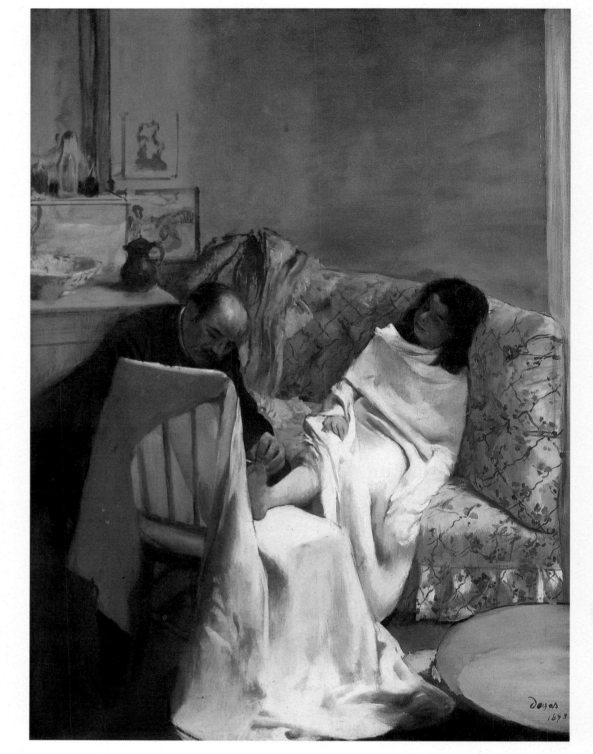

The Pedicure, 1873

Essence on paper mounted on canvas
24×18½ inches (61×46 cm)
Paris, Musée d'Orsay

This intimate genre picture, showing the stepdaughter of Degas's brother attended by a chiropodist, also originated from his New Orleans visit but may not have been finished until he returned to Paris. The little girl wrapped in the towel is Josephine Balfour, whose mother Estelle Musson married her cousin René De Gas after her husband was killed in 1862 during the Civil War.

Several features in this delightful painting herald Degas's subsequent handling of motifs in his series of bather pictures, executed a few years later. The arrangement of a still life of bowls, jugs, vases and bottles on the marble slab of a dresser, a shallow round metal bath, a body wrapped in a towel and a deep-buttoned couch are all recurrent later elements. In the sense that the spectator has glimpsed unobserved a private part of an individual's toilet performed in a bedroom, it emanates a similar quality of detachment.

The perfumes on the dresser shelf suggest that Josephine is in an adult bedroom, perhaps that of her mother, and the child-like drawings pinned up next to the mirror could be her own. There is something splendidly regal about this diminutive, swaddled little girl, faintly suggestive of an invalid, who is enthroned on an adult couch with a man on his knees absorbed in the welfare of her feet. If it were not a child but an adult having her feet attended to, the painting would have seemed, even to Realist tastes, rather coarse in subject; a little like Dutch genre paintings of the seventeenth century, which show women picking fleas from their body. Toenail cutting is without precedent in nineteenth-century subject matter.

Degas illumines the pair of figures with sunlight from a window on the right, creating a corruscating, dappled variety of whites and greys on the towel and sheet draped over the foreground chair.

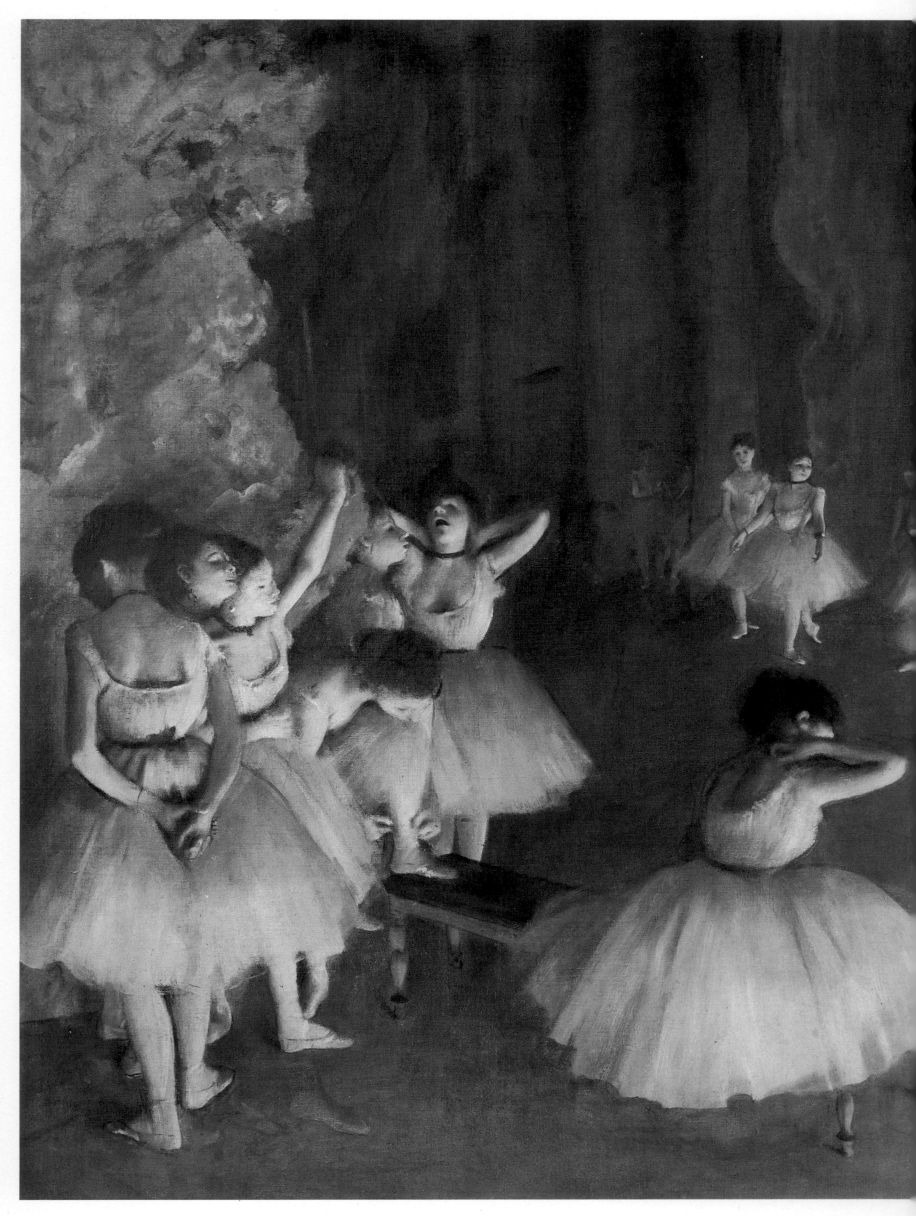

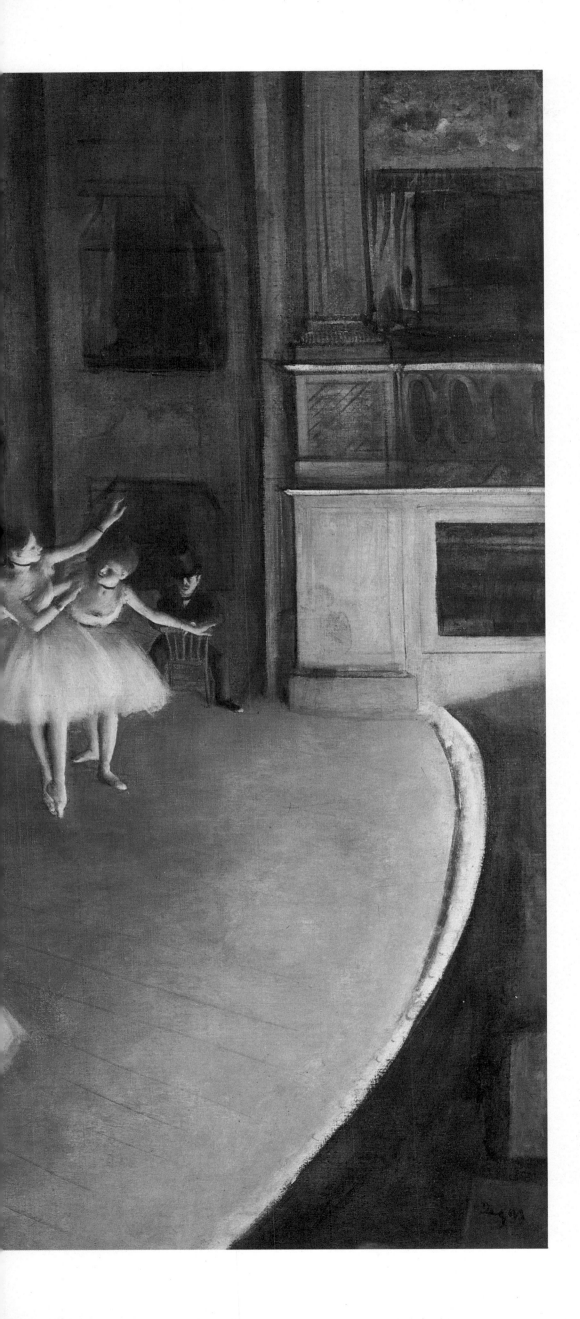

Ballet Rehearsal on Stage, 1874

Oil on canvas
25⅝×31⅞ inches (65×81 cm)
Musée d'Orsay, Paris

After his successful trip to the United States, Degas returned in February 1873 to Paris, where he took up the theme of ballet rehearsal which he had first explored in the minute canvases of 1872. A new treatment with rehearsal taking place on the Opéra stage exists in three variants and the critical consensus is that this is the first. It was the only time that Degas painted in monochromatic grisaille, probably to explore the tonal values of the picture as they would reproduce in a wood-engraved print for a magazine (the reasons for this are discussed further with the next picture). The painting's surface is extremely thin and subsequent fading makes it possible to see several alterations made during its creation, including changes to the feet of the dancers in the left foreground and the elimination of a seated man in front of the pilaster at the end of the stage on the right.

Degas adopts a conservatively panoramic viewpoint, without figure cropping or complex spatial play. He made over 20 drawings and paint studies of individually posed figures – as methodical an approach as he had used in the building up of his earlier history paintings. The moment depicted is ambiguous but seems to be that just prior to the baton tap of the conductor when dancers, like runners on the blocks, are privately absorbed in limbering up before being called to collective action.

Watching their efforts is the black-suited seated man – an *abonné* of the Opera, possibly a member of the French Jockey Club, who might be part of the exclusive group of 50 which occupied the seven stage side-boxes in front of which he sits. These boxes, reserved exclusively for male use, established a proximate relationship with the dance on stage that would nowadays seem almost disadvantageous in its restricted one-side view of the total proceedings, but then more personal objectives were usually in mind which went well beyond any aesthetic overview that might be better achieved from the stalls.

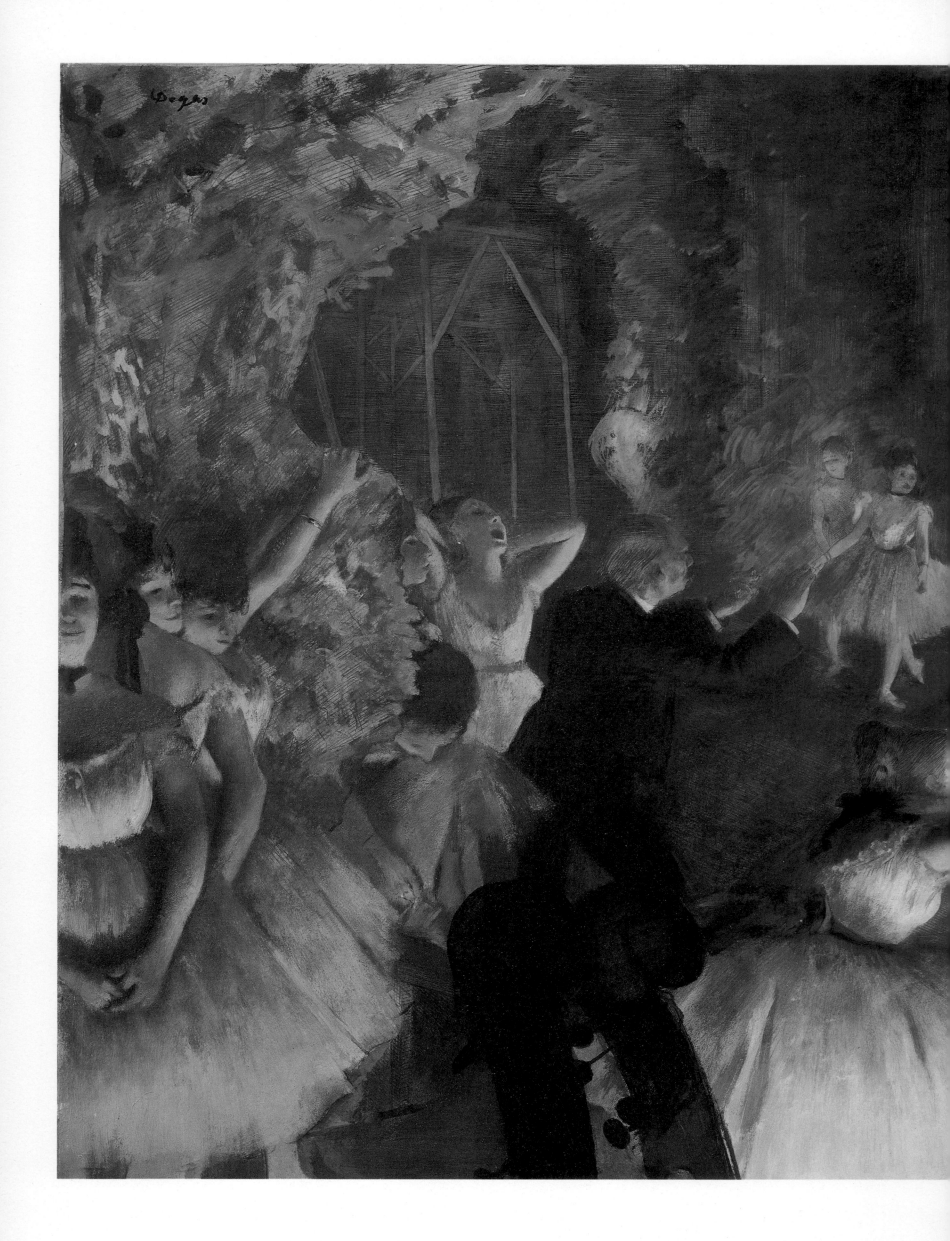

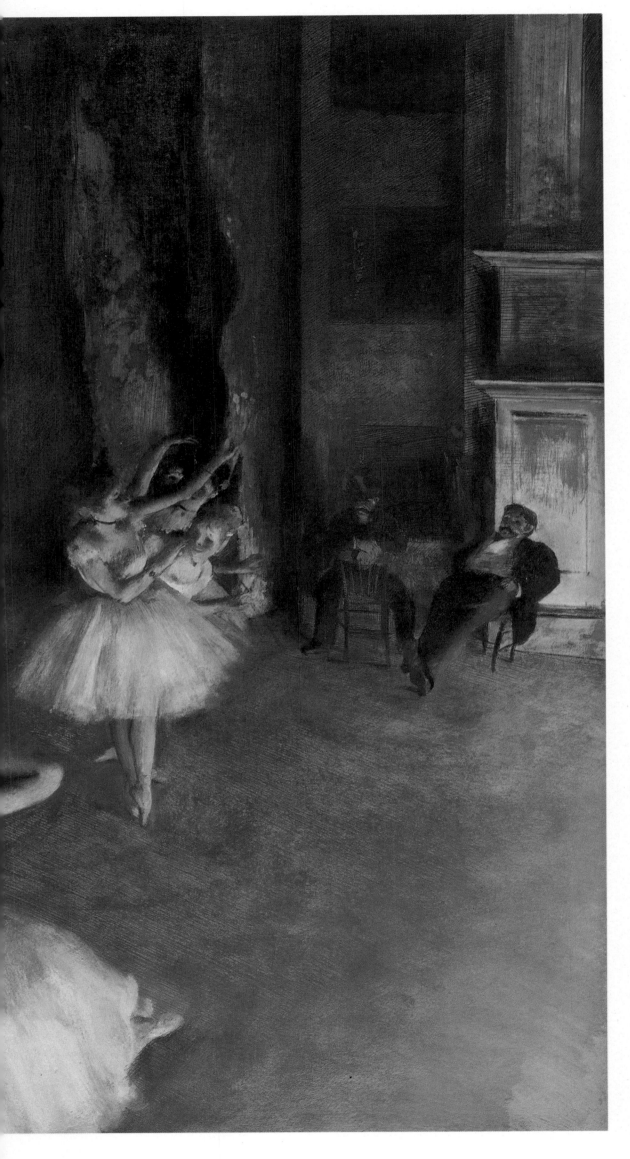

The Rehearsal of the Ballet on the Stage, ?1874

Essence, watercolor and pastel on paper, mounted on canvas
21⅜×28¾ inches (54.3×73 cm)
Metropolitan Museum of Art, New York

This, the second version of the subject, once belonged to Walter Sickert, the artist who most strongly represented Degas's pictorial values within British art. When Sickert lent it in 1891 to the exhibition of the New English Art Club in London, the critic George Moore described it as:

Originally a drawing done for *The Illustrated London News*, but the *News* could not make use of the drawing on account of its rectory circulation. There are some who would not think it wrong to watch a performance of a ballet, but would deem a picture of a ballet highly improper however chaste the treatment might be, and it is with this kind of stupidity, in itself an immorality, that the English artist has to contend.

Degas's targeting of *The Illustrated London News* was part of his focus on the English market, encouraged by his friend Tissot writing from forced exile in London. The *News* and *The Graphic Magazine* enjoyed international reputations during the 1870s and 1880s. Their double page 'artists' impressions' of contemporary events and selected genre were translated into strong black-and-white wood engravings. Aside from the potential financial reward, this was a respectable modern Realist genre that attracted several socially conscious British artists and one which, in the early 1880s, the young Vincent Van Gogh felt could have become his life's work.

Degas's approach is more adventurous and immediate in this second version. The conductor is now amidst the throng of dancers, who are shown cropped by the picture edge; the orchestra pit is not seen but implied by the pair of over-large double-bass necks that protrude into the bottom edge and the *abonné* has been joined by another conspicuously lounging companion, who was planned for but painted over in the earlier monochrome version. The perceived obscenity that caused the picture to be rejected by *The Illustrated London News* is probably connected with this ogling duo and the borderline prostitution within the ballet that their presence so clearly connoted to contemporary viewers – a factor that Degas may have considered in his indecisive alterations.

The Rehearsal, c. 1874

Oil on canvas
30×39 inches (58.4×83.2 cm)
Burrell Collection, Glasgow

In February 1874 Degas was working on this picture in his studio at 77 rue Blanche when he was visited by Edmond de Goncourt, co-author of the novel *Manette Salomon* which Degas said had finally converted him to Realism. De Goncourt enthusiastically described this work in his Journal after inaccurately and rather pompously taking credit for being the inspiration behind Degas's choice of *danseuses* as a suitably modern subject:

It is the *foyer de danse* with the legs of a dancer descending a small staircase outlined fantastically against a lighted window, with an unexpected bright accent of red from a tartan and a ridiculous ballet master acting as a rascally foil right in the middle of these billowing white clouds. In the forefront, captured in reality, were the graceful, twisting movements and gestures of those little monkey girls. The painter shows you his picture and adds by way of explanation a mime of a *développement* or *arabesque*. It is very funny to watch him standing on a point, his arms arched – joining the aesthetic of a painter with that of a ballet master while talking about the delicate darks of Velázquez and the silhouetting talent of Mantegna.

Sabine Neyt, Degas's housekeeper, modeled the tartan-shawled mother of a dancer, and the red shirt that de Goncourt found such an obvious depth cue is worn by a ballet master who may be a conflation of Louis Merante, who appeared in the earlier *Dance Class at the Opera* (page 76), and Jules Perrot, whom Degas celebrated in *The Dance Class* (page 90).

Instead of the hermetic private atmosphere that pervades so many of these rehearsal pictures, Degas here fills the room with pools of bright sunlight. This sense of openness is extended by the striking spiral staircase down which pour dancers from outside this space – another Japanese print-inspired motif.

Degas at this time was gathering a bank of superb studies of dancers who had posed in his studio. This repertoire, from which he was to produce his dance paintings and pastels for the next 30 years, was based upon a thorough understanding of the language of the ballet. Although he had enthusiastically attended the Opéra, it is doubtful that he knew in detail the vocabulary of the dance until he focused on it for his own pictures. It must have been with a touch of pride, as well as humor, that he demonstrated to the surprised de Goncourt his familiarity with the steps.

Degas's remark to de Goncourt about Velázquez and Mantegna suggests that he was still pursuing the reconciliation of colorist and linear values that had preoccupied him since he was a student in Italy.

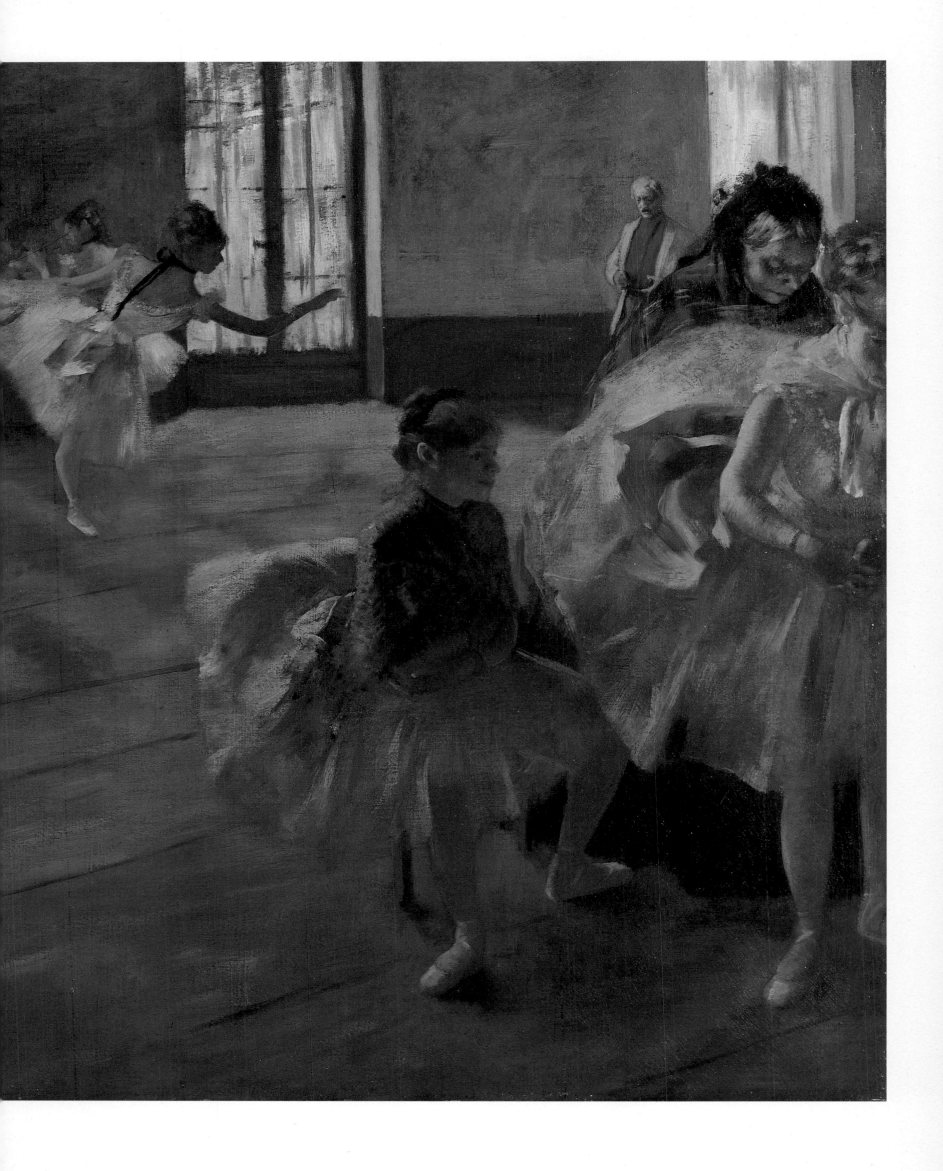

The Dance Class, 1874

Oil on canvas
33×31¾ inches (83.4×79.4 cm)
Metropolitan Museum of Art, New York

'Perrot the aerial, Perrot the sylph, the male Taglioni!' is how Théophile Gautier described Jules Perrot (1810-92), the grey-haired 64-year-old ballet master represented in this picture, who had been one of the greatest nineteenth-century male dancers. He had partnered the legendary Taglioni, spending ten years in St Petersburg with the Bolshoi before returning to Paris in 1859. His infrequent supervision of classes at the Opéra were understandably well attended.

Ballet masters are the only male dancers to appear in Degas's ballet pictures. Quite apart from his obvious predilection for ballerinas, the roles for male dancers in French ballet were declining, with the public preferring performances in which female spectacle predominated and a dance style that, although strongly rooted in the past, was more vigorously athletic than would previously have been considered correct.

Of the two versions of this picture, this is

the more forceful; a much greater use is made of blacks – in mirror frame, shadowed left foreground, deep rear shadows, Perrot's staff and the hair of the dancers. Against this the whites of the dresses and the mirrored sky stand out with an unnaturally sharp clarity, like that of landscape before a thunderstorm. Strong blacks and whites were part of the regular vocabulary of Dutch seventeenth-century paintings of interiors. Mary Cassatt emphasized this connexion with her comment that this picture was in her opinion 'more beautiful than any Vermeer I ever saw', and in 1915 she suggested to an exhibition organizer that if they could not get a Vermeer to show they should borrow this picture instead.

The tiered stand set up at the back of the room gives one of the clearest intimations of the gang of protecting stage mothers who kept watch over their girls at rehearsal while they waited to be individually put through their paces. However, no specific rehearsal is depicted here; the room is generalized. As usual bows, ribbons and dresses are those for performance not rehearsal, and the figures are arranged to Degas's compositional liking.

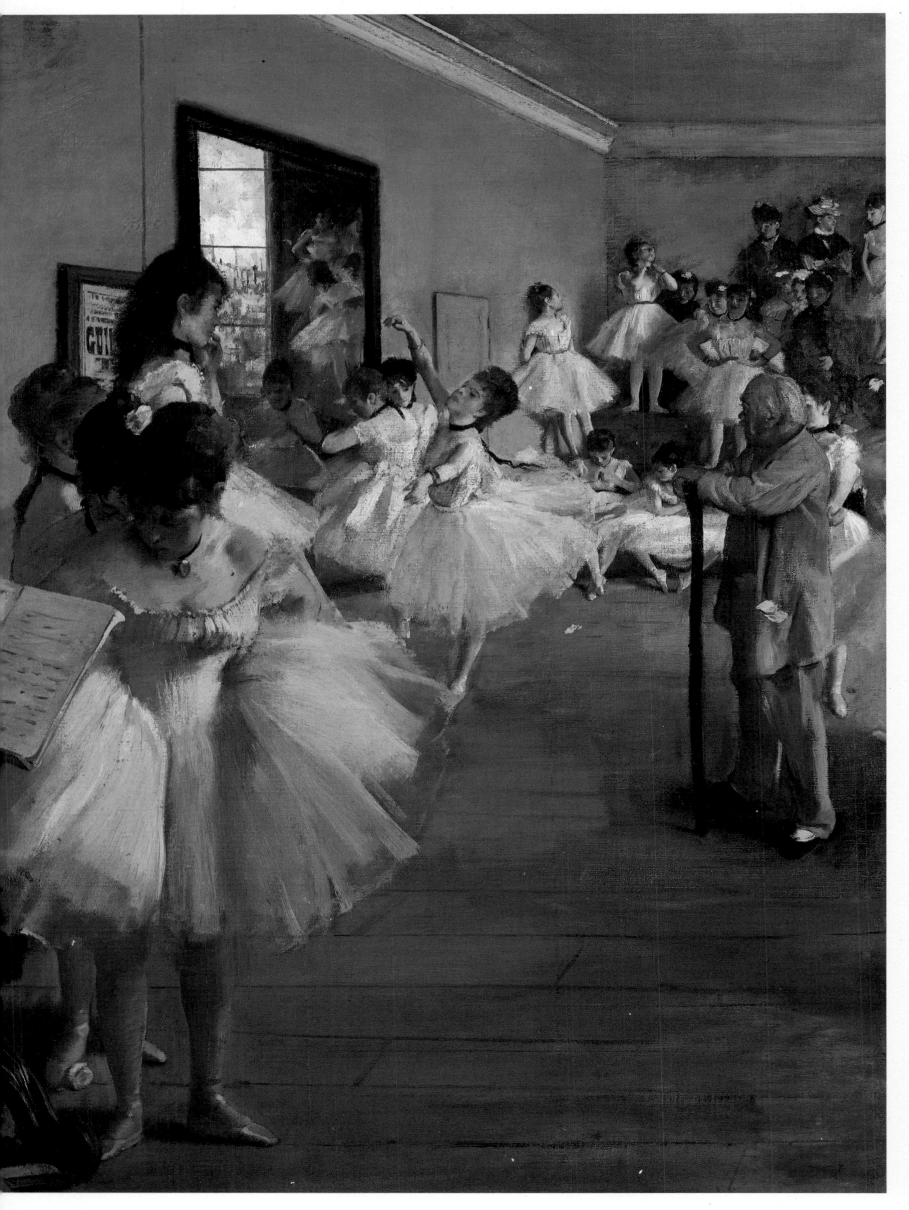

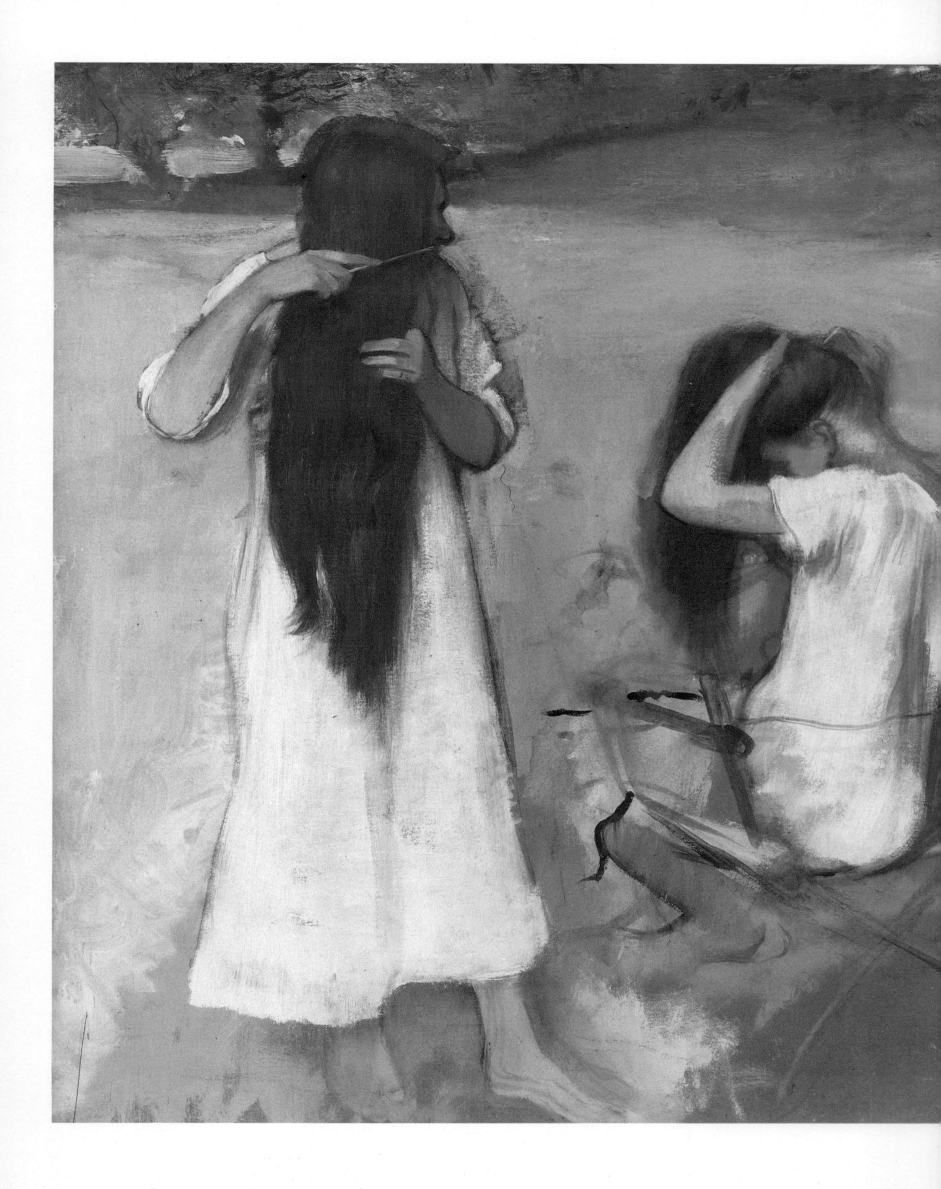

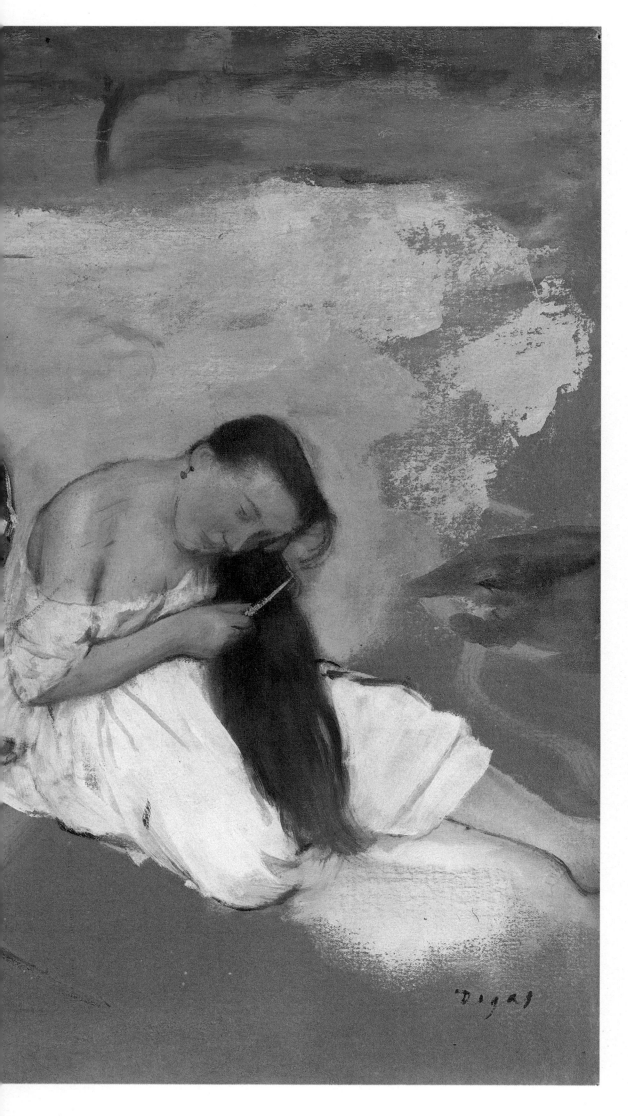

Women Combing their Hair,
c.1875-6

Oil on paper mounted on canvas
12¾×18⅛ inches (32.3×46 cm)
Phillips Collection, Washington DC

This is the first example of the theme of female hair combing and arranging which developed over the next three decades into an important sub-species of Degas's bather pictures and sculpture. The women shown were drawn from one model taking up different poses and were painted naked before Degas added their white chemises. For someone as art-historically sensitive as Degas, their careful arrangement must have called to mind the compositional problem that for centuries had absorbed painters and sculptors – the perfect organization of three women, as in the depiction of the judgment of Paris. Indeed, it is the rather obviously schematized structuring of this picture that is most striking, particularly the insistent diagonal that bisects the picture from top right to bottom left, along which the heads of the women are distributed.

Iconographically, loose hair has invariably been associated in western art with sexuality, indicating both purity – virgins are distinguished from the married or widowed by their long uncovered hair, and knowledge – Venus's hair is one of her most important attributes and Mary Magdalene is deviantly obvious by her exaggerated tresses. Degas had exploited the symbolical function of hair in his earlier picture *Scenes of War in the Middle Ages* (page 44), where it was used to suggest violation. Insofar as this picture can be connected with an historical type, it can be placed within what is really a sub-section of the Mary Magdalene theme, where young women are shown combing their hair in front of a mirror as an image of *vanitas* – highlighting the corruptibility of physical beauty and the need to pursue higher spiritual goals.

Of course, at one level, it is possible to see this picture simply as a formal orchestration of three human figures – a neutral decorative harmony, a little like similar variations painted by Albert Moore, the friend of Whistler. However, the sheer variety of associations, formal and narrative, of this subject-type suggests that Degas in this and related images was perhaps exploring what he only finally resolved in his 1886 series of bathers – the way in which the modern nude might be made as monumental as an Old Master.

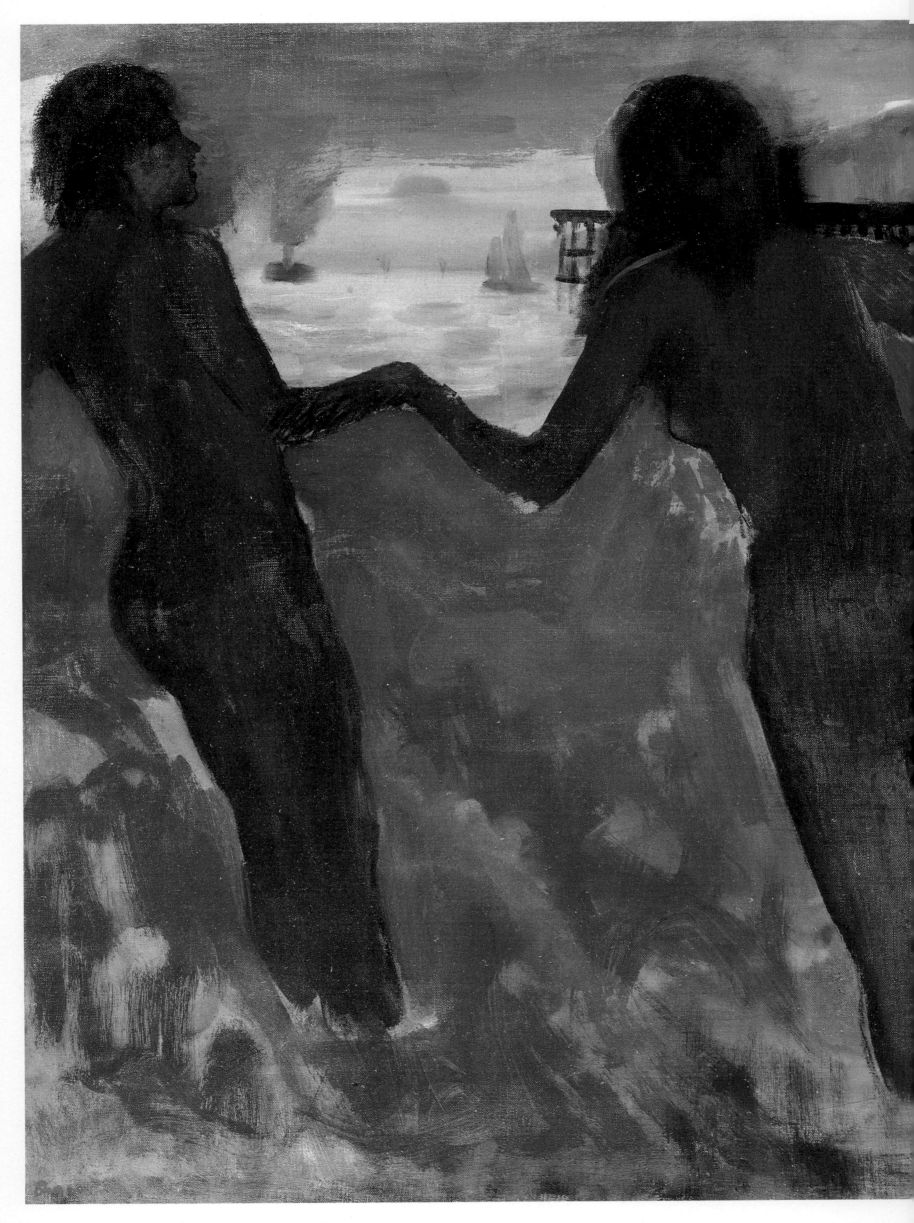

Three Girls Bathing, 1875-6

Oil on canvas
25⅝×37⅛ inches (65×81 cm)
Private collection, London

There is about this work such an unin-
hibited animal intensity that were it not
known to be by Degas, one might seek to
locate it in the *oeuvre* of Gauguin or one of
his Expressionist followers. It is one of the
earliest examples of Degas's return to the
nude, and although intended for exhibi-
tion in 1876 was left over until the follow-
ing year, when it was shown along with
another beach scene of the young girl
having her hair combed by a nurse (*Beach
Scene*, page 104). The contrast between
these naked free-spirited peasants and the
decorous repression of the young bour-
geois girl, which would in our post-Freu-
dian age have been highlighted by any
number of critics, went unremarked by
contemporary reviewers. Although Degas
may never have intended them to be
viewed in tandem, he was probably work-
ing on them simultaneously.

A disturbing feature of this image are the
disparities in scale between the three back-
ground figures – out of scale in relation to
each other and over-large in relation to the
foreground trio. As an antithesis to the joy-
fulness of the dance an elegiac note is
struck by the girl furthest away who
appears to hold her sides and looks down-
ward with a reflectively sad gaze. This
rather gloomy reading is compounded by
the sinking sun and long shadows across
the beach.

Like the picture of similar date to which
this is related, which shows three women
combing their hair on a beach, Degas may
here also be experimenting composition-
ally with the traditional Three Graces for-
mula. This has always been one of Degas's
most perplexing pictures and at his studio
sale in 1919, despite its being a large oil, it
only made 5500 francs.

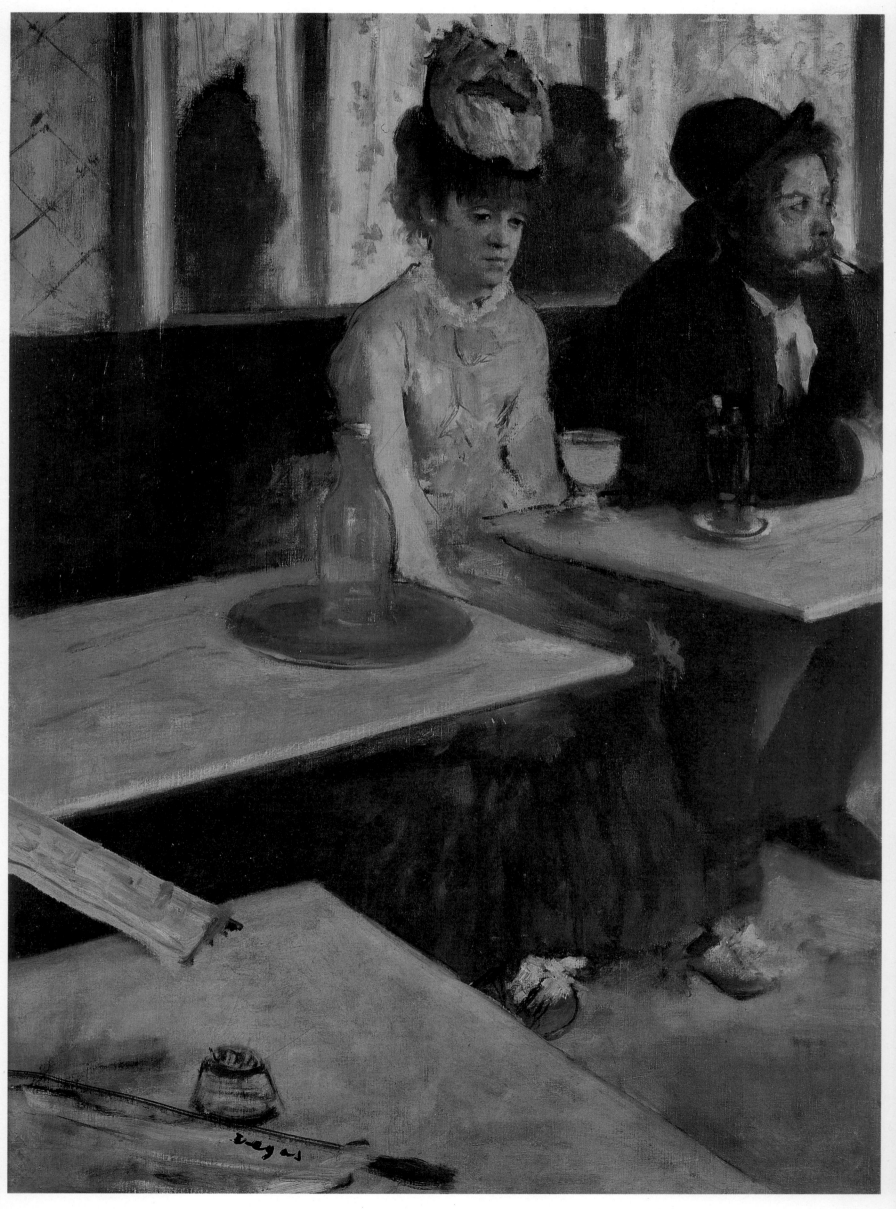

In the Café (L'Absinthe), 1876

Oil on canvas
36¼×26¾ inches (92×68 cm)
Musée d'Orsay, Paris

Forty years after posing for this seated woman in what is arguably Degas's most famous painting, Ellen André recalled, 'I am seated in front of an absinthe, Desboutin in front of a soft drink – what a turn around! And we do look a pair of idiots'. Ellen André was a successful pantomime artist, fashion model and avant-garde actress. Marcel Desboutin was an artist-etcher, whose relaxed appearance, smoking his famous clay pipe, belies the fact that in real life he was trying to bring up eight children on very little money, after exhausting his considerable private fortune in Italian real estate speculation. Both were friends of Degas and habitués of the Café de la Nouvelles-Athènes, the setting of the painting and the social focus from about 1875 for the Manet/Duranty Realist group, after they moved away from the Café Guerbois.

Although Degas's Realist intentions for this canvas were undoubtedly to show a miserable single woman, probably a prostitute, drinking alone, it is not clear that he was specifically highlighting alcohol abuse. Only in 1893, when the picture was exhibited in London, was the alternative and now famous title L'Absinthe given to it

and it then received extremely hostile criticism.

As in his earlier pictures of couples in Interior (page 58) and Sulking (page 71), there is uncertainty about the relationship, if any, between the man and woman depicted. Mild despair and time-hardened mutual indifference is the predominant mood. Manet also painted a similarly posed picture La Prune (National Gallery, Washington), inspired by this work and set in the same café, showing a pretty melancholic woman with an unlit cigarette seated before an uneaten pudding – more pensive and altogether less desperate than Degas's image, a little like the difference in personality between the two artists.

Degas's double-viewpoint, looking both down at the planes of the tables and directly at the figure of the woman, is a Japanese-inspired spatial play, while the cropping of Desboutin's knee and pipe gives a cut 'slice of life' reality to the work. Although café interiors were taken up as suitable contemporary genre by several artists, Degas was only briefly involved with it as a theme in the mid-1870s and did not incorporate it into the repetitions made of his favorite subjects in later life.

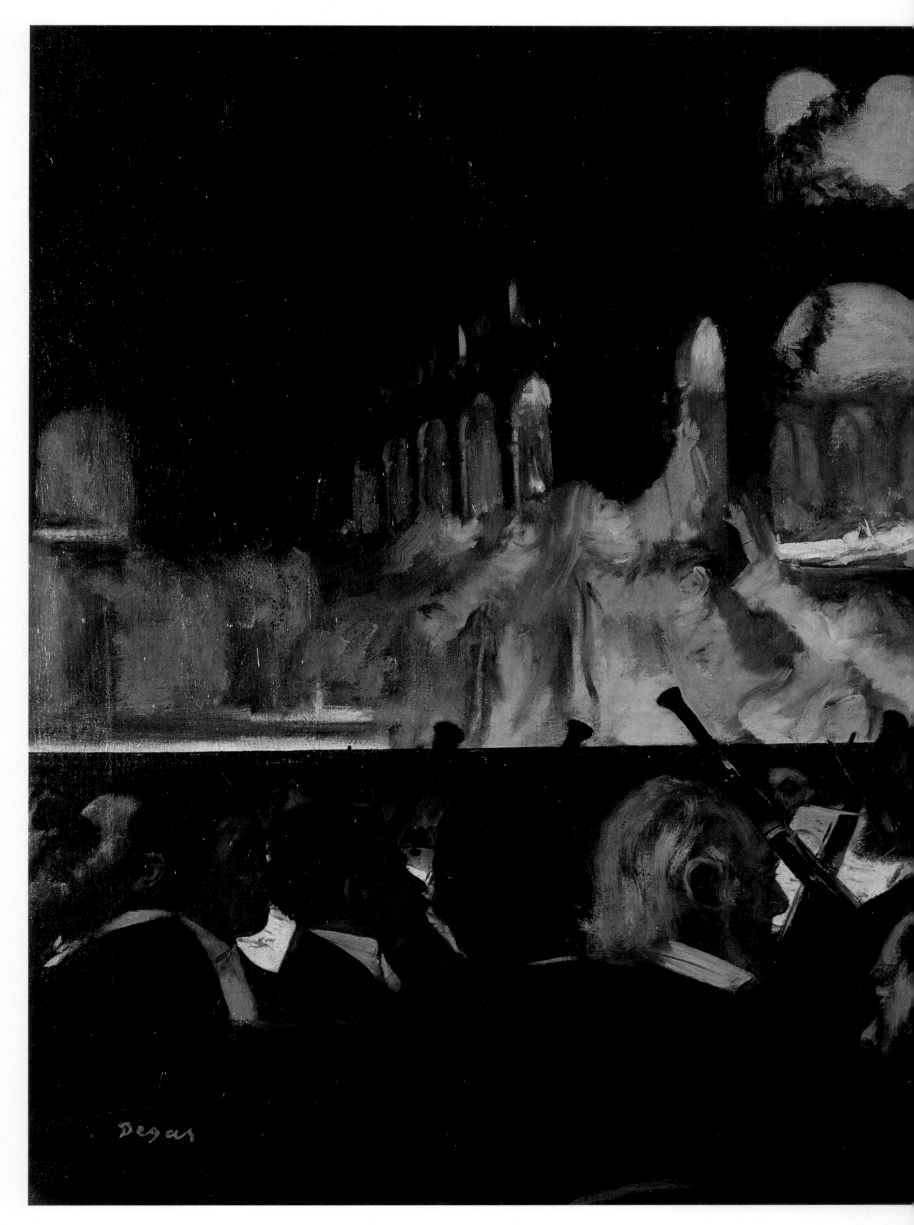

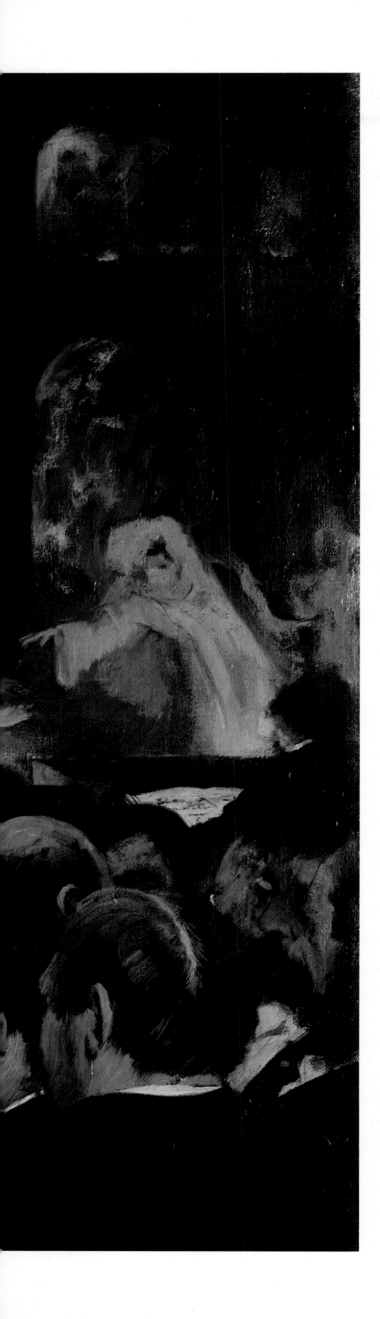

The Ballet Scene from 'Robert Le Diable', 1876

Oil on canvas
29¾×32 inches (76.6×81.3 cm)
Victoria and Albert Museum, London

In the half light, the shadows gradually take shape. Out of the depths, with a soft rustling like the beating wings of a moth, rise to life indistinct bodies, silhouetted against columns, ascending like vapour from each grave stone. Bright electric light shines through the archway, highlighting in the blue void the white shrouds of the womens' bodies which glow with macabre sensuality.

Thus in 1870 did the writer Théophile Gautier describe the visual thrill of the famous scene from Giacomo Meyerbeer's ballet *Robert Le Diable*, where a bacchanalian orgy of living and dead nuns cavort by moonlight in a ruined monastery. It was an immensely successful work, performed 785 times between 1831 and 1893, and, like *La Source* (page 56) that Degas had painted in 1866, partly owed its success to the complexity of the stage business and the exploration of new lighting techniques.

Degas saw five performances between 1885 and 1892, and probably several before that. This is the second of two painted versions; the first is a smaller vertical picture. Both were painted for the singer Elie Faure. This second version was done in 1876 and exchanged with the original in Faure's possession because Degas was dissatisfied with his first treatment.

The coloring, with its simplified *chiaroscuro*, veers towards the same monochromatic approach that Degas experimented with in *The Dancing Class* of 1871 (page 74). The paint surface, especially that used for the nuns, is fluid enough to suggest the flitting, just-decipherable movement of the ghostly figures.

In the orchestra pit, Désiré Dihau plays his bassoon. The front row of the audience includes Degas's friends Ludovic Lepic and Albert Hecht, the latter turning away from the stage to observe the boxes behind through his binoculars. He has grown indifferent perhaps to the sensational atmospherics of the production, which continued to appeal to Degas, partly because it was such a familiar old chestnut in the repertoire of the Opéra, and possibly also because it still retained for him some of its orginal Romantic potency. It is the sort of subject, after all, that would have attracted Delacroix.

The Star, 1876-7

Pastel over monotype
22⅞×16½ inches (58×42 cm)
Musée d'Orsay, Paris

The prima ballerina, who bows after a movement that has left her completely out of breath, swoops forward towards the footlights with such élan that if I were the conductor I would think about reaching out to support her.

So wrote a delighted reviewer of this picture when it was first shown. It is one of a group of pastels over monotype that Degas produced in 1876-7 and included in the third Impressionist exhibition of 1877. Monotype gave Degas the chance to turn prints out rapidly (see Introduction for a further explanation of the process). A half-hour could produce a finished print, the time it could take simply to ink up properly a large etching or aquatint. With the dominant tonal values established in black and white, Degas could then, as he did with this picture, work over the one or more printed impressions in pastel, chalk or paint. The debts of the Degas family were only finally computed in January 1877 and Degas felt honor-bound to take on considerable repayments – enough perhaps to make him attracted by the possibilities of an artistic medium for turning out saleable 'pot-boilers'.

Caillebotte, a co-exhibitor at the Impressionist Exhibition with substantial independent means, bought this picture and in 1894 it was left with other Impressionist works to the French state. Caillebotte's bequest, which provoked great controversy, included six other pastels by Degas. Of all the Impressionist artists' work offered in the bequest, Degas was the only artist to have all his pictures accepted. Yet he was irritated that he was to be so poorly represented in the Musée du Luxembourg collections, and described this work to his friend Daniel Halévy as 'an impromptu and more or less rapid sketch' – a curiously disparaging remark for what is now one of the best loved of all his works.

As in so many of his ballet pictures, Degas offers the spectator a privileged viewpoint, more than the average Opéra visitor could ever see: layered wooden flats, dancers in the wings, a couple chatting behind the silent evening-dressed male figure. He is possibly the 'guardian' of the star – faceless, anonymous and slightly sinister, he waits to take charge of his frothy beautiful object once she has done her public turn. Her black neckband links colorifically to his clothing and its ribboned tails flutter in his direction. Amid the glittering prettiness, financial necessities ultimately dictate – an apposite if perhaps unintended comment by Degas on his own parlous circumstances at this time.

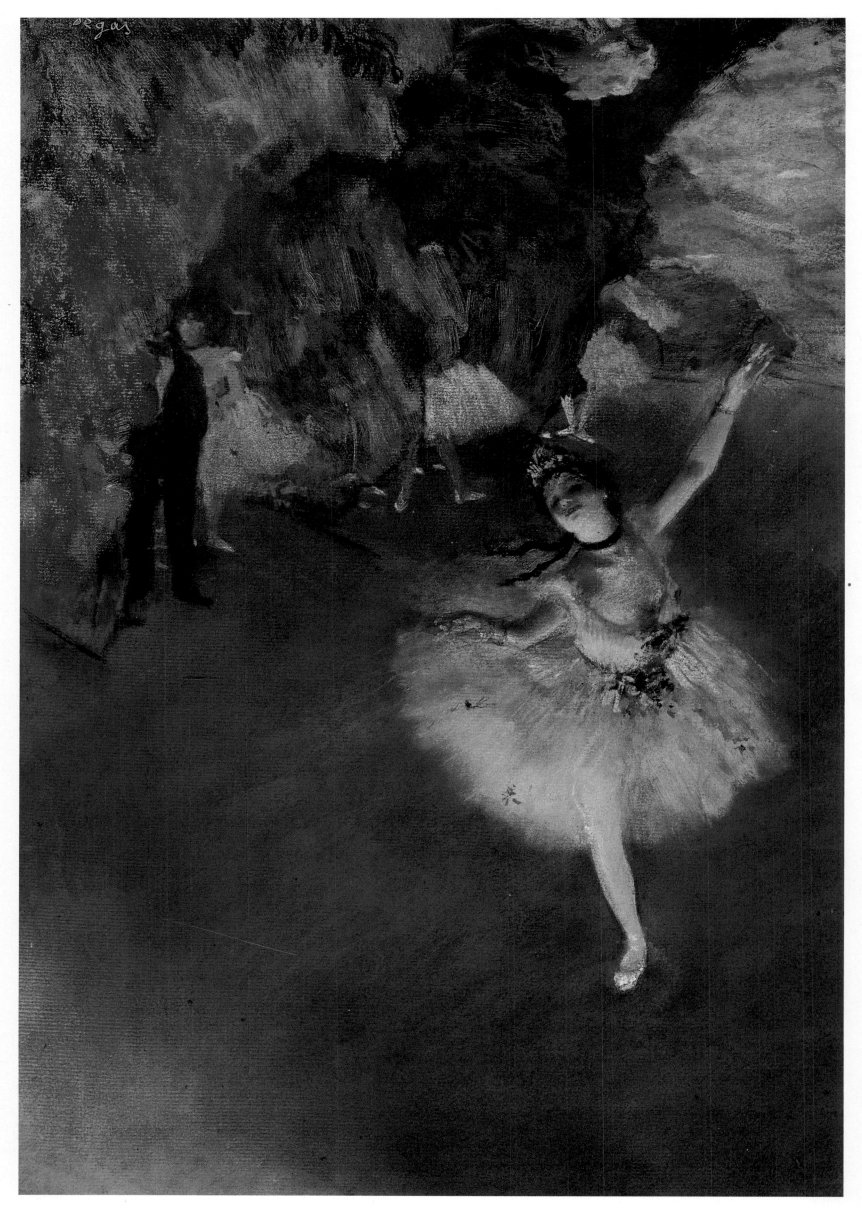

Woman at her Toilette, 1876-7

Pastel over monotype
18×23¾ inches (45.7×60.3 cm)
Norton Simon Foundation, Pasadena

The most poignant aspect surrounding this pastel is that Monet, in order to obtain it for his collection in 1895, was obliged to exchange it with the dealer Portier for one of his own works. Despite having exhibited together for years, Degas, dismissive of Impressionism, never reciprocated Monet's admiration and they never got around to exchanging pictures. Monet may first have seen this work in 1877, as it is possibly one of the two unidentified bathers listed in the Impressionist exhibition catalogue for that year.

Around 1874 Degas returned after a decade to the nude and from 1876-7 it played a major part in his many monotypes of brothel scenes and bathers. It is not entirely clear how far some of the prints and pastels of bathers made between 1876-83 may be considered a sub-branch of the brothel scenes. Unlike the great 1886 suite of bathers, several are ungainly in pose, some are ambiguous – possibly even lewd – and the majority, including this, cluttered with boudoir paraphernalia.

Because of her rather flashy red slippers, the bright blue stockings that peek out from her discarded voluminous petticoat and the open door that creates the expectant sense that someone – a client, protector or simply a maidservant – might at any moment enter, this bather lacks grandeur or monumentality. In the original very indistinct and dark monotype of this subject (this is a working up in pastel done on top of the second fainter print), Degas shows the woman with her hair up. A superb subsequent pencil and chalk study was done from a studio model's back and copied for this pastel. The untidy flowing hanks of hair in the study were kept in the final work and they too add a rather slatternly note.

This picture shows particularly fine examples of Degas's interest at this period in the workings of artificial light. Two gas brackets on either side of the mirror cast their direct and reflected mirror-light on to the woman's torso, producing the complex overlapping shadows on the counterpane of the bed and the dappled interplay of highlights and shadows that permeate the room.

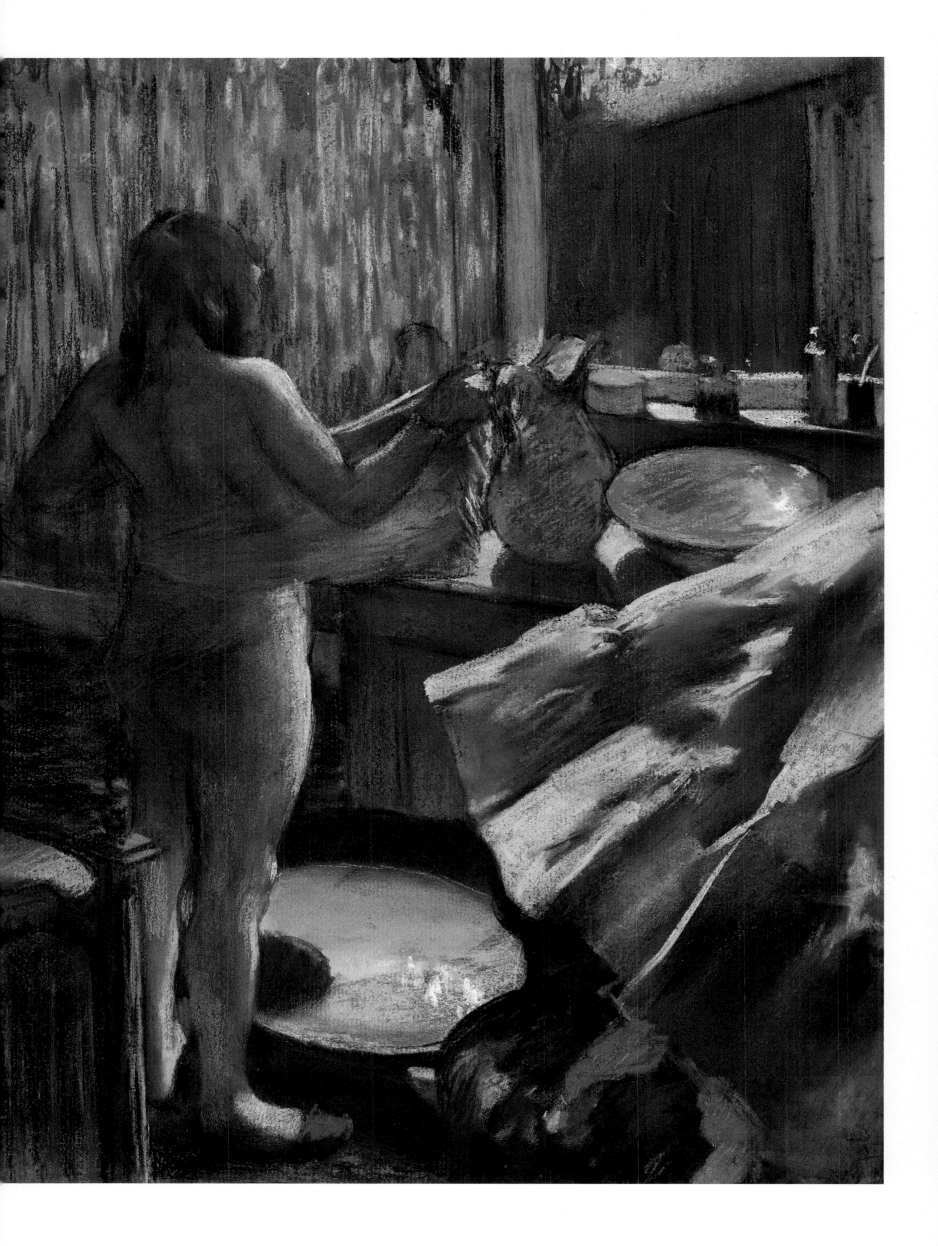

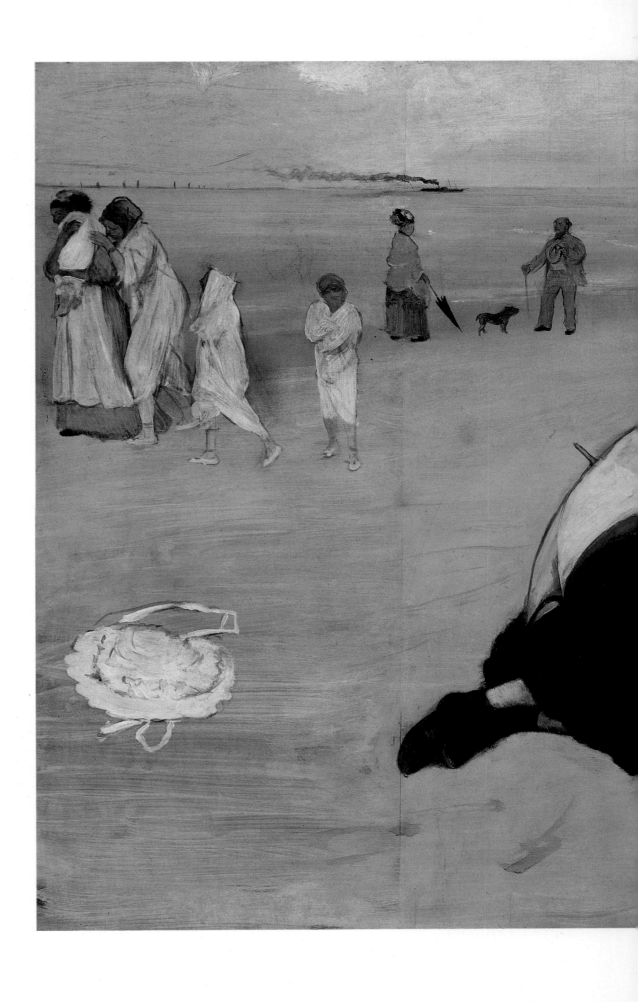

Beach Scene, 1876-7
Oil and essence on paper mounted on canvas
25⅝×37⅛ inches (65×81 cm)
National Gallery, London

Eight years after his series of pastels of the coast of northern France, Degas returned briefly in 1876 to the theme of the sea and seabathing. Elements in this picture are derived from these earlier pastels, combined with figures posed in his studio and a considerable repertoire of freely-created caricature-like figures based upon memory, imagination and possibly studies.

Ambroise Vollard recalled a visitor to Degas's studio teasing the artist about this picture after Degas had just been very abusive about Monet's landscapes and out of doors paintings in general, 'How then did

you manage, Monsieur Degas, when you painted that *plein air* called *La Plage*, the one Monsieur Rouart has?' Degas replied, 'It was quite simple. I spread my flannel vest on the floor of the studio, and had the model sit on it. You see, the air you breathe in a picture is not necessarily the same as the air out of doors.'

Analysis of this painting has often placed greatest emphasis on its formal qualities, without much weight being given to any narrative content. The striking sensuousness of the lithe young girl having her hair combed by her bulky maid

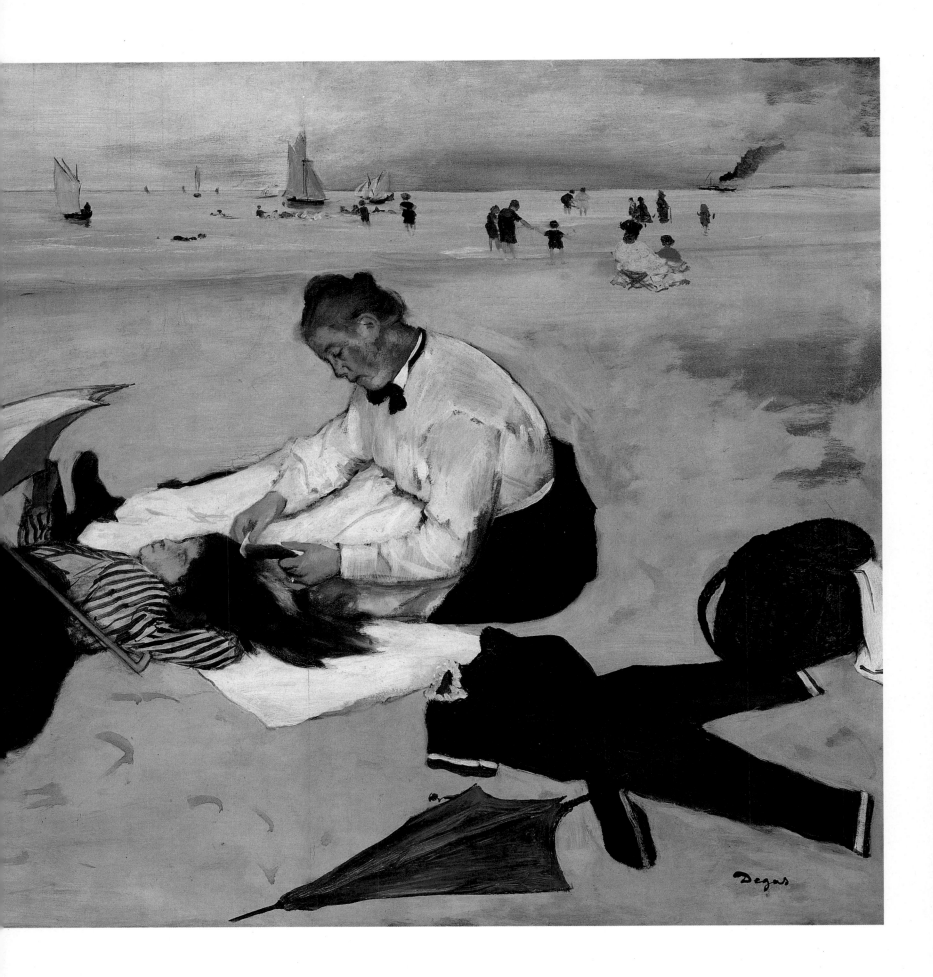

anticipates the underlying theme of his later bather series – a female who relaxedly gives herself over to the soothing, stroking, calming ritual of her toilet. There is a spreading openness in the young girl's gestures and scattered possessions. Collectively her exaggeratedly frilly feminine bonnet cast to one side, her open-legged wet bathing suit, and her right hand abstractedly toying with the point of an umbrella spoke, all suggest physical abandon. The background young boy has stopped short to take stock of this ambivalent vision of adolescent languor. Mean-

while, on the edge of the beach, a middle-aged man and woman greet each other – distanced by umbrellas, sticks and social conventions. Their more predictable formal conduct is in comic contrast to the natural ease of the expansive young girl. The figure of the man is based upon that of the ballet master Louis Merante in the 1872 *Dance Class at the Opera* (page 76).

The picture is made up of three pieces of paper joined together, with that on the left-hand side added last. The join is visible where it touches the girl's foot and bisects the woman with the umbrella. Degas in-

troduced this third section to obtain a three-fold balance: a balance of volume in the beach to the left and right of the central girl; a balance of color in the introduction of the white towel-wrapped bodies that counterbalance the nurse's blouse; and a balance of shape in the oval bonnet that echoes the large basket in the right-hand corner.

The painting was shown at the 1877 Impressionist exhibition, along with the painting of three brown-skinned peasant girls bathing naked in the evening (page 94).

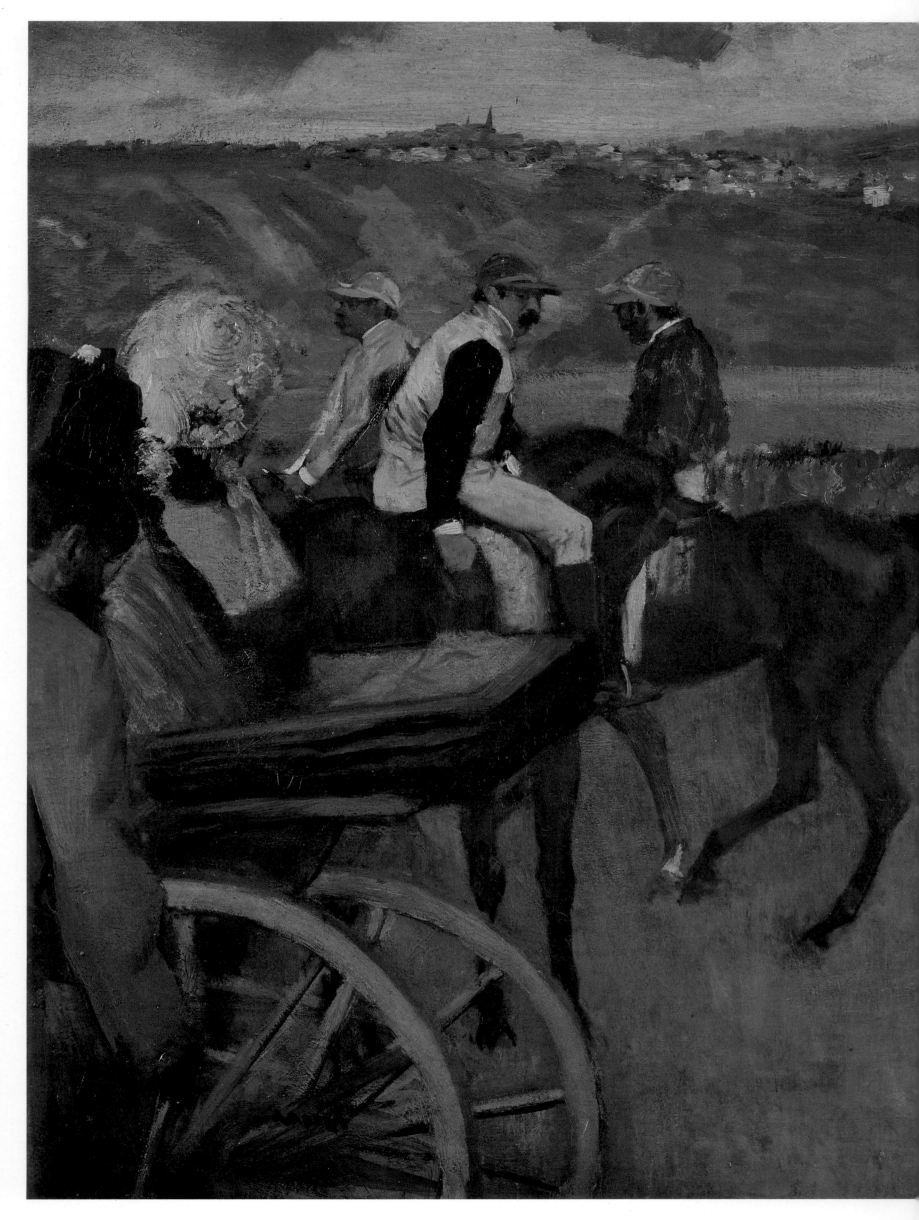

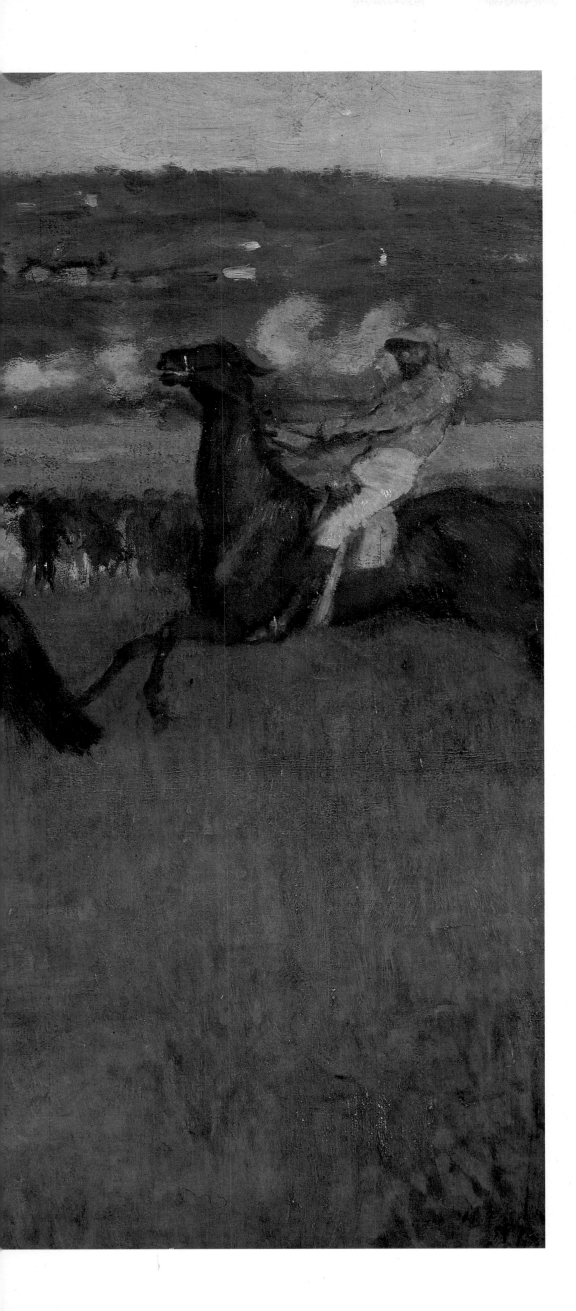

The Racecourse, Amateur Jockeys, 1877-80

Oil on canvas
26×31⅞ inches (66×81 cm)
Musée d'Orsay, Paris

Thirteen years of reworkings went into this painting. Degas sold it to the baritone Elie Faure in 1874 but only delivered it in 1887 after the threat of prosecution. From 1876 onward he wrote promising delivery 'in a few days' but somehow each minor alteration of figures involved a protracted re-tuning of the entire canvas in addition to all the other demands upon his time. Rather than the emphatic right-hand clutter of jockeys and overlapping cropped spectators, the original composition as revealed by x-radiography was more centralized.

On the left-hand side what at first looks like the steaming breath of the agitated, reined-in horse turns out to be the smoke of a railway train crossing the valley. One of Degas's recurrent sub-themes in several of his racecourse pictures up to about 1890 is the depiction of the interpenetration of town and country. With chimneys, factories, expanding suburbs and leisure-hungry crowds like the pressing line of figures to the rear of this race, Degas's racecourses, far from being nostalgically linked to country sports, are offered as images of urban mass society. Only in the 1890s did he drop the socialized settings and buildings to concentrate on a more reflective poetic treatment of the horse and jockey in undisturbed landscape.

In this picture it is the rich who provide the spectacle. These are gentlemen jockeys, surrounded by their privileged carriage-using friends in the foreground – a woman wears a blue favor ribbon in her hat identical to the colours of the silks of the mounted jockey whom she faces. The masses look on from the sidelines.

Among the many landscape settings that Degas invented or generalized for his horseracing pictures, this is among the most convincing as a possible real location. It is evocative of some of the Auvers landscapes of the early 1870s by Cézanne, rather than the more feathery-brushed Impressionist landscapes of Monet or Renoir.

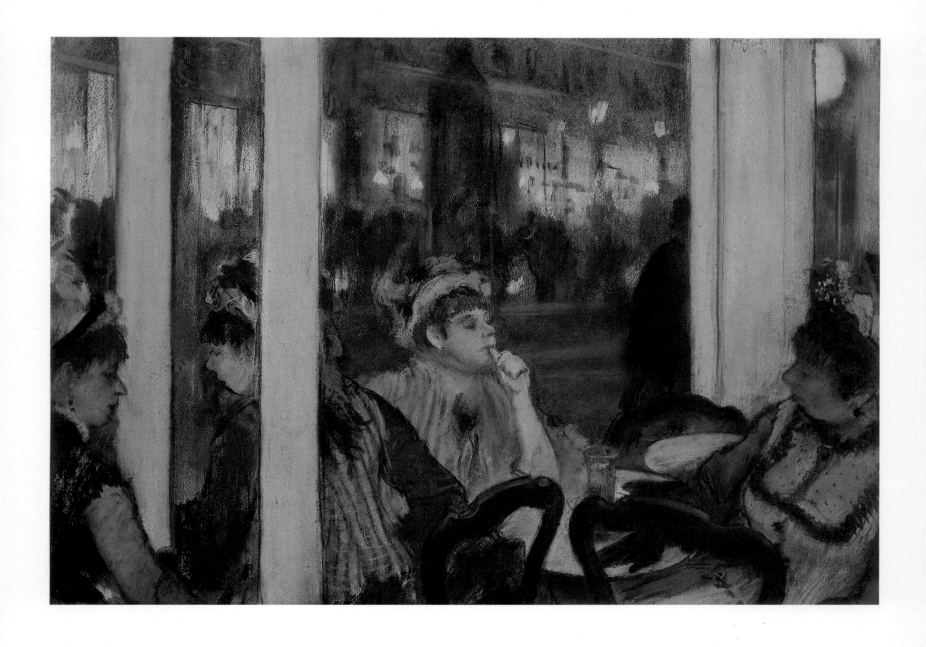

Women on the Terrace of a Café, 1877

Pastel over monotype on white woven paper
16⅛×23⅝ inches (42×60 cm)
Musée d'Orsay, Paris

This large pasteled monotype, showing a gaslit group of prostitutes seated on a terrace in front of a café, was exhibited at the third Impressionist exhibition in 1877, and shocked reviewers with the daring of its subject. One critic, Alexandre Pothey, thought Degas was deliberately trying to cause a sensation with these 'painted faded creatures exuding vice who cynically tell each other about the day's activities and accomplishments'. It is as well that Pothey never saw the monotypes of brothel interiors.

The most striking feature of this work is its daring compositional complexity. The bare, flat columns of the terrace cut the picture into strips. Figures and chairs weave in and out of these insistent pale verticals without ever completely integrating with them. This picture defies unity and can only be read in bits; rather like serial glimpses from a viewpoint that is about two feet above the women – the viewpoint of a standing, possibly walking, individual, a waiter, or even possibly a prospective customer. This particularly jarring vertical foreground motif is ultimately derived from Japanese prints and is very like certain foreground treetrunks used by Hiroshige in prints from his *Hundred Views of Edo* series. Degas uses this device superbly to achieve a fracturing of space that engenders instantaneousness and, above all, movement. The women shown are lumpish and exaggeratedly ugly, and Degas late in life is reported to have thought the pastel 'rather on the cruel, cynical side'.

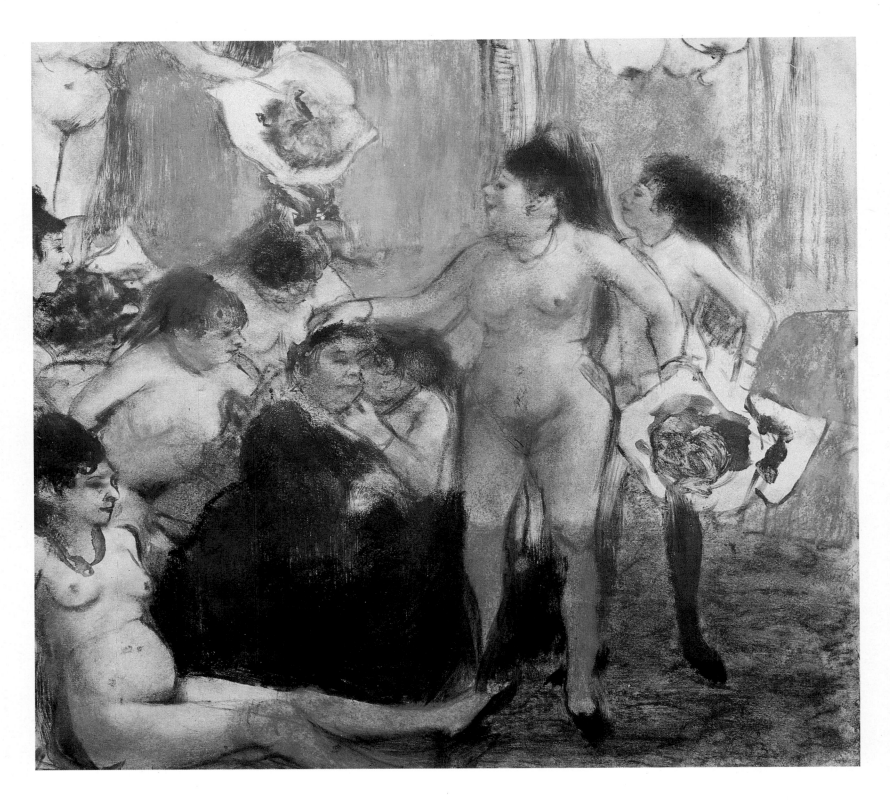

The Name Day of the Madame,
1878-9

Pastel over monotype on paper
10½×11⅝ inches (26.6×29.6 cm)
Musée Picasso, Paris

The scene is the salon of a brothel, where the prostitutes are patting, cuddling and congratulating their madame whose saint's name day it is: a group of happy self-absorbed women in a welcome break from routine work. Over 50 monotypes of brothel subjects were made by Degas around 1876-7. The majority are in black ink; a few like this were worked up in colored pastel. They have provoked considerable speculation about Degas's intentions and also the source of his inspiration. Although Degas was sexually active in his youth, he is not known to have had any close involvement with women after about 1870; indeed, his apprehensiveness with women was known and commented upon by Manet, among others. Recollection, literary sources and imagination, rather than recent first-hand experience, are the likeliest sources of his ideas. The prints were not publicly exhibited during his lifetime, although their existence was known. Renoir, who owned one said:

Any treatment of such subjects is likely to be pornographic and there is always a desperate sadness about them. It took Degas to give to *The Name Day of the Madame* an air of joyfulness and at the same time the greatness of a bas-relief.

Picasso owned this picture. He thought it a masterpiece and at the age of 90 produced a series of his own sexually explicit brothel scenes in which he sometimes included the figure of Degas as an observer.

Degas's overall approach in the brothel prints is one of rather ruthless detachment, showing the boredom, grossness and occasional humor of prostitutes at work. There is a caricature-like quality about the whole series. Degas's uncritical acceptance of brothels as part of life has been commented upon by recent historians, and these images have been seen as part of the revived case against Degas as a misogynist, representing complacent nineteenth-century patriarchal values.

Jockeys before the Race, 1878-9

Essence on paper
42½×29 inches (104×74 cm)
Barber Institute of Fine Arts, Birmingham

Painting in essence, the distinctive turpentine-diluted and oil-reduced paint that he often used, Degas exploits the watery properties of the medium to evoke the atmosphere of a dank misty morning race gathering. The disc of sun that hangs in the sky like a pale balloon and the slight twig of a tree immediately beneath it are delicate counter-balances to the emphatic vertical of the foremost horse, with its overlapping legs, and the white domed hat and white jacket of the rider. Flat, emptied of all superficial detail, and with color kept so limited that one small red jockey hat in the middle of the picture seizes spectator attention, Degas's minimalist treatment here comes the closest in his entire *oeuvre* to the spatial handling of a Japanese print.

The prominent vertical flagpole, placed roughly in accordance with the dictates of the golden section and slicing the picture in two, achieves a similar immediacy to the use of columns in his café concert picture (page 110) and the spiral staircase descended by ballerinas in *The Rehearsal* (page 88).

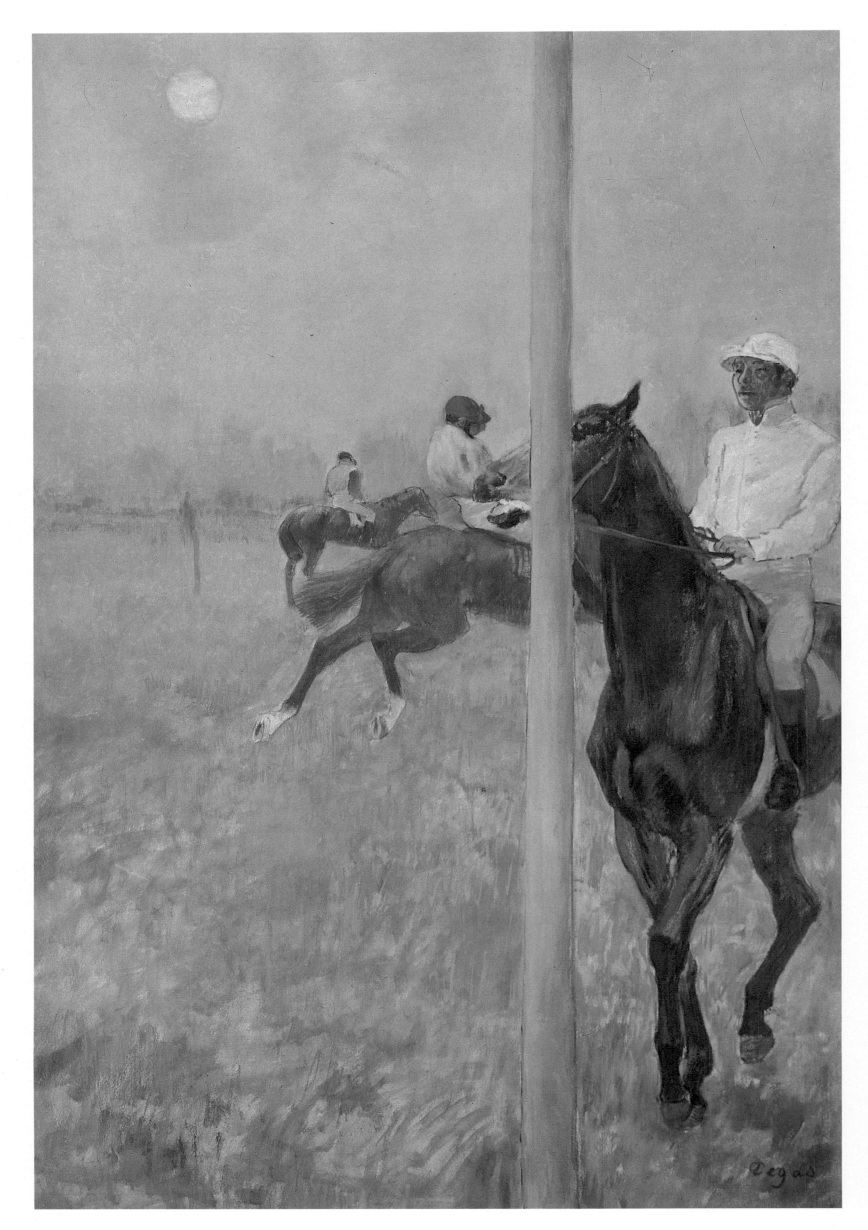

111

Portrait of Henri Michel-Lévy,

1878
Oil on canvas
16⅛×10⅝ inches (41×27 cm)
Calouste Gulbenkian Museum, Lisbon

Henri Michel-Lévy was a portrait, genre and landscape artist, son of the publisher of the de Goncourt novels, who was a friend of Degas from about 1868 onward and is thought to have been the model for the man in *Interior* (page 58). He was not apparently connected with the Impressionists, and exhibited principally at the Salon. This portrait was exchanged with Michel-Lévy for a portrait that he had painted of Degas, which has since disappeared.

Degas's dealer and friend, Ambroise Vollard, recorded that one day in the early 1890s, he and Degas met Michel-Lévy in the street.

Degas passed him by without a glance. 'We once exchanged pictures,' he explained to me afterwards, 'and would you believe it, I found the one I had given him for sale in a shop. I took his own back to him the next day.' 'What did he say to that? I shouldn't think that a man who can afford Watteau would ever find himself in need of ready money.' 'Oh I didn't even ask to see him. I just left his canvas on the doorstep along with the morning's milk.'

Degas depicts Michel-Lévy in a broadly similar pose to that used in *Interior*. He

looks like a man who returns from the Opéra late at night and, after shedding coat, tie and waistcoat, surveys the familiarity of his studio – his pictures and the lay figure used for costumes.

Sickert, who saw this painting when it passed through Christie's saleroom in 1920, thought that it was a self-portrait by Degas and saw it as 'a sermon in paint', in which Degas had 'actually been at pains to illustrate in a painting what amounts to a cynical protest against the extreme Impressionist tenets'. The point of Sickert's argument is that the lay figure on the floor is the same as that in one of Michel-Lévy's paintings, and that Impressionist obsession with truth to outdoor light overode their concern for truth to human character.

Despite his mistake over the subject, Sickert may be right in suggesting that Degas is gently mocking the use of lay figures. However, as in the *James Tissot* portrait (page 54), the various references in the work may be private and known only to Degas and Michel-Lévy.

Degas also fell out with Renoir when he took advantage of the very high prices paid for Degas's work and sold a picture that had been a gift.

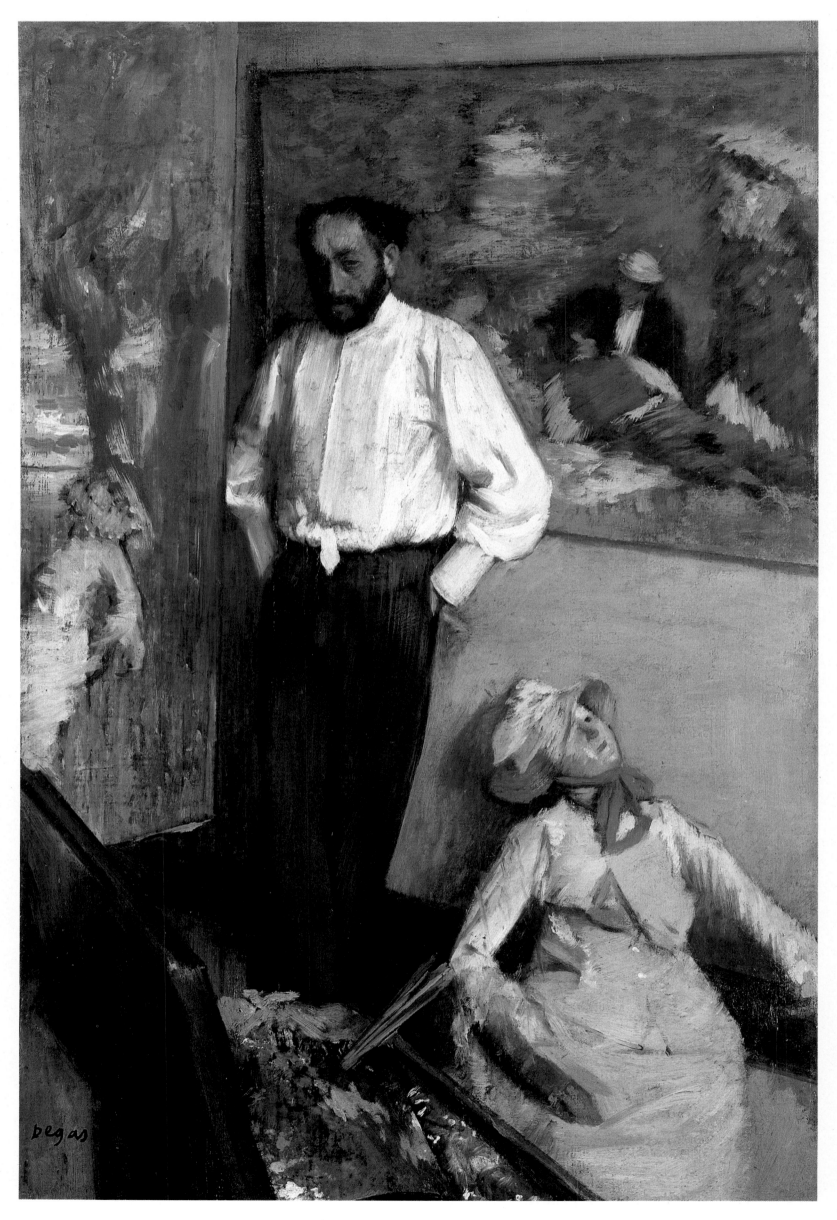

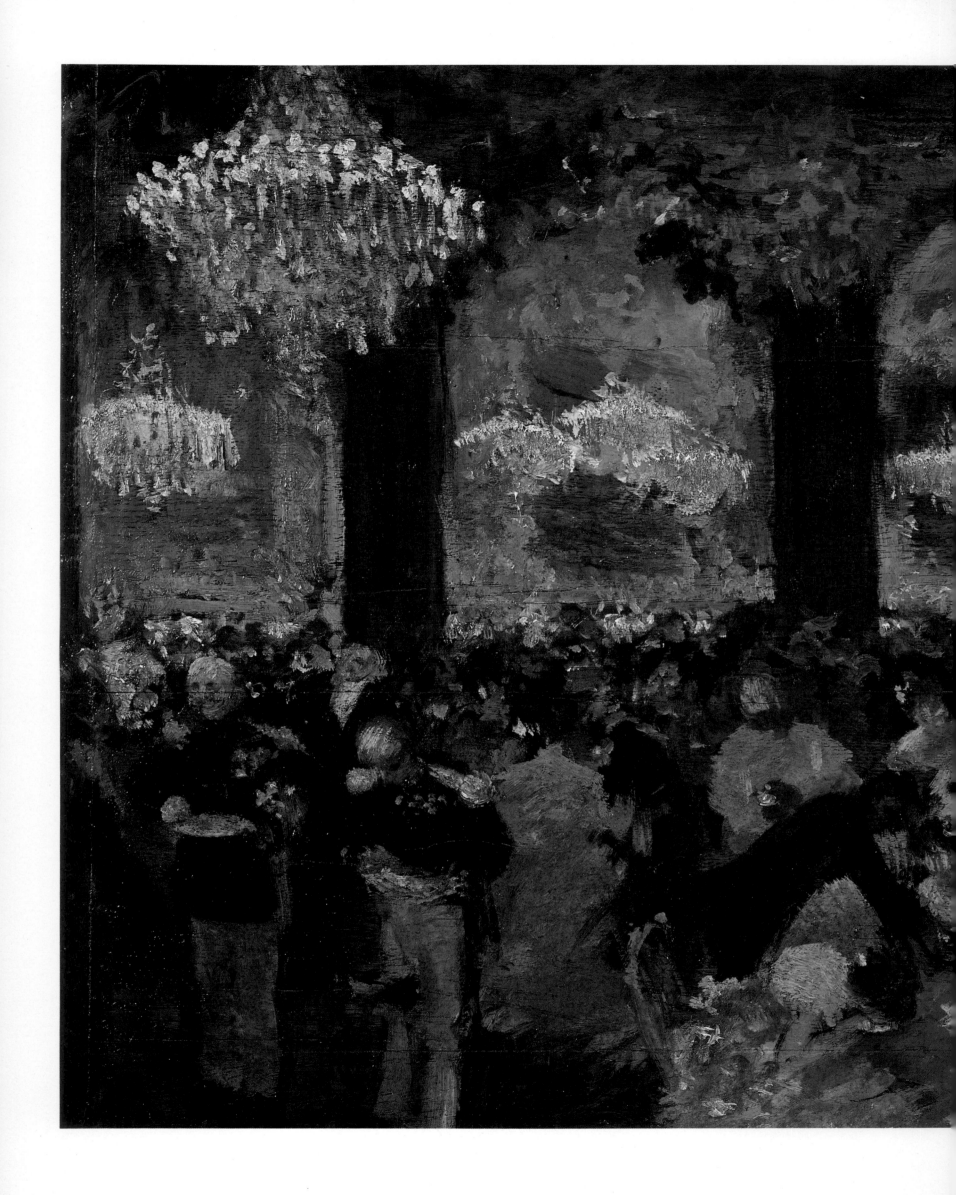

114

Ball at the Prussian Court, 1879

Oil on canvas
18×25¾ inches (45.5×65.5 cm)
Musée des Beaux-Arts, Strasbourg

Degas saw Adolf Menzel's *Balsoper* when it was exhibited in Paris at Goupil's gallery in 1879. This copy is the only fully resolved transcription that he ever made of a picture by a contemporary artist. Menzel, a leading German artist, was probably drawn to Degas's attention by the critic Duranty, who owned some of his drawings including one of a worker's head that Degas subsequently bought for his own collection. Menzel's diverse art embraced historicist paintings and prints of the life of Frederick the Great, Realist interiors, views of industrial steel works and largescale treatments like this of the social life of the Prussian court. During the 1850s he made a series of theater pictures, some in pastel which, although more panoramic than Degas's later Opéra-inspired works, share certain similarities of approach.

Menzel visited Paris in 1855 for the Exposition Universelle, where he saw Courbet's Realist pavilion. When he returned for the 1867 Exposition, time spent at Manet's Realist exhibition inspired his picture *Music in the Tuileries Gardens*, closely based upon Manet's work of the same title. Using a freely handled paint-facture that has similarities with Impressionism, he did a number of rather cluttered scenes of Parisian life. Degas met Menzel on this second visit at the home of his friend Alfred Stevens. It is curious, perhaps simply coincidental, that Degas turned to pastel for the first time in the same year that he met Menzel, and that his theater subjects began around this time too.

Degas told Pissarro that what he admired in Menzel's bustling canvas of supper at a ball was 'the careful study of particular types'. In this copy (possibly from memory) rather than trying to pin down types he deals with the broad scheme of pictorial structure and color organization, and Menzel's precision is translated into a vivid loosely-worked canvas. Degas never again attempted a picture of such a large group of people. His own study of particular types was at its best with closeups of individuals and smaller gatherings of people.

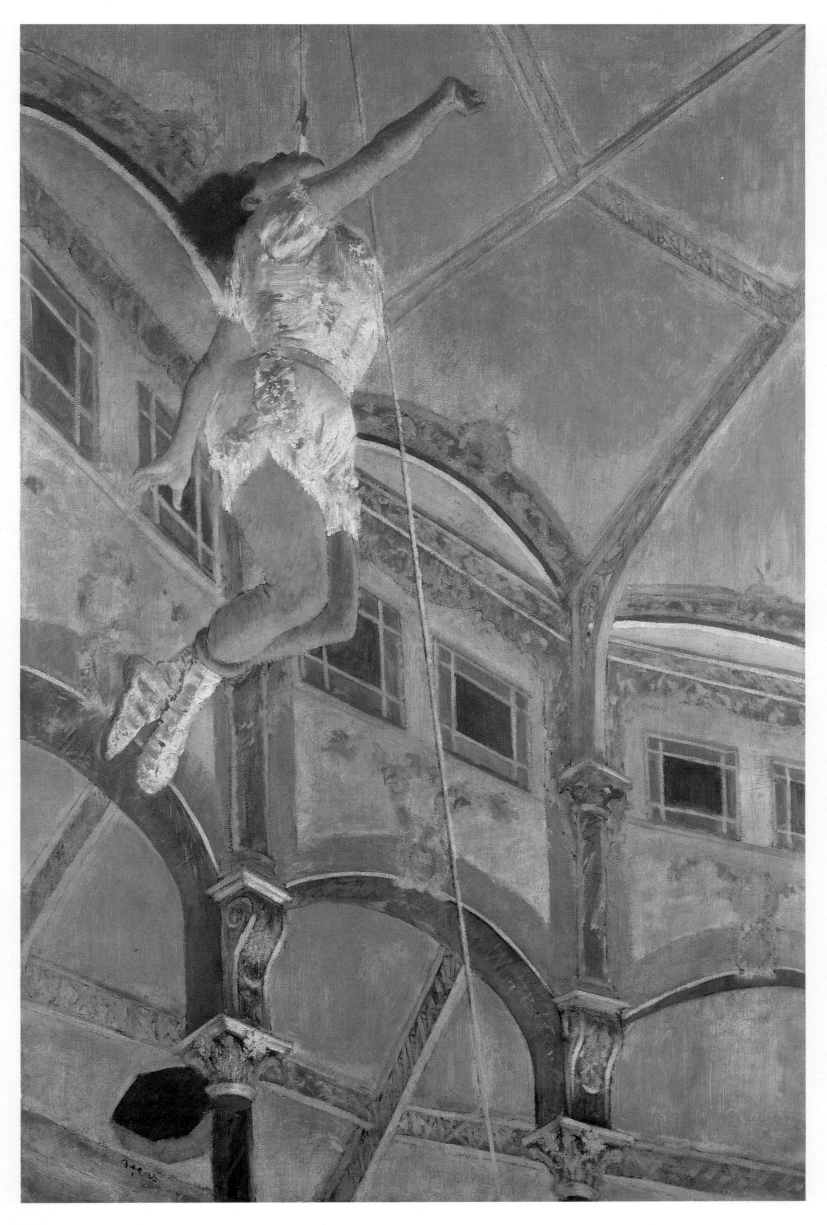

116

Miss La La at the Cirque Fernando, 1879

Oil on canvas
46×30½ inches (116.8×77.5 cm)
National Gallery, London

Miss La La was a mulatto circus artiste who performed extraordinary feats of strength with her teeth. Billed as 'the cannon woman', her most celebrated act was to hold in her teeth, suspended on the end of a chain, a cannon which was then fired. In this picture, Degas shows her in another of her star turns – being hauled by her teeth, on the end of a rope suspended over a pulley, into the roof of the Cirque Fernando, a permanent circus building put up in 1875 on the corner of the rue des Martyrs and the Boulevard Rochechouart. La La appeared there in early 1879 before going on in March to further success in London. Degas went at least four times to see her act and to sketch her at work.

In this, the dizziest picture he ever made, Degas most boldly fractures spatial convention. There is simply no ground to give the spectator an anchoring purchase. As she is hauled further into the green-gridded and orange-panelled roof void, La La stretches her arms and counterbalances with clenched ankles and large boots, to prevent spinning. At the same time this angled extension of her body in two directions away from the vertical of her trunk gives convenient pictorial bulk to her figure, so that she can occupy more of the top right-hand corner of the painting. Like a well-muscled dancer, she is completely in command of the specialized physical skills needed for her work and, quite apart from the appeal of such an act to any imagination, La La must have been irresistible for Degas, with his interest in ballerinas and laundresses.

Diego Martelli, 1879

Oil on canvas
43½×39¾ inches (110×100 cm)
National Gallery of Scotland, Edinburgh

In 1879 Degas painted a group of portraits of male sitters in their working environment which collectively represents his most important statement on Realist portraiture. This portrait of Diego Martelli, the Florentine writer and art critic, is the most adventurous of this fine group.

Martelli was an advocate of Realist values. He wrote the first definitive defence of Impressionist principles in Italian and became known to Degas through a mutual friend, the Italian artist Signorini. They became closer during Martelli's thirteen-month sojourn in Paris in 1878-9. Martelli found Degas witty and talented, but also darkly depressive. Degas was attracted by Martelli's intelligence, and for a short while they were friends.

Degas shows Martelli in his rented Parisian apartment, surrounded by a circle of familiar objects. At about this time Degas wrote in a notebook, 'Include all types of everyday objects positioned in a context to express the *life* of the man or woman'. A well-used meerschaum pipe, an inkwell, a gaudy handkerchief next to what is possibly a fez, a portable scissor chair and a striking pair of boat-like red-lined slippers form an interconnected ring of Martelli's personal possessions, which he probably brought with him from Italy. Degas uses all these and combines them with Martelli's distinctive side-hugging posture to show this large avuncular man absolutely in character.

This painting is the best example of the higher viewpoint that Degas adopted at this period. In order to achieve new perspectives on his subjects, he contemplated building a series of tiers in his studio so that he could look down on figures from above. There is a powerful foreshortening in Martelli's body, particularly in the legs, which the critic Duranty, whose portrait also formed one of this singular 1879 series (page 120), and who was usually appreciative of Degas's work, thought misplaced. Sickert suggested that Degas had chosen this visual angle because so many bad portraits were being done on 'studio thrones', and he likened the bird's-eye viewpoint to the street scenes painted from high balconies by Pissarro and other Impressionists.

The steeply raked floor of Martelli's apartment slopes up toward a large blue sofa, and there is a happy visual congruity between the plump, round writer and this punning piece of furniture. The segmented circular or semi-circular color wall chart behind Martelli's head has not to date been satisfactorily explained.

118

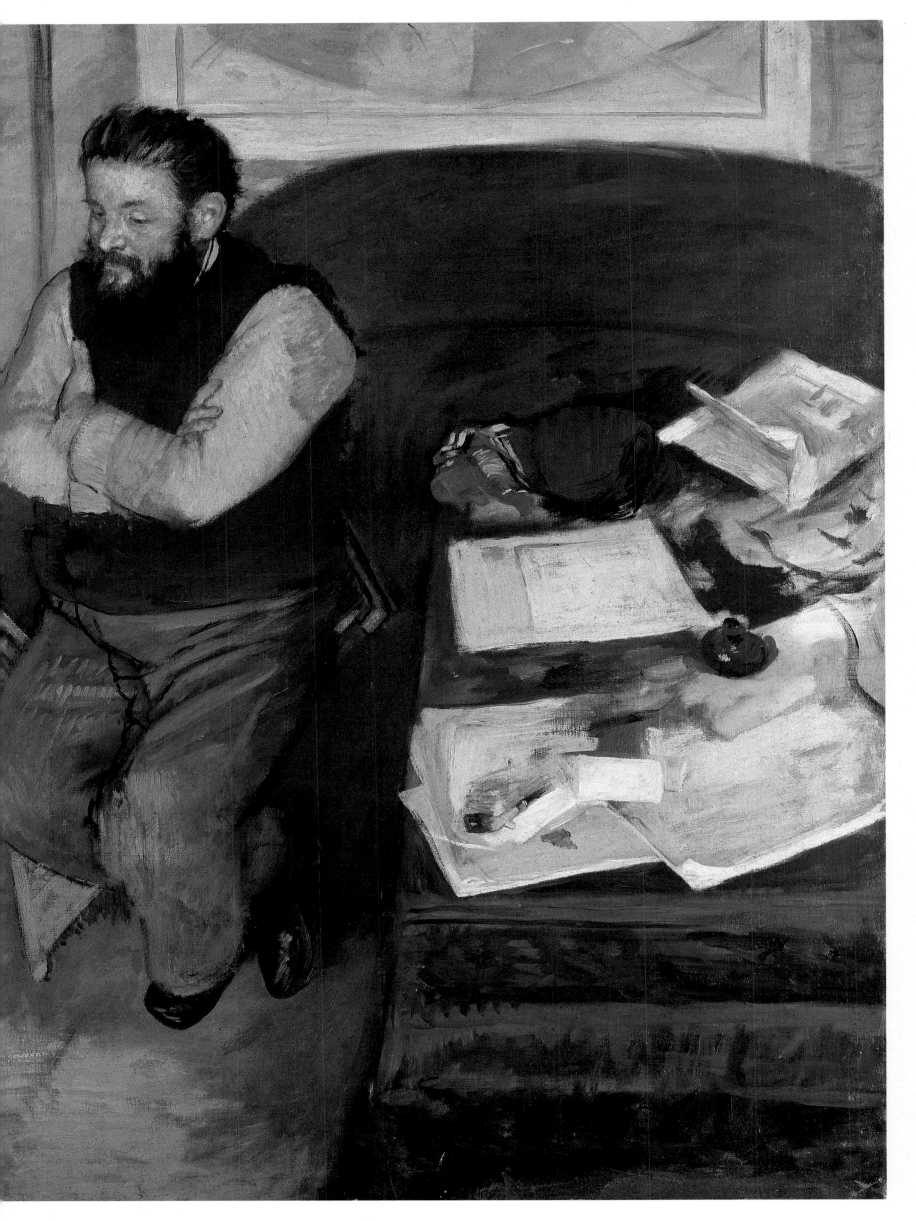

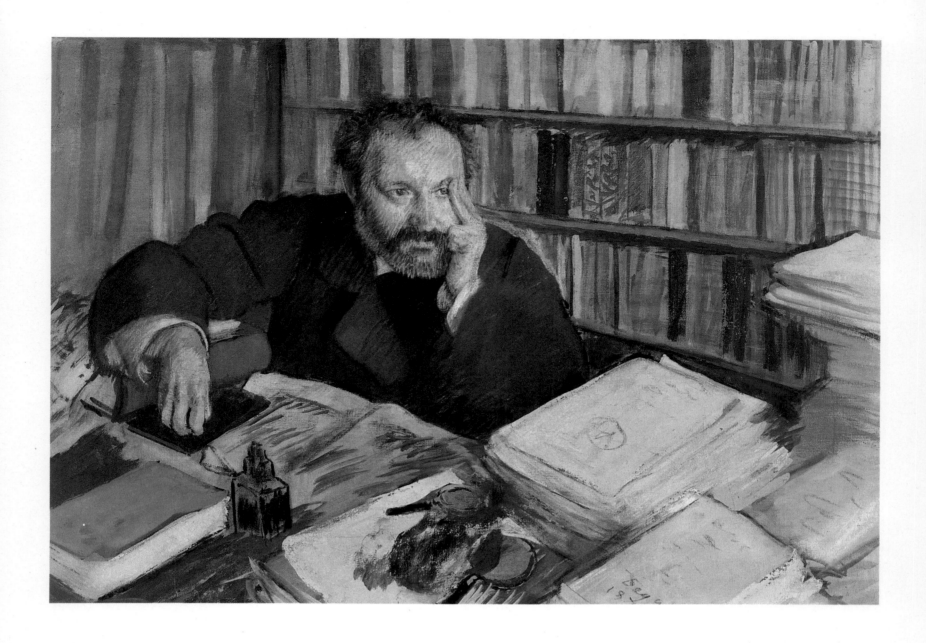

Edmond Duranty, 1879

Distemper and pastel on linen
39⅝×39½ inches (100.9×100.3 cm)
Burrell Collection, Glasgow

The author and journalist Edmond Duranty (1833-80) was a friend of Degas, a strong supporter in print of his work, and an advocate of shared Naturalist principles. He may have modeled for Degas's painting *Sulking* of 1869-71. His pamphlet *The New Painting*, published in 1876, was so enthusiastic about Degas that some believed the artist had dictated it. This portrait, painted in spring 1879 and exhibited at the fourth Impressionist exhibition, was put on show again by Degas at the fifth Impressionist exhibition in 1880, following Duranty's death nine days after the exhibition opened. Both Degas and Zola were executors of Duranty's will; Degas donated three pictures to the estate sale, and persuaded other artists to help financially Duranty's companion, Pauline Bourgeois. Duranty's pose in his study surrounded by his prints and books perfectly sums up the guiding principles of the new painting which he described in his pamphlet:

What we need are the special characteristics of the modern individual – in his clothing, in social situations, at home or in the street. The fundamental idea gains sharpness of focus. This is the joining of torch to pencil, the study of states of mind reflected by physiognomy and clothing. It is the study of the relationship of a man to his home, or the particular influence of his profession on him, as reflected in the gesture he makes; the observation of all aspects of the environment in which he evolves and develops.

The critic Huysman, who wrote extensively about this picture when he saw it at the 1880 exhibition, praised the accuracy of Degas's depiction of Duranty's characteristic gestures:

His slender nervous fingers, his bright mocking eye, his acute searching expression, his wry English humorist's air, his dry joking little laugh – all of it recalled to me by the painting.

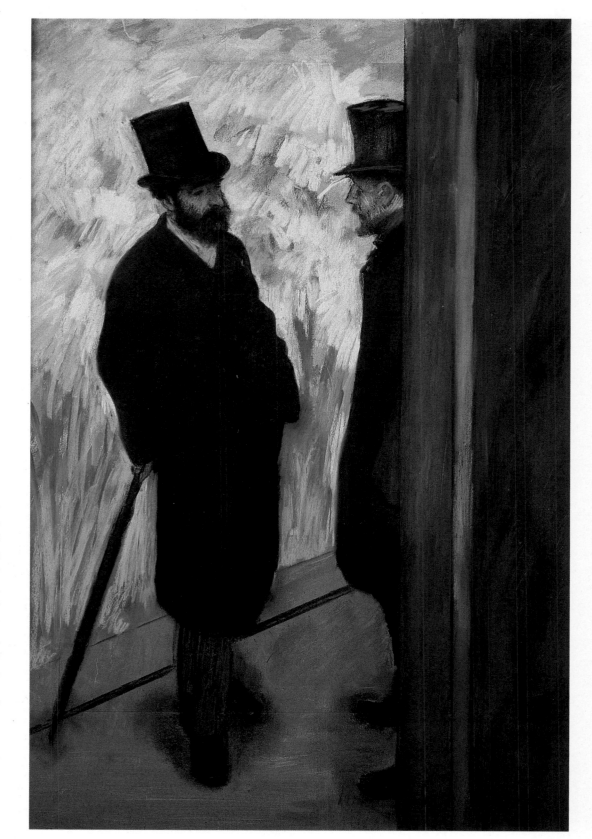

Ludovic Halévy and Albert Cave,
1879

Pastel on paper
31⅛×21⅝ inches (79×55 cm)
Musée d'Orsay, Paris

Ludovic Halévy (1834-1908) was at school with Degas, and combined a career as a successful civil servant with writing. His work included librettos for Offenbach, the libretto for Bizet's *Carmen* and a popular series of short stories about the Cardinal family – a rather seedy mother and father whose two daughters, Virginie and Pauline, were dancers at the Opéra. Inspired by these stories, Degas made over 30 monotypes showing backstage life with the flighty Cardinal girls, their predatory admirers and the formidable bulk of Madame Cardinal. Halévy's bearded features appeared in many of the prints, cast in the role of narrator, and the idea for this painting may have grown out of the print series.

When this picture was shown at the fourth Impressionist exhibition in 1879, Ludovic Halévy wrote in his diary that Degas had deliberately shown him looking rather pompous in a frivolous context. Halévy had retired as a civil servant in 1874. His companion, Albert Cave, however, was still a senior civil servant in the Ministry of the Interior. Both men wear the formal day clothes associated with government office, each with the red ribbon or pin of the Légion d'Honneur in his buttonhole – two tiny little red accents of color in their dark clothing. Degas's often expressed contempt for this government honor suggests why he may be gently poking fun at his two friends. He once told Vollard that when Mallarmé had come to him to see if he would accept the Légion d'Honneur, 'If it had not been for the table between us I don't think I should have let him get out of the house alive'.

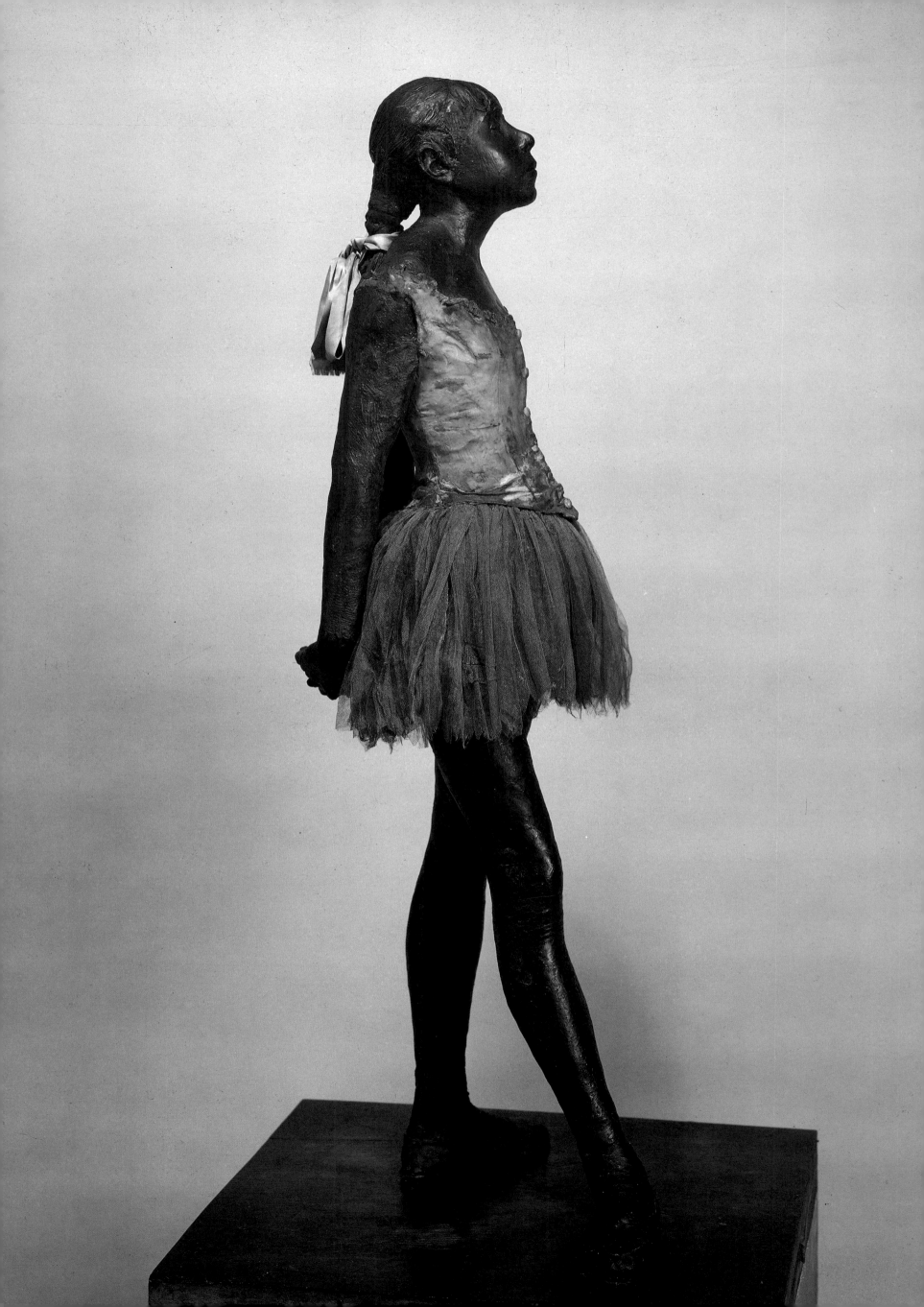

The Little Fourteen-Year-Old Dancer, 1880

Yellow wax
Height 39 inches
Collection of Mr & Mrs Paul Mellon,
Upperville, Virginia

'At one blow, M. Degas has overturned the tradition of sculpture just as before he has been upsetting the conventions of painting', wrote Karl Huysman in response to seeing this work at the 1881 Impressionist exhibition. The was the only sculpture that Degas exhibited publicly during his lifetime. The shocking realism of a two-thirds lifesize flesh-tinted wax figure, dressed in a linen bodice and a gauze tutu and with a head of genuine hair, caused confusion, some horror and considerable praise. Even allowing for partisan exaggeration, the statue was clearly seen by critics as being without precedent.

The model, Maria van Goethem, was one of three sisters who were ballet students. Her father was a tailor, her mother a laundress, and she made her debut at the Opéra in 1886. During 1878-9, Degas made at least 16 studies of her in charcoal, chalk and pastel, and a smaller nude wax version was modeled prior to this fully clothed figure.

The tone of critical comment displays a curiously recurrent equation of realism with depravity. Granted that there is a precociousness and an ambivalent sexuality about the pouting little girl, this scarcely seems to justify the remarks of Paul Mantz that she has 'the instinctive ugliness of a face on which all the vices depict their detestable promise', or the comment by Jules Claretie that she had a 'vicious muzzle'.

Degas's inspiration for the sculpture has been variously ascribed to waxworks (like Madame Tussaud's), earlier polychromatic sculpture, both Renaissance and seventeenth-century, and the fact that discussions about the appropriateness of wax for obtaining a closer approximation to reality were very much 'in the air' among artists and connoisseurs known to Degas.

Why Degas chose Maria van Goethem as his model is not clear, but her features are distinctive, her body angular and awkward, and her hair apparently exquisite. She is as much the un-idealized product of a poor Parisian background as the boys and girls in the painting of *Young Spartans* (page 36), a picture started earlier but worked on by Degas until 1880. Both this young dancer and *Young Spartans* were intended for showing at the 1880 Impressionist exhibition, but neither were actually shown. The statue was held over until the following year, and the painting was never exhibited. Degas's intentions in such co-exhibiting, or what critics may have made of them, are two of the more interesting speculations surrounding his exhibited work.

Degas may have worked further on the statue in 1903, when Mary Cassatt tried unsuccessfully to persuade him to sell it to her friend Louisine Havermeyer. Over twenty bronze versions of the statue were cast in 1921.

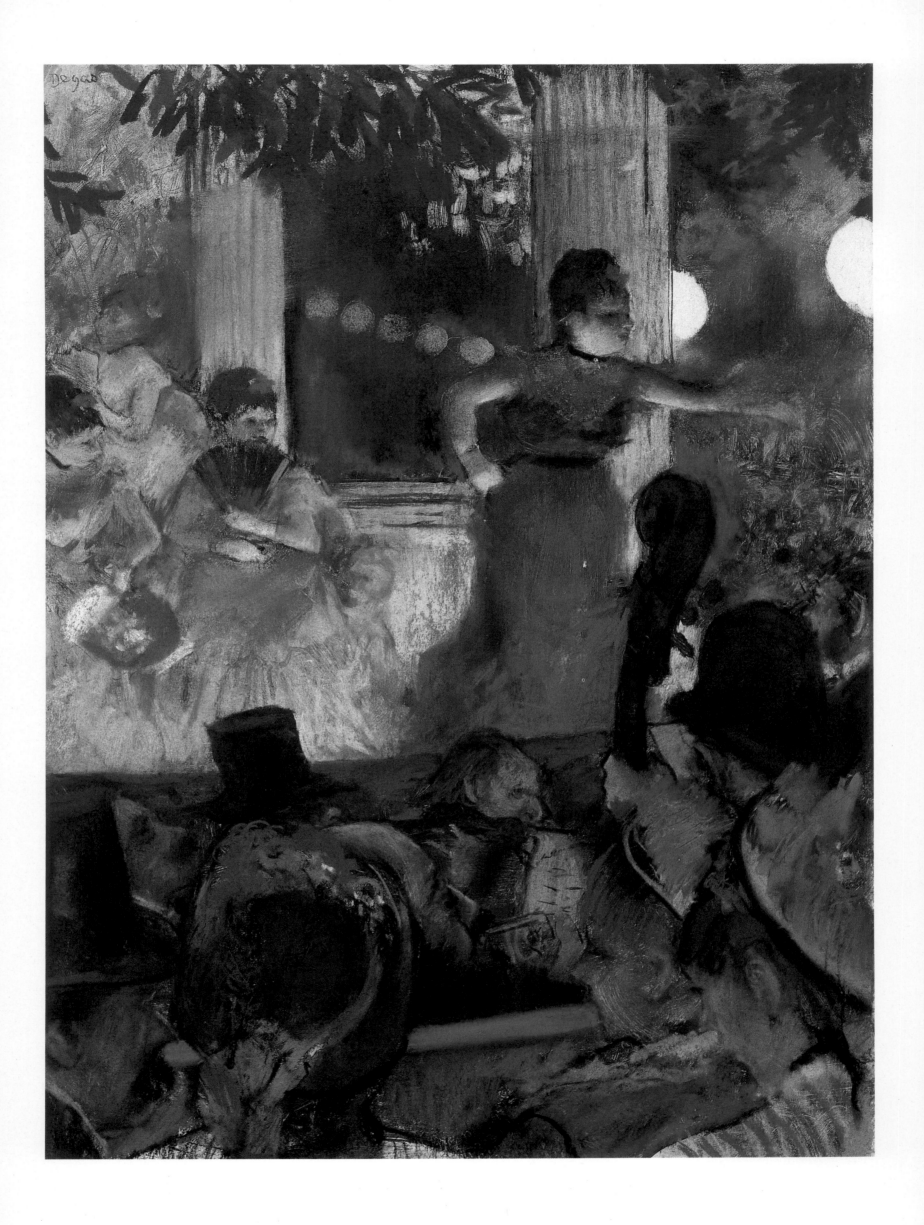

Café Concert at the Ambassadeurs, c.1875-7

Pastel over monotype
14½×10⅝ inches (37×27 cm)
Musée des Beaux Arts, Lyon

Café concerts were held on warm summer Parisian evenings in outside bandstands. The Ambassadeurs was one of the most successful and was set in a kiosk under the trees of the Champs Elysées. The audience could sit, drink, stroll past, stand without charge, and take in the spectacle of up-to-the-minute comedy on newsworthy events and heart-on-sleeve sentimental ballads. Vulgar songs were sometimes so *risqué* that they attracted the attention of the public censors. Maurice Chevalier was perhaps the greatest product of the '*caf-con*'.

Degas's brother René wrote in mock-despair to his wife in 1872 that Degas had forced him to go to a performance in the Champs Elysées which included 'songs by idiots, such as the song of the journeyman bricklayer'. Aimed principally at working class male and female audiences, the concerts were also stalking grounds for single male middle-class *boulevardiers* in search of cheap after-dinner entertainment.

Degas uses the format and viewpoint of his earlier *The Orchestra of the Opéra* (page 62), with the neck of a double bass protruding from the orchestra pit in front of the performers, and a view of the stage from the first few rows. Indeed if it were not for the branches of chestnut leaves and the gas lamp orbs receding down the street like a string of chinese lanterns, one could be forgiven for thinking that this scene was set indoors – not in the Opéra, for the clothes of both the audience and the singers are too vulgar, but possibly in a music hall.

Degas began experimenting with café concert subjects in 1876, making black and white monotype prints to explore the dramatic nocturnal effects of illumination where streetlight and stagelight blend. In this picture, which is done over a monotype base, he worked up his colors in pastel, making special use of the focusing power of red – in the lead singer's ample dress, the small head bows of her fellow singers awaiting their turn, and small touches in the fussy decoration of the hats of the two foreground women. Just as in *The Dance Class* of 1871 (page 90), where he used subtle red accents to provide formal unity between dancers, the same device is here used more flamboyantly and emphatically to link the group of singers with their audience.

Uncle and Niece, c. 1876-77

Oil on canvas
39¼×47¼ inches (99.8×119.9 cm)
Art Institute of Chicago

The little nine-year-old girl leaning on the back of her uncle's chair is Degas's Italian cousin Lucie, the orphaned daughter of Edouard Degas who died when she was aged three, predeceased only nine months earlier by his wife. Lucie was brought up first by her uncle Achille Degas and then, following his death, by Henri Degas the man shown here reading a newspaper and holding a cigar. He too died just three years after Degas painted this portrait, leaving Lucie to be handed on to more relatives.

All these family deaths, coupled with the idea of a young girl being brought up by aged bachelor uncles, compounded by the look on Lucie's face and the dark tonality of paint, have led some to extract a psychological reading from this picture that places strong emphasis on the sadness of

Lucie and her distance from her uncle. In Degas's earlier family portrait of the Bellellis (page 30), the tensions and distance between the individuals are quite starkly evident in pose and facial expression, but such conflict seems less obvious here and the relationship between the sitters that Degas shows suggests a couple interrupted in intimate conversation by the painter's sudden entry into the room. Indeed it is among the least formal of Degas's Italian family portraits.

Attendance at funerals and the need to untangle his father's estate took Degas to Naples at least three times between 1873 and 1876 and the sittings for this picture probably took place in June 1876, perhaps in the Palazzo Degas. The black clothes of both sitters are probably connected with mourning. This picture was presumably given by the artist to Henri Degas who left it, together with his entire estate, to Lucie and she in turn bequeathed it to her daughter who later sold it.

126

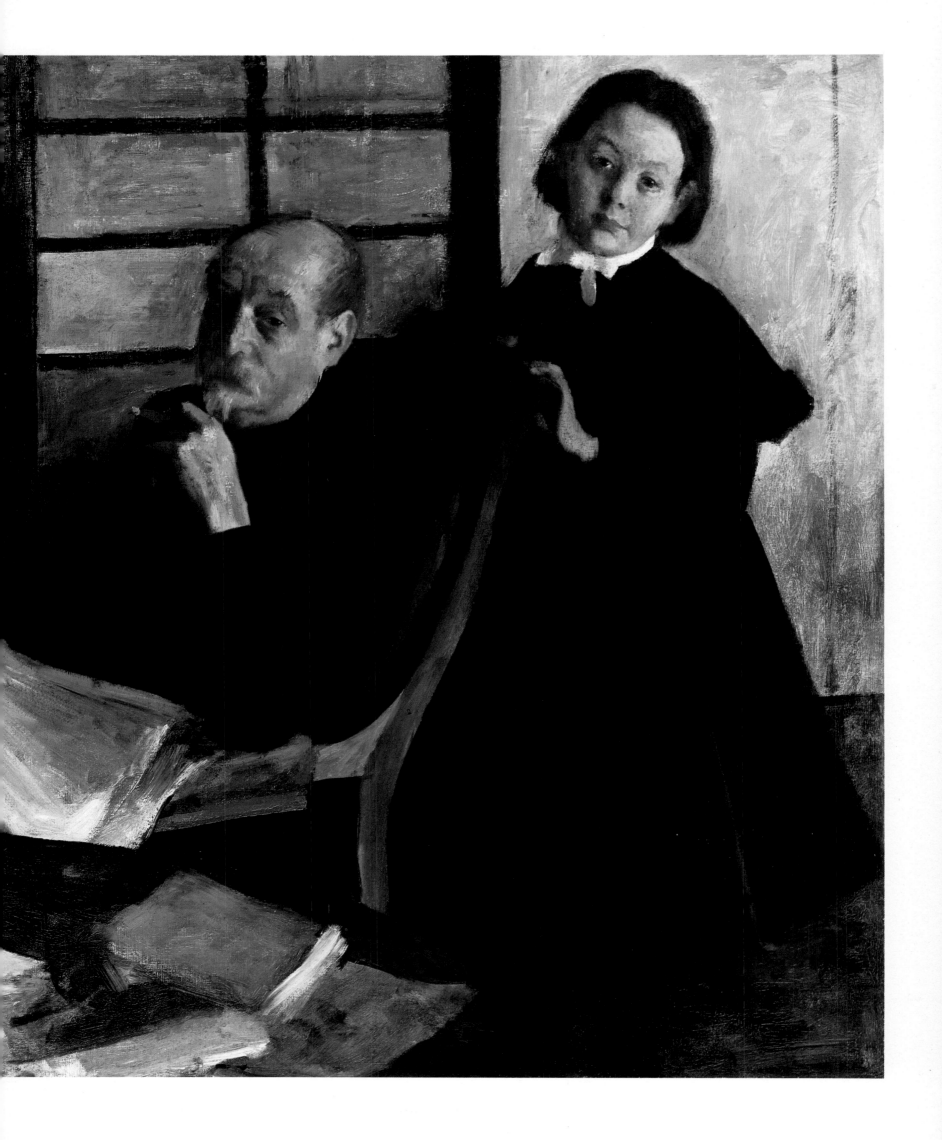

Singer with a Glove, c.1878
Pastel and liquid medium on canvas
21×16¼ inches (53×41 cm)
Harvard University Art Museum,
Cambridge, Massachusetts

With a viewpoint scarcely eighteen inches from the singer's bosom, this shockingly direct close-up is one of a group of images in Degas's *oeuvre* that raises questions about his connexions with photography. Nowadays we could accept that a night shot with fast exposure using high-speed film and a zoom lens could approximate the seized instantaneity of this scene. In the late nineteenth century, this image could only have been captured photographically in a studio using strong lighting and with the pose artificially held. Degas, seizing such glimpses at night, was technically superior to contemporary photographic possibilities, and at the same time disconcertingly close to what have become the conventions of photographic and cinematic art in the twentieth century. 'Pans', 'tilts' and 'close-ups' were investigated by Degas in seeking to approximate our ocular experience long before they were 'invented' for film.

The French magazine *Le Charivari*, which regularly skitted the Impressionist exhibitions, reproduced a small cartoon of this picture in April 1879, with the caption 'special sale at 7 francs 50 a pair! Eight buttons! (an excellent sign for the glove-seller!)' Ironically the picture remains impervious to such teasing, since it is not inconceivable that the comic song of the *chantreuse* might include such self-deprecating lyrics.

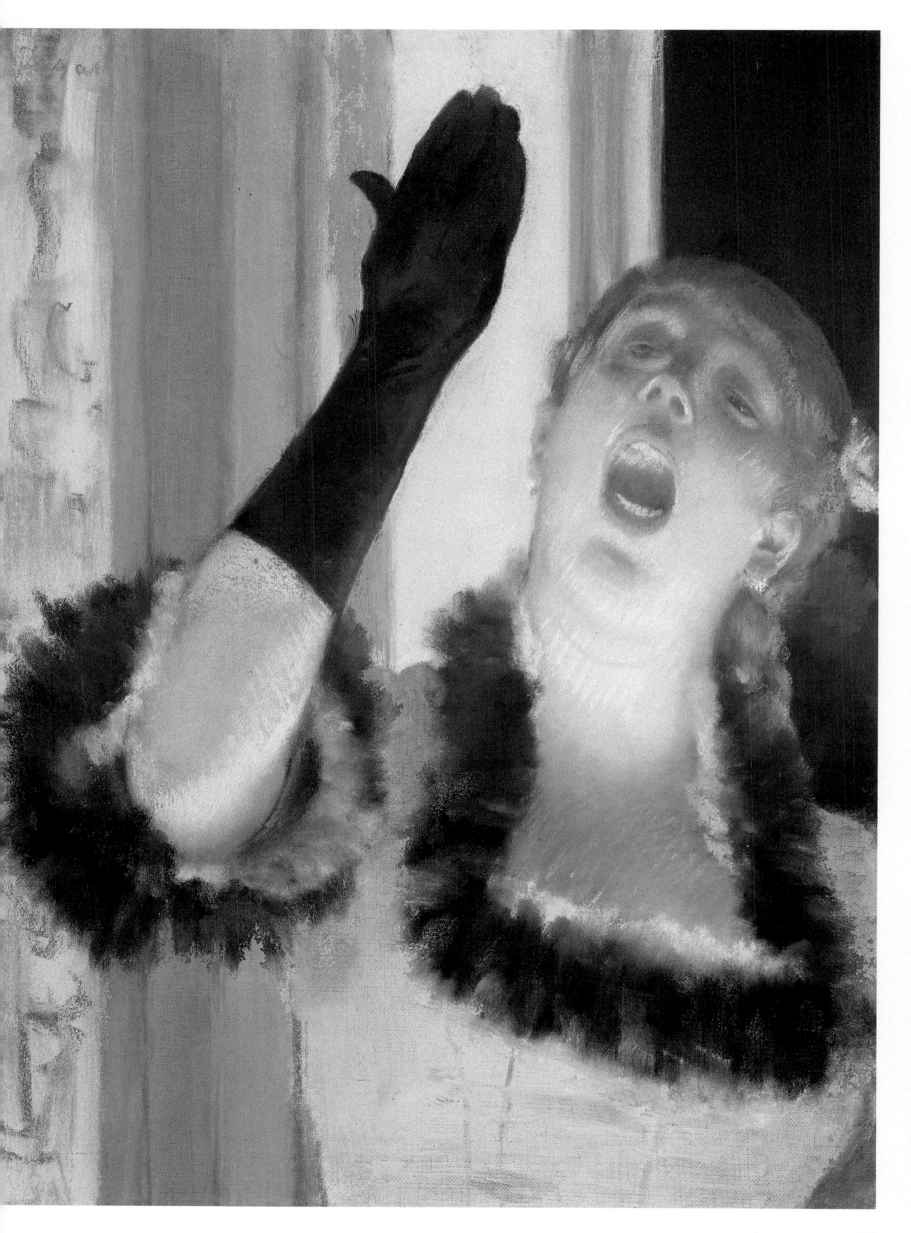

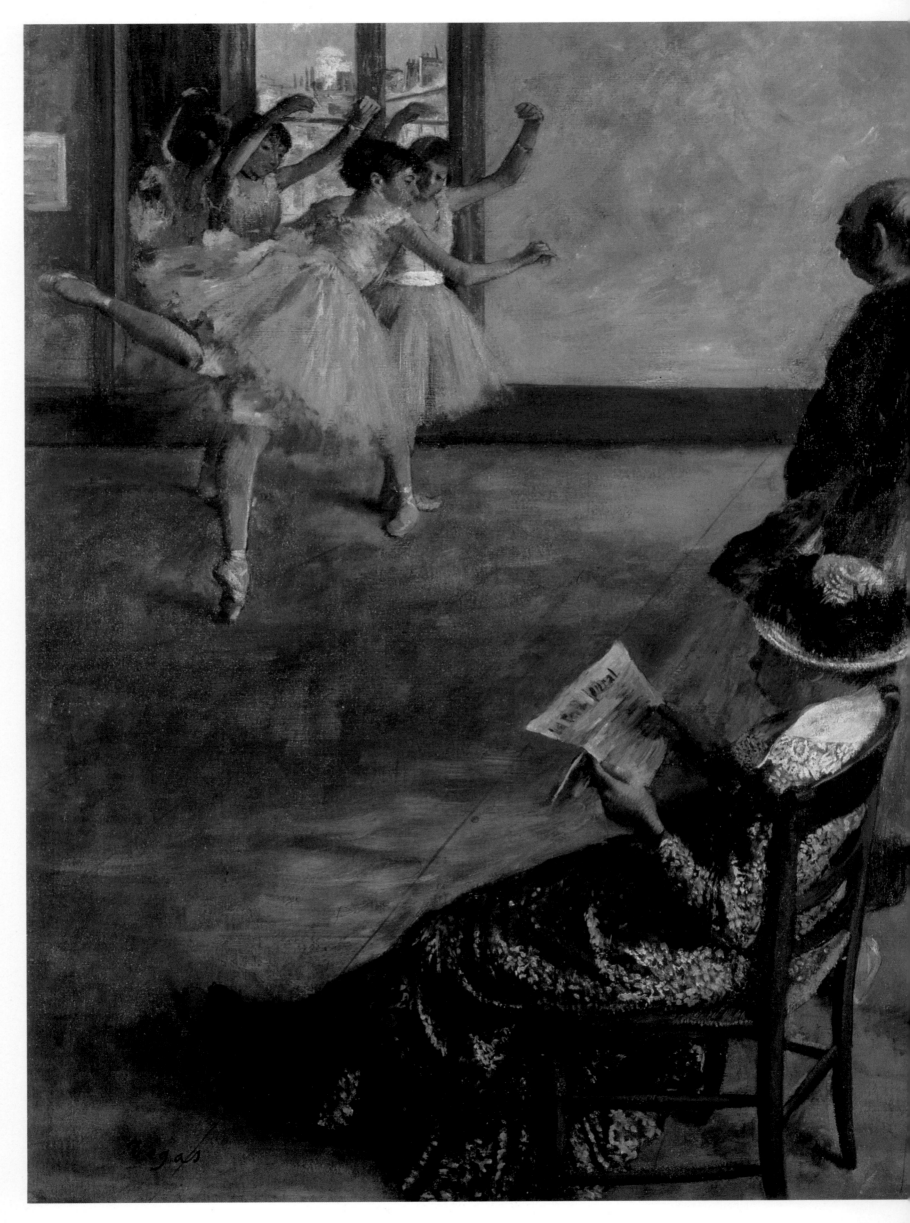

The Ballet Class, 1878-80

Oil on canvas
32⅛×30⅛ inches (81.6×76.5 cm)
Museum of Art, Philadelphia

This is one of Degas's wittiest dance paintings, depicting the younger dancers – the *petit rats* of the Opéra – going through their warm-ups rather less elegantly than their elders. The puff-checked foreground woman engrossed in her newspaper is completely indifferent to their endeavors, while in contrast the ballet master or supervisor scrutinizes their young efforts with an eagle eye. Degas sets up a delightful tension between these three foci in the painting.

Nester Roqueplan, writing in 1885 in *Les Coulisses de l'Opéra*, described the *rat* as a child of the Opéra building, who nibbles, chatters, and plays; she is:

A little girl between six and fourteen, a ballet pupil who wears cast-off shoes, faded shawls and soot-coloured hats, who warms herself over smoking oil lamps, has bread sticking out of her pockets, and begs you for ten *sous* to buy sweets.

The *petit rats* were drawn from the working class and lower middle class ranks of Parisian society. Mlle Fiocre, whom Degas painted in 1868 as the star of *La Source*, was a *rat* made good. Her father was a tradesman and she followed the painful path as a *petit rat* to the first great goal when, aged ten and having shown promise, she, like others, was paid a salary of 900 francs a year and could continue the slow progress up the ladder to the chorus and beyond.

Degas's original organization of this canvas had a ballet dancer on a chair rather than the almost caricatured woman in blue. The painting was destined for Mary Cassatt's brother in Philadelphia, and Degas substantially reworked it to obtain a satisfactory equipoise. It was months overdue in delivery but he would not cease his refining and alterations. Somewhat improbably, but apparently accurately, Mary Cassatt later wrote that the model for the foreground woman was the same as that for the statue of *The Little Fourteen-Year-Old Dancer*, Maria van Goethem.

Dancer with a Bouquet, c.1880

Pastel over monotype
15⅞×19⅞ inches (40.3×50.5 cm)
Museum of Art, Rhode Island School of
Design, Providence

It is usually men who watch women in Degas's Opéra pictures, and in this work what at first appears to be a woman watching a dancer is in fact a woman watching men watching. Seated in her box, she peers over the top of her fan down at the stalls, detachedly distant from the applause for the prima ballerina. In the contrast between the proud preening electric-lit star and the half-shadowed observer, a conflict is hinted at: the conflict of modesty versus brashness, the opposition between public women and private ladies, and the unclapping passivity of a middle-class woman unable to let herself go in a public place. Degas made other pasteled variations on this theme with a woman holding but not using opera glasses – in each case the emphatic stillness of the female in the foreground contrasting with the fluttering bustle of the stage dancers. In each case the foreground is large and the woman cropped and set to one side, leaving enough space for the viewer looking over her shoulder at the stage to feel that they, too, inhabit this box at the Opéra.

In several ballet scenes including *The Star* (page 100), to which this picture is related, Degas sets up a powerful visual contrast by using a black-suited male figure lurking in the wings as a foil to the luminosity of stage-lit ballerinas. Employing a similar formula now spatially reversed, Degas places a giant black fan in the front of the picture, thus amplifying further the dramatic leap from foreground to background which is the most striking characteristic of this work and gives it such convincing immediacy. The dance that has just finished may be a virtuoso section of a full-length ballet or one of the short dance interludes that often punctuated operatic performances during this time at the Opéra.

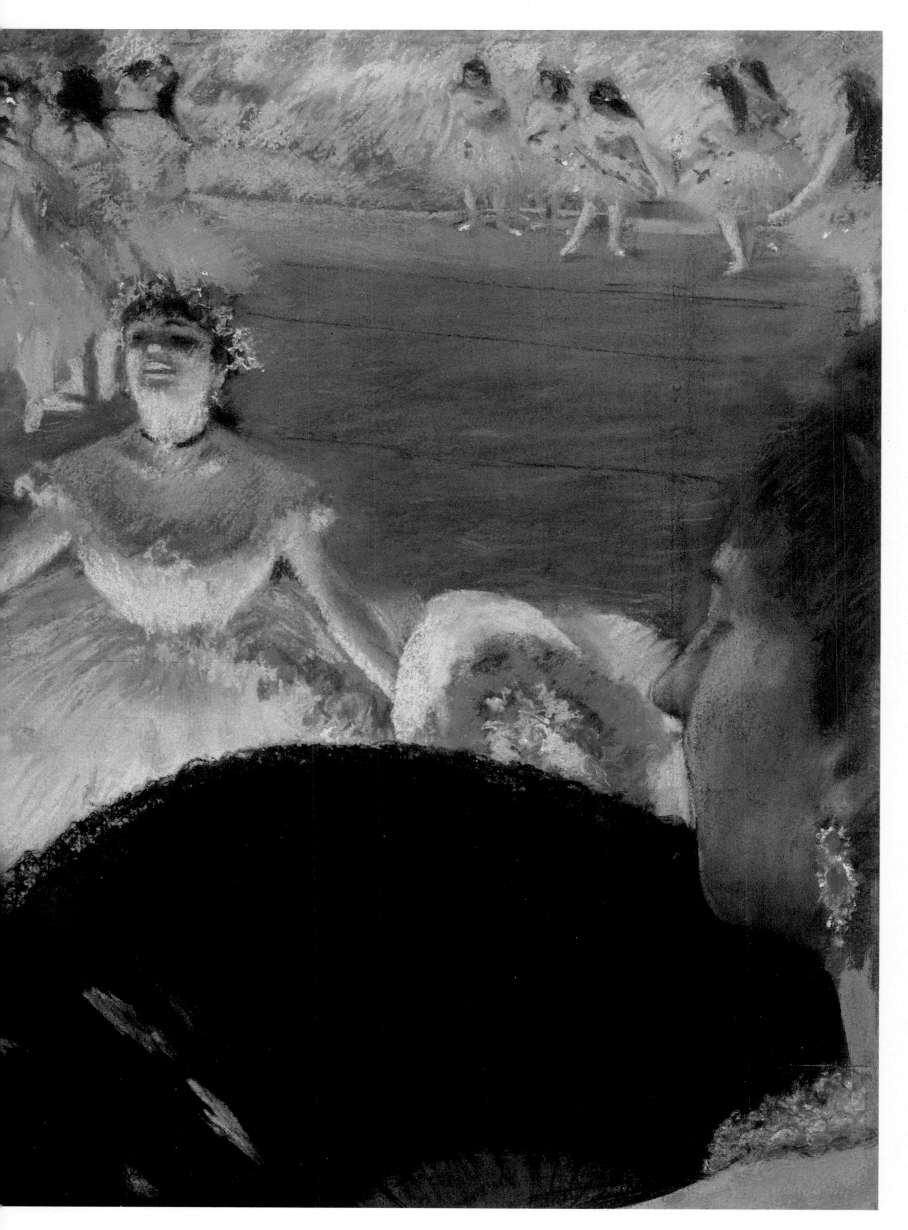

Fan: The Café Concert Singer
1880
Watercolor and gouache on silk mounted
on cardboard
12⅛×23⅞ inches (30.7×60.7 cm)
Staatlichen Kunsthalle, Karlsruhe

Fans appeared regularly as stock oriental
props in Japanese-inspired paintings by
Whistler, Tissot and Degas from the
mid-1860s onwards. Japanese fans could
be bought in Paris and also available
among the large quantity of near-contem-
porary and run-of-the-mill Japanese prints
were several fan print, oval, wedge-shaped
and semicircular, but uncut from their
rectangular sheets of paper. It may have
been these that inspired the notion of fan
designs as independent works of art,
whether or not they were ever made up for
practical use. When Degas exhibited some
of his fans at the fourth Impressionist ex-
hibition in 1879, he showed them with a
surrounding rectangular card mount
framed up and glazed. In total he made 25
fans and tried for the 1879 exhibition to
have on show a room full of fans designed
by various Impressionists.

Degas's own fans are mostly on the
theme of the dance – on stage, in the
heavens or in ambiguous contexts. The
semicircular fan format was less amenable
to strong gridded horizontal and vertical
organization, and Degas loosened up his
paint handling and let his fingers and set-
tings move more freely, exploiting the half-
vortex of the fan shape to suggest the swir-
ling flow of movement itself.

In this fan, the red-dressed singer, con-
spicuous foliage and line of gaslit globes
are all motifs taken from the *Café Concert
at the Ambassadeurs* (page 124) of a few
years earlier. Rather than any hand-on-hip
bellowing out of song to a crowd, however,
this woman lifts her hem as though about
to dance off dreamily into the amorphous
void of the stained silk foliage. Michael
Pantazzi has suggested that she may be
Mlle Becat, whose distinctive jerky danc-
ing while singing lyrics famous for their
grossly lewd suggestiveness, caused her to
be dubbed the originator of '*le style épilep-
tique*', and to be censored by the authori-
ties.

Woman Ironing, 1882
Oil on canvas
32×26 inches (81.3×66 cm)
National Gallery of Art, Washington

Degas sent five of his new laundress sub-
jects to the second Impressionist exhibi-
tion of 1876, including an earlier version of
this image. This reworked treatment is the
most elegant of his laundresses and was
painted for the singer Faure, who also
owned a version of the Paris *Women Iron-
ing* (page 141) that is approximately the
same size. As a pair they contrast sharply –
this woman irons gently and rather gra-
ciously without any of the sweating ex-
ertion evident in the companion work.

The same detailed scrutiny that Degas
devoted to his dancers is evident in the en-
tire laundress series. From about 1869
onward he studied their work, recording
the distinct vocabulary of ironing. He was
as interested in the precise sweeps and
strokes, the application of pressure on
cloth and the various sizes of iron, as he
was in the subtleties of a ballerina's dance
steps. Intruding again as an unobserved
spectator into a specialist world occupied
almost entirely by women, he offers
glimpses of figures, usually set against the
bright light of glazed doors, as though seen
through a shop window.

In this painting Degas concentrates on a
color play with the three primaries, red,
yellow and blue, within a contrasting white
and muddy-dark defining structure, using
color variables similar to certain earlier
racecourse pictures, such as *Racehorses
before the Stands* (page 52), but substitut-
ing blouses for the silks of the jockeys.

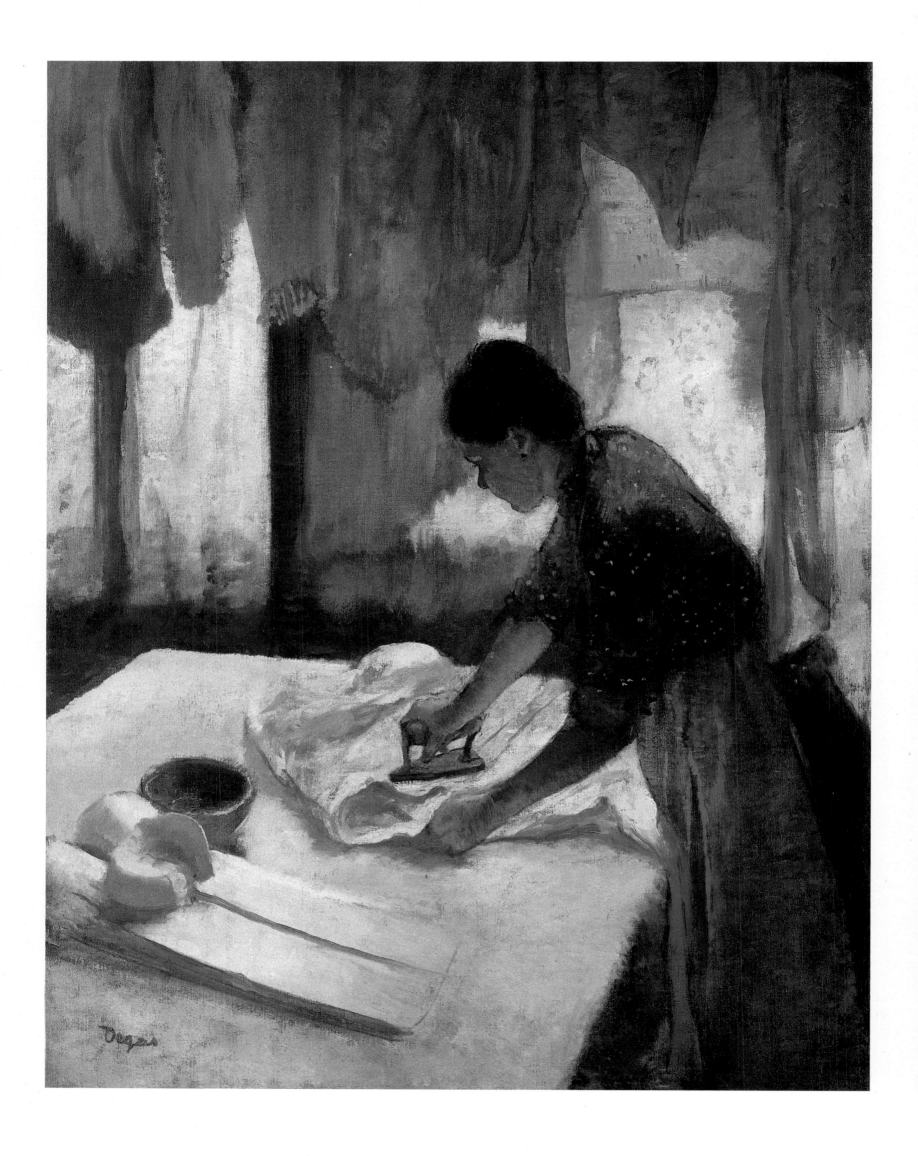

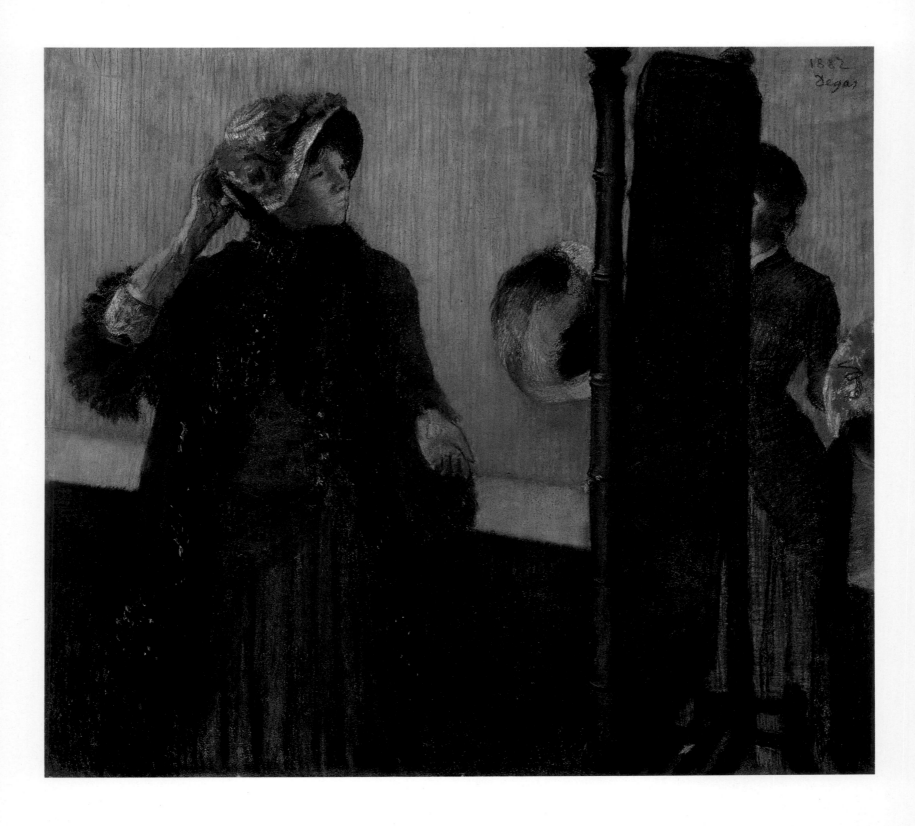

At The Milliners, 1882

Pastel on paper
29¾×33¾ inches (75.6×85.7 cm)
Metropolitan Museum of Art, New York

Bourgeois women in Degas's pictures inhabit the semi-public realm of their own salons or the privacy of family drawing room or study. Shown passively seated or standing before mirrors, occasionally playing a musical instrument or leaning back to have their hair combed, they contrast with the working class dancers, singers, laundresses and prostitutes – women who move. Only his New Orleans cousins, vigorously rehearsing a song (page 82), show the least hint of middle-class female perspiration.

The exceptions to this general female domestic stasis are the pictures of Mary Cassatt at the Louvre and the 1882-6 milliner pictures, which Mary Cassatt also posed for. They are the only works by Degas showing a woman of his own class in an overcoat, dressed for outdoor action, even if only choosing a hat or scrutinizing sculpture. One reviewer of this picture, when it was shown in Glasgow in 1912, felt

it worth noting that it showed an 'energetic' woman who actually tried on the hats in the shop herself!

Degas's powers of observation were legendary and he knew the truth of a gesture. Cassatt, when asked if she posed for him, often said she only did so occasionally when Degas found the movement difficult or the model could not seem to get the idea; he needed someone who regularly bought hats to re-enact trying one on.

Much heavy weather has been made of class divisions in this picture – Cassatt confident, absorbed, studying her own appearance, the *modiste* deferential, cut in half by the glass like a human hatstand. It is hard to find gravity in this warm light-hearted series, in which Degas insinuates himself into yet another area of women's life. He is only very gently mocking, and Cassatt is as likely to turn to the assistant for an opinion and expect democratic honesty as to treat her as a drudge.

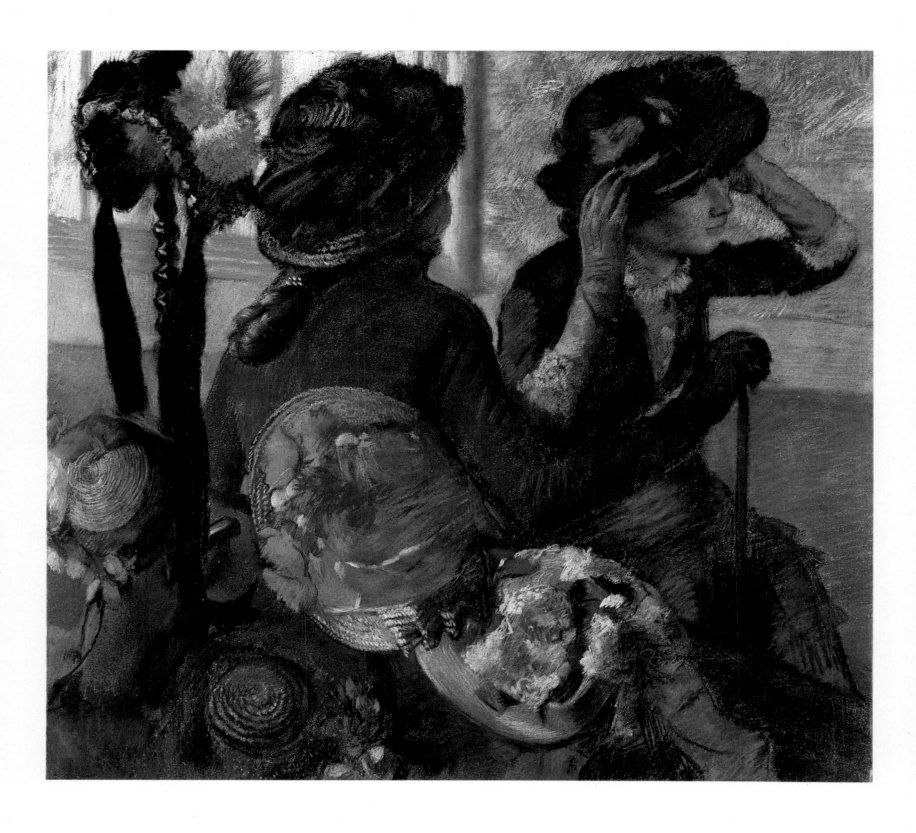

At The Milliners, 1882
Pastel on paper
29⅞×33⅜ inches (75.9×84.8 cm)
Thyssen-Bornemisza Collection, Lugano

Looking down through a gorgeous display of silks, feathers, satin and straw in a milliner's shop window, toward two fashionable young women trying on hats, is the unusual viewpoint adopted by Degas for this picture. Along with his earlier portrait of Madame Valpinçon with a bunch of flowers (page 46), this is one of the few occasions when Degas made still life such a prominent feature.

Mary Cassatt, who took Degas on shopping expeditions with her, may have modeled for these two women. The back of the left-hand figure has broad affinities with the back view of Cassatt leaning on an umbrella in one of Degas's standing portraits of her in the Louvre. Edmond Duranty, in his 1874 pamphlet on Realism, suggested that 'by means of a back' an individual's social standing could be quickly

isolated. Degas, who was particularly attracted by Cassatt's elegance, focused on more than one occasion on the poise and swagger communicated by her shoulders.

There may well be some private discourse between Degas and Cassatt within this picture and the milliner pictures generally (similar to that implied in certain of his pictures of artists in their studio). Cassatt's self-portrait in the Metropolitan Museum, New York, shows her leaning sideways in a pose that Degas used for at least three milliner pictures, and she wears in her own portrait a bonnet with a long bow tie very similar to that on the left-hand hatstand. Degas may be gently teasing her that only after working through the entire selection of circular decorated straw hats will she settle on the one that is most characteristic of her usual taste.

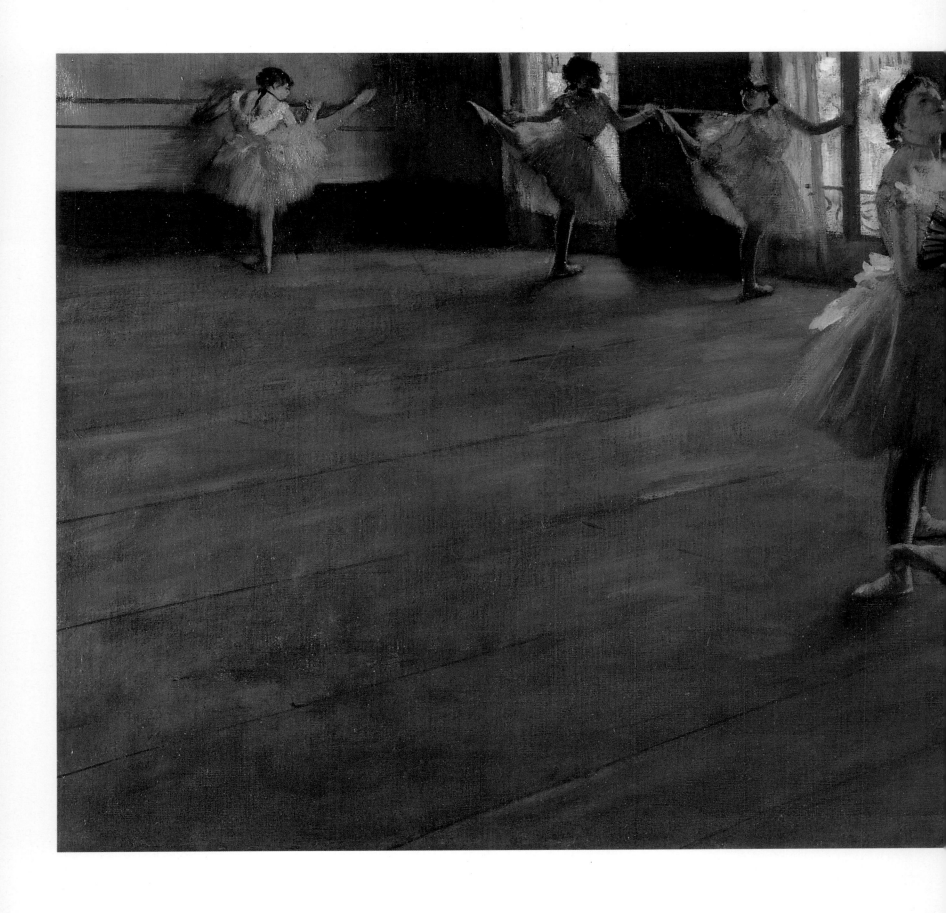

The Dancing Lesson, 1883-5

Oil on canvas
15½×34¾ inches (39.4×88.4 cm)
Stirling and Francine Clark Art Institute,
Williamstown, Massachusetts

This picture is one of the finest examples of a group of about 40 frieze-like pastels and canvases, all roughly similar in proportion, made by Degas between about 1878 and 1895. Several adopt the spatial formula of a wide empty floor raking up toward the corner of a room, one side of which is lit by narrow windows, and with the room depth emphasized by a leap in scale from a group of larger ballerinas in the foreground, seated resting or adjusting their clothing, to a group of smaller figures on the back walls, who are practising at the barre. In-

sofar as there is a distinct theme in these works, it is the contrast between the exhaustion, in some cases near-collapse, of the foreground dancers, and the busy activity of those at the barre. Poses are repeated in several of the group and also in Degas's more traditionally shaped rectangular ballet pictures. The seated dancer tying her stocking and the dancer holding a fan are connected with the multiple series of drawings that Degas made for the statue of the little fourteen-year-old dancer. Both share the same pointed facial features of

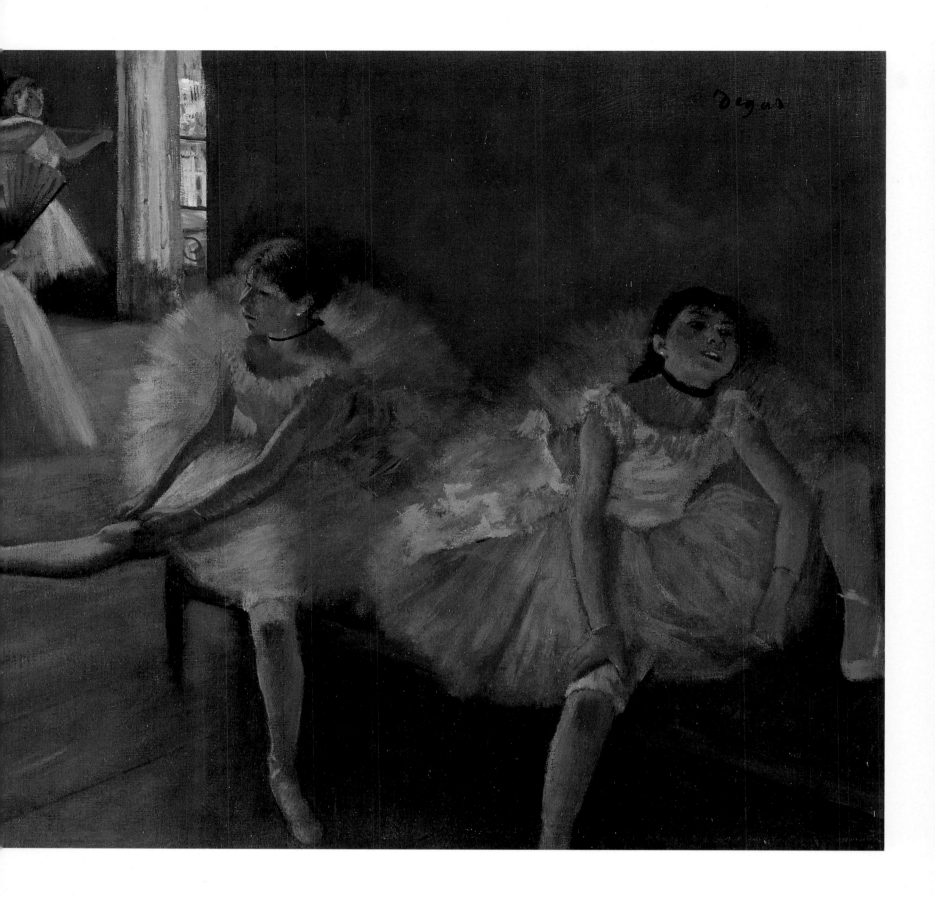

Maria van Goetham who posed for the statue and there are similarities between the standing figure and the finished statue in the tilt of the head and position of the trunk.

Of all Degas's works these narrow pictures most clearly suggest a potential decorative ensemble. It would be possible to arrange a series end-to-end in a room. It is one of the most striking omissions in Degas's career that he never decorated a public building; no frescoes or large oils were ever commissioned by the French state or a local authority, nor did any private individual approach him for a suite of pictures that might furnish the walls of a room. Considering how much Degas admired fifteenth-century Italian wall paintings, and how much his heroes Delacroix and Ingres had contributed to public buildings and churches in Paris, it is surprising that Degas never espoused the cause of largescale decorative art. The rebuilt Paris Opéra would, of course, have been the most natural place for his subjects and talents to be employed.

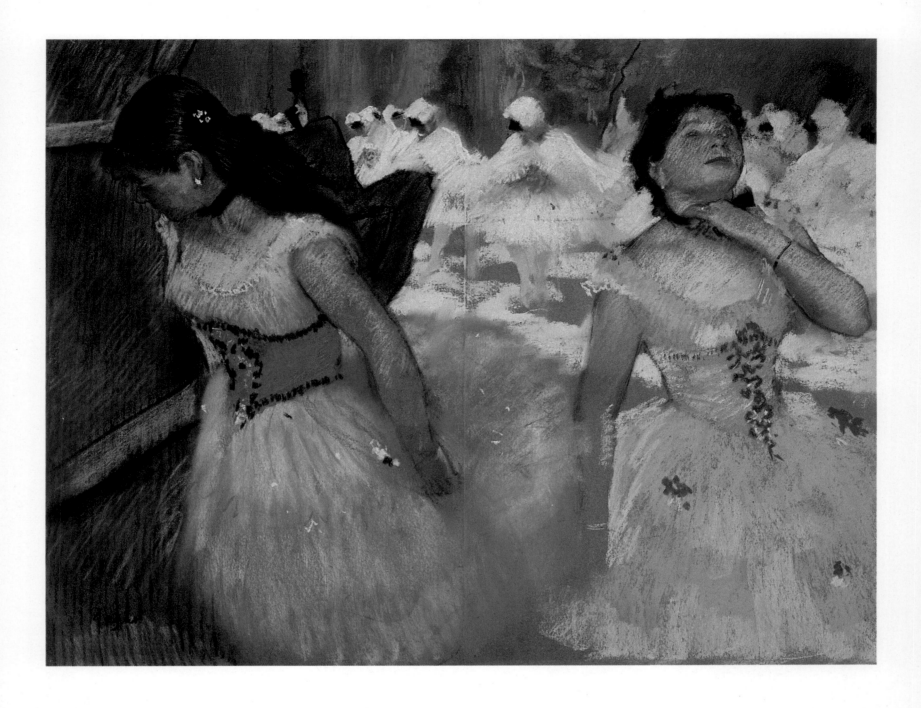

The Entrance of the Masked Dancers, 1884

Pastel on paper
19¼×25½ inches (49×64.7 cm)
Sterling and Francine Clark Art Institute,
Williamstown, Massachusetts

Mozart's *Don Giovanni*, from which this scene is taken, was performed often from 1886 onwards both at the Opéra and at the Théâtre-Lyrique with Jean Baptiste Faure, the singer who was one of the earliest collectors of Degas's paintings, taking the title role. In 1876 Degas made a pastel of the swashbuckling male chorus from the first act, and it is another first act episode that is shown here - the *Trio des Masques*, where a row of caped dancers, with eyes masked to give them the appearance of sinister birds, slide on stage. It represents one of the few occasions when Degas depicts a specific ballet.

The foreground pair of dancers have just left the stage; one adjusting her neck bow, the other hastily ducking down beneath a flat to avoid being seen. They are of great interest to the top-hatted man in evening dress – another of those predatory *abonnés* of the Opéra, who lurk in the wings of so many of Degas's dance pictures.

Degas's use of pastel is especially free. Even allowing for the artificiality of make-up, of lighting and of set colors on stage, there are considerable deviations from the local color in the figures, particularly in the lime green glimmer down the arm of the foremost dancer wearing a turquoise dress, and the shadow of her neck shown in greens and blue. The darker-toned areas of forms were modeled by Degas using the grey-brown paper itself, so that the surface color is almost entirely of brighter pastels.

Space is powerfully condensed, even cluttered, and the image would be difficult to read clearly had Degas not chosen to give the right-hand dance line a strong electric-yellow-white intensity so that the dancers grab the spectator's eye. The glorious pair in the foreground, who compete for attention, are thus outshone.

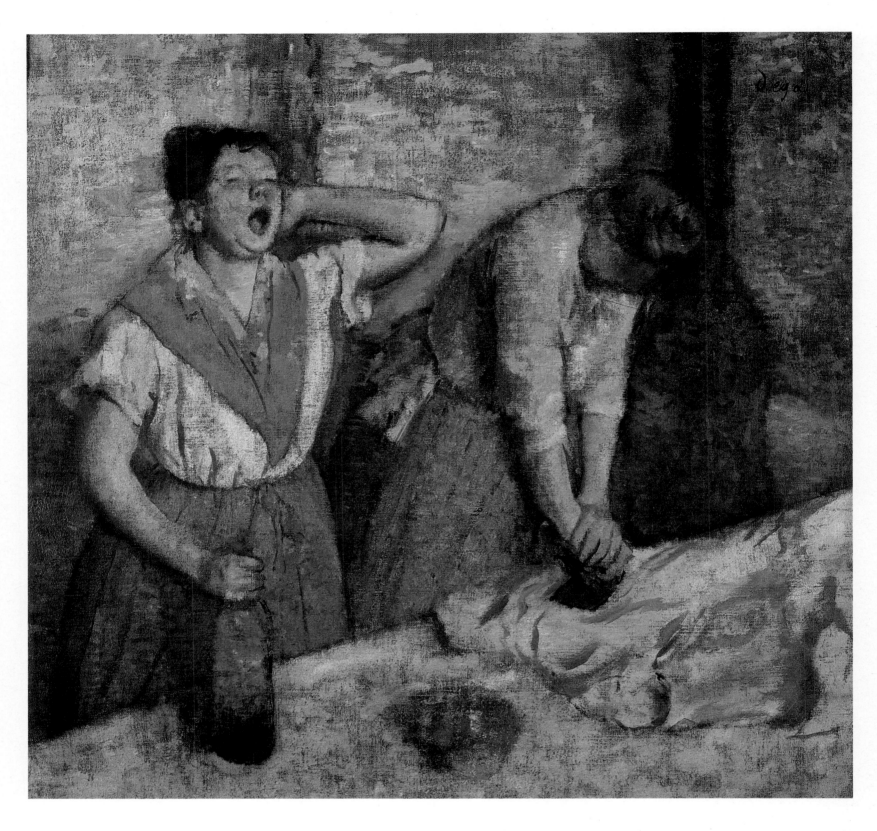

Women Ironing, c.1884

Oil on canvas
30×31⅞ inches (76×81 cm)
Musée d'Orsay, Paris

The laundress series depicts the most mundane side of working class life that Degas ever tackled. Unlike earlier Realist treatments of washerwomen by Daumier and others, Degas does not usually monumentalize his women or surround them with proletarian heroics – except perhaps here.

Of the four versions of this image that Degas made, this painting seems to pursue a deliberate roughness, in construction and in mood. The canvas, which shows through in several places, is of an unusually coarse weave; there is an almost gritty texture to the paint surface and the women are neither pretty nor conventionally feminine. The hair of one has fallen down out of place and she is too preoccupied with her labour to tuck it up; the other yawns and scratches her neck, while simultaneously reaching to swig from a nearly empty wine bottle. Because of her slightly ridiculous appearance, this picture

has often been viewed as an example of Degas's humour – a curiously insensitive reading of what is surely, like his head-holding and weeping ballerinas, a truthful glimpse of the sheer human exhaustion that lies behind any beautiful appearance, whether a theatrical spectacle or simply a starched shirtfront.

Degas's laundresses have often been linked with Emile Zola's best-selling novel *L'Assommoir*, published in 1877, which charts the alcoholic disintegration of Gervaise Macquart who for a while was a successful laundress. Degas's depiction of the unlovely truth of hard work and the emphasis he gives to the wine bottle are clearly close in sentiment to Zola's central message of the destructive power of alcohol amid the drudgery of the life of the poor, a theme that Degas also touched upon in his painting *In the Café (L'Absinthe)* (page 96).

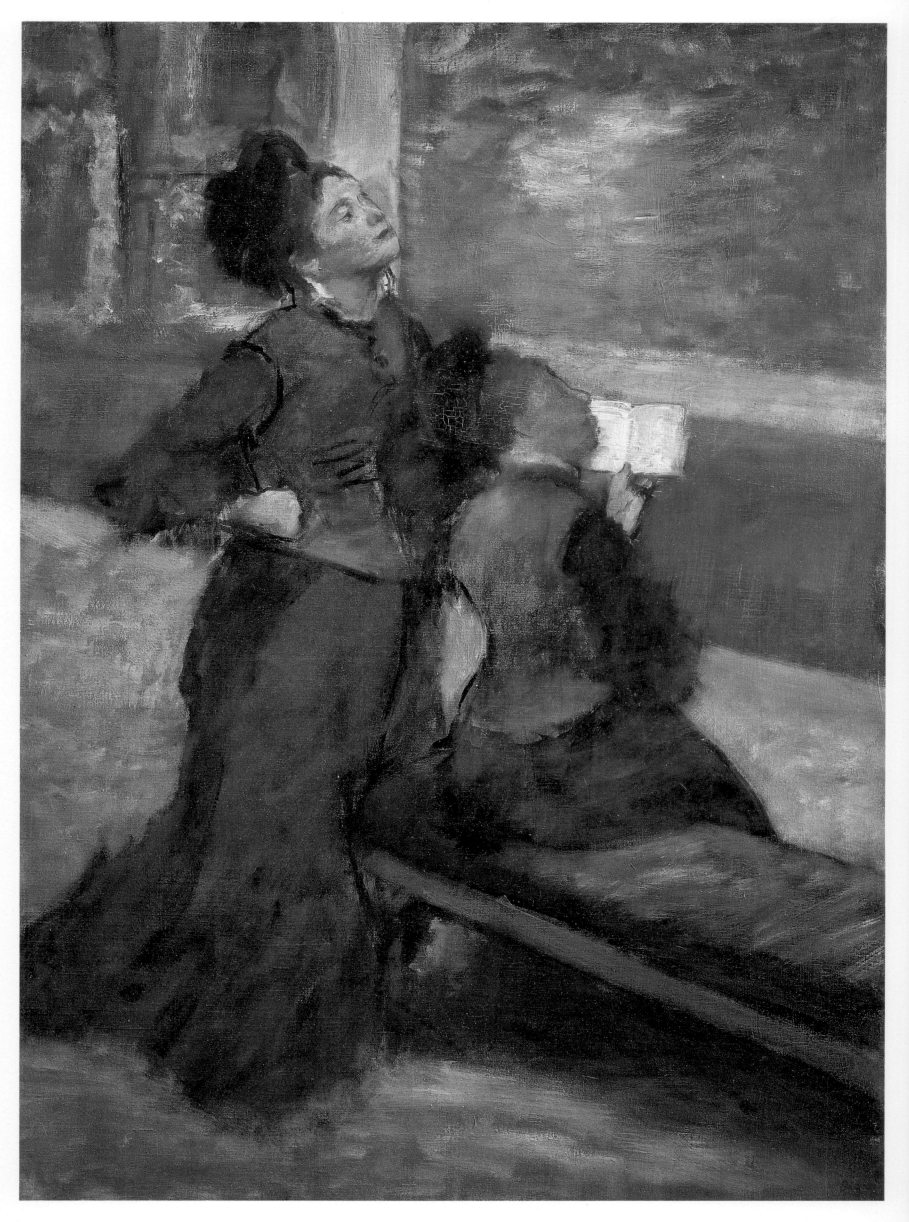

Visit to a Museum, c.1885

Oil on canvas
36⅛×26¾ inches (90×67 cm)
Museum of Fine Art, Boston

The woman confidently standing, hand on hip, head thrown back and abstractedly biting her bottom lip, is based upon drawings modeled by Mary Cassatt, the American artist who, from 1877, was a close friend of Degas. In contrast her seated companion possesses none of her swagger and rather cautiously consults or possibly reads aloud from a guidebook. She may be Lydia, Mary Cassatt's semi-invalid sister. This picture is one of a group on the theme of women visiting the Louvre that Degas made between 1877 and 1885, and includes etchings, drawings and pastels.

Walter Sickert watched Degas working on this, or the related picture in the National Gallery in Washington, when he made his often-quoted remark that he wished 'to give the idea of that bored and respectfully crushed and impressed absence of all sensation that women experience in front of paintings'. It is difficult to believe that Degas really thought women incapable of emotion in front of pictures or of articulating their feelings about art. It is an especially curious remark given that the original model for the series of works was a sophisticated woman who came closer than anyone to being a pupil of Degas, whose art and intelligence he greatly admired, and whose picture that she exchanged with him held pride of place in his apartment. Rather than his comment being further evidence of Degas's misogyny, it may perhaps be better to see it simply as a teasing remark at Sickert's expense – aside from any questioning of the accuracy of Sickert's reporting.

The Battle of Poitiers after Delacroix, c.1885-9

Oil on canvas
21½×25⅝ inches (54.5×65 cm)
Collection of Barbara and Peter Nathan,
Zurich

Degas's enthusiasm for Delacroix's work was lifelong. Between 1858 and 1865 he copied Delacroix's pictures in pen and ink, watercolor and occasionally oil, and in his own early history paintings he emulated both his violent subject matter and higher-keyed color. From about 1865 until the early 1880s, when Degas was most closely concerned with Realist themes, Delacroix's influence is less evident. This picture represents part of a refocusing of attention on Delacroix's art which Degas shared with several other artists. In 1878 Renoir copied *The Jewish Wedding in Algiers*, and three years later traveled to North Africa to paint pictures inspired by the same landscape that had inspired Delacroix. The thrusting young Pointillist painter Seurat sought justificatory precedents in Delacroix's use of color for his own scientific theories about optical color mixtures. The more dreamlike Symbolists, who were gathering in strength in the early 1880s, viewed Delacroix as an heroic precursor of their attempts to generate poetic mood and meaning through evocative color and dramatic subjects. Despite Degas's remarks to Sickert in 1885 that color was occupying artists at the expense of line, he too was deeply absorbed in the issue.

This painting is a copy of an oil study made about 1829 by Delacroix for a much larger picture, and Degas probably saw it at a picture dealer's after it was sold at auction in 1880. That he chose to copy the study rather than the larger fully-resolved picture at Versailles suggests that he was seeking out the very earliest color organizational principles of the picture. The copying is anything but slavish; Degas took what was already a confused and summarily painted *mêlée* of fighting foot soldiers and a horseman and reduced it further, to an almost abstract pulsating textured shimmer of color and broken line. The result is a living copy – an independent work of art in its own right which, with a framework grounded in an understanding of a previous painting, explores new pictorial concerns. As such, it belongs in a great tradition of such copies made by Titian, Rubens and Delacroix himself.

Degas's passion for Delacroix grew in his later life. Increasing sales of his own pictures made it possible to develop his collection. At his death, Degas's Delacroix holdings included 13 oil paintings, over 200 drawings and watercolors, and many lithographs and prints.

Hélène Rouart in her Father's Study, 1886

Oil on canvas
63⅜×47¼ inches (161×120cm)
National Gallery, London

The striking blue dress prevents Hélène Rouart's small figure from being hemmed in and dominated by the objects in her father's study. Degas was very close to the Rouart family and keen to paint this portrait. Henri Rouart had been at school with him and served in the same artillery company during the Franco-Prussian War, and Degas was a regular Friday evening dinner-guest at his home.

Rouart spent some of the fortune that he made as an engineer and inventor on paintings, including several works by recent French artists. The Barbizon School, the Realists and Symbolists and above all the Impressionists were well represented on his crowded walls. He shared with Degas a love of the landscapes and portraits of Corot. Corot's *Bay of Naples* is in a gold frame behind Hélène. Rouart also owned Corot's portrait entitled *The Woman in Blue*, showing a young woman leaning on a piece of furniture with paintings on a wall behind, and elements from Corot's portrait influenced Degas in structuring this picture. Beneath the landscape is a drawing of a peasant girl by Jean François Millet.

Rouart's other collections included antiquities, oriental prints and fabrics, and Egyptian statues in wood and stone, like those in the glass case on his desk that he probably brought back from his trip to Egypt in 1878. The largest statue of Ptah-

Sokar-Osiris is of a kind that often contained fragments of mummified corpse and papyrus rolls, inscribed with extracts from the *Book of the Dead*. Above the case is a red and gold Chinese wall hanging; because such embroideries were used at wedding altars, this may be a reference to Hélène's marriage, which took place in 1886, the year the picture was painted.

Hélène leans conspicuously on a large empty chair belonging to her father; a motif that suggests both his continued presence in the room, and her strong affection for him. Among the portraits by Van Dyck that Degas saw, admired and sketched in Genoa in 1859 was one of a woman standing by an empty chair implying a similar affection for an absent man. Of all the various pictures that Degas did of the Rouart family, this is the most important. He seems to have set out quite deliberately to create pictorial problems in the picture – boxing Hélène in within the various rectangular shapes, making the edge of the wall hanging go through her head, generating a conflict between the warm advancing red in the background wall hanging and the cooler retreating blue of the dress. This is an almost mannered Degas, who juggles with the full range of his spatial skills.

The picture was never owned by the Rouart family, and was kept by Degas in his studio until his death.

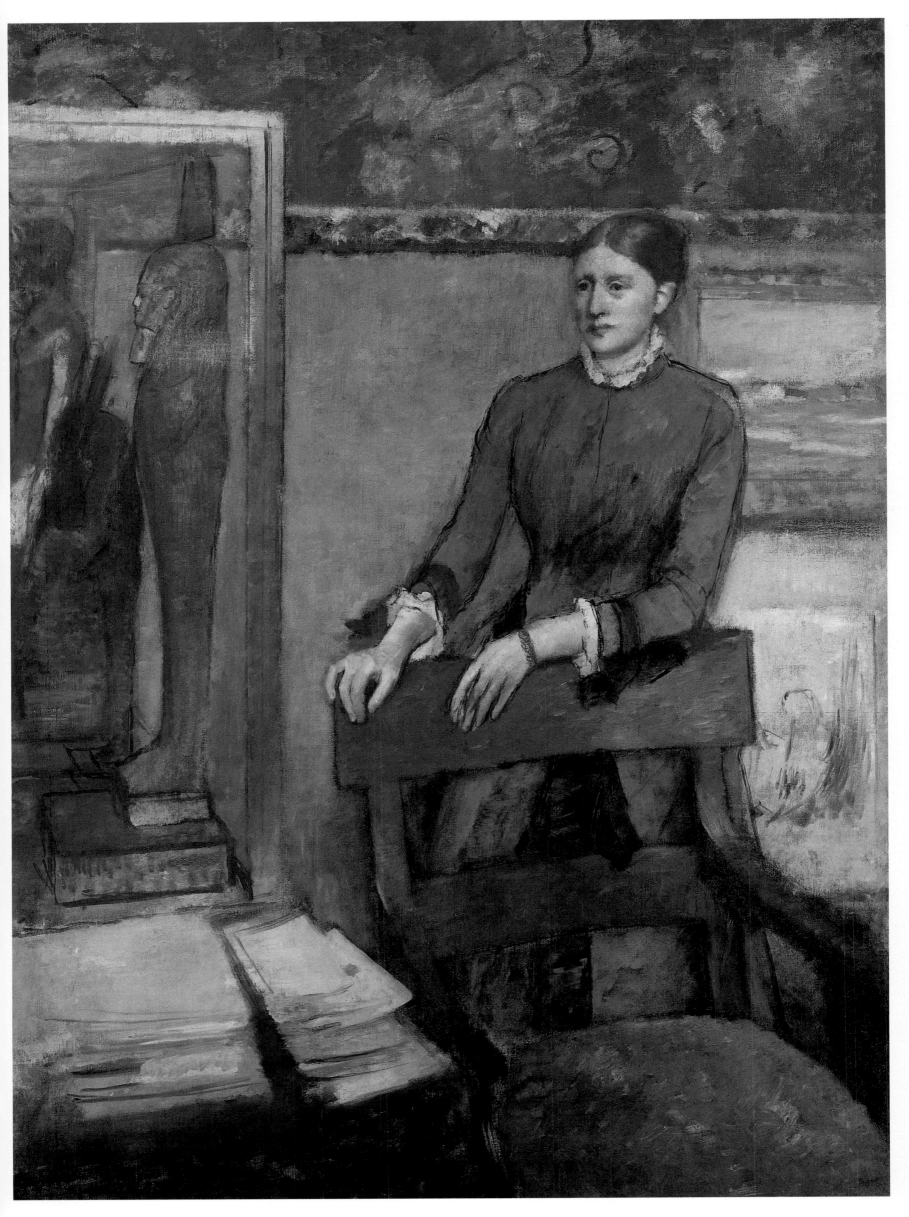

147

Woman Bathing in a Shallow Tub, 1885-6

Pastel on paper
23⅞×32⅝ inches (60×83 cm)
Musée d'Orsay, Paris

At the eighth Impressionist exhibition in 1886, Degas planned to exhibit ten, and certainly exhibited six, of a series of nude women bathing. It is clear that he intended to make a significant statement about his art with this 'suite', described in the catalogue as 'nudes bathing, washing, drying themselves, wiping themselves, combing themselves or being combed'. Many critics and journalists commented upon his work, and Degas seems to have been at pains to make his intentions explicit. To the Irish writer George Moore, he explained:

Hitherto the nude has always been shown in poses that presuppose an audience, but these women of mine are simple straightforward creatures only concerned with their physical habits.

Gustave Geoffroy wrote:

Degas wanted to show the woman who, not knowing she is being watched, is as one would see her if hidden behind a curtain or looking through a keyhole.

Sickert, who talked the previous year with Degas about these pictures and his overall plans, recollected Degas saying:

They are all exploiting the possibilities of color. And I am always begging them to exploit the possibilities of drawing. It is a richer field.

The 'they' whom Degas attacked were not only the first generation of Impressionists, Monet, Renoir and Pissarro, who were using higher-keyed color, but also Seurat, whose novel pointillist canvas *La Grande Jatte* was included at Pissarro's insistence in the 1886 exhibition and was, along with the bathers, the main centre of press comment.

What Degas seems to have been positing, and making clear in his conversation with writers, was that, working within the parameters of the traditional academic study of the nude and using uncompromisingly naturalistic poses, it was possible to produce a series of figures with that noble simplicity and calm grandeur that was the aspiration of any classicist. Degas did achieve with this series a truly monumental naturalistic *gravitas*. As he said of himself:

Two hundred years ago he would have made paintings of Susanna and the Elders, and now he painted a woman at a tub.

Although this exquisite sun-dappled figure was undoubtedly drawn from life, Degas was also inspired by the armless and headless antique statue of the *Crouching Venus* in the Louvre. Seen from a high viewpoint, he uses again the familiar Japanese-inspired flat dresser top, across which are arranged jugs, brushes and a hairpiece – their round shapes echoing and punning the shape of the bath and the woman's body. This pastel is one of the softest, most highly-finished of the group, and the one that attracted most critical approval.

149

The Morning Bath, 1885-6

Pastel on paper
26⅜×20½ inches (67×52.1 cm)
The Henry and Rose Pearlman
Foundation, Princeton University

Degas used a much heavier, older model for this pastel and for another related pastel of a woman putting on her chemise. Both were also shown in the 1886 Impressionist exhibition. As a pair they fit closest the description that the critic Fénéon gave of the group as women who have 'bodies that bear the bruises of marriage, childbirth and illnesses', and they were the focus of the strongest critical disdain. The model was possibly the wife of a nearby butcher. In the sequence of morning bathing actions that Degas seems to have intended, this is the first; with a woman stretching and possibly warming her buttocks before the fire in the chimneybreast, which makes such an emphatic strip at the left of the picture.

Among the many reactions to the pictures in the series were stock dismissals of their obscenity and ugliness; a considerable body of comments about the superb accuracy of Degas's draftmanship; and also some unpleasantly misogynistic remarks by some writers, who suggested that Degas had at last shown up women as he really saw them. Huysman, while remarking how chaste and unsexual the women were, saw them as evidencing 'scorn and hate', displayed in 'the humiliating posture of intimate hygiene'. He might have better substantiated his case with some of the never-exhibited brothel monotypes, but he was still able to extract extraordinary loathing from these pastels. George Moore thought this picture the chief work of the group and described it as:

A short-legged lump of human flesh who, her back turned to us, grips her flanks with both hands – Degas has done what Baudelaire did – he invented a *frisson nouveau*. Terrible, too terrible is the eloquence of these figures. Cynicism was one of the great means of eloquence in the Middle Ages and from Degas's pencil flows the pessimism of the early saint and the scepticism of these modern days.

It is curious that 'cynicism' and 'pessimism' should have been found in a group that are popularly seen nowadays as among the greatest celebrations of the female body. These responses to Degas say more in the end about the attitude of the writers than about Degas.

The Tub, 1886

Pastel on paper
27½×27½ inches (70×70 cm)
Hill-Stead Museum, Farmington,
Conneticut

This pastel belongs to the 1886 suite of nudes but may not have been exhibited at the eighth Impressionist exhibition, and is one of four related works that show a woman stooping, holding a sponge with her outstretched hand. Of the entire series, this most exquisitely speaks of the geometry of Degas's figure construction. In the absolute square of the picture's format, the woman's body is angled like an isosceles triangle inside the circle of the tub. Her limb reaching down like one arm of a com-

pass might be rotated about her trunk to inscribe the perfect circle within which she is contained.

Despite the geometric clarity of the image, which suggests premeditated posing, there is no reason to doubt that this, like all the series, was produced in Degas's usual studio manner when, with the props of the zinc bath, sponge and towel, he invited the model to go freely through unrehearsed actions until he found one that interested him. One critic described the bather series as a series of 'anatomical problems' that Degas had solved. Georges Jeanniot, visiting Degas's studio in the 1890s, watched him going through this unclassical mode of posing and was struck by how extraordinarily contorted the human

body can look in reality – at odds with our mental notions of its capacities or appearances – as demonstrated by the photograph taken by Degas in 1896 (page 23). This woman's rigid-legged pose was painful to hold, particularly given the balletic positioning of her feet.

Among the many artists who drew inspiration from this series was Gauguin, who later wrote:

Drawing has been lost, it needed to be rediscovered. When I look at these nudes I am moved to shout 'it has indeed been discovered!'

Degas explored further the formal problem of the nude figure contained within the circle of a bath in the wax sculptures made about this time.

A Woman having her Hair Combed, 1886-8

Pastel on paper
29⅛×23⅞ inches (74×60.6 cm)
Metropolitan Museum of Art, New York

Critics commenting upon the 1886 group of bathers saw parallels with the great naturalistic nudes by Rembrandt, and connexions have often since been made between the pose of the woman in this pastel and Rembrandt's painting of *Bathsheba with David's Letter* which was once owned by Louis Caze, a friend of Degas's father. Although this pastel was apparently intended for the Impressionist exhibition of 1886, it was not shown, possibly because it was not finished but perhaps because it is not in the same mood. It differs in being two-figured, in the centering of the naked

woman who is smaller in scale, in the greater emphasis given to the rich button-backed divan and background fabrics and in the fact that, unlike the exhibited nudes, the woman's features are clearly seen. The self-confident thrust of her body is altogether less modest than the exhibited bathers, whose faces, breasts and pudenda are always shaded, covered or turned away. If it was excluded deliberately by Degas it may have been to retain the refined simplicity of his group as a whole.

There has emerged recently a debate about whether the 1886 group as a whole shows prostitutes bathing – a belief that seems to have underpinned some of the contemporary critical reaction. In support of this argument attention has been drawn to the apparently rather shabby interiors of the rooms, and to the fact that a respectable bourgeois woman would not use a zinc bath, whereas a prostitute hastily bathing between clients might use one. This rather specific social reading of the exhibited group is difficult to sustain once comparisons are made within the bathers series as a whole. It also assumes that Degas was not attracted to the circular zinc tub above all because of its beautiful formal possibilities (one also appears in *The Pedicure*, page 83, showing his young niece), and does not allow for the fact that the rooms are generalized treatments with freely constructed color arrangements in carpet and wallpaper. Some of the bathers may indeed be prostitutes and this image, which includes no circular zinc tub, could just about sustain a reading of a pampered kept woman being prepared for her assignation.

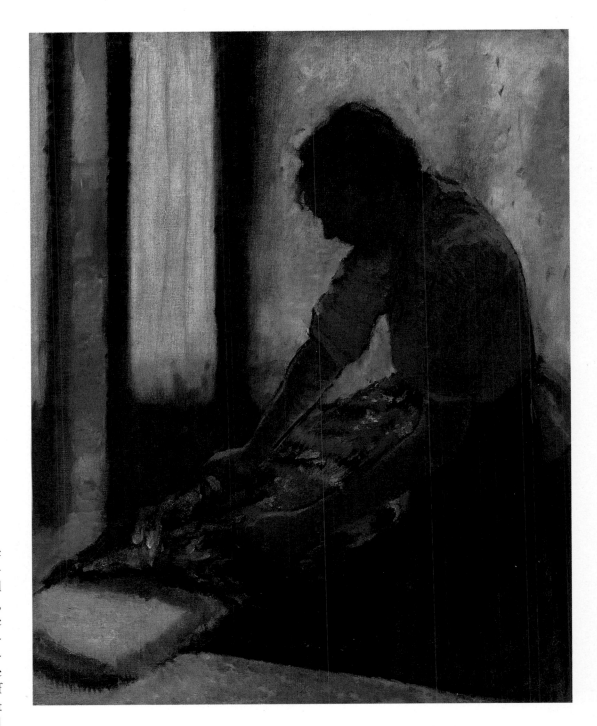

Woman Ironing, c.1890

Oil on canvas
31½×25 inches (80×63.5 cm)
Walker Art Gallery, Liverpool

An altogether more refined and rather distant air than in the Paris version (page 141), with its almost deliberate roughness, pervades this later image of a woman ironing. Light from the partially open double doors at the left throws the side of her face nearest to the spectator into shadow. Degas intensifies this effect by the elimination of eyes, mouth and any distinctive facial expression. He paints her face as a generalized passage of orange and brown. As a result she becomes anonymous, a more distant depersonalized figure performing an action.

Degas may have intended to evoke a domestic interior rather than a laundry. She irons a dense brocade fabric on a board rather than on a large table, without any racks or piles of damp clothes or obvious sign of largescale work. The diagonal ironing board resting on the table in the foreground is a right-angled arrangement of planes that is strikingly similar to the cafe tables in what is possibly Degas's most famous painting, *In the Café (L'Absinthe)* (page 96). In both pictures there is that distinctive double viewpoint, both looking down at the table or board and at the same time directly at the figure. Additionally, the emphatic verticals in the glazed double doors are related to the mirror verticals in the café interior. It confirms once again the almost abstract approach that Degas adopted in organizing containing linear structures for his figures.

A smooth linen with a lushly textured paint surface is used for this picture, and there is no evidence of the warp and weft of canvas visible in the earlier laundresses subject.

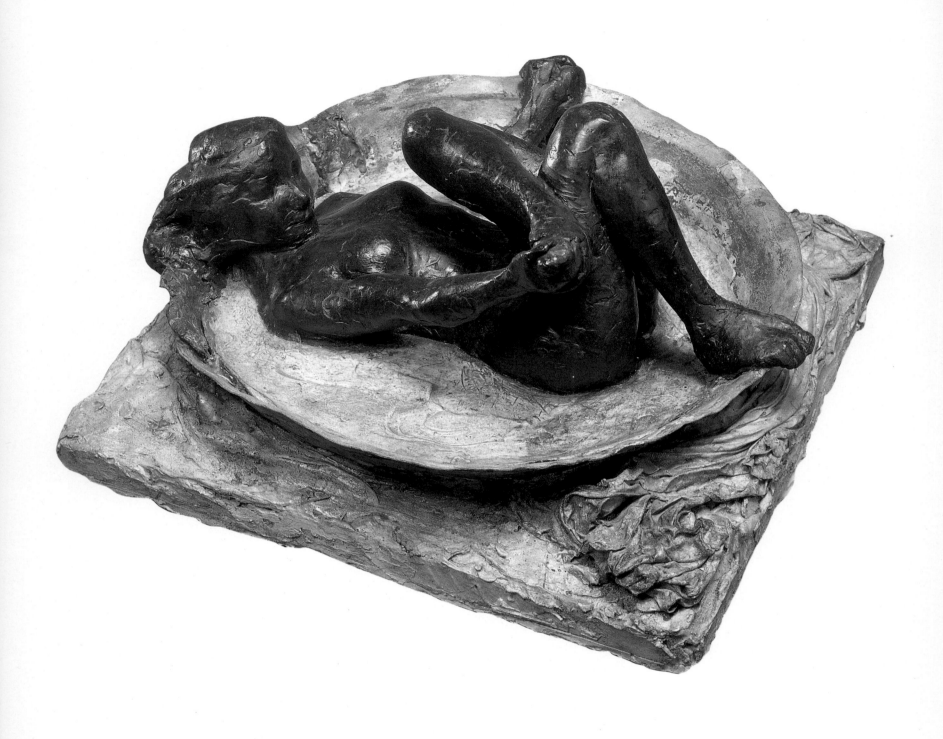

The Tub, 1889
Brownish red wax, lead, plaster of paris,
cloth
Diameter 18½ inches (47 cm)
National Gallery of Art, Washington

A major visual symbol from the late fifteenth century onward, representing the Renaissance idea of 'man as the measure of all things', was a perfect circle overlapping a perfect square within which a man with one trunk and head and two outstretched sets of arms and legs touches the inner edges of both square and circle. Degas's woman within her circular tub on a rectangular base puns this image: a Realist reworking of one of the touchstones of ideal human proportion, which combines all the cerebral satisfaction of an exquisitely balanced pose with the appeal of contemporary naturalism.

As in the fourteen-year-old dancer, exhibited in 1881 (page 122), Degas's verism extends to the use of everyday materials – a real sponge, a lead basin and thick plaster-

soaked rags shaped by hand into the rough plank base. The red wax of the bather's body evokes real flesh.

Among Degas's many bather sculptures, this is the most important. He described to his friend, the sculptor Batholomé, the processes that he used and indicated that he had spent a great deal of time on it. As completely resolved and exhibited a piece as the earlier fourteen-year-old dancer, it was nevertheless not seen by the public until after his death. Despite the interplay that Degas maintained between his two-dimensional work and his sculpture, there are no versions in pastel of a woman lying in a flat tub – surprisingly since the geometric concern of this piece seems so naturally to grow out of the 1886 tub pastels (page 150 and 151).

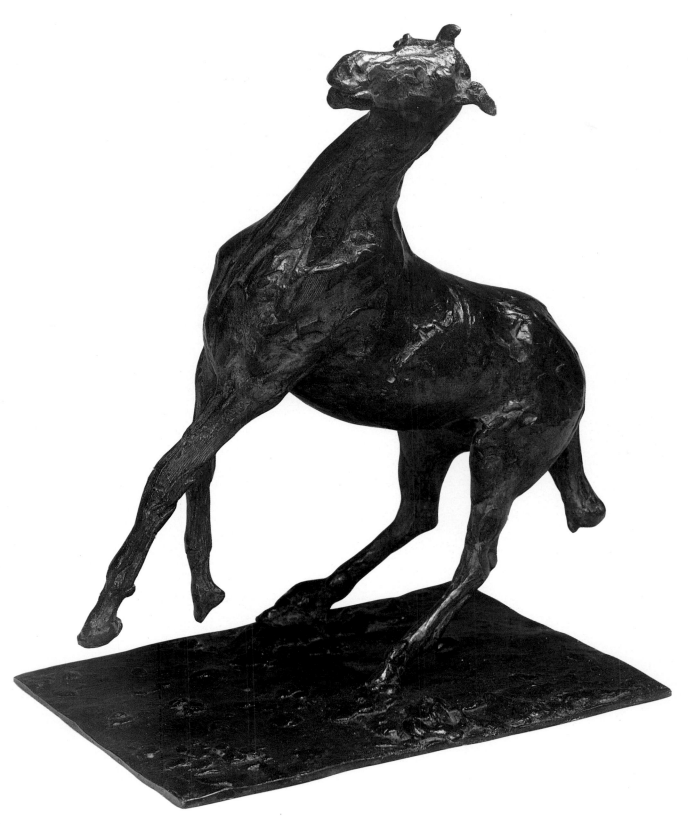

Rearing Horse, 1889-90

Red wax
Height 12⅛ inches (30.8 cm)
Collection of Mr & Mrs Paul Mellon,
Upperville, Virginia

Degas's very first piece of sculpture was probably the horse that he modeled in wax around 1867 and then copied for the drinking horse that appears in his picture of *Mlle Fiocre in the Ballet 'La Source'*. He explained to Thiebault-Sisson in 1897 that, like Dickens making small figures of his characters so that he could envisage their actions and dialogue, he occasionally needed to 'resort to three dimensions' in planning a picture. Out of a total of 74 of his sculptures that were in a sufficiently solid state to cast into bronze, 17 are of horses and two include jockeys.

This piece could not have been made before 1887, since it is based upon a plate in Eadweard Muybridge's book *Animal Locomotion*. Muybridge was the first to use very rapid shutter speeds to photograph the movement of humans and animals. His photography undermined the traditional mode of representing the gallop of the horse, with legs stretched out front and back like a rocking horse. Degas incorporated Muybridge-based poses from these photographs into a number of his horse pastels.

How far Degas's comments about the connexion between his sculpture and pictures is to be taken at face value is open to question. Despite his stated wish that his sculpture should simply crumble and turn to dust and never be cast in bronze, Degas lavished an enormous amount of time on these works. It exasperated his dealer Vollard to see him making and remaking from the same ball of wax; there were times when sculpting seems to have become a carthartic involvement in form for its own sake. He told Vollard:

If you gave me a hat of diamonds it could not equal the happiness I get from demolition for pleasure and starting all over again.

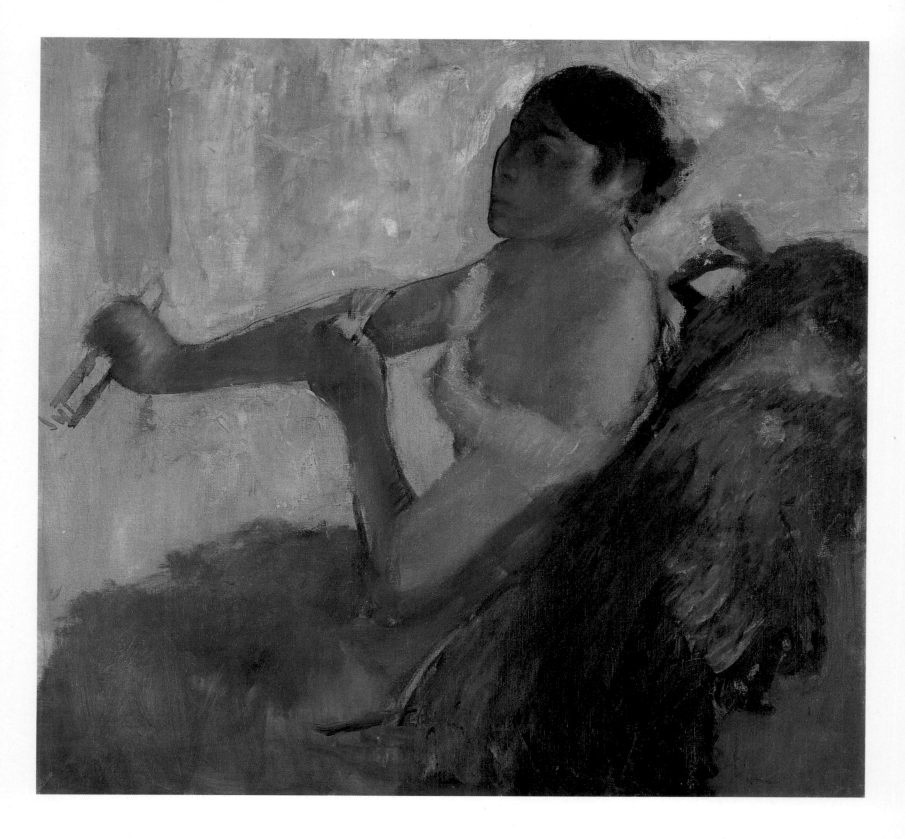

Portrait of Rose Caron, c.1890

Oil on canvas
30×32½ inches (76.8×83.2 cm)
Albright Knox Gallery, Buffalo

Degas often heard the soprano Rose Caron at the Paris Opéra between 1885 and 1892. He was particularly enchanted with her performance as Brunehilde in Ernest Reyer's *Sigurd,* which he saw at least 37 times. Degas considered that in addition to peerless rhythm, Caron had a particularly expressive manner of moving her arms. Of the 20 or so surviving sonnets written by Degas, one is dedicated to Rose Caron playing the part of Brunehilde, and it provides, in its combination of images of pain and pleasure, an interesting insight into Degas's conception of a living *femme fatale.*

Long noble arms now passionate slow enfold,
Protracted, humane, yet such cruel caress,
Mistake to fall into such deep morass
The barbed points from out a goddess soul.

Her crown belies the flushed rosy cheek
A silenced queen, her people now all slaves
A broken woman step by step descends
Love-full, shamed and so dolorous meek.

Cast off this o so decorative snare
This voice that shall forever last
That Sigurd trapp'd and destiny foretold.

For me this beauty is a lifelong joy
If blinded may my hearing linger on
To conjure gestures out of sound alone.

 In September 1885, Degas had dinner with his heroine. In the same year he painted a fan with a woman who is probably Caron, holding her arms aloft in a scene from Sigurd, and he later told his friend the sculptor Bartholomé that he planned a statue of her. At dinner Degas flatteringly told Caron that she was like a figure from a picture by the Symbolist painter Puvis de Chavannes.

 This portrait dates from about 1890; in the thin sketchy handling, blurring of facial features and loose vertical rectangles of light in the right-hand corner, it has similarities with the *Woman Ironing* (page 153) picture of the same time. The powerful figure of Madame Caron is not dressed in any recognizable theatrical costume but in generalized evening dress, holding a fan, and with the arms that inspired Degas in the mildly titillating process of peeling off one of her long gloves. Her discarded rich peacock green cloak may be a theatrical prop. There is no evidence that Degas intended selling this picture. It is a private record of a woman, the sight and sound of whom gave him the greatest of pleasure.

Landscape, 1890-2

Monotype in oils heightened with pastel
10×13⅜ inches (25.4×34 cm)
Metropolitan Museum of Art, New York

Over 20 years after producing his seaside monotypes, Degas made a second major foray into landscape in 1890, with a substantial group of works inspired by the countryside at Dienay in the Côte d'Or area of Burgundy. 25 of these pictures were exhibited by the dealer Durand-Ruel at his Paris gallery in 1892 – the first one-man exhibition Degas had ever agreed to hold.

The brief visit that Degas made to Dienay, to the home of his friend and fellow artist and printmaker Pierre Georges Jeanniot (1848-1934), is one of the best documented periods of his life. In company with the sculptor Paul-Albert Bartholomé, Degas travelled by horse and gig, eating well but eccentrically at inns en route, and when they eventually arrived at Jeanniot's village they were feted with great mock ceremony. Using Jeanniot's printing press, copper and zinc plates and a large roll of china paper, Degas set to work, with dilute colored oil paint rather than black printers ink, to create a series of views that had particularly struck him on his coach trip. He worked without studies, drawing upon his fecund memory, and with authoritative dexterity he conjured an image from nothing with apparent ease. Several of these landscapes have an ethereal atmos-

pheric haziness that invites comparison with the later pictures of Turner.

Like the earlier Boulogne landscapes, these later works are only generally connected with the area they show; a loose association that has led them to be seen by some as anticipating the abstract concerns and colorific freedom of many twentieth-century artists. When Degas exhibited them at Durand-Ruel's gallery, the reviewer Arsène Alexandre, in a fulsome eulogy, drew attention to passages of paint which he believed Degas had worked on with wads of cloth and with the tips of his fingers, 'like a child making patterns in mud'. Ludovic Halévy quizzed Degas on his approach in these works: 'What kind are they? Vague things?' Degas laconically replied 'Perhaps'. 'Are they a reflection of your soul?' asked Halévy. 'A reflection of my eyesight. We painters do not use such pretentious language', was Degas's curt response.

Degas made it quite clear that these landscapes were from memory and to an extent imaginary, and that he was not bound by what he described as 'the tyranny of nature' which led artists such as Monet to try to pin down accurately the look of a place.

The Billiard Room at Menil-Hubert, 1892

Oil on canvas
25⅝×31⅞ inches (65×81 cm)
Staatsgalerie, Stuttgart

At times for Degas painting was a way of belonging, in which he obtained vicarious access to sides of life that, through chance or choice, were denied him in reality. This was never more true than with his friendship with the Valpinçon family. He was always welcome at their chateau at Menil-Hubert and they kept ready a studio for him.

In August 1892 Degas holidayed there and painted this picture. Henri and Hortense, the children he had portrayed 20 years before, were grown up. Paul, his friend from schooldays, had only two years to live. Nostalgic memories of a place and family that he loved, coupled perhaps with intimations of changes to come, prompted Degas to paint this and another interior view of Menil-Hubert. They are the only occasions in his entire *oeuvre* when Degas painted rooms without people, and both

pictures (the other is a bedroom that he probably used regularly) adopt a curiously traditional box-like spatial construction and a precise recording approach – they are clearly 'portraits' of rooms so close to reality that Theodore Reff has identified certain of the canvases that hung on the billiard room wall from Degas's transcription of the pictures. The elegiac tone of this pair of interiors is compounded by a fall of light from windows that casts long shadows – like that made by the leg visible under the billiard table – suggestive of evening and dusk.

While working on this picture Degas wrote to his sculptor friend Bartholomé:

I wanted to paint and I started billiard interiors. I thought I knew a little of perspective. I knew nothing and thought I could replace it with verticals and horizontals and measuring angles in space, just through an effort of will.

The problems caused by the conventional perspective structure that Degas felt he had to adopt for this interior crop up again a few years later in the Saint-Valéry-sur-Somme landscapes (page 164).

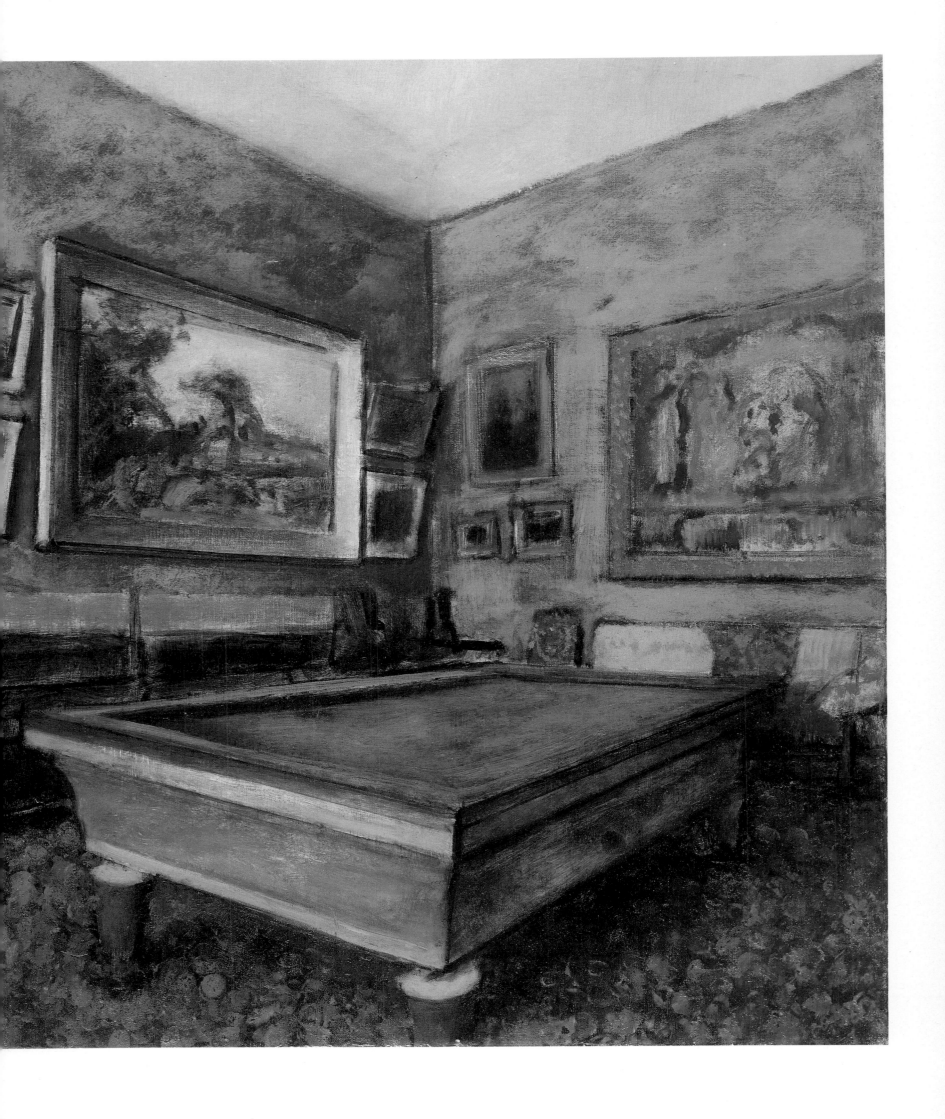

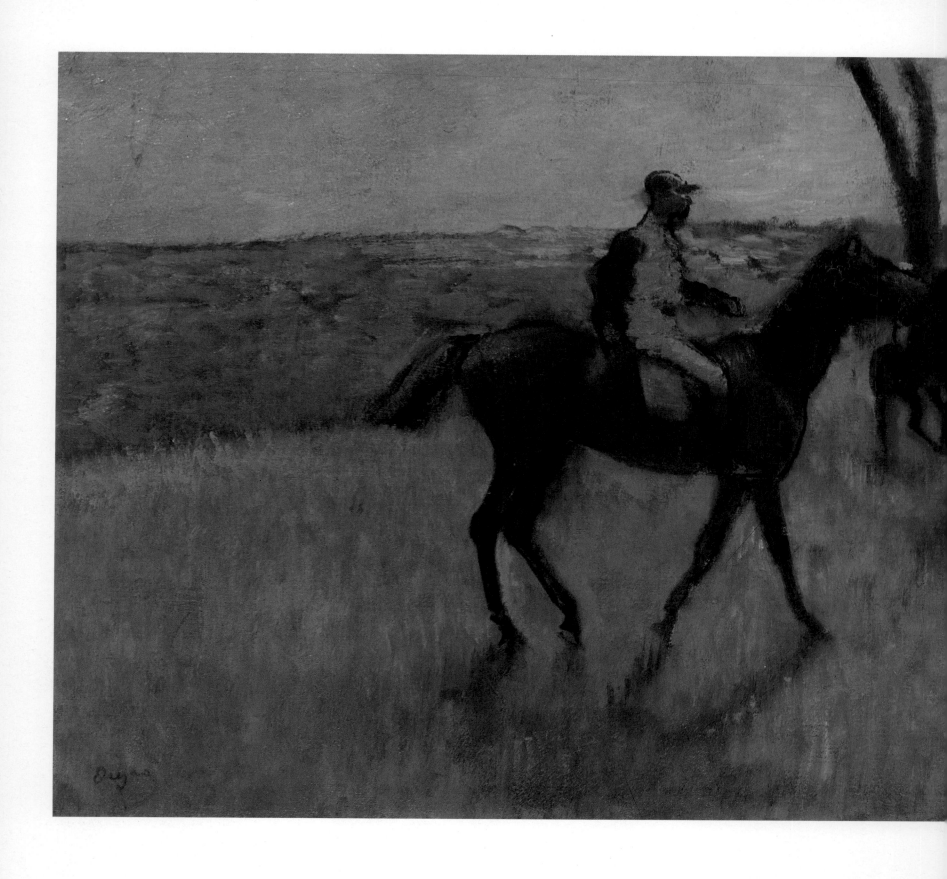

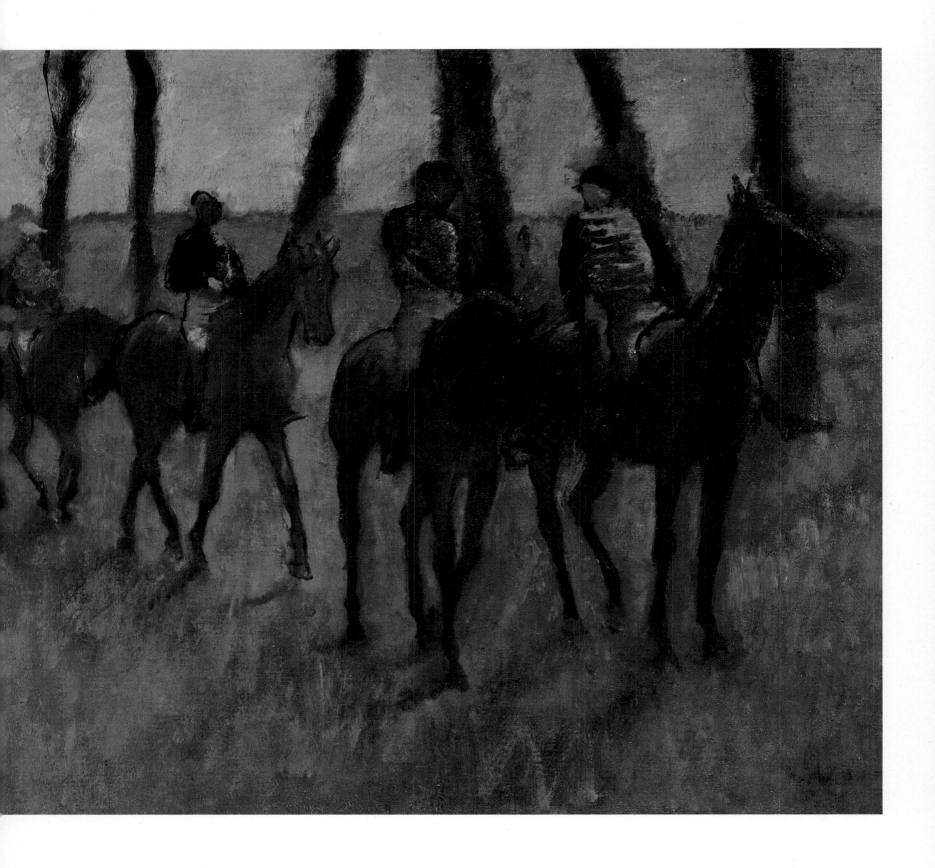

Hacking to the Race, 1895

Oil on canvas
15½×35 inches (29.4×89 cm)
Collection of Mrs John Hay Whitney

This is one of nine frieze-format horse paintings made by Degas which are similarly proportioned to his group of narrow dance paintings. Much more melancholic in mood than many of his earlier horse paintings, this shows a twilit scene of riders slowly going up to or returning from a race. Degas concentrates less on artful combinations and contrasts of brightly colored silks than on a muted overall tonality. As with the dance pictures in this format one is inclined to think in terms of how the work might have fitted into some overall decorative scheme. John Rewald has drawn attention to similarities between this grouping and Benozzo Gozzoli's *Journey of the Magi* in the Palazzo Medici

Riccardi in Florence. Connexions might also be made with antique bas-relief groups of horses and, perhaps closer to the contemplative spirit of this work, to the *Mares and Foals* series by George Stubbs.

Of the six horses in view, four are based upon studies that Degas made from photographs reproduced in Eadweard Muybridge's *Animal Locomotion*, published in 1887. Muybridge's revolutionary contribution was to show the movement of horses frozen in a series of photographs and for the first time to dispel prevailing notions about the position of the legs during a gallop. Degas was interested both in energetic movement and the correct position of legs and carriage in relatively slow movement.

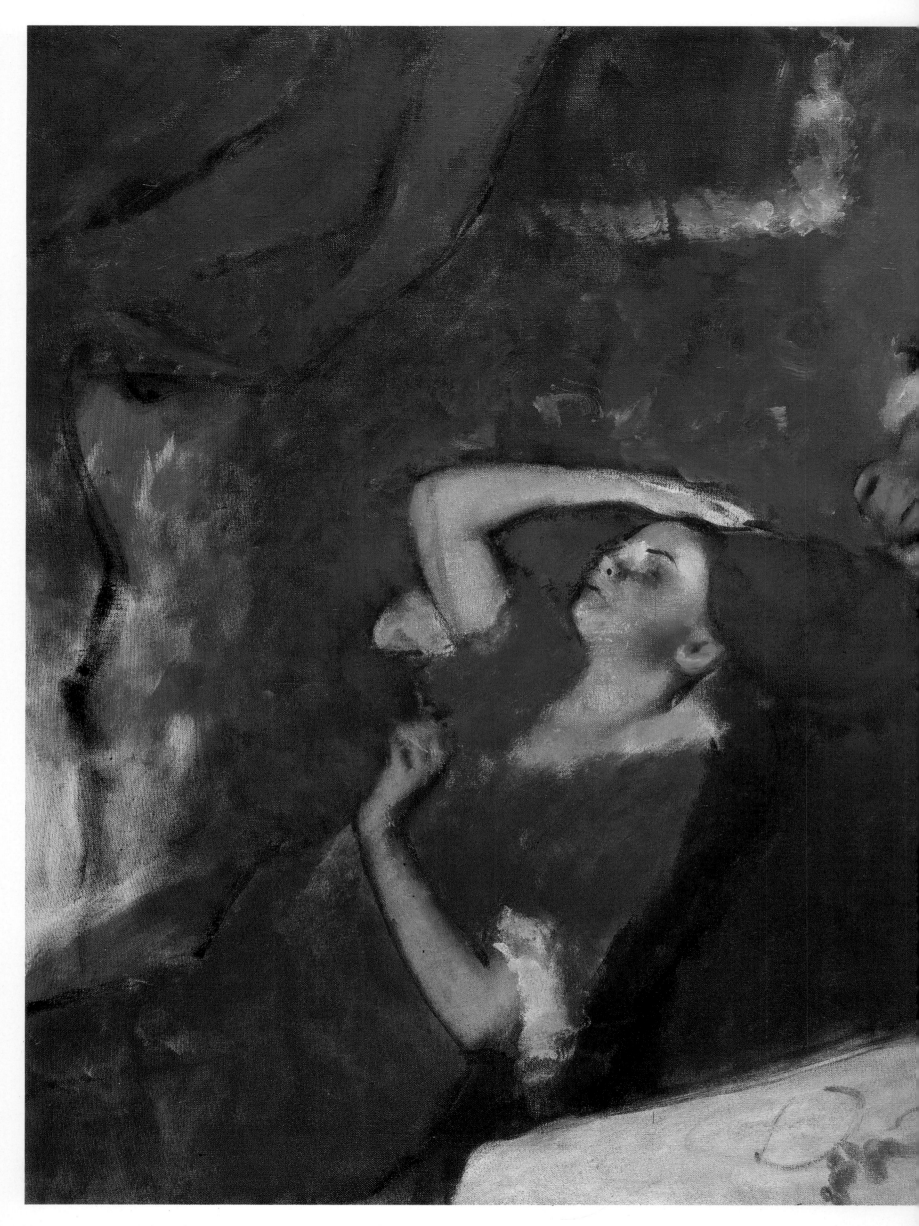

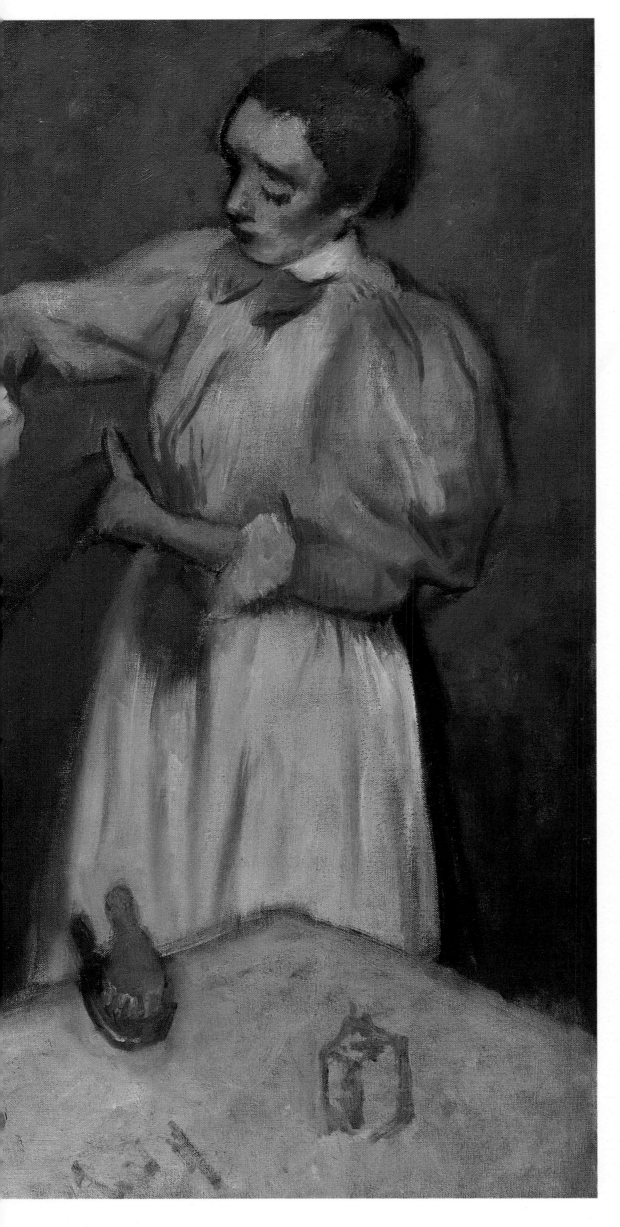

A Maid Combing a Woman's Hair, c.1896

Oil on canvas
48⅞×59 inches (124×150 cm)
National Gallery, London

In this, his largest and one of his last explorations of hair-combing, Degas again uses a powerful diagonal composition, as in his first treatment of the subject in 1876. Almost all rhythms and lines are subordinated to the dominant thrust from bottom left to top right. The taut body of the pregnant woman leans back at an angle of 45 degrees towards the maid servant, whose vigorous combing with one hand, while pulling the long tress back with the other, extends the line of emphasis. On the blank table whose edge is made to echo the major diagonal, only an amber-yellow hairbrush with a carefully angled handle and shadow point away from the bottom right corner and back up toward the black-outlined hand of the maid and the main pictorial directions. A curtain swag cuts off the top right corner. A picture frame which, in an earlier painting, would have been an emphatic rectangle as part of a gridded structure, is here reduced to a pale hazy trace – the only vestigial horizontals and verticals in this flowing picture.

Within the reduced range of reds, oranges and yellows that Degas employs, he exploits the power of a strong red to advance and arrest spectator vision by making the chair and dress of the woman tonally vibrant, and using a paler receding orange for the servant's hair and background wall. The color, high-keyed and artificial, has a Fauves-like intensity and it is not surprising that, of the many pictures that emerged from Degas's studio after his death, this was specially attractive to Matisse who owned it for 15 years before his son sold it to the National Gallery.

Zoë Closier, Degas's servant, modeled for some of the preparatory drawings of the combing maid. In earlier pencil studies of the woman there is a suggestion of pained discomfort which has led some to see awkwardness and possibly suffering in the pregnant figure in this painting. Rather than reclining in comfortable bliss, she may be clasping her aching head, a tension that the combing may be designed to alleviate.

Landscape of a Small Town,

c.1898

Oil on canvas
20⅛×24 inches (51×61 cm)
Metropolitan Museum of Art, New York

It is curious, and perhaps not merely coincidental, that Degas's only production of a discrete group of oil-painted landscapes which approach fidelity to the motif were made after Monet had broken with the *plein air* practice of orthodox Impressionism. It seems that Degas derived considerable pleasure and amusement from confounding his friends with these pictures, which show close involvement with 'the tyranny of nature' that he so often attacked. He did not, however, exhibit them publicly or offer them for sale as he had with his earlier monotype landscapes. Kept out of the public domain, they only appeared after his death.

The group as a whole shows Saint-Valéry-sur-Somme, set on the edge of the sea in north-east France. Degas was there in 1896 with his friend the landscape artist, Louis Braquaval, whom he apparently lectured about the false quest for accurate reproduction in landscape art. From 1898 onward he returned with his brother René and his nieces. René and Degas had recently become reconciled after years in which Degas refused to accept his younger brother's desertion of his blind wife Estelle. As boys, both had occasionally holidayed at Saint-Valéry-sur-Somme, and Degas was content to rediscover his childhood affections for the setting with some of his remaining family.

Unlike the ethereal Burgundian landscape monotypes, Degas here uses the receding orthogonals of traditional perspective. Into this well-defined linearity color is built up, sometimes in dense passages, at other times with a fluid delicacy that recalls the earlier monotypes. In this picture the walls of houses glow under a setting sun and Degas takes a viewpoint that almost looks over the shoulder of the town through backyards and gardens. Ultimately, as with many of the pictures in the group, it is the moody elegiac quality of a damp autumnal seatown that comes across most strongly.

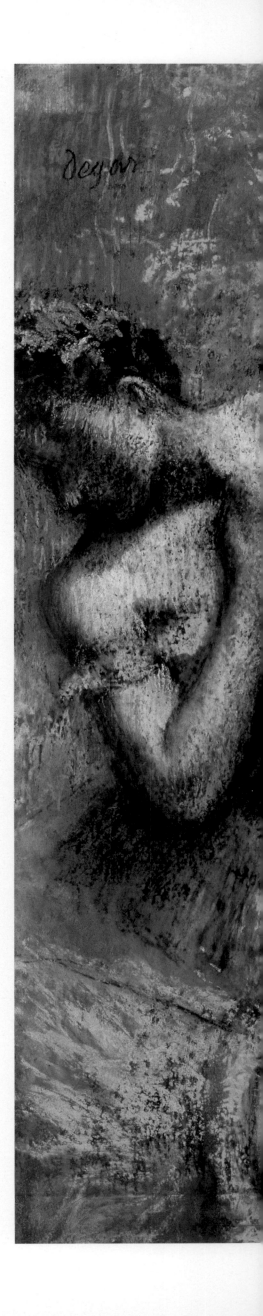

Four Ballerinas Behind the Scenes, 1898

Pastel on paper
26×26⅜ inches (66×67 cm)
Pushkin Museum, Moscow

Among the archival and documentary material donated to the Bibliothèque Nationale by Degas's brother, René, are three glass collodian photographic plates of ballerinas – two adjusting shoulder straps and a third steadying herself by holding a screen, while peering down to check the undersole of her foot. The three main dancers in this picture are based upon transcriptions and reversals of these photographs and it belongs to a substantial group of studies and similar square-format pastels that Degas made employing these figures. They are the only surviving evidence that Degas used photographs as an alternative or supplement to sketches and tracings in constructing ballet pictures. Although it is not proved that Degas took the photographs or dictated their posing, they are generally assumed to be his work.

As collodian plates they could be viewed from either side, held up to the light and moved around, to explore slight shifts of strength in the emphatic toplighting of the dancers' arms and shoulders that is the most unifying characteristic of both the plates and the finished picture. Degas's viewpoint looks down in close-up at the dancers and he schematically arranges the thrust of limbs, the line of a back and the angle of a shoulder to create a diamond shape, centered within the overall square format of the picture. Adding the head of the foremost dancer provides an echoing counterpoise to the top ballerina's hand. More than any other picture in this group, Degas in this work used a controled, almost abstract, manipulation of form. Among the several distinctive color combinations used for the series, here it is the sheer intensity of blue that is explored.

The pastel images made by Degas in 1898-9 approach the technical peak of his handling of the media. His ability to fix each layer allowed a build-up level by level, like the glazes of an oil painting, to produce dense and brilliant hues.

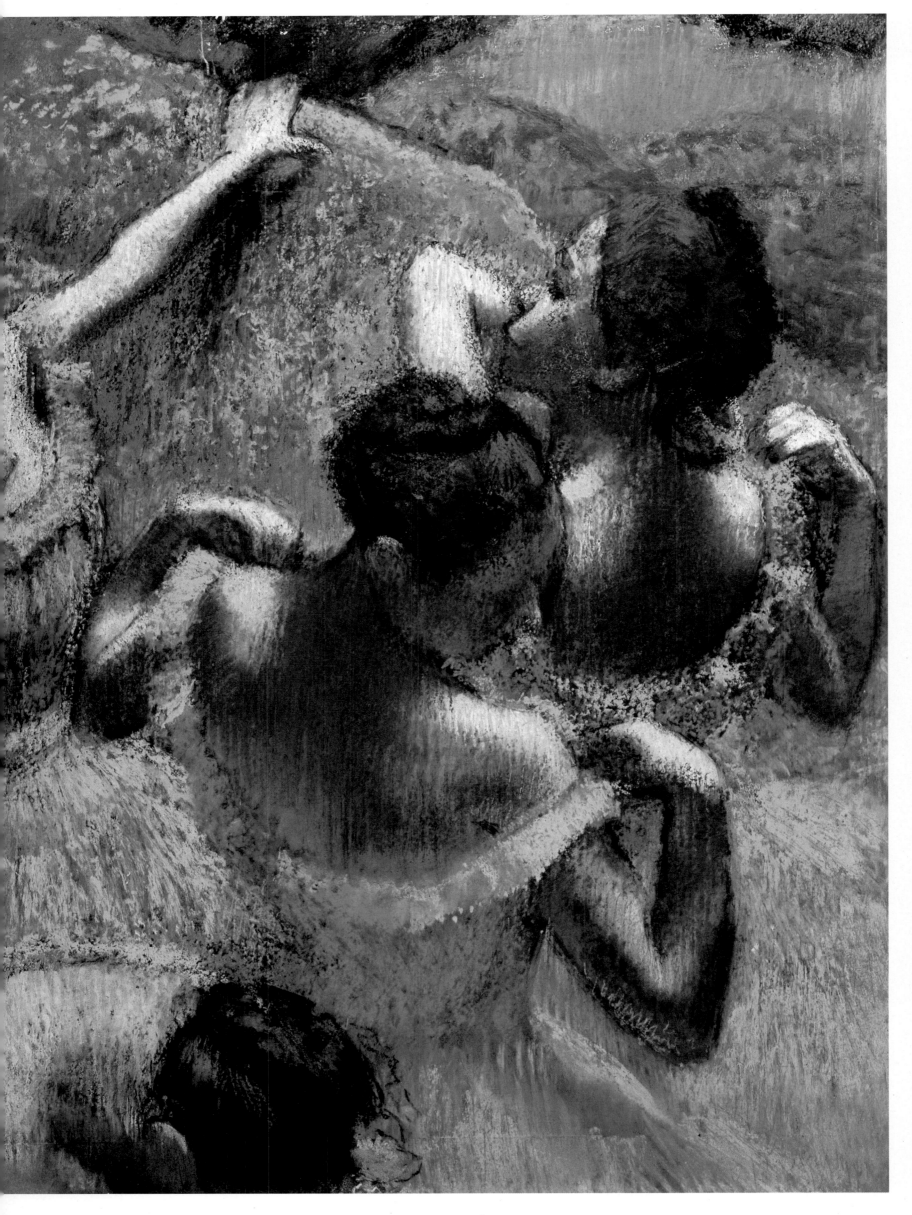

Russian Dancers, 1899

Pastel on tracing paper
14¾×25½ inches (62.9×64.7 cm)
The Metropolitan Museum of Art, New York

In contrast to the stiff tutus, taut angularity of limb and dramatic off-centre viewpoints of so many of Degas's ballerinas, these baggy-dressed and big-booted Russian dancers are lyrically melded into one compact centered image. Interconnected soft and rounded serpentine curves blend together, and make this and the many related pastels of this group evocative of a carved bas-relief frieze of Greek dancers. They represent an unusually strong classical note in the late work of the artist.

Suggestions as to Degas's source for this Russian theme have included the appearance of Russian dancers at the Folies-Bergère in 1895, and Lillian Browse's proposal that they might have been inspired by the first visit by Diaghilev's Russian company to Paris in 1909. If the latter were true it would provide a romantic link between Degas, the greatest chronicler of the nineteenth-century French ballet, and the company that revolutionized twentieth-century dance, as well as showing, as it does, that Degas's fully competent picture making extended so long into his old age. Julie Manet, daughter of Manet's brother and Berthe Morisot, visited Degas on 1 July

1899 at his studio, accompanied by two friends, and saw this picture; her journal published in 1979 gives details. On the day she visited, Degas was in an extremely good mood, possibly because on that same day he had added two Delacroix paintings to his collection. Appropriately, color was much in his mind.

M Degas was as solicitous as a lover. He talked about painting then suddenly said to us, 'I am going to show you the orgy of color I am making at the moment', and then he took us up to his studio. We were very moved, because he never shows work in progress. He pulled out three pastels of women with Russian costumes with flowers in their hair, pearl necklaces, white blouses, skirts in lively hues, and red boots, dancing in an imaginary landscape, which is most real. The movements are astonishingly drawn, and the costumes are of very beautiful colors. In one the figures are illuminated by a pink Sun, in another the dresses are shown more crudely and in the third the sky is clear, the sun has just disappeared behind the hill, and the dancers stand out in a kind of half-light. The quality of the whites against the sky is marvelous, the effect so true.

This picture is the first listed by Julie Manet. All three that were shown to her were done on tracing paper with pastel – Degas first established his linear structure before working over and over again in various vibrant color combinations.

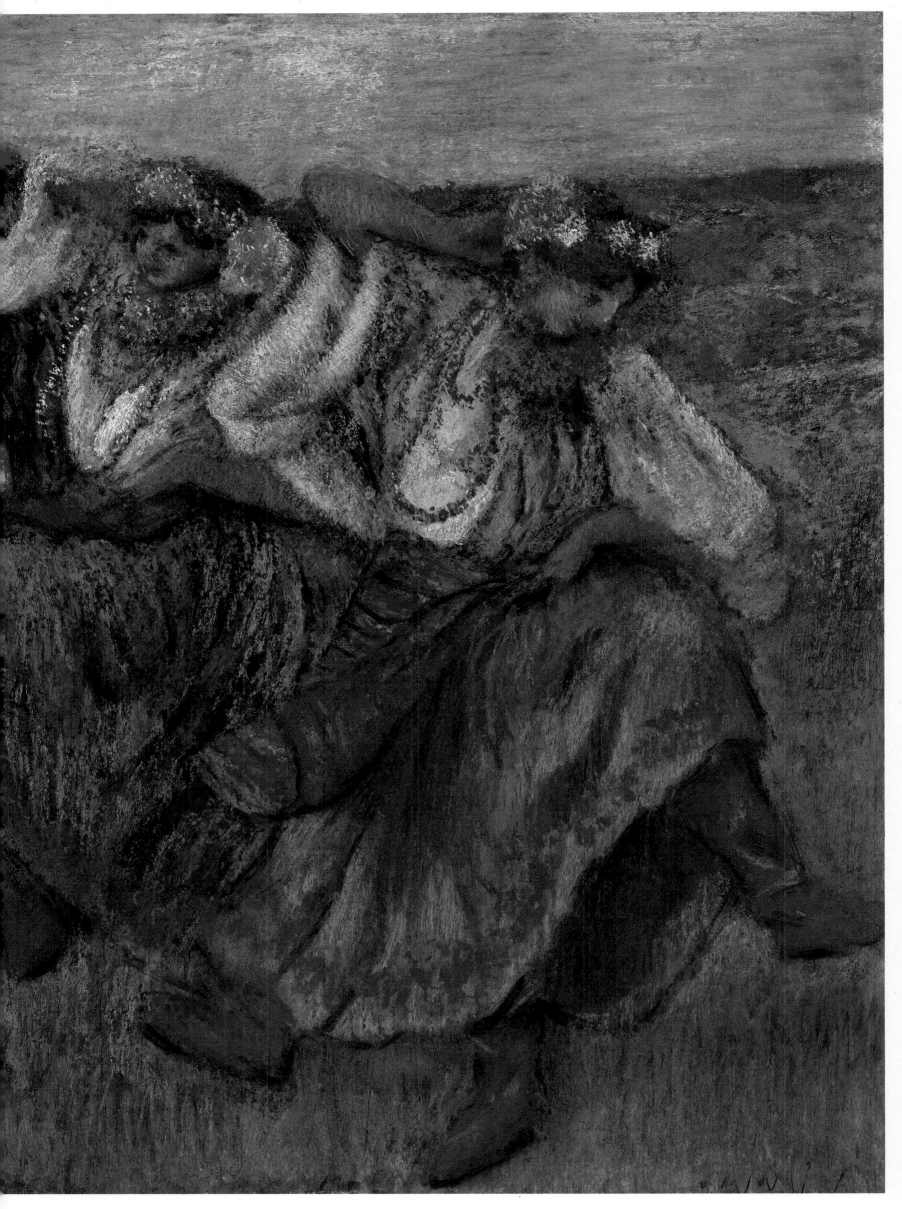

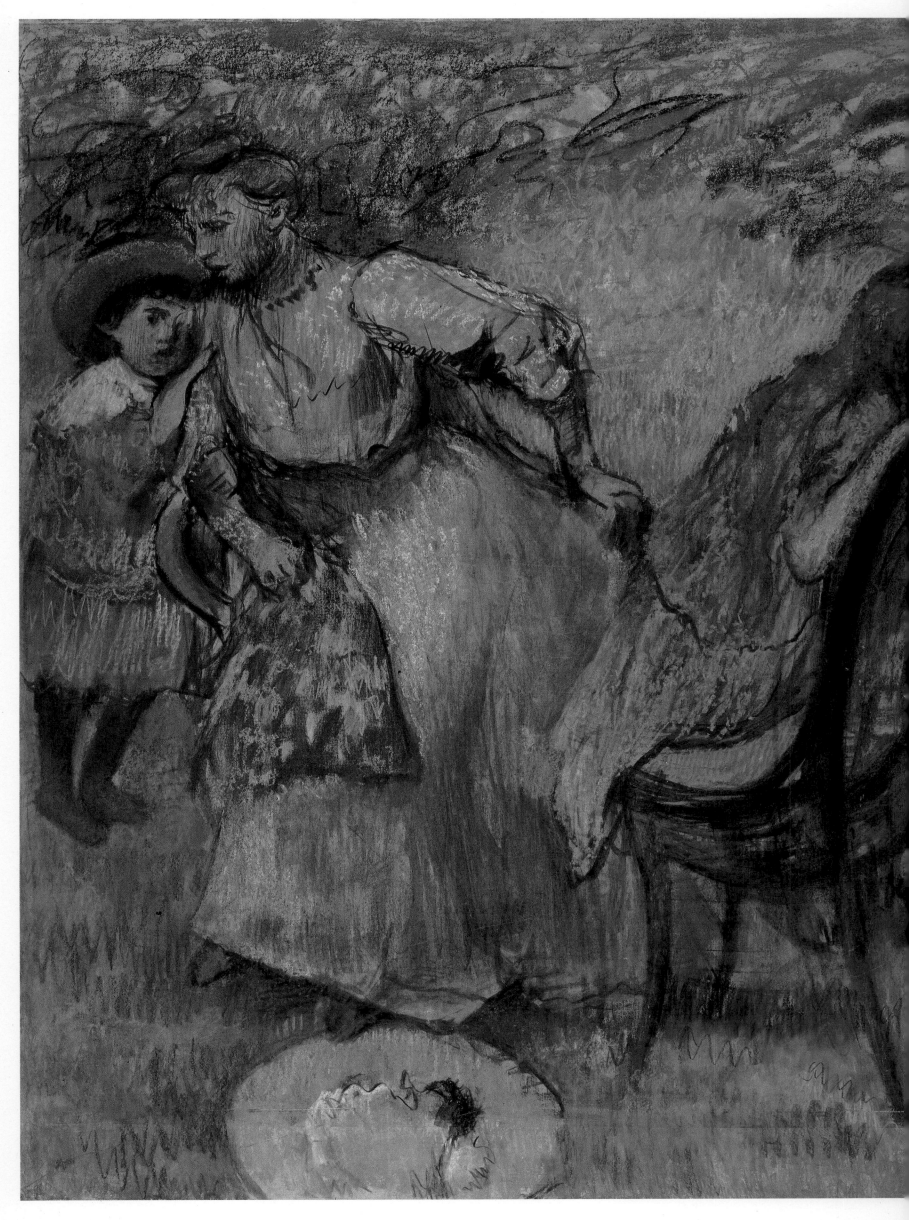

170

Madame Alexis Rouart and her Children, c.1905

Charcoal and pastel on tracing paper
63×55½ inches (160 × 141 cm)
Musée du Petit Palais, Paris

Degas's final portraits are all of the Rouart family. He grew closer to them from the early 1890s onwards; a combination of death and the Dreyfus affair eroded his circle of friends and family. In 1893 Achille, his brother, died, followed in 1894 by Paul Valpinçon and then in 1895 by his sister Marguerite. In 1897 he broke with his close friends the Halévy family because he could no longer stand the liberal pro-Dreyfus dinner table conversation of the younger members. The Rouarts, like Degas, were strongly anti-Dreyfus and he clearly felt relaxed with them. Rather pathetically he described them in 1904 as 'my family in France'.

This is Degas's very last portrait and possibly one of his last pictures. It is executed on a large scale, possibly because of his declining sight but also because he was attempting something substantial.

Lemoisne, who first catalogued Degas's pictures and who spoke with the Rouart children, wrote:

One feels that Degas tried in vain to capture a precise resemblance that kept escaping him. These sketches are the tragic witnesses of this battle of the artist against his infirmity, and the children of his old friend have not forgotten the unhappy impression that these sittings left when the admirable portraitist, endlessly increasing the size of his sketches would only be able to produce something which was almost heartbreaking. Only as a colorist could he still do some remarkable things.

The coloring is more subdued than the bathers and dancers that he was working on at the same time and in places rather thin and washed out.

Degas's final portrait of a mother and two children, instead of being a swansong image of calm and peace, is full of tension. Figures are positioned uncomfortably. The conflict which did exist between Mme Rouart and her daughter Madeleine is explicit in the latter's turning away in a sulk, while the little boy looks on apprehensively as his mother, possibly in anger, rises suddenly from her chair.

At the Milliners, c.1909

Pastel on paper
35¾×29½ inches (91×75 cm)
Musée d'Orsay, Paris

Wrestling with a recalcitrant piece of blue ribbon, a faceless milliner tries to shape it to the brim of a hat while a maid rather timidly offers a conflicting blue ostrich feather as a suggested addition. On the table are a pile of discarded or possible alternative decorations. As the image of an attempt to bring harmonic colored order out of chaos, this pastel sadly parallels Degas's own struggle to continue work with rapidly deteriorating eyesight. What makes it doubly poignant is that this stiff angular milliner should also evoke the whimsicality, good humor and lyrical elegance of the hat-shopping pictures of two decades before (pages 136 and 137), for which Mary Cassatt had posed.

With little tonal diversity to suggest depth, Degas has blocked out his pastel in flat areas rather like a chromolithographed poster. His colors are vibrant – even strident; Degas can still command, but now unsubtly and the man whose facility as a draftsman was greater than any artist of the second half of the nineteenth century is here at the end of his art.

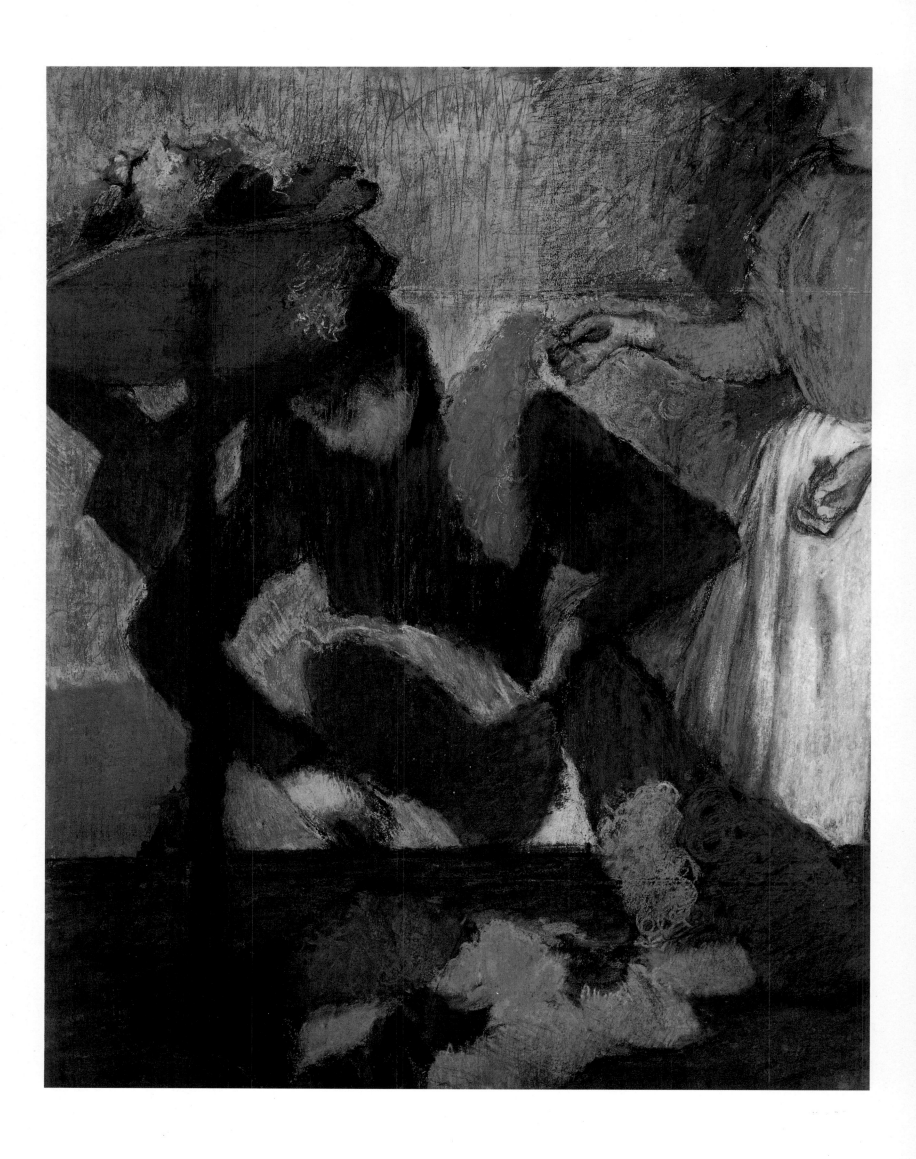

173

Index

Figures in *italics* refer to illustrations; all works of art are by Degas unless otherwise indicated.

Alexandre, Arsène 157
André Ellen *96-97*, 97
Animal Location, book by Eadweard Muybridge *19*, 155, 161
Apotheosis of Homer by Ingres *21*
Assommoir, L', novel by Zola 141
At the Milliners, 1882 *136*, 137
At the Milliners, c1909 *172-73*
Awakening Conscience, The by Holman Hunt 58

Balfour, Josephine 83, *83*
Ball at the Prussian Court 114-15
Ballet Class, The 130-31
Ballet Dancer in Position 14
Ballet Master, The 17
Ballet Rehearsal on Stage 84-85
Ballet Scene from 'Robert Le Diable', The 98-99
ballet scenes *1*, 6, 13, 14, *14*, 16, 17, *17*, 22, *56-57*, *62-63*, *74-77*, *84-91*, *98-101*, *130-33*, *138-40*, *166-67*
Balsoper by Menzel 115
Balzac, Honoré de 11
Barbizon school 146
Bartholomé, Paul-Albert 154, 156, 157, 158
Bathsheba by Rembrandt *14*
Battle of Poitiers after Delacroix, The 144-45
Battle of the Schools – Realism versus Classicism, The by Daumier *10*
Baudelaire, Charles 10, 44, 150
Beach Scene, 95, *104-05*
Bellelli Family, The, 9, *30-31*, 64
Bellum by de Chavannes 44
Billiards Room at Menil-Hubert, The 158-59
birth and family background of Degas 6
Boucher, Franois 22
Braquaval, Louis 164
brothel scenes 18, *18*, 102, 108, 109, *109*, 150

Café Concert at the Ambassadeurs 124-25, 134
Café de la Nouvelles-Athenès 20, 97
Café Guerbois 13, 14, 71, 97
Café Interior by Manet *12*
Caillebotte, Gustave 20, 61, 100
caricatures *10*, 13, 14, *16*
Caron, Rose 156, *156*
Carriage at the Races 66-67, 72
Cassatt, Mary 18, 20, 21, 22, 23, 64, 90, 123, 131, 136, 137, 143, 172
Castagnary, Jules 19
Cave, Albert 121, *121*
Caze, Louis 152
Cézanne, Paul 13, 15, 22, 47, 107
Charivari, journal 13, *16*, 128
Children on a Doorstep (New Orleans) 64, *81*, 82
Cirque Fernando *116-17*
Closier, Zöe 163
Collector of Prints, The 50-51
Communards 14, 22
Copy after Delacroix's Entry of the Crusaders into Constantinople 34
Corot, Camille 22, 146

Cotton Exchange, The, 76, *78-79*, 81
Cotton Merchants 80
Courbet, Gustave 10, 13, 57, 115
Cranach, Lucas 55
Crucifixion by Mantegna 20, 35
Crucifixion, after Mantegna 40-41

Dance Class, The, 88, *90-91*, 124
Dance Class at the Opéra 76-77, 88, 105
Dancer Standing in the Fourth Position 22
Dancer with a Bouquet 132-33
Dancing Class, The 74-75, 99
Dancing Lesson, The 138-39
Daughter of Jephthah, The 34, *35*, 41
Daumier, Honoré 10, 13, *14*, 141
Day of God, The by Gauguin 23
de Chavannes, Puvis 28, 44, 156
death of Degas 23
Death of Sardanapalus by Delacroix *9*
Degas family
 Achille, brother 6, 14, *78-79*, 79, 171
 Auguste, father 6, 15, 24, 41, *68-69*, 69
 Célestine 6, 12
 Marguérite, sister 6, 23, 48, 171 René,
 brother 6, 13, 14, 15, *78-79*, 79, 82, *82*, 83, 124, 164, 166
 Thérèse, sister 6, 12, 23, 48, *48-49*
Delacroix, Eugéne 6, 8, *9*, 22, 28, 34, 35, 43, 44, 61, 99, 139, 144, 168
della Francesca, Piero 8, *8*, 10, 39
Desboutins, Marcellin 17, *96-97*, 97
Desoye, M and Mme 50
Diaghilev, Sergei 22, 168
Diana Resting after her Bath by Boucher 22
Diego Martelli 118-19
Dihau, Désiré 12, 14, 63, 99
Dihau, Marie 18, 63
Dobigny, Emma 71, *71*
Don Giovanni, opera 140
Dreyfus affair (1894) 22, 171
Durand-Ruel, Paul 14, 15, 22, 43, 157
Duranty, Edmond 13, 70, 71, *71*, 97, 115, 118, 120, *120*, 137

Ecole des Beaux-Arts 7, 24, 32
Edmond Duranty 120
Edouard and Thérése Morbilli 48-49
Entrance of the Masked Dancers, The 140
etchings 8, *8*, 10, *10*
Evils of War, The by Lies 44
exhibition of Degas' work held by Durand-Ruel 1892 157, *see also* Impressionist Exhibitions, Salon system
Exposition Universelle 1855 7, 24, 115 1867 14, 71, 115

Fan: The Café Concert Singer 134
Faure, Elie 99, 107
Faure, Jean-Baptiste 66, 140
Fvre, Jeanne 23
Fiocre, Eugénie *56-57*, 57, 131
Florence 31, 161
Four Ballerinas Behind the Scenes 166-67
Franco-Prussian War (1870-71) 14, 72, 146

Garvani, Paul 13
Gauguin, Paul 20, 21, 22, 23, 95, 151
Gaujelin, Joséphine 75
Gautier, Théophile 57, 90, 99
Gentlemen's Race – Before the Start, The 42-43
Girl Washing her Hair above a Tub by Kunisada *11*
Goncourt brothers 13, 18, 112
 Edmond de 16, 21, 70, 88
Gozolli, Benozzo 8, 161
Grande Jatte, La by Seurat 148

Hacking to the Race 160-61
Halévy, Daniel 23, 36, 100
Halévy, Ludovic 6, 17, *17*, 18, 22, 121, *121*, 157, 171
Havermeyer, Louisine 123
Hecht, Albert 99
Hélène Rouart in her Father's Study 146-47
Herring, J F 53, 66, 71
horse racing scenes 6, 10, 13, 16, *19*, *42-43*, *52-53*, *66-67*, *106-07*, *110-11*, *160-61*
Hugues, Mlle 76
Hunt, Holman 58
Huysman, Karl 120, 123, 150

Illustrated London News, The, magazine 87
Impressionist Exhibitions 15, 128
 First, 1874 15;
 Second, 1876 64, 79, 81, 134
 Third, 1877 16, 17, 100, 105, 108
 Fourth, 1879 *16*, 120, 121, 134
 Fifth, 1880 10, 37, 120, 123; Sixth, 1881 16, 123
 Eighth, 1886 16, 148, 150, 151, 152
Impressionists 6, 7, 15, 19, 57, 65, 102, 112, 118, 134, 146, 148, 164
In the Café (L'Absinthe) 16, 71, *96-97*, 141, 153
Infant Margarita, The by Velasquez 10
Ingres, Jean 6, 7, *7*, *9*, 21, *21*, 22, 24, 31, 32, 34, 35, 48, 61, 139
Interior, *14*, *58-59*, 70, 71, 97, 112
Italy 7, 8, 24, 28, 31, 34, 35, 39, 41, 88, *see also* Florence, Naples, Rome

James Tissot 54-55, 112
Japanese woodblock prints 11, *11*, 12, 50, 55, 80, 82, 88, 97, 108, 134
Jeanniot, Pierre Georges 157
Jewish Wedding in Algiers, The by Delacroix 144
Jockeys before the Race 110-11
Journey of the Magi by Gozzoli 161

Lamothe, Louis 6, 24, 32, 55
Landscape 157
Landscape of a Small Town 158, *164-65*
landscape painting, Degas' dislike of 65
laundresses 18, 134, *134-35*, 136, 141, *141*
Legend of the Holy Cross, The by della Francesca 8
Lepic, Ludovic 17, 99
Leys, Henri 55
Lies, Joseph 44
Little Fourteen-Year-Old Dancer, The 16, *122-23*, 131
London 14, 15, 87
Lorenzo Pagans and Auguste De Gas 68-69
Louvre Museum, Paris 6, 10, 39, 41, 55, 61, 136, 137, 143, 148
Loyrette, Henry 48

Ludovic Halévy and Albert Cave 121

McMullen, Roy 44
Madame Alexis Rouart and her Children 170-71
Madame Camus 70
Madame Gobillard (née Yves Morisot) 64, 70
Maid Combing a Woman's Hair, A 162-63
Manet, Edouard 10, 11, *12*, 13, *13*, 14, 18, 22, 39, 47, 50, *60-61*, 61, 65, 69, 97, 109, 115, 168
Manet, Julie 168
Manette Salomon, novel 13, 88
Mantegna, Andrea 8, 10, *20*, 28, 31, 35, 41, 88
Martelli, Diego 118, *118-19*
Massacre of Chios by Delacroix 44
Matisse, Henri 21, 163
Meissonier, Jean 33
Menzel, Adolf 115
Merante, Louis 76, *76-77*, 88, 105
Michel-Lévy, Henri 112, *112-13*
Michelangelo 7
Millais, John 14
Miss La La at the Cirque Fernando 116-17
Mlle Fiocre in the Ballet 'La Source' 11, *56-57*, 131, 155
Mlle Hortense Valpinçon as a Child 72-73
Monet, Claude 11, 13, 14, 15, 19, 20, 21, 22, 23, 82, 102, 104, 107, 148, 157, 164
monotypes 16-17, *17*, 18, *18*, *100-03*, *108*, *109*, 121, *124-25*, 150, *157*
Moore, George 39, 87, 148, 150
Morbilli, Edouard 48, *48-49*
Moreau, Gustave 7, 8, 11, 12, 28, 34, 35
Morisots 12 Berthe 14, 15, 19, 22, 64, 168 Yves 64, 64
Morning Bath, The 150
Music in the Tuileries Gardens by Menzel 115
Musson family 12, 14, 15, 82 Estelle 82, *82*, 83, Michel *78-79*, 79, 81, 82
Muybridge, Eadweard *19*, 155, 161

Name Day of the Madame, The 109
Naples 8, 31
Napoleon III at the Battle of Solferino by Meissonier 53
Naturalists 11, 13, 15, 16, 28, 120
New English Art Club 87
New Orleans 6, 12, 15, 22, 44, 64, 76, *78-79*, 79, 80, *80*, 81, *81*, 82, 83, 136
Neyt, Sabine 88
Normandy 12, 43, 47, 66, 72, 158

Orchestra during the Performance of a Tragedy by Daumier *14*
Orchestra of the Opéra 14, *62-63*, 124

Pagan, Lorenzo *68-69*, 69
Paris 6, *6*, 9, 11, 12, 13, 14, 21, 22, 35, 41, 44, 58, 64, 72, 83, 85, 97, 115, 124, *124-25*, 134, 139, 157, 168

Paris Commune (1871) 14, 72
Paris Opéra 16, 17, 38, *56-57*, *62-63*, 75, *76-77*, *84-89*, 90, *98-101*, 115, 121, 123, *130-33*, 139, *140-41*, 156
Pedicure, The 83, 153
Perrot, Jules 88, 90, *90-91*
Picasso, Pablo 21, 109
Pieta by Delacroix 35
Pissarro, Camille 14, 19, 20, 22, 61, 115, 118, 148
plein-airism 13, 19, 57, 104
Portrait of Emile Zola by Manet *13*, 50
Portrait of Henri Michel-Lévy 112-13
Portrait of Monsieur and Madame Edouard Manet 60-61
Portrait of Rose Caron 156
Pothey, Alexandre 108
print-making 8, 16-17
Prune, La by Manet 97

Racecourse, Amateur Jockeys, The 106-07
Racehorses before the Stands 52-53, 134
Raffaelli, Jean François 19, 20
Raphael 7
Rape, The 58-59
Realism 10, 11, 13, 14, 19, 20, 24, 26, 28, 36, 47, 61, 66, 70, 71, 87, 88, 97, 115, 118, 137, 141, 144, 146, 154
Rearing Horse 155
Reff, Theodore 50, 158
Rehearsal, The 88-89, 110
Rehearsal of the Ballet on the Stage 1, *86-87*
Rembrandt 8, *8*, *16*, 24, 152
Renoir, Auguste 13, 15, 19, 20, 21, 22, 82, 107, 109, 112, 144, 148
Rewald, John 161
Robert Le Diable, ballet *98-99*
Roman Beggar Woman, A 26-27
Rome 7, 26, 32
Rossetti, Dante 28, 58
Rouart family 18, *170-71*, 171 Henri (Degas' friend) 22, 104, 146 Hélène, Henri's daughter 146, *146-47*
Russian Ballet 22, 168
Russian Dancers 168-69

Salon state-sanctioned system 9, 14, 19, 20, 28, 34, 35, 44, 55, 70, 112
Scenes of War in the Middle Ages 9, 14, *44-45*, 93
Schmetz, Jean-Victor 26
sculpture by Degas 21, 22-23, *122*, 123 155, *155*
Seascape 65
Self-Portrait 24-25
Semiramis Building Babylon 38-39
Seurat, Georges 144, 148
Sickert, Walter 87, 112, 118, 143, 144, 148
Singer with a Glove 128-29
Sisley, Alfred 13, 15, 19
Song Rehearsal, The 15, 82
Source, La, ballet *56-57*, 99, 131

Star, The 100-01, 132
Steeplechase, The 14, *19*
Stubbs, George 161
Study of a Nude 32-33
Sulking, 14, 53, 71, 97, 120
Sultan on Horseback by Delacroix 35
Symbolism 28, 144, 146, 156
Symphony in White No.3 by Whistler 11, *12*, 57, 70

Thérése Raquin, novel 58
Three Girls Bathing 94-95
Tissot, James 10, 14, 15, *54-55*, 55, 79, 80, 87, 134
Toulouse-Lautrec, Henri de 63
Triumph of Caesar by Mantegna 35
Tub, The, 1886 *151*
Tub, The, 1889 *154*
Turner, Francis Calcraft 66
Two Portrait Studies of a Man 7

Uncle and Niece 126-27
United States 14, 15, 76, 85, *see also* New Orleans

Valodan, Thérése *126-27*, 127
Valpinçon Bather, The by Ingres 7
Valpinçon family 12, 18, 43, 72, 158
 Paul (Degas' friend) 6, 12, 47, 66, *66-67*, 158, 171
 Edouard, father 7, 24 Henri, son 66, *66-67*, 72, 158
 Hortense, daughter 72, *72-73*, 158
van Goethem, Maria *122-23*, 123, 131, 138
Van Gogh, Theo 47
Van Gogh, Vincent 18, 22, 47, 87
Velasquez, Diego 10, *10*, 26, 61, 88
Villa Medici 7, 26, 32
Visit to a Museum 142-43
Vollard, Ambroise 21, 22, 34, 53, 61, 65, 104, 112, 121, 155

Waiting for the Client 18
Whistler, James McNeill 11, *12*, 21, 55, 57, 64, 70, 75, 93, 134
Woman at her Toilette 102-03
Woman Bathing in a Shallow Tub 148-49
Woman Having her Hair Combed, A 152-53
Woman in Blue, The by Corot 146
Woman Ironing, 1882 134-35
Woman Ironing, c.1884 134, *141*
Woman Ironing, c.1890 153, 156
Woman on a Terrace 28-29
Woman with Chrysanthemums, A 2, *46-47*
women, Degas' attitude to 18-19, 109
Women Combing their Hair 92-93
Women on the Terrace of a Café 108

Young Man in a Velvet Cap by Rembrandt 8
Young Spartans (also called *Young Spartan Girls Taunting Boys*) 10, *36-37*, 123
Young Woman and Ibis 28-29

Zola, Emile 11, 13, *13*, 50, 58, 79, 80, 120, 141

Acknowledgments

The publisher would like to thank Martin Bristow, the designer; Mandy Little, the picture researcher; Jessica Orebi Gann, the editor; Pat Coward, who prepared the index; and the museums, individuals and agencies listed below for supplying the illustrations.

Albright-Knox Art Gallery/Charles Clifton, Charles W Goodyear and Elisabeth H Gates Funds: page 156

The Art Institute of Chicago: Helen Birch Bartlett Memorial Collection, page 23(top); Mr and Mrs Lewis Larned Coburn Memorial Collection, page 126

The Barber Institute of Fine Arts, University of Birmingham: pages 12(bottom); 111

Bibliothèque Nationale, Paris: page 6

Birmingham Museum and Art Gallery: page 27

The Brooklyn Museum, New York: page 56-7

The Burrell Collection, Glasgow Museums and Art Galleries: pages 88-9; 120

Calouste Gulbenkian Foundation: page 113

Dumbarton Oaks Research Library and Collection: page 82

Fogg Art Museum, Harvard University Art Museums/Bequest of Meta and Paul J Sachs: page 12(top); 15(left)/Gift of Herbert N. Straus Esq: page 80

Galerie Nathan: page 144-5

The J Paul Getty Museum: page 23(bottom)

Graphischen Sammlung Der Staatsgalerie Stuttgart: page 17(top)

Harvard University, Bequest of Maurice Wertheim, Class of 1906: page 129

Hill-Stead Museum, Farmington, CT: page 151

Kingston-upon-Thames Museum and Heritage Centre: page 19(top both)

Kitakyushu Municipal Museum of Art, Japan: 60-1

Kupferstichkabinett der Staatlichen Kunsthalle, Karlsruhe:page 134

Collection Stephen Mazoh: page 29

Collection of Mr and Mrs Paul Mellon, Upperville, Virginia: page 122

Metropolitan Museum of Art, New York/Mr and Mrs Richard J Bernhard Gift, page 157/Bequest of Mrs Harry Payne Bingham, page 90-1/Gift of Horace Havemeyer, 1929. The H. O. Havemeyer Collection, pages 1, 86-7/Bequest of Mrs. H. O. Havemeyer, 1929. The H. O. Havemeyer collection, pages 2, 46-7, 51, 64, 71, 74-5, 152, 155, Robert Lehman Collection, pages 164-5, 168-9/ Rogers Fund, 1922, pages 14, 54

The Minneapolis Institute of Arts/John R. Van Derlip Fund: pages 72-3

Musée des Beaux-Arts de Lyon: page 125

Musée des Beaux-Arts, Pau: 78-9

Musée des Beaux-Arts, Tours: 40-1

Musée du Louvre, photo (c) Réunion des Musées Nationaux: pages 7(bottom); 9(bottom); 16(bottom); 18; 20

Musée d'Orsay, photo (c) Réunion des Musées Nationaux: pages 9(top); 13(bottom); 15(right); 21(top); 22(both); 25; 30; 38-9; 42-3; 44-5; 52-3; 62; 65; 68; 76-7; 83; 84-5; 96; 101; 106-7; 108; 121; 141; 149; 173

Musée Picasso, photo (c) Réunion des Musées Nationaux: page 109

Musée de Strasbourg: page 114

Musée de la Ville de Paris, Photothèque: page 170

Museum of Art, Rhode Island School of Design: pages 132-3

Courtesy, Museum of Fine Arts, Boston: Lee M. Friedman Fund, page 8(bottom)/Gift of Robert Treat Paine, page 49/1931 Purchase Fund, page 66-7/Gift of Mr and Mrs John McAndrew, page 142

National Gallery of Art, Washington: Rosenwald collection, page 17(bottom)/Chester Dale Collection, page 70/Collection of Mr and Mrs Paul Mellon, page 135

The Trustees of the National Gallery, London: pages 36-7; 104-5; 116; 147; 162-3

National Gallery of Scotland: page 119

Norton Simon Foundation: page 102-3

Ordrupgaardsamlingen, Copenhagen, photo Ole Woldbye: page 81

Henry and Rose Pearlman Foundation, Inc., on loan to the Art Museum, Princeton University: page 150

Philadelphia Museum of Art: The Henry P McIlhenny collection in memory of Frances P McIlhenny, pages 58-9/W P Wilstach Collection, page 130

The Phillips Collection: page 92-3

Private Collection, photo courtesy James Kirkman Ltd: 94-5

Private Collection, on loan to Kunsthaus Zurich: page 34

Scala/Arezzo Chiesa di San Francesco: page 8(top)/Pushkin Fine Art Museum, Moscow, page 167

Staatsgalerie Stuttgart: page 158

Sterling and Francine Clark Art Institute, Williamstown, Massachusetts: pages 7(top); 19(bottom); 138-9; 140

Smith College Museum of Art, Northampton, Massachusetts: Purchased 1933, page 35

Thyssen-Bornemisza Collection: page 137

Victoria and Albert Museum, London: page 98-9

Vincent Van Gogh Foundation/National Museum Vincent Van Gogh, Amsterdam: page 11(bottom)

Von der Heydt Museum, Wuppertal: 32-3

Walker Art Gallery, Liverpool: page 153

Weidenfeld Archive/Bibliothèque Nationale: page 21(bottom)

From the Collection of Mrs John Hay Whitney: page 160-1